"Bringing a new perspective and pr[...] concept of 'Orientalism,' Adam Gec[...] introduced 'Transorientalism.' His intent[...] Occident, West and non-West. He insists 'shifting boundaries' exist within what we have thought as 'globalization' and provides compelling world examples. Geczy pushes readers to question ideas of identity for individuals and cultures about what is fixed, fluid, and hybrid. Geczy proposes we view 'culture and identity as a balance between what has been imposed and what has been created.'"
Joanne B. Eicher, Editor-in-Chief, *Berg Encyclopedia of World Dress and Fashion*, and University of Minnesota, USA

"In a sweep from West to East Asia through a number of its visual cultures, as different as Turkish fashion and urban-based Indigenous art, Adam Geczy unpacks a matrix of insurgent aesthetic strategies through which local values have creatively engaged with global currents. He is equally adept at sweeping up into his critical vision the many manoeuvres of contemporary theory as if they are so many specialised weapons to blast structuralism's straightjackets. This is a new voice in a rewarding trend of criticism that, following Edward Said's seminal study of orientalism 40 years ago, deconstructs the East/West binary in productive ways that return agency to those it othered."
Ian McLean, University of Melbourne, Australia

"Geczy's coinage of Transorientalism is very much of the moment and defines the new Orientalisms of the global new millennium. Erudite, lucid, sensitive and eloquent, the depth of its research and the intellectual range is impressive. It fulfils on its ambitions in a way that few scholars could achieve. Fashion, film and art are used as lenses for the means by which cultural identities are shaped, and re-shaped. There have been many books on cultural formations and on transnational aesthetics, but none like this. This will prove to be an essential resource and a highly influential text for many years to come."
Melissa Chiu, Director of the Hirshhorn Museum, Washington, USA

TRANSORIENTALISM IN ART, FASHION, AND FILM

TRANSORIENTALISM IN ART, FASHION, AND FILM

Inventions of Identity

ADAM GECZY

BLOOMSBURY VISUAL ARTS
LONDON • NEW YORK • OXFORD • NEW DELHI • SYDNEY

BLOOMSBURY VISUAL ARTS
Bloomsbury Publishing Plc
50 Bedford Square, London, WC1B 3DP, UK
1385 Broadway, New York, NY 10018, USA

BLOOMSBURY, BLOOMSBURY VISUAL ARTS and the Diana
logo are trademarks of Bloomsbury Publishing Plc

First published in Great Britain 2019
Paperback edition first published 2020

Copyright © Adam Geczy, 2019

Adam Geczy has asserted his right under the Copyright,
Designs and Patents Act, 1988, to be identified as Author of this work.

For legal purposes the Acknowledgements on p. xii constitute
an extension of this copyright page.

Cover design by Adriana Brioso
Cover image: Bahram (Villains), from The Book of Kings series, 2012.
(© Shirin Neshat. Courtesy the artist and Gladstone Gallery, New York and Brussels.)

A catalogue record for this book is available from the British Library.

A catalog record for this book is available from the Library of Congress.

ISBN: HB: 978-1-3500-6014-2
PB: 978-1-3501-7533-4
ePDF: 978-1-3500-6015-9
eBook: 978-1-3500-6016-6

Typeset by RefineCatch Limited, Bungay, Suffolk

To find out more about our authors and books visit
www.bloomsbury.com and sign up for our newsletters.

To Ulrika

"Thou by the Indian Ganges' side/ Shouldst rubies find"

CONTENTS

ILLUSTRATIONS

ACKNOWLEDGMENTS

I would like to thank the many artists that have assisted with their time and generosity in this project, including Halil Altindere, Ghada Amer, Blak Douglas, Mona Hatoum, Servet Kocyigit, Tracey Moffatt, Nasim Nasr, and Shirin Neshat. Thank you also Alan Cruickshank for your support and advice and of course my close colleague Vicki Karaminas. I am grateful to Rey Chow for several invaluable comments and insights. To my sons, Marcel and Julian for their ongoing curiosity and interest in my projects. Thank you to my place of work, Sydney College of the Arts, of the University of Sydney. This project was also generously supported by a grant from Visual Arts Board of the Australia Council for the Arts.

INTRODUCTION

We are thankful to the Chinese for the long, quiet, soothing and uniform streets, where house after house stands blue and modest in a still blue row, and where each holds and acknowledges the other, at least as fine and as discrete as in Paris. We are thankful to the English for the wide, beautiful, clean and comfortable pathways, the graceful garden precincts, and the wonderful tree plantations, which are perhaps the most beautiful in all Singapore.

HERMANN HESSE[1]

In 1911, at the age of thirty-four, Hesse traveled across South-East Asia and India. While this may have been some typical act of European bourgeois fascination or rite-of-passage in the Orient, these travels had special resonance for him, as his grandparents had served on a Protest Mission earlier in the previous century, his mother having been born there in 1842. The musings, recollections, and essays of his travels have the shared characteristic of needing to find a penetrating and sympathetic insight, although lapses were inevitable.

As someone in almost perpetual transit, Hesse alighted upon the way in which the towns, ports, and cities he visited were diverse, always in flux, and a confluence of influences that belied strict generalization. In one of his travelogues he observes the wayward course of cultural authorship in the manufacture of textiles. In this quotation he is writing from Singapore, a nexus of many cultures, and an early example of what we today call a multicultural nation. He sees

beautiful, dark, noble-looking people in the very same screaming, bright, relentlessly motley costumes, much like local masked balls given by young, spirited shop assistants—true caricatures of local costume! The smart merchants from our West have made Indian silks and linens dispensable by dyeing cotton and printing calico much brighter, more Indian, more gay, wilder, more pungent [*giftiger*], than had before been seen in Asia, and the good Indians together with the Malaysians become welcome customers and carry

on their bronzed hips the cheap, lurid [*farbengrellen*] fabrics from Europe. Ten
of these Indian figures are enough to make a populous street stir with color, in
one go turning it into an inauthentic "Orient".[2]

This is more than just economic imperialism at work. The English found they had
to adapt and deploy their own economy or otherwise be at the whims of overseas
markets. And one would have to read more of Hesse's travelogues and
observations to palliate what here reads as traditional imperialist snobbishness
and superiority. There are two things to be gleaned from this passage at this
stage, and that is not only the accurate observation that the Orient has the Orient
sold back to them—much as China is now selling the West back to the West.

The second is the slip of calling the Orient "inauthentic," a point that is
elucidated in an essay from shortly afterward, entitled "Singapore Dream" in
which he dilates on the amorphousness of the Orient, which is a symbol of
captivation and escape. In this case the word is "Asia": "Asia was not a part of
the world but rather a very specific yet mysterious place, somewhere between
India and China. From there was the wellspring of cultures; from there were the
roots of all of humankind and the dark wellspring of life; there stand the images
of Gods and the tablets of law."[3]

It was Hesse who was one of the leading figures to make the Orient mean for
the West a passage of self-discovery, in which authenticity is spiritual and ethical
rather than material. His *Siddhartha* (1922), a German language parable mirroring
the story of Buddha, would become to the hippie and yippie generation of the
late 1960s and the 1970s what Nietzsche's *Thus Spoke Zarathustra* (1883–
1891) was for troops of the First World War, a rally to conduct and action, a tract
that promised to salvation through perseverance and self-transformation. But
more compellingly, Hesse also reached audiences in India and other parts of the
"Orient." These twists, in which authenticity occurs across cultures, are at the
crux of what can be called transorientalism.

It was at about the same time as Hesse's popularity flourished in the United
States and other Anglophone cultures that Edward Said began working on his
critique of the Western observer's colonization of the East. Since his
groundbreaking and still debated book, *Orientalism* (1978), "Orientalism" has
had a decidedly problematic ring. Said emphasized that colonization occurred
both physically and mentally. The compelling nature of this hold is that of what
Said calls authority, and "authority must in large part be the subject of any
description of Orientalism."[4] In Said's persuasive hands, colonial countries—
primarily Britain and France—are responsible for shaping negative and limiting
images that have affected whole modes of thought, policies, and the colonized
themselves. Orientalism began as a philological and archaeological field of study
in Europe and evolved in America after the Second World War into "attitudes of
cultural hostility."[5]

Said's words sound like a prophetic philosophical template for recent events, such as when, on November 8, 2016, the newly inaugurated President of the United States, Donald Trump, sought to place a ban on Muslim countries deemed a national security risk, a measure affecting over 200 million people, and placing all manner of people in confusion and peril. The proscription was blocked, but the egregiousness of the attempt had immeasurable effects. History can be written as a narrative of the way borders are enforced and expanded, but at the beginning of the twenty-first century, such a dramatic stance in the name of national security by the self-proclaimed leader of the democratic world, the nominal upholder of liberal values,[6] was shocking not only for its violence but for what would ramify from it. It was above all an unequivocal sign that Islam, but also the "Orient," continued to be a locus of alarm as much as it had always been of fascination. Trump's edicts were also very much in a venerable vein of anxiety over the "Orient" that conflated geography with unverifiable, unqualifiable generalizations about whole social groups. But while it had much in common with extremist xenophobia and brash *Fuhrerprinzip* authoritarianism, the more different and nuanced conditions remain obscure, as they do with actions that appear so clear-mindedly simple.

Although the evidence for upholding Said's notion of the power for the Orient is compelling, where Trump's jaundiced position is just one among many—including the mass hysteria over refugees from Syria, Libya, and many more besides—its breadth of critique tends to be as limited as those of the ideological extremists it deplores. This is not to say that Said's message is not without its merits, far from it. It is a message that places a writer like Hesse as one who plunders the East, expresses his veneration for its ways, yet returns to the comforts of his home in safe and salubrious Switzerland. Said would later temper his position in *Culture and Imperialism* (1993) in light of revisionist cultural perspectives, many of which pledged their debt to his earlier work. As a result also of changes in contemporary history (the book was published after Perestroika for example), Said reflects that, "For the first time, the history of imperialism and its culture can now be studied as neither monolithic not reductively compartmentalized, separate, distinct."[7] Said goes on to acknowledge the "separatist and chauvinistic" discourses of countries such as India and Lebanon, but argues that these are salutary expressions of the need to escape domination.[8] (How one would apply this argument to fundamentalist movements such as ISIS, despite the responsibility of the United States in abetting them, would be much harder to formulate.) At the end of the introduction, Said states that he writes from the United States as a Palestinian educated in the West. He admits: "Ever since I can remember, I have felt that I belonged to both worlds, without being completely of either one or the other. During my lifetime, however, the parts of the Arab world that I was most attached to either have been changed utterly by civil upheavals and war, or have simply ceased to exist."[9] In his "Reflections on Exile," Said calls on the

twelfth-century Saxon monk, Hugo of St Victor: "the man who finds his homeland sweet is still a tender beginner; he to whom every soil is as his native one is already strong; but he is perfect to whom the entire world is as a foreign land."[10]

The new perspective of Said, and the subsequent generations of the newly formed discipline of postcolonial theory, can perhaps be encapsulated by parsing the second sentence and replacing "however" with a word like "furthermore" and "moreover," for the "however" insists on a kind of essentialism whose contours are more and more eroded.[11] This changed perspective is eloquently and poignantly summarized by the Nigerian-born New York-based writer Teju Cole in his essay on James Baldwin:

> I disagree not with his particular sorrow but with the self-abnegation that pinned him to it. Bach, so profoundly human, is my heritage, I am not an interloper when I look at a Rembrandt portrait. I care for them more than some white people do, just as some white people care more for aspects of African art than I do.[12]

He acknowledges such shifts in attitude as residual from the sorrow of Baldwin (or Said's anxiety). It is as if his own sense of balance is an after-effect of their suffering, a suffering that had to transpire against the backdrop of turpitude. He is content to embrace multiple worlds with equanimity:

> There is no world in which I would surrender the intimidating beauty of Yoruba-language poetry for, say, Shakespeare's sonnets, or one in which I'd prefer chamber orchestras playing baroque music to the koras of Mali. I'm happy to own all of it. This carefree confidence is, in part, the gift of time. It is a dividend of the struggle of people from earlier generations. I feel little alienation in museums, full though they are with other people's ancestors.[13]

Such deliberations are far from unique, but rather encompass a new contemporary social, racial, and ethical standard, what Cole elsewhere calls "in-betweenness."[14] Instead of being outside, it is one of belonging to the fold of more than one place or idea.

In a similar vein, Chinua Achebe, writing about postcolonial writer's use of English, also quotes Baldwin and his "quarrel with English." Baldwin saw himself as a conduit, an imitator of a language not truly his own. To this, Achebe counters: "Baldwin's problem is not exactly mine, but I feel that the English language will be able to carry the weight of my African experience. But it would have to be a new English, still in full communion with its ancestral home but altered to suit its new African surroundings."[15] More than any language, not only in its susceptibility to idiom, but because of the colonial dominance of Britain, there is more than one English, and the many global literatures can attest to that.

Thus Cole's comfortable in-betweenness and Achebe's contented "communion" of his identity in the language of another are a site of activity and belonging different from that of the downhearted exile. Unlike their predecessors, their belonging is not experienced as a yawning, consuming crevasse, but contrarily as a place of mobility. That does not mean that there are not still exiles cut from similar cloth as Said, as there are many. It is simply to state that race and identity have more moving parts than ever before, and Said's example can be used as a marker within a landscape that has more than one horizon.

The word "transorientalism" is one that I coined in my book *Fashion and Orientalism*[16] for precisely these manifold circumstances, to get out of the more binary logic of Orient and Occident, as well as the opprobrium and guilt that subtends from the word "Orient." It provides for the mobility of identity and anticipates the shifting boundaries. Said ventures into this territory when he states that he cannot "condone" reactionary positions that, for example, "require Arabs to read Arab books, use Arab methods, and the like. As C. L. R. James used to say, Beethoven belongs as much to West Indians as he does to Germans, since his music is not part of the human heritage."[17] But when Cole confesses to feeling perfectly at home in foreign worlds, without guilt or hesitation, then a new dimension has been reached altogether.

Yet the diverse channels in which ownership is forfeited to the softer term of influence come at a price. For ownership belongs to belonging, and the securities that that may bring. Just before his death in 2003, Said confessed: "I still have not been able to understand what it means to have a country."[18] As Tony Judt avers, it is ironic that the intellectual that upheld and represented such strong views about reclaiming sovereignty against the perennial failure of Euro-America to understand the fate of colonialized and diasporic nations should himself have such heterogeneous and displaced origins. For

Edward Said lived all his life at a tangent to the various causes with which he was associated. The involuntary "spokesman" for the overwhelmingly Muslim Arabs of Palestine was an Episcopalian Christian, born in 1935 to a Baptist from Nazareth. The uncompromising critic of imperial condescension was educated in some of the last of the colonial schools that had trained the indigenous elite of the European empires; for many years he was more at ease in English and French than in Arabic and an outstanding exemplar of Western education with which he could never fully identify.[19]

An empirical, materialist logic of common sense would have the opposite. That is, the best defenders, the best witnesses of a cause are those with the most authentic relationship to it, its language and its lore. But what if the opposite was just as true? And what if this condition, while always existing as an outlier in the endlessly protean re-shaping of discourse that is the life of languages and

civilizations, is especially pertinent to what Judt calls "the age of displaced persons,"[20] but also the age of multi-layered and multiple identities effected by globalization?

It is the contradictions at the heart of Said's own conditions that require definition as no longer an exception but something more substantive. Hence "transnationalism" is a word, married to the idea of globalization, germane to the abstractions of identity, and the name for cross-cultural exchange on a social, economic, and political level. Philosophically, it is leveled at those people that Judt, commenting on Said, calls "always at a slight tangent to his affinities." "Transorientalism" is tethered to this notion of exchange—a term that has tended to replace the former one of the West plundering from the Orient—while retaining the more ideological volatile word "Orientalism," which enshrines presumption with desire for the exotic. It also contends that the gaze is not focused in one direction, for as this book will argue and recount in many ways, the gaze is a double helix or a room of mirrors, no less than when people, most conspicuously artists, designers, and writers, train the gaze on themselves, participating in their own "Orientalisation" usually in places outside of their assumed identity. Or they can have mixed identity: the late literary and cultural theorist, Ihab Hassan would frequently announce during his public lectures that he could speak several languages, all with a foreign accent.[21] "For identification," notes Homi Bhabha, "identity is never an a priori, nor a finished product; it is only ever the problematic process of access to an image of totality."[22] Globalization, over-population, recurring major refugee crises, mounting ecological threat—including to social ecologies—have brought the nature of the "problematic process of access" unerringly to the fore.

Before the age of naval travel and exploration from the late fifteenth century, still less from an overpopulated populated and digital world, the lines of ethnicity were, relatively speaking, much easier to define. Migrant, émigré, or exile, the notions of having been born in one country while residing in another, or of identifying with one country more than another, while mixed up with all the incommensurabilities of human knowledge and experience, were relatively easy to grasp. But once cultural identity is transacted in language, art, design, and other means of communication, then what had existed in a limited sphere of definition now reaches outward into spaces that are well outside borders or the delimitations of physical bodies. For one of the distinguishing features of early modern European culture was the rise of masquerade, and the consciousness that wearing the clothing of the other had a redemptive or transgressive power, harnessing the virtues of the spirit or amplifying the pleasures of the flesh. But it is only very recently that scholars, as well as artists and designers interested in the negotiation of otherness, have come to be conscious of the fluidity of the way identity is represented and asserted. What an individual deems as essential to his or her culture has usually multiple, and often quite irregular, roots. The vicissitudes

and back-flips in visual identifiers of race and identity can be very challenging, as they are material examples of the way in which a "stable" cultural identity is really an agglomerate of signs, which, as with any linguistic system, are in the constant process of modification and change. This is no different from basic subjectivity: the idea of a stable individual self is in fact constituted by change itself. Claims to cultural orientation always occur between the individual representative objects that act as signifiers of inheritance and belonging.

However, it may be astonishing to know that many of these signs originated in places remote from those with which they are associated. Perhaps the most universal example is a souvenir made in China when not a souvenir of China. Well-known examples that spring immediately to mind include: the way that the Tree of Life motif has been claimed alternately by both Indian and Chinese designers; the Willow pattern on ceramics, which was not conceived in China but in the West Midlands of England around 1790; and, most dramatic of all, the case of the pattern we identify as paisley, which derives its name from the Scottish town known for its textile mills where the Indian *buta* was developed, and which in recent times has been renationalized in India, but heavily inflected by the modifications that it underwent while appropriated in Britain.

Civilizations, and the concepts of nations that subtend from them, define themselves as much according to their rules and qualities as in terms of what they are not. The illusory autonomy of a nation is in fact only made accessible, meaningful, and whole according to its antagonisms, namely foreigners, the generic "Jew," refugees—what in earlier times were called the barbarians, *barbaroi*, an inelegant designation for anyone of foreign language and custom.[23] Appropriately enough, the word's current meaning carries a distinctly aggressive connotation. While the period after the Second World War was one of an extraordinarily fluid, and in most cases generous, flow of nationalities, the present era has witnessed an ever-increasing intolerance of migrants, and especially refugees.

With rare exception, it is the nature of nationalism to fight and obscure any signs of unity, when such unity is either a sham or short-lived. This is no better demonstrated in modern times than with the Edward Gibbon's great and still lasting magnum opus, *The History of the Decline and Fall of the Roman Empire* (1776–1789). In the words of Norman Davies, "Its magnificent narrative demonstrates that the lifespan even of the mightiest states is finite."[24] The mightiest states are finite because cultures are porous. Where they do not perish they are remade. The two most salient examples of this in recent memory are Japan and Turkey. The Meiji era of Japan opened its doors to the rest of the world but in a tactical way, seeking ways of modernizing and superseding a West that they perceived was overtaking them. In this process, half the population, the men, adopted Western dress and what were perceived as other masculine forms of consumption and deportment such as drinking alcohol and smoking cigars.

But while the men were largely Westernizing, the women were effectively "re-Orientalized," encouraged to wear more vivid and flamboyant clothing than they had worn before. It is as if the swiftness of these changes entered into the national pathology which, while clinging sternly to traditions, is also highly adept at responding to modern constructs as in the *kawaii* ("cute") phenomenon of the last thirty years or so, and the still growing cult of cosplaying.

But from this more contemporary vantage point of the last thirty or so years, the kinds of transformations that have occurred are harder to place into firm contours because of the many effects of globalization. Japan and Turkey could carry out their reforms because of a still credible and conceivable historical view of what the nation was and had been, its borders (albeit a contested issue in Turkey), its history, and its other constituents. Our time, observes Peter Sloterdijk is "a story of space 'revolution' into the homogeneous outside. It undertakes the explication of the Earth, insofar as its inhabitants are capable of grasping, that the categories of what it means to have direct neighbors no longer suffices in order to interpret the nature of living together with other people."[25] Sloterdijk describes Marshall McLuhan's "implosion" of the world but on a much larger and more intricate scale. He also invokes Martin Heidegger's "Age of the World Picture."[26] In our time the place where we live is just a material necessity for the purpose of gaining access to any number of different places and people. To envisage an open world, however, is different from one without borders, as it is precisely these borders that allow people to make sense of difference as they cross them physically, in cyberspace, or in their imagination.

Yet to see these shifts as neutral or benign is to be thoroughly mistaken and naïve. "Globalization" is a term used unreservedly by politicians, businessmen, and journalists, and usually for the flow of capital. One distinct component of transorientalism is the acknowledgment of peoples who neither know nor care of the ideological issues at stake in postcolonialism, nor have time to pause to do so. The underclasses have no means to cross borders, physically or virtually. Sloterdijk makes the challenging but tenable point that a globalization generates the "Globus" or "globe," a region of in and out: those who have the privilege to inhabit it and those outside. Globalization is not about the distribution of capital but the opposite, its containment.[27] Teju Cole, for all his salutary containment within Western culture and mores, is aware of occupying several cultural positions. He is cognizant of his privileges, is still voluble about racism, and keenly aware of the widening economic and cultural inequities at the heart of globalization: "The genuine hurt of Africa is no fiction."[28] These observations, or convictions, are essential. And while they inhabit the shadows of this book, and for the moment serve to explain the conditions under which "East" and "West" continue to exist, they are not limited to geographic co-ordinates. Rather one stands for "exotic," the other "prosperous," one "despotic," the other "liberal." On a factual level, to argue for the accuracy of these terms is preposterous, yet

they are divisions that in many ways are essential to one another, just as Indigenous and non-Indigenous are in fact the name not so much of a binary but two terms within one method of identity economy.

This means that identity, and how it is expressed in art, is not as easy to locate and we must find new tools and terms of reference with which to discuss it. Cross and dual nationals have of course existed with migration, which became especially noticeable after the World Wars and the Depression of the last century. But there are now altogether new kinds of identities to complement the old virtual identities, and identities that exist across cultures, hence the increasing currency of the term "transnationalism." An émigré can feel like an exile, such as an Irishman in the early twentieth century who still wholeheartedly considered himself Irish. Then there was the term, popular in the 1980s and 1990s of having a "hyphenated" identity such as Chinese-American or Asian-Australian. More recently the relationship can be better thought of with an ampersand, "&," wherein identities exist concordantly or parallel to one another, where the individual thinks of him or herself less as a blend or a composite, but as existing in different frameworks at different times. Some of these are material and cultural, or they can be molded through individual will as aliases and invented entities online or as cosplay personas.

Or then there can be a cultural persona that is nourished by another culture—it cannot exist as such except in a different domain. Arguably the most striking visualization and enactment of this is in the case of women artists from the Middle East who live and thrive in London, New York, and elsewhere (Sydney, Paris). At the beginning of the twentieth century—not so long ago—women in developed and "Christian" countries were still discouraged from becoming artists, and the opportunities for studying art were severely hampered by the restrictions on what was deemed acceptable to draw, paint, or sculpt. The nude was out of reach, except perhaps in the form of plaster copies of classical sculptures. Such circumstances on a far more constrained scale pertain in countries such as Iran and Saudi Arabia. Art still exists under the shadow of the traditional Islamic prohibition of sacred imagery, and so for a woman to attempt any kind of image for her own sake is likely to be considered a double blasphemy. Art exists in such places either as historic artifacts, or as investments purchased from the West, but "Contemporary art," which is supposed to be experimental and critical, is culturally anathema. Middle Eastern women artists living abroad, such as Shirin Neshat and Ghada Amer, both of whom currently reside in New York, are only allowed free expression of their culture in a city remote from it. Another famous example is Mona Hatoum: a Lebanese-born artist who identifies as Palestinian and lives in London. You cannot get more transoriental than that. (There are naturally many other instances that are not confined to the Middle East.) These artists and their work and others will be examined in detail later in the book.

What is also noteworthy is that "East" and "West" are not traditional binary concepts but highly labile terms. It cannot be over-stated that the Orient is a

highly incoherent concept that embraces more a feeling than a tangible place. The same can be said to apply to the "Oriental's" embrace of the West. This latter relationship is gnomically encapsulated by Orhan Pamuk in an essay on André Gide. Here he relates how Ahmet Hamdi Tanpinar, whom he suggests was the most eminent Turkish writer to have admired Gide in his lifetime, expressed elation when Gide won the Nobel Prize in 1947. Tanpinar's response, Pamuk explains,

> can be better understood if we remember that the Westernizing intellectual depends on an ideal of the West rather than the West itself. Even if he is someone who regrets the loss of traditional culture, the old music and poetry, and the "sensitivity of former generations," a Westernized intellectual like Tampinar can only criticize his own culture and can only move from a conservative nationalism to a creative modernity to the extent that he clings to a fairy-tale image of an ideal Europe or the West. *At the very least, this grip allows him to open up an inspiring and critical new space between the two*.[29]

The observation at the end of this statement is crucial, as it destabilizes any belief in cultural autonomy, and instead recognizes that although the West had been held as a kind of gold standard of culture, it was through the coupling of the two, and the difficulties involved in such a coupling, that new ideas and entities could emerge. While accounting for the many imbalances—perceptual, economic, aesthetic, and more besides—between cultures, it is this "third term," which is continually being reborn, that is the focus of this book. These spaces are not strictly of indebtedness to one side or another. One of the most persuasive earlier theorists to think of this term, of what he termed Third Space (capitalized) is Bhabha: "It is that Third Space, though unrepresentable in itself, which constitutes the discursive conditions of enunciation that ensure that the meaning and symbols of culture have no primordial unity or fixity; that even the same signs can be appropriated, translated, rehistoricized and read anew."[30] The dynamic of refabrication and redeployment ought not to be understated, although it can frequently make for cultural configurations that resist easy, glib definition.

For the third term or third space is a cipher of plurality, and a protean state. They stand for what are a diversity of cultural realities that can in turn stand for many more terms, but all with the common denominator that they stand outside the tyranny of the two. As such it draws sustenance from what the artist and theorist Trinh Minh-Ha has called the "inappropriate/d other" to designate the "elsewhere," the "liminal subjecthood" that exists across boundaries and across disciplines.[31] Trinh is also engaging with the effects of "refugeeism" which has become an attribute, if not stain, of the global present, and an issue that calls for philosophical reflection almost as urgently as logistical and practical solutions.

This is the least glamorous or romantic aspect of the exotic. For historically in its mingling of fact and fabrication, the lure of the exotic involves a dangerous

unknown that is sublimated in some way—the transformation of realities into metaphors—which has rightfully been a point of contention of the criticism of orientalism. Now if transorientalism brings these mechanisms of transformation and alteration into sharper relief, it is also a bringing-to-attention of the dangers of generic orientalism in the global present. In his acerbic critique of the disingenuous liberalist ideologies within multiculturalism, Slavoj Zizek notes that the praise of cultural hybridity means vastly different things depending on the demographic. The passage needs to be reproduced in full:

> It is easy to praise the hybridity of the postmodern migrant subject no longer attached to specific ethnic roots, floating freely between different cultural circles. Unfortunately, two totally different sociopolitical levels are condensed here: on the one hand the cosmopolitan upper- and upper-middle class academic, always with the proper visas enabling him to cross borders without any problem in order to carry out his (financial, academic . . .) business, and thus able to "enjoy the difference": on the other hand the poor (im)migrant worker driven from his home by poverty or (ethnic, religious) violence, for whom the celebrated "hybridity" designates a very tangible traumatic experience of never being able to settle down properly and legalize his status, the subject for whom such simple tasks as crossing a border or reuniting with his family can be an experience full of anxiety, and demanding great effort. For this second subject, being uprooted from the traditional way of life is a traumatic shock which destabilizes his entire existence—to tell him he should enjoy hybridity and the lack of fixed identity of his daily life, the fact that his existence as a migrant, never identical-to-itself, and so on, involves the same cynicism as that art work in the (popularized version) of Deleuze and Guattari's celebration of the schizo-subject whose traumatic pulverized existence explodes the paranoiac "proto-Fascist" protective shield of fixed identity.[32]

At various intervals, this book will circle back to this theme, so as not to forget that the liberation of hybridity, the lure of the exotic, the interest in the other, the possibilities available in self-othering, and the rewards of cultural displacement are haunted by an underside that is easily, conveniently overlooked.

For those who have the opportunity to escape straightened and traumatic events, there is the possibility of reclaiming identity. The majority of us are born with a name, a nationality and sundry of circumstances over which we have no control, however it is a common subjective instinct to investigate these conditions. Subjective identity is largely defined by the nature of this question. An increasing effect of postcolonialism has been the reinsertion of identity, particularly as applies to indigeneity—here more commonly applied to people adversely affected by colonization. Similarly, "indigenous" may be more commonly applied to a Tibetan than to someone from Beijing. Gayatri Chakravorty Spivak has

theorized this inclination of focus, this tipping, in her studies of the subaltern. She also explores such tensions according to the "double bind" in which formerly colonialized subjects find themselves in a variety of cultural spheres. "Let us think of culture as a package of largely unacknowledged assumptions, loosely held by a loosely outlined group of people, mapping negotiations between the sacred and the profane, and the relationship between the sexes."[33] Culture, then, is always an approximation but more for some than for others according to what is bartered, stolen, and (re-)created.

The meaning, structure, and communication of indigenous identity has also changed in recent decades, and to the extent that there are numerous subject positions that need to be taken into account. While claiming, owning, and representing indigenous identity has always been a fraught topic, it is especially hard to navigate in the instances where indigenous peoples identify with their heritage years after their birth. Whereas Islamic artists depart their country of origin in order then to explore, dissect, and enrich what it means to be from their place of origin, many indigenous artists embark on paths of reclamation and return. This return is to the physical places, but it is also imagined, spiritual, and symbolic. The role of language is central to this process, as identification comes from naming, as names designate and situate the subject: the name is the "what" bound to the "who." Many countries are behind in understanding this, however New Zealand is a distinguished example of mixed language—English and Maori—signs in its public places.

It is a linguistic juxtaposition that points to an ontic one. For in the age of the reclamation of culture—which can be said to begin in the protest era of the late 1960s—there is now a discernibly more widespread phenomenon. Distinguishing oneself as an ethnic minority is often carried with the language emphasizing minority status, so that "Afro-American" or "Indigenous Australian" is redolent of the implication that "American" and "Australian" are imposed, if not foreign, terms describing a juridical but not spiritual affiliation. But since at least the new millennium, the adoption and invention of multiple online personas means that more people occupy multiple spaces, where they can be of one identity (race, gender, whatever else) on one platform, and another somewhere else. The ease with which this can be done has percolated to everyday life, in which an individual may pose and act in different capacities according to the needs and expectations of a particular context. A parallel example in identity shifting is that of cosplay, a practice originating between Japan and America that has emerged over the very same period.

The understanding that the spaces of culture are mutually exclusive, blended, melded, and plural has been vitiated by 9/11, the refugee crises, and the ongoing threat of ISIS, which, among others, have polarized and ruined many lives and communities. In the presence of real and imagined danger, and mired in riddles of "known unknowns" and the like, the "East" has resurfaced as something of a

solid concept, namely synonymous with *jihad* and militant Islam. Where, earlier in the Orient, fear reigned it was accompanied by desire and uncertainty. The East is simply a place where the ills foment. Yet these immoderate conditions have not deleted the East in the artistic and aesthetic imaginations. If anything, they have contributed to a new rise in interest, where the Orient is manufactured, situated, and represented throughout the entire world.

The examples explored in this book will help to clarify the many levels at which cultural otherness is manufactured, sutured, instated, or reinstated. But to conclude it is worth turning to a passage in Hegel's analysis of the glories of classical Greek art, which he and his contemporaries upheld as exemplifying the glories of Western civilization. The passage helps to elucidate how the Orient is inscribed into the essence of their culture. The Greeks, he states, drew substantially from the art, religion, social interaction, and lore

> from Asia, Syria and Egypt: but they have so greatly obliterated the foreign nature of this origin, and it is so much changed, worked upon, turned around, and altogether made so different, that what they, as we, prize, known and love in it, is essentially their own. . . . The foreign origin they have so to speak thanklessly forgotten, putting it in the background—perhaps burying it in the darkness and the mysteries which they have kept secret from themselves.[34]

To this, Zizek adds, "The notion of the Greek miracle as the outcome of organic, spontaneous self-generation is thus an illusion grounded in brutal repression," which is its essential impurity and its flaw.[35] Flaw or not, the inscription of one within another is what is fundamentally at stake.

Transorientalism is not the erosion of culture but the recognition of its repeated re-assertion, a dynamic evident in art, fashion, and film. The other term, from which this book draws heavily, is of course literature. But if the principles of transorientalism as I define them are not already amply demonstrated in literature, they have in different ways already been subjects of deeper study. A significant example, whose writings this book will draw from, is V.S. Naipaul, a Trinidadian who made his way in England and who spent the larger part of his career describing the predicaments of the era after colonialism, that, problematic to some, were not always sympathetic to the erstwhile colonized. In Naipaul's work, as in that of his younger brother Shiva, we are made witness to the contradictions of the postcolonial who attempts to surmount his inferiority while in equal measure placing impediments in his own path. These challenges expose the national imaginary: the way that nationhood is more a product of imagination and belief, just as the "West" is an amorphous word for prosperity and escape, more than something factual. The space of transorientalism is that of the way East and West are blended, while also keeping a distinctive quality of difference from one or another. It is also a space of multiple dimensions, of straddling cultures.

The emphasis on art, fashion, and film, while already sufficiently broad, can be justified by what Rey Chow has called "visualism." Inspired after Foucault's archaeological approach of using visual data in his research, Chow asserts that cultural otherness has an overwhelming basis in visual characteristics, suggesting that ethnicity is more an arbitrary term that is built on classifications based on images.[36] While Chow's critique extends primarily to feminist discourse and the way women are treated as visual images, it is applied here also to forms and objects of representation, just as she turns to cinema. Visualism emphasizes the way in which meanings are visually accounted for and constructed. Another of Chow's sources for the use of this term is Gilles Deleuze's study of Foucault, who interprets "visibility as the structuration of knowability."[37] Visibility as such is not to be taken as the obviously seen, but applies to the status of the way knowledge comes into being, and involves "consideration of the less immediately and sensorially detectable elements helping to propel, enhance, or obstruct such visibility in the first place," as well as "the often vacillating relations between the visible and the invisible."[38] Chow's immediate terms of reference from which these lines were taken are film—to be discussed in more detail—but they can also naturally apply to fashion and art. A related precedent to Chow's visualism—perhaps to her misgiving—can be found in Adorno's *Aesthetic Theory*, wherein the "aesthetic" is the name for the sensory configuration that enshrines a deeper, less accountable logic of being able to combine ideas, narratives, instances, which could otherwise not be if subjected to logic or ideology. The aesthetic is for Adorno a particular epistemic modality, not only the object of reflective judgment or taste.

The chapters in this book have been arranged as discrete "departments." Their principal emphasis lies in the ways in which key cultures associated with orientalism—Turkey, China, India, Japan—have undertaken their own creation and refashioning with examples in art, fashion, and film. One approach may take precedence over others if it better illustrates the transorientalist condition. The first chapter, however, centers on how culture is a very particular and dense matrix of imagining, as famously developed by Benedict Anderson. It will also delve into the reflexive analyses of culture, especially that of Spivak. The following two chapters are devoted to Turkey, first from the way in which its Westernization was brokered along the lines of dress and appearance. The other chapter examines the global contemporary Turkish artist, with reference to four artists who grapple with Turkey's layered past and its complex status as a nexus between East and West. In a similar way, Chapter 4 looks closely on women Muslim artists whose practice as such is enabled only by living abroad. This is followed by a chapter on contemporary Chinoiserie, "China style," focusing on the 2015 exhibition, *China: Through the Looking Glass*, and on examples of the cross-cultural and intertextual nature of Chinese cinema. Chapter 6 investigates Japan's numerous modern renaissances, starting with the Meiji Restoration, and

culminating in the re-figuring, re-packaging, and re-selling of itself after the shame of the Second World War through popular culture, particularly manga and anime. The elusive, Svengali status of "Japan but not Japan but Japan" also finds its embodiment in a designer such as Rei Kawakubo, and the manner in which Japanese fashion has become a vessel for cultural affirmation through repositioning. India was also compelled to rethink itself. When it took on independence in 1947, it was drawn to an ancient, mythic past, while at the same time trying to decide which of the many imposed laws and mores of the British Raj were desirable, meaningful, or expedient. India is still beset with a crippling caste system that for many is a lesser evil that integrates a varied and over-populated nation. Drawn from the higher and merchant classes, the exponents of contemporary Indian fashion provide yet more evidence of cultural appropriation from outside and within. The final chapter adumbrates the highly contested space of trans-nationality as debated in Indigenous studies in the last few decades. Trans-indigeneity is not only an emotive notion, it is far from universally embraced, seen by some as a sham and a betrayal, by others as an affirmation of the multiple identities that have flowered as a result of globalization. Because of the experience of the author, this discussion will revolve around Australian Indigenous cultures for whom art is a vehicle for negotiating, affirming, or resisting this "trans" status.

When applied to individuals and groups, the word "belonging" sags under the weight of its many disingenuous xenophobic applications. It is both nostalgic, and yet refers to an instinct that is basic for people of any kind to prosper. The safety of belonging to a place, a group, a culture, or a creed underpins any individual's course of action and view of the world. Yet belonging now has a special resonance in this day where millions are cast out of where they belong through political upheaval or natural calamity. A countless number of the world's population are forced to live their life out in "trans" zones, from camps to detention centers. For this countless many the space of transition is made permanent, the only certainty being a constant state of uncertainty.

I have been at pains at certain junctures in this book to alight upon depredations such as these, as well as grisly social injustices such as being born innocently into a caste that consigns you to the most abject service. Although not exhaustive, they deserve attention in order to remove the romantic strains proper to traditional orientalism, and to do some moral justice to a word much used in this book: "diversity." For diversity is not necessarily benign, it can pertain to caste and class, and to opinions and laws that thwart a voiceless multitude.

With this in mind, we can nonetheless turn to the positive meanings of "trans" in transorientalism. As has repeatedly shown, just as postmodern critics have argued that postmodernity already lay within modernity, analogously transorientalism is already pregnant within orientalism. Given that orientalism is by nature an amorphous concept, guided by desire more than geography,

this can be taken to be stating that transorientalism and orientalism are one and the same. Rather, transorientalism highlights the speciousness of the Orient–Occident divide when viewed against fashion, film, and art of recent decades, which show the methods by which foreignness is renounced, or the opposite: reinvigorated, rehearsed, and resuscitated. A world divided into two has the advantage of simplification, but simplification leads to obfuscation. Transorientalism is not the denial of belonging, nor does it cheapen the legitimacy of those who argue entitlement to one or another group, nation, or identity. Rather transorientalism is a term for the queering of cultural identity, for it emphasizes its modulations and movements. Nations, cultures, and subjectivities are never static. How and with whom we belong and identify can change over time by choice or by circumstance. The notion of transorientalism brings to light how we are complicit in such change through the power of imaginative construction, therefore viewing culture and identity as a balance between what has been imposed and what can be created.

1
HISTORIES OF CULTURAL FABRICATION

*What then is truth? A mobile mass of metaphors, metonyms,
anthropomorphisms—in short, a sum of human relations which are
decorated poetically and rhetorically, increased and transferred, and which
after lengthy usage are for a group of people considered fixed, canonic
and binding: truths are illusions that have been forgotten they are thus.*

NIETZSCHE[1]

In popular nationalist vernacular, one's country is mutually exclusive with personal
conduct and activity. One's relationship to a country, culture, or creed is a highly
linguistic affair, signaled in the repeated use of the word "meaning" in question of
belonging. Alternatively there are actions and beliefs that are thought to be
threatening to the nationalist stronghold which are blighted the prefix "un-." At both
poles, from the stalwart nationalist to the tentative subaltern, what it means to be
of a race or country is a constant point of contention. Aside from the many material
features cited for this reference, the events that lead to this meaning are more than
usually traumatic and, even when recalling loss, triumphant. The components of
what it means to one or another group are traditionally based on recognizable
objects and of widely known past events, all of which are given a pictorially iconic
character, usually starting with the flag. More elusive if not more structurally valid
and the more subtle are the events, changes, upheavals, and manipulations that
have coalesced into the stable and concrete concept of nation. The concept of
rootedness from where there is only shifting sands makes the famous quote from
Nietzsche strongly apposite. Nationhood is carved from many things, but it is
conceived as immutable and commensurate with the truthfulness of one's own
being. Nietzsche continues: "We still do not know where this urge for truth comes
from: for until now we have only heard the obligation from society that it exist: to
be truthful means to lie according to the customary metaphors—in moral terms:
the compulsion to lie according to fixed convention, to lie herd-like in a common-
bound style."[2] If we remove the reproach for now, what remains is the strength of

common language and its transference into conviction and into psychopathology. This chapter traverses the tenuous and delicate subject of the relationship between individual, culture, and belonging with the emphasis on the ways in which it has been formed. The basis for this formation can be ironic, traumatic, or both. For some sense of clarity on a subject that emphasizes the convoluted and obscure, this chapter will be divided into two parts: the macrocosmic (nation, countries), and the microcosmic (individuals, subjects). In setting up a philosophical set of co-ordinates, the focus is not limited to the Orient, as general as the term may be, but takes a broader view of the assumptions and re-assumptions of national identity in order to form a picture of its pliability and the role of imagination, to show the oscillation between fictive construction and inner necessity.

The net image of all of this could be unnerving since to reveal the instability of one's soil is to destabilize the security of home. But the intention is not to instill anxiety but to show how the superstructure of national coherence is built on a cloud, except that some clouds may be a little denser than others.

Making nations

Another helpful synopsis of the twists of identity formation is offered by the philosopher Slavoj Zizek in a discussion of Russian nationhood:

> There were three steps in the formation of Russian national identity: first, the substantial starting point (premodern Orthodox Russia); then, the violent modernization enforced by Peter the Great, which continued throughout the eighteenth century and created a new French-speaking elite; finally, after 1812, the rediscovery of "Russianness", the return to forgotten authentic origins. It is crucial to bear in mind that this rediscovery of authentic roots was only possible *through* and *for* the educated eyes of the French-speaking elite: "authentic" Russia existed only for the "French gaze". This is why it was a French composer (working at the imperial court) who wrote the first opera in Russian and thus started the tradition, and why Pushkin himself had to use French words to make clear to his readers (and to himself) the true meaning of his authentic Russian terms. Later, of course, the dialectical movement goes on: "Russianness" immediately splits into liberal populism and conservative Slavophilism, and the process culminates in the properly dialectical coincidence of modernity and primitivism: the fascination of the early twentieth-century modernists with ancient barbaric cultural forms.[3]

It is also instructive that Zizek concludes with the binary of the civilized modernist observing the primitive and barbaric. A barbarian is simply the earlier version of the Oriental, deriving from the Greek *barbaroi*, meaning "foreign." (However the

subsequent usages of the word add a frisson of violence and transgression, which is also essential to the Orient, as it enshrines something noble but also distinctly different and daring.) The exchanges between Russian and French are also vividly staged in Tolstoy's *War and Peace*, when Pierre, during the siege of Moscow, in his dealings with people on the street becomes self-conscious of the fact that he speaks Russian with a French accent, thereby leaving himself vulnerable to the defensive violence against all things French. Yet it is Pierre who is the stalwart of Russian cultural integrity, in all its tenacity and fragility. But Pierre comes to this realization once aware of the changes in power relations, in which language inevitably plays a part.

Pushkin, Tolstoy's great predecessor and rival for Greatest Russian Writer, was from the start embroiled in Orientalist narratives of some sort or another. For although he hailed from one of Russia's most prominent nobility, his maternal grandfather was an African, Ibrahim Hannibal. As the legend would have it, he was an Abyssinian prince whom the Turks took hostage, and redelivered as a gift to Peter the Great in 1705, by a Russian envoy who had rescued him from the court of the Ottoman Sultan. Hannibal became Peter's adopted son, received military training in France, and eventually became a general in the Russian army. He was later granted a massive estate, Mikhailovskoe, on the border of today's Latvia by Peter's daughter Empress Elizabeth. It was here that Pushkin wrote some of his greatest works. Pushkin was also a great admirer of the great literary Orientalist, Byron, especially evident in his fascination with the character Don Juan. His exotic ancestor was also a great source of literary capital as seen in the incomplete novella *The Moor of Peter the Great*, and in instances such as in *Eugene Onegin* when the protagonist yearns for "the sun of my Africa."[4]

Yearning is a central part of the envisioning and conceptualization of nationhood: the yearning to return, the yearning of what was or what could be. They are powerful expressions of desire in which the addressee, the state, is everywhere and nowhere. The decenteredness and the yawning absence betoken its power. Nation, with a capital "N" is an empty signifier around which selective incidents and signs of the past and present come to rally. In the words of Zizek again in an earlier study on the psychology of political economy:

in a political discourse, the Master-Signifier (Our Nation) is this kind of empty signifier which stands for the impossible fullness of meaning, that is, its meaning is "imaginary" in the sense that its content is impossible to positivize—when you ask a member of the Nation to define in what the identity of this nation persists, his ultimate answer will always be, "I can't say, you must feel it, it's *it*, what our lives are really about."[5]

The compulsions of Nation are typically at their strongest when there is the sense of something lost. This can range from the sense in the United States of the

country having lost its grip on world power and economic dominance to the feeling in developing powers such as India, which, as we will later see, by degrees clings misty eyed to a shapelessly obscure, long-lost past.

Just as the victors write history, the priorities given to which histories are written belong preponderantly to those meting out funding, which are the dominant states. Thus, as Davies remarks, "siren voices sing that today's important countries are also those whose past is most deserving of examination, that a more comprehensive spectrum of historical knowledge can be safely ignored."[6] It is also in the interests of these dominant histories that the presumption remains that the country in question is coherent, and observations of coherence are nonetheless serenely made from a standpoint of clarity and circumscription. Equally the studies of the great ancient civilizations—Greece, Egypt, Rome— work from standard assumptions, most often conveniently gleaned from art and architecture, however much their empire may have expanded and contracted. Indeed it is the visual manifestations of culture, from the Egyptian Pyramids to the Roman Coliseum, that tend to give a state and culture its metonymic balance, however much that they too were prey to alteration and decay.

Davies' book, *Vanished Kingdoms: The Rise and Fall of States and Nations* is a set of connected historical essays on the appearance and disappearance of countries in the region of greater Europe, including Russia. His study can scarcely contain the diverse and ongoing shifts in borderlines and borderlands, however his book is a series of enlightening case studies that lays the groundwork for thinking of country, state, and nation in a less homogenizing fashion, as susceptible to time and change as any individual mortal soul. One of the salutary effects of this growing consciousness of the vicissitudes of culture has been a renewed interest in looking at this mutability. It is an area of study that was also borne out by post-millennial events, such as Russia's lawful-unlawful reclamation of Crimea, and Britain's "Brexit," which in turn has stirred up renewed debate about Scottish independence. If this were to take place it would be hard to use the well-worn term "United Kingdom," since Great Britain, divested of its most lavish colony, India, since 1947, would no longer be great at all.

The many histories and cultures bear witness to their sheer perishability. When scrutinized, these histories show that any culture is constituted by a diversity of conditions, embedded in the material and eidetic moment. That is, they are fashioned from the political, geographic, and technological circumstances, and much more. But how they are is impossible to gauge since all these factors build to an idea that is immaterial but helps to organize these data that makes the individual comprehensible to the group, and vice versa. Davies begins with Tolosa, which made up the majority of the southwest region of what is now France, the state of the Visigoths from 418–507 and ends with the Soviet Union (1924–1991). The rise and fall of states, he argues, makes for consternation amongst historians because the causes vary and are often "random." As he observes

the definition of a nation should include its past and future, its memories and illusions. To paraphrase an old critic of Renan, a nation is a group of people united by a mistaken view about the past, a hatred of their present neighbors, and dangerous illusions about their future. (For example, today's Slovenes are united by myths about a Slovene kingdom in the eighth century, their hatred of [at this moment] the Croats, and the illusion that they are on the way to becoming the next Switzerland.) Each historical form is a totality which encompasses not only its retroactively posited past, but also its own future, a future which is by definition never realized: it is the immanent future of the present, so that, when the present form disintegrates, it undermines also its past and future.[7]

Nationhood is porous but at the same time what in political economy and sociology is called a universal. It is held up as an ideological *fait accompli* in which biology and destiny are intertwined. For even if this is a fantasy, to think otherwise is to encounter destabilization and ruin. Nationhood is a mythic solipsism from which any one of us can only escape by degrees; to be an exile is to be an exile from somewhere. To be stateless is to feel a pathological lack that is tantamount to orphanage or paternal rejection: the state, like the parent, is present through its absence.

In the age of kings and princes, the changes in borders are in some cases far easier to qualify, since they were due to deaths, marriages, and the expansion or contraction of dynasties. There are other cases where states have risen and fallen to some unaccountable measure: the precise reasons for the fall of the USSR are still open to debate.[8] Davies concludes that "Successful statehood, in fact, is a rare blessing." It is attributable to having neighbors that do not pose a great or ongoing threat, and to "a sense of purpose to aid growth and to reach maturity."[9] In other words, participation in the collective idea of what it means to belong to that nation, and how one manifests within it. It is this intangible vision, albeit linked to innumerable material constituents, that ensures a state's longevity. "In the chronicles of the body politic, as in the human condition in general, this has been the way of the world since time immemorial."[10]

The condition of belief and conviction in the collective requisite for the endurance of the collective is always, however, a mixed blessing, as it has the taint of nationalism, or rather "Nationalism" in which ideology is imbued with a quasi-religious fervor. As Benedict Anderson observes in his important study, *Imagined Communities*, "nationalism" itself does not follow a single or comprehensive definition. Anderson leans on the word "imagined": "because even the members of even the smallest nation will never know most of their fellow-members, meet them, or even hear of them, yet in the minds of each lives the image of their communion."[11] Kinship cannot be verified except according to conviction. It is delimited according to borders and who does not belong, it

frequently refers to upheavals such as wars and revolutions, and it presumes a shared set of values and belief in narratives critical to the state's formation.

Reflecting on previous studies of nation-building and nationalism, Anderson concludes that they were all noticeably too Eurocentric. His "problem," as he states, "was how to sail between the Scylla of the nineteenth-century European-derived romantic fantasies about umpteen thousand years of Chinese, Japanese, Vietnamese, etc. nationhood, and the Charybdis of Partha Chatterjee's splendidly indignant later indictment of all anticolonial nationalisms outside Europe as 'derivative discourses.'"[12] Anderson refers to Partha Chatterjee's *Nation and Its Fragments: Colonial and Postcolonial Histories*, which demonstrates the presence of different kinds of nationalisms alive in the spirit of anticolonialism. Writing from the perspective of India, Chatterjee emphasizes the role of spiritual imagining in safeguarding a reservoir of belonging on which communities could draw, separate from the impositions of colonial dominance.[13]

Writing about the formation of modern Turkey, Zeynep Kezer states: "The concept of modern nationality comprises an amalgam of spatial imagination and spatial practices that are internalized through explicit and implicit lifelong experiences acquired both by immersion in formal settings—such as schools."[14] Hence the role of education as *formation*, the word more commonly used in French that emphasizes the ways minds and morals are influenced and brought into shape.

In their respective ways, Anderson, Chatterjee, and Kezer all emphasize the creative energy devoted to the nationalistic act, and the ability to share consensual myths lends these myths their credibility. It is through the mechanisms of sharing, through communication and community, that nationalism (not "Nationalism") might be redeemed, and only in recognition of the porosity, fragility, and protean nature of the concept.[15] Sharing belief in fictions for the sake of maintaining a stronger communal perspective is evident, for example, in the way Chinese cinema and cinema about China have had a richly symbiotic relationship, both building on the constructs and liberties that they take. This will be explored in a later chapter.

Who studies whom and how

Symbiosis and exchange, while ostensibly benign notions, are nonetheless ones that are highly vexed. For the presumption in a plural, postcolonial, postmodern society is that there are multiple language systems, different mores and, correspondingly, never a unified way of understanding or representing the world—despite the continuum of capitalist (Euroamerican) strains of dominance in fiscal and cultural economies, and beyond. If cultural sensitivities are to be observed, then it seems only legitimate to suggest that an insider has a greater

entitlement to be observer and to broker representations than someone who is not. Someone who has access to the language and cultural systems is better suited to explain them and to offer them for study and consumption. From a postcolonial standpoint, there are cultural sensitivities to consider, especially given a history of having had stories effaced and rewritten by the colonial power. All of this appears simple and fair at first, but it comes with an ever-mounting list of caveats and exceptions. One is that to place too rigid ideological controls over representation generates a solipsism that begins to mimic the kind of imperialist power that it sets out to counter. Another is that an outsider's perspective may have a refreshing view. Another still is that miscegenation, hyphenated identities, and so on, mean that people often inhabit more than one world at the same time. To make the "third world" the custodian of its own history is a "hazardous" one, warns Gyan Prakash, as "it seems to reek of essentialism," especially what constitutes "theirs" and "ours."[16]

Such tribulations and subtleties of culture and representation are dissected and evaluated by Trinh Minh-ha, to some extent in all her work as a filmmaker and theorist, but also specifically in a paper from 1986, "Outside In Inside Out."[17] Here she asserts that "to see things from the native's point of view speaks for a definite ideology of truth and authenticity."[18] It is a mistake to pretend that the break from the colonialist to postcolonial mind is a smooth one, given the ongoing prejudices that repeat themselves. The Outsider who seeks knowledge is conventionally one who inhabits the power–knowledge axis that is strengthened from learning from the Insider. Thus "what the Outsider expects from the Insider is, in fact, a projection of an all-knowing subject that this Outsider usually attributes to himself and to his own kind."[19] The Outsider (the postimperialist, the Euroamerican, the non-exotic privileged, articulate subject) is indeed expected to look elsewhere, and the extent of his (Trinh presumably maintains a metonymic irony to gender where "he" equals the dominant party) curiosity goes unnoticed. However "that a Third World member makes a film on other Third World peoples never fails to remain questionable to many." Moreover the attempts to blur the line between Inside and Outside are also met with resistance for numerous reasons, including the fact that to remain exotic is to remain marketable, a subject of fascination and scrutiny.

On the other hand, and, Trinh adds, the Outside is more than willing to use its own auspices to encourage and sanction the Insider's view of itself: "'We would like to see Asians as told by Asians'; or We want 'to *teach* people with a culture different from ours to make motion pictures depicting their culture and themselves as *they* see fit'."[20] It is a stance, she argues, that amounts to another deliberate but mildly insidious form of control. It fills a gap that whites are, as the narrative goes, unable to fill, and it is an undertaking that aimed at making the Other more complete, less Other. Yet it is an operation that "is ultimately dependent on white authority to attain any form of 'real' completion."[21] It is a charity mission in the form of the transaction of knowledge. Its danger, as Trinh argues, is that the

"colonial Savior" is still presiding, but concealed under revisionist clothing.[22] But then, how might the Insider, the non-white Euroamerican, assert herself independent of such rulings and formal parameters of power allocation? Note again Spivak's repeated invocation of the double bind: similarly, Trinh, with a sense of personal reflexivity, suggests that the Insider step away from the Inside. "She necessarily looks in from the outside while also looking out from the inside." She avails herself of multivalent perspectives. Elsewhere Trinh comments on the limitations of a term such as "multiculturalism," which straddles difference but also ensures that difference is still present, while obscuring the fact that differences already pertain within any one culture. Moreover, any one individual can be thought of "multicultural," as a product of the confluence of many cultures, just of differing combinations. "Intercultural, intersubjective, interdisciplinary. . . . To cut across boundaries and borderlines is to live aloud the malaise of categories and labels; it is to resist simplistic attempts at classifying, to resist the comfort of belonging to classification, and of *producing classifiable works*."[23] For this multi-zoned self-positing, Trinh uses the term, "Inappropriate Other" for whom "the criterion of authenticity no longer proves pertinent."[24] This does not mean that origins and cultural affiliation are deleted or annulled, rather it is an effort not to "naturalize the 'I'" by constant deferral to the shadow of origins and cultural inheritance.[25] It is a subjectivity that looks continually to its renewed constitution and contradictions of self. It ensures that "culture" is never in stagnation but an entity whose renewal comes from interaction between Inside and Outside. It is a performative stance that foregrounds the staging of culture, whether that be through ownership (Inside) or influence (Outside). "To me," Trinh confesses, "the most inspiring works of art are those that cut across the boundaries of specific art form and specific cultures, *even in their most specific aspects*."[26] In doing so such works insist on their non-compliance, their difference. Trinh emphasizes that this kind of "difference is not otherness." The constant reminder of difference is to unsettle "every definition of otherness arrived at."[27]

The study of culture

The word "staging" goes a long way in helping to grasp the elusive, nebulous notion of "culture," eloquently defined by Spivak in the Introduction. It is worth repeating: "Let us think of culture as a package of largely unacknowledged assumptions, loosely held by a loosely outlined group of people, mapping negotiations between the sacred and the profane, and the relationship between the sexes." To this she adds,

> On the level of these loosely held assumptions and presuppositions become belief systems, organized suppositions. Rituals coalesce to match, support,

and advance beliefs and suppositions. But these presuppositions also give us the wherewithal to change our world, to innovate and create. Most people believe, even (or perhaps particularly) when they are being cultural relativists, that creation and innovation are their own cultural secret, whereas others are only determined by their cultures. This habit is unavoidable. But if we aspire to be citizens of the world, we must fight this habit.[28]

Another problem arises, she argues, with the differences in the way that cultures perceive one another, especially when a more powerful group views a less powerful one as static as opposed to dynamic. It is a convenient binary in which the dynamic, evolving, and progressive group may exhibit its progressiveness through the thorough examination of the static group, which is all the more easily able to be examined objectively because of its very stasis. Yet another concern are the limitations enshrined in an overly deft and glib formulation of culture, and the claims regarding "cultural memory." For "'Cultural memory,'" Spivak claims, "is a crude concept of narrative re-memorization that attempts to privatize the historical record."[29] Cultural memory is an immediate presumption of ownership by a nebulous collective subjectivity. It disposes of facts and myths, and is also a negative symptom to outside pressures. It is, however, endemic to any collective, any society, and thus its mores and laws.

The examination of cultures is the natural and logical coefficient of the early historical stages of globalization since the fifteenth century. Consumption of foreign goods occurred on every level, including treasures, curios, and hence culture itself. It is in the sixteenth century that the first museums were created: the *Wunderkammern* and *Kunstkabinette*, storehouses of acquisitions and gifts reflecting the wonders of the natural world and of human creation. Once amassed, they required taxonomy. Thus the observation of culture was reciprocally twofold, namely on the level of the sense gleaned through relics, artifacts, and specimens which then provided the criteria for the assessment of the "real" and existing cultures themselves—and vice versa. Understandably, anthropology is married to museology, as both were conceived according the same impulse to draw knowledge through ordering systems, almost all of which were based on visual data.

Anthropology as a discipline was reborn as "Cultural Studies" as result of social and epistemic upheavals of the 1960s. The luxury that anthropology had always cherished and languished in was that it was comfortable with its own apparatus—what Foucault would call a *dispositif*—and powers of deduction for labeling the outside, the other. It was a system that was labeled imperialist and "phallocentric," and its supposedly neutral order was in fact an illusion or a fragile edifice held together by myopia and misprision. As Spivak puts it, while "colonizers founded Anthropology in order to know their subjects" the new order of "Cultural Studies was founded by the colonized in order to question and

correct their masters."[30] The main difference is that anthropology assumes that the culture under scrutiny is static and determined, while cultural studies maintains that cultures—both studier and studied—are "dynamic and evolving."[31] But alteration in perspective does not liberate the operation of study from what Spivak repeatedly refers to as the "double bind," which, among other examples, is where the process of revision is demonstrably best undertaken under the aegis of the culture that is being revised: hence Said and Spivak thriving in the United States.

Echoing this view, in an earlier essay on diaspora and Caribbean cinema, Stuart Hall extends two definitions of cultural identity. The first is the most obvious, understood, and the most staid. Namely the identification with, and of, a common past. It is a past that is unified by literature, art, and film, which are accepted as representative of an overarching shared experience.[32] The other is more nuanced, that takes into account not only what is shared but what is also different. It is a view that looks at the evolution of identity—"what we have become." As he asserts: "Cultural identity, in this second sense, is a matter of 'becoming' as well as 'being'. It belongs to the future as well as the past. It is not something that really exists, transcending place, time, history and culture." As opposed to being obsessed with "recovering" the past, this second view holds to a future to be created, and for new but still related identities to be deployed into an unnamed elsewhere.[33] Such identity has an historical state but is in practicality stateless. We must acknowledge, he argues, for a particular "diaspora aesthetic" that is a distinctive "aesthetics of 'crossovers' and 'cut-and-mix', to borrow Dick Hebdidge's telling phrase." Hence the representation he exhorts is one "able to constitute us as new kinds of subjects, and thereby enable us to discover places from which we speak."[34]

Statelessness and dispossession

The notion of dynamic and evolving cultures takes on a far darker face when confronted with the extraordinary number of displaced peoples as a result of war and natural disasters—but where even "natural" is a euphemism for something with a human cause earlier down the line. In her meditation on war and cataclysm in recent memory, Trinh paints a picture of dispossession on a scale that defies the imagination:

Who's fleeing and where to? Through defiance and loss, from wasteland to wasteland, into the transborders zone of the denizens whose earthwalk is characterized by an indefinite state of being-in-expulsion: exiled, expatriated, segregated, deported, displaced, discarded, repudiated, estranged, disappeared, unsettled and unsettling. Countless shadows of terrified bodies

in flight, moving alone en masse, searching in vain for the lost ones, faring in a no-man's-land as a no-nation people. . . . Neither citizen not simply a living being, the one who leaves, the phantom-turned-refugee, hurtles along with loads of other empty bodies, driven by the sheer movements of waves of humanity in distress.[35]

It is a stirringly desperate picture that only comes to the privileged public in fits and starts because it is uncongenial to entertainment news. The stateless individual, deprived of rights and denuded of identity has become a normative problem throughout the world. It is a category that must also include the United States as a result of consistently regular natural disasters, in which thousands have had their livelihoods torn from them and their lives placed in a semi-permanent state of abeyance.

The paradox of globalization is that the price of everything-at-hand comes at the expense of millions for whom next to nothing is at hand through social and financial inequity, through disaster, or a combination of all of these. It is a condition that has received rising attention and which perhaps has its philosophical roots in recent memory in Giorgio Agamben's *Homo Sacer: Sovereign Power and Bare Life*,[36] and whose more recent voices include Zizek and Trinh. Refugeeism and rootlessness is now no longer an exception, but a widening problem whose solutions seem obvious but are sedulously deferred. This contemporary condition is thus the deplorable dimension of the "trans" state of ineluctable limbotic suffering, and it is one that will be returned to at regular intervals throughout this book. This is not to say that the diversity and multiplicity available in the idea of transorientalism are not to be cherished, it is only to infer that there are different faces to the prism. Global culture is climax of capitalism itself whose survival depends on being able to absorb and feed off the constituent contradictions.

2

OCCIDENTALIZING THE ORIENT: MODERN TURKEY

In his essay on Gide, Pamuk, the only Turkish citizen to win the Nobel Prize for Literature, begins with a meditation on the veneration with which Turkish intellectuals "admired Gide, especially those who looked to Paris with reverence and longing." Gide, was viewed as a consummate literary mind, and with his Journal, a beacon of self-reflection that spawned a small industry from later writers in the confessional genre and the memoir. Gide, who was also an avid traveler, recounts his visit to Istanbul with unerring distaste, finding it a mish-mash of tastes and thus culturally superficial, insincere. Pamuk quotes Gide: "Nothing sprang from the soil itself, nothing indigenous underlies the thick froth made by the friction and clash of so many races, histories, beliefs and civilizations." His harshest criticism is aimed at Turkish dress: "The Turkish costume is the ugliest you can imagine, and the race, to tell the truth, deserves it." He declares his inability to hold affection for a country when so out of sympathy with its people.[1]

Pamuk concludes his essay with Atatürk's dress reforms two years after he established the Republic in 1923. He cites a comment by Atatürk regarding the aimless heterogeneity of the national clothing, for example mixing a fez coupled with a turban, and a *mintan*, or collarless shirt under a Western style suit jacket. Atatürk exclaims, "Would a civilized person let the world hold him up to ridicule by dressing so strangely?"[2] Pamuk asks whether Atatürk and Gide shared similar views on "dress as a measure of civilization"[3] whereupon he quotes Gide again: "When the citizens of the Turkish Republic declare that they are civilized, they are obliged to prove that they are so through their family life and their lifestyle. A costume which, if you excuse the expression, is half flute, half rifle barrel is neither national nor international."[4] Pamuk remarks that the tensions relating to dress continue in his day, with police "still chasing people going about the conservative neighborhoods of Istanbul in traditional dress."[5] He notes a "shame" at the Westernizer's alienation from Europe, in the recognition of always being incomplete, marginalized, and inadequate. "He is ashamed of who he is and who he is not. He is ashamed of the shame itself; sometimes he rails against it and sometimes he accepts it with resignation."[6] Pamuk is not necessarily holding

anyone or anything to account, since in retrospect it is easy to argue that Turkey's modernization was inevitable, although painful—although this is a belief that has also been perennially challenged. Both geographically and ideologically, both truly and mythically, Turkey stands at the juncture between East and West. It provides what is most likely a unique case in modern times of the mixture of cultures. Significantly these changes were brokered most conspicuously along the lines of fashion and dress.

Turkey and Orientalism

What Turkish and Chinese Orientalist styling had in common were the connotations of despotism. Always conceived in the abstract, despotism proved fertile ground for other notions to grow, for absolute authority also suggested the satisfaction of hidden and forbidden desire. Turkey and *turquerie* were always redolent with the scent of the harem, the imaginative epicenter of the (male) Orientalist imagination: sexual, forbidden, and foreign. It is worth briefly revisiting the more traditional notions of Turkey and Orientalism, as it helps to anchor the issues, active to the present day, of Turkey's de-Orientalizing. Most present are the many conflicting opinions about the veil, arguably the most loaded symbol of gender relations, enshrining notions of propriety, honor, and desire. As a signifier of gender difference (and for detractors gross inequality), it is also one of the key signifiers of Turkey's difference from the West.

An early literary example of the way in which the erotic is played out through Turkish dress appears in Daniel Defoe's *Roxana*, published in 1724. It is the story of the rise and fall of a courtesan, involving scenes of mild pornography to grisly episodes where she murders her own child. One of the novel's central scenes involves two performances that Roxana makes for the court of Charles II in Turkish costume in order to seduce the King and become his mistress. Maximillian Novak remarks that these dances in Turkish costume bring to the fore some of the novel's key points of commentary: "the sexual immorality of the Restoration and with it the comparison with contemporary morality; and the attack on disguise and deception."[7] In retrospect, Turkish costume is the only choice to be made since it is a masquerade in which erotic implications are writ large. The most lasting equivalent in music, no doubt, is Mozart's *Entführung aus dem Serail* (1782).

The instances of Ottoman Orientalism in painting are too many to enumerate, but suffice a few examples. In America, John Singleton Copley made a series of portraits of both men and women wearing *turquerie*. In her examination of his portraits of women before the American Revolution, Isabel Breskin contends that Oriental costuming was used as a means of expressing a particular colonial identity. For while *turquerie* fashions were well-established in Britain, they could

also be used to register colonial difference. In the climate of "emulation and rebellion" in this time of America's history, dressing up in *turquerie* afforded a displacement of the consciousness of an inferior position. For while the women in *turquerie* could easily be read as "the subjugated colonial," the clothing also allows the expression of "a note of defiance." "These women are, for this self-created moment, among the 'only free people in the empire'."[8] As with the popular masquerade that flourished in the eighteenth century, other cultures were used with disregard for authenticity. They served as aesthetic and ideological vehicles for self-expression at all levels, from genteel to sexual.

The adoption of Turkish costume has a long history in Western culture, particularly in the imperial states of Britain and France. A very early reported example is that in the 1530s Henry VIII wore Turkish costume to a masquerade ball. Masquerades were a significant part of courtly life across Europe until the end of the eighteenth century. In 1714, the French ambassador to Istanbul, the Marquis de Ferriol, published an album of images of people in Ottoman dress, derived from the Dutch painter, Jean Baptiste Vanmour. In England, in 1757, Thomas Jeffrey published what would be a celebrated album for masquerade adaptations, his *Collection of the Dresses of Different Nations*, where Ottoman dress was handsomely represented.[9]

But the taste for Ottoman clothing did not stop at masquerade, for it served a more socio-political function. The writings of Lady Mary Wortley Montagu, about her experiences of her brief stay in Istanbul between 1716 and 1718 while accompanying her husband as the British ambassador to the Ottoman Empire, had a singular and widespread effect on the women of her time. This had largely to do with, in the words of Onur Inal, "Ottoman women's rights over their husbands, such as the right to refuse conjugal sex, to own property, to enter into contracts, or to divorce their spouses."[10] It was knowledge afforded by the expanding image of the world precipitated by imperialism. "These rights came to be symbolized by Ottoman women's dress, especially by *salvar*, a voluminous undergarment in white fabric shaped like what are called today 'harem pants'."[11] In order to assimilate, Montagu dressed as other Ottoman women while abroad, then continued the practice back in England, something that not only added to her exotic pre-eminence but was also taken as support for the burgeoning British women's movement. Her *Embassy Letters* (1763) continued to have influence well after death. A significant figure in Montagu's wake was Elizabeth Craven, whose *A Journey through the Crimea to Constantinople* (1789) again fed the fascination for the harem, which she discussed not from the male erotic viewpoint but as a privileged female space where women have numerous freedoms not available to European women. She was followed by a number of women in the nineteenth century who journeyed to the Ottoman Empire, brought back clothes and artifacts, and corrected Orientalist clichés and misprisions.[12] Notable women such as Lady Archibald Campbell and Ottoline Morrell wore the *salvar* to register

their impatience with traditional British values. The *salvar* enjoyed a robust life and ultimately transformed into the bloomer—named after Jenks Bloomer—the garment of women's suffrage. The Orientalist view of Ottoman women as retiring and passive needs correction, especially when considering the significant place that their mores and dress had for the growth of modern female identity in Europe.[13]

This short itinerary adumbrating the many subtleties of the reception of Turkey to the Western imagination, and its role in the shaping of modern womanhood, will prove a counterpoint to the convoluted and shifting history women's dress, particularly the scarf, that unfolded in the twentieth century.

Turkey, modernization, and reform

Except for clichés and their own unlicensed appropriations of it, contemporary Westerners do not have a particularly comprehensive knowledge of Turkey, as with any country that is not dominant or a symbol of aspiration. At best, Euro-American understanding of Turkey is as a country that straddles East and West both geographically and culturally, that has long sought inclusion into the ailing European Union, the reasons for which vary according to whom you consult. From the Euro-American perspective, it may come as some surprise that Turkey's desire for inclusion is less economic than it is symbolic. Ever since its citizens were mandated to wear European clothing and were instructed to look Westward rather than Eastward, Turkey became a country that craved European approval, only to have felt its cold indifference. Even though it had never been a colonized state, the condescension Turkey felt from the West had a colonialist air. After numerous attempts to join, the continual rebuff from the European Community has been decisive in consigning Turkey to cultural limbo. For it is recognized as neither Western nor Arab: its dress is predominately Western, and its script is Roman. It does nonetheless suffer from internal pressures of its various Muslim groups, who are hostile to those who embrace the "decadent" West, as evidenced in recent times when in late 2016 a gunman let loose in an exclusive nightclub in the Westernized district of Beşiktaş. Turkey is a country in which notions of difference and ambivalence—in history, religion, appearance, and so much more—lie at the center of its identity. While Turkey, and its largest city, Istanbul, formerly known as Constantinople, have always been a crossroads of cultures, it maintained coherence all the while it had military strength and strong governance, with the Ottoman Empire that began its rise in the thirteenth century. It reached its apogee with the reign of Suleiman the Magnificent (who reigned 1520–1566) and began its decline at the end of the seventeenth century. By the nineteenth century the Ottoman Empire had considerably constricted and was socially and financially devastated by the brutal Crimean War (1853–1856).

Modern Turkey is a product of the First World War, which left the once proud Ottoman state in ruins. The cause of the disastrous result of the War was widely held to be backwardness of the country. Its clinging to anachronistic ritual and ideas had severely slowed the rate of progress. As the effects of the War showed, if the stagnation could not be addressed, it would end in the dissolution of the state altogether. In 1920 under the Treaty of Sèvres, Sultan Mehmed VI was forced to cede vast sections of his territory to Britain, France, Greece, and Armenia. Henceforth known as the "Sèvres Syndrome," Turkish citizens became beset with the fear that their country would disappear altogether, much as the Treaty of a Trianon had done to Austria and Hungary. With the Turkish War of Independence (1919–1922), led by Mustafa Kemal (later Atatürk), the treaty was challenged and replaced by the Lausanne Treaty (1923), which laid the boundaries of the Turkey known to this day.

While traditionally the outside "Orientalizing" Western vision has and continues to typecast the Ottoman and the Turk as all one Muslim race, the reality is quite different, mirroring more the diversity of cultures of the Austro–Hungarian Empire before its collapse at the end of the First World War. Historically the "core" of the Ottoman Empire, roughly what Turkey is today, was the refuge for Muslim peoples, including those banished or fleeing persecution. For instance, when Russia invaded the North Sea in 1774, thousands of Crimean Tatars migrated to Anatolia. They were followed by the Muslims from the northern Caucasus, also driven out by the Russians. From the 1860s onward, Circassians from the Abkhaz to the Chechens were driven into the Ottoman Empire. In 1877, Austria's annexation of Bosnia-Herzegovina resulted in an influx of tens of thousands of Muslim refugees. The Balkan Wars of 1912–1913, while causing the Ottoman Empire's age-old territories over Albania, Bulgaria, Greece, Kosovo, Macedonia, and Romania, also resulted in the immigration of innumerable Muslims. And under the Lausanne Treaty many Muslim Turks in Greece and Greek Orthodox citizens of Turkey effectively traded places. Up until today, Turkey's ethnic minorities have an acute sense of their local identity, a sense that tends to be sharpened when threatened from other groups or socio-economic upheaval and strain. Added to all of this, in the nineteenth century until at least the First World War, Turkey was in deep sympathy with large portions of Hungarian community disaffected with Austrian supremacy. These sympathies were strong enough to provoke philological, historical, and ideological debates into the Turkic origins of the Hungarian peoples and their language.[14]

Atatürk understood the need to integrate Turkey's many ethnic groups and at the same time to try to bring the country on better par with the more prosperous European nations. As Kezer puts it: "Having internalized Orientalist criticisms of the Ottoman state and culture, they sought to introduce Westernizing reforms that would affect day-to-day lives of the citizenry on an unprecedented scale."[15] Known later as Kemalism, his program consisted of six "arrows" or trajectories,

areas of focus to ground the new modern state: nationalism, populism, republicanism, revolutionism, secularism, and statism. After the adoption of the Constitution in 1924, Atatürk embarked on a series of swift, stark, and dramatic reforms, including the abandonment of the Arabic script for the Latin, and shifting the capital from Istanbul to Ankara. Relocating the capital Atatürk saw as an important symbolic gesture to distance the new modern state from the historic seat of the caliphate. "Authentic" Turkish identity would be the sum of many newly assumed parts. Not only was the fez outlawed, but wearing anything that resembled Muslim dress was strongly discouraged. All outward signs of religious orders were made to seem retrograde and reactionary. One of the most salutary measures was to grant female suffrage and to allow women to be elected as representatives of Parliament.

Since the Turkish republic had come into being as a result of the War of Independence, the military had always played a significant role in the new regime, and Atatürk had devoted as much energy to transforming the military as he had to civil society. The military's devotion to Atatürk meant that it saw itself as responsible for preserving his legacy, resulting in the military coups of 1960, 1971, and 1980. It was also involved in the coups of 1997 and 2002.

In addition to the military, religion continued to maintain a strong hold on Turkish society. Along with the dress reforms in the early 1920s, religious schools had been closed as had Sufi religious orders. Yet the changes came a little too swiftly, and many members of Turkish society clung to religion as a way of staying the uncertainty of change. In the words of Lenore Martin, "Many citizens remained wedded to Sunni Islam and a conservative mindset. They kept forming political parties, though the courts continued to outlaw them, claiming they were undermining the secular nature of the state and therefore unconstitutional."[16] These struggles would continue to haunt Turkish politics and society, until the AKP, formed from a previously legally disbanded Islamist Party, achieved a parliamentary majority in 2002, going on to win two more elections in 2007 and 2011.

Since the noticeable decline of the Ottoman Empire by the mid-nineteenth century, religion played a central role in determining differences form the West. Ussama Makdisi uses the phrase "Ottoman Orientalism" to designate the complex nature of Ottoman reform that, while turned to the West as an antidote to its perceived backwardness, nonetheless sought to retain national autonomy. "Just as European Orientalism was based on an opposition between Christian West and the Islamic Orient, the Ottomans believed that there were some essential differences that distinguished them from the West—especially a notion of Islam."[17] Reformers sought to address the West's misinterpretations of the East, with Islam as its linchpin, while also accommodating secularist views. Reform entailed what Makdisi calls a "double movement," which entailed moving toward European modernity while drawing away from the prejudices of Oriental

stagnation and indolence.[18] This meant emphasizing parts of its history that countered such notions. In effect, the redrawing of history meant that Turkey was undertaking its own Orientalizing, since it was embedded in what set it apart from the West. He concludes: "Ultimately, both Western and non-Western Orientalisms presuppose a static and essential opposition between East and West; yet both are produced by—and are an attempt to overcome—a crisis in this static opposition created by the same dynamic colonial encounter."[19] This cultural brokering of emulation, while remaining faithful to the past, would prove to have lasting consequences simply because what exactly constituted this difference, and to what one should remain faithful, were very much at the mercy of differing points of view.

Early reforms and hats

Laws governing dress had long been used as in the Ottoman Empire as a way of controlling and homogenizing its various people. "The importance of clothing laws," aptly states Hale Yilmaz,

> lies in the fact that they are never simply about the clothes the subjects or the citizens wear, but rather they are reflections of the broader cultural, political, social, or economic concerns and changes. They serve as "instruments of negotiation" between states and ethnic, religious, or other communities, between élites and other social classes. Their enforcement, social meanings, and eventual success or failure are not determined by the state alone but are shaped in large part through these negotiations.[20]

Inevitably, such reforms were received in different ways according to the social group. Class, religion, and the divisions between urban and rural life all had their part to play, to the extent that dress laws tended to amplify and deepen such divisions.

Under the sultanate of Mahmud II, in 1827 it was decreed that the fez be the official head covering for the military, and a year later this was extended to all members of the civilian male population. Occurring just before the "Tanzimat," or reform period, (1839–1876) that began after Mahmud's death, this measure had a number of intentions. Pre-eminent among them to bring together, in appearance Muslims and non-Muslims, to soften the representations of class, and to make the difference between civilians and government officials less obvious. As Camilla Nereid explains,

> Male headgear as an arbiter of identity was a well-established practice, but as the empire declined both economically and militarily, the turban came to be a

marker of professional status and independent political power rather than a sign of loyalty to the ruler. As the use of the turban was restricted to the military and the religious classes of the empire, the non-Muslim subjects of the empire were excluded from displaying their loyalty or lack of such towards the Ottoman rule.[21]

To ensure popular support for these reforms, teachers and religious leaders were enlisted to advance their ardent enthusiasm for the changes. The changes also had to be by higher example. Mahmud was the first sultan to dress noticeably according to European custom, jettisoning his turban, and wearing trousers instead of the traditional loose pants (*salvar*). But such efforts met with mixed responses, much of them directed at the grounded suspicion that the Sultan was paying lip service to the West through disapproval of traditional dress.

Even if the fez was a compromise over the turban, it was not, however, an item that had been exhumed from the depths of Ottoman history, but rather derived from North Africa. Having been worn for generations in Tunisia, Algeria, India, and Morocco, the fez also had the advantage of expressing fealty with these countries, symbolizing religious and historical bonds. It was an attractive option because of its relatively neutral geometric shape, and because it distinguished itself from Western brimmed hats. Yet in alignment with Western habits, men were expected to keep their beards short and to limit the amount of jewellery. Intended to strengthen the Turkish state, the Tanzimat reforms extended to all strata including the replacement of religious law with secular law, the decriminalization of homosexuality, and the reform of the banking system. The guild system was also dismantled. It was largely the workers who objected to these upheavals, showing their dissent in their refusal to wear the fez.

It did not take long for the fez to meld itself smoothly into the national psyche. Sultan Abdülhamid II (who reigned 1876–1909) regarded the fez as a symbol of tradition that united national and Islamic interests. But while such interests were being defended, there were now several generations that showed their allegiance and indebtedness to Western culture, particularly the French. (Pamuk later recounts how his father fled the family for several years to take up in Paris where he translated several celebrated writers including Paul Valéry. Further, Atatürk was himself highly competent in French and would often speak it with friends.) Indeed, French was a favoured source for creating new words.[22] Western manners and customs were all particularly valued as they are today, where to speak the language of an economically prosperous country such as Germany is deemed a sign of intellectual flexibility and international mobility. (By contrast, from the 1970s onward, elite Japanese considered learning French a badge of prestige and good taste.) By the end of the nineteenth century, despite the still current expectation that Turkish men show their national faith in wearing the fez, higher Ottoman officials, particularly diplomats stationed in Europe, began to

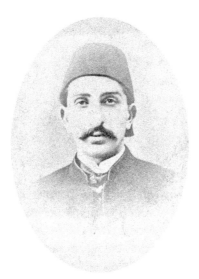

Figure 1 Sultan Abdülhamid (1842–1918). London Stereoscopic & Photographic Co. Printcollector/Gettyimages.

show their cosmopolitanism by wearing bowler and fedora hats. Within the Empire, non-Muslims were also apt to do so. For gradually the fez had become less a symbol of Ottoman unity and more one of Islam, "thus demonstrating the malleability of cultural constructs" as Nereid concludes.[23] The outward trappings of Western appearance announced their difference from Muslim subjects, and by extension, their superiority. It was the signification of this difference, and the potential it had for sowing dissent that culminated in Sultan Abdülhamid banning the European hats in 1877, instating the fez as the hat that men were expected to wear. The reprisals for not doing so were particularly steep, such as termination of employment and even imprisonment for especially government officials.

However, as much as the fez may have played an operative role in assuming Turkishness, fezzes were not necessarily all made in Turkey. Austria's annexation of Bosnia-Herzigovina in 1908 resulted in a boycott of Austrian imports, among them fezzes. The protests, which included destroying fezzes made abroad, renewed discussion of the matter of appropriate headgear and caused alternative ones to be worn such as the *kalpak* (a high-crowned cap made of felt or sheepskin) and the *külah* (a cone shaped hat). A year later in 1909 the *kalpak* was adopted as the official military hat, as it distinguished young officers of War of Liberation from the fez-wearing establishment. The *kalpak* could have continued to have been the sign of the new Turkey, but the urge to join Europe and to break with the past was too strong. Yet before Mustafa Kemal Atatürk's Hat Law was promulgated in 1925, Turks after the War continued to wear a

variety of different kinds of headgear. In the wars of independence in 1923 the fez was equated with the old regime and, therefore, as Yilmaz observes, "loyalty to the fez must have been weakened in that process."[24] It also helped to internalize the need for change, with clothing playing a cardinal role, "in the sense that clothing changes require changes to one's established habits."[25] Under Atatürk these habits faced serious threat, and the violence underpinning the changes cannot be underestimated.

For the fez was not only the most prominent sartorial feature for men, but also, because it covered the head, it perforce became the symbol of attitudes and frames of mind. "Old head" was a commonplace Turkish expression for a mentality outdated or left behind, and it was used liberally and interchangeably in relation to hat style. The Hat Law was enacted as part of the overarching Law on the Restoration of Order of March 4, 1925, which gave the government the power to prohibit "all organizations, provocations, exhortations, initiatives and publications which cause disturbance of the social structures."[26] Wearing the wrong hat was precisely one such instance of "provocation" and "disturbance," as it violated the national campaign for modernization and improvement. As Atatürk himself explained two years after enacting the Hat Law:

> It is necessary to abolish the fez, which sat on the heads of our nation as an emblem of ignorance, negligence, fanaticism, and hatred of progress and civilization. To accept in its place the hat, the headgear used by the whole civilized world, and in this way to demonstrate that the Turkish nation, in its mentality as in other respects, in no way diverges from civilized life.[27]

A remark such as this, laced with its own kind of fanaticism and urgency, helps to understand the rifts the reforms caused in Turkish life. It was also at the heavy price of denigrating the past and by all accounts denigrating the culture as a whole, with the danger of consigning the new face of the country to the status of eternal simulacrum.

Just as the earlier sultanate relied on educators and religious leaders to endorse reforms, Atatürk went to great lengths to ensure that his and his government's policies were firmly integrated into school curricula. More widely, popular media was also enlisted in refashioning of old ways. A cartoon from March 1924, on the cover of the newspaper *Karagöz*, still printed in the traditional Arabic script, shows a man on a balcony throwing out a book, an urn, and a skull, reflecting the title "The Disposing of Old Mentalities and Laws." The skull is the old mentality, the urn refers to the Sèvres vase and thus to foreign occupiers, and the book to otiose dogma. A man in a turban in the background looks on with an expression of consternation. As Yasemin Gencer remarks, "the mullah is thus visually marginalized and symbolically incapacitated. As a result, this cartoon communicates a revolutionary message, pitting Turkishness against Islam, and

Western secularism against the 'antiquarian' Ottoman-Islamic legal system of *shari'a*."[28] She argues that cartoons such as these gave the new republic "a second level of visibility that was achieved by rationalizing, promoting, and illustrating what were already very visible social changes."[29]

Atatürk's equation of modernization with secularization and the dismantling of Muslim codes proved to be deeply divisive, for it opposed Kemalist reason with a vision of Islam as a way of life that limited progress. Detractors warned, as Nereid states, that "the construction of a Turkish identity based on superficial Western mimicry was equal to the internalization of inferiority."[30] Further, dress codes created little more than "a masquerade hiding the gap between ideal, Westernized élite of urban Istanbul, and the reality, the poor peasants of rural Turkey."[31] This proved to be irrepressibly true, for the peasantry were by nature less open-minded and less economically disposed to change. Those who could not afford the hat, or were simply disgruntled, wore a cap with a brim on the side or the back. While the extent of resentment at the law is next to impossible to evaluate, as suggested earlier, resentments tended to entrench themselves further with economic hardship. In remote and poor areas, people were also restricted because of lack of money and scarcity of the new "civilized headgear" ("*medeni serpus*"). Simple caps and other improvised adaptations became the norm in rural areas, causing the government to inform local governors to issue the relevant decrees, whose enforcement was irregular at best. A net effect was not only to emphasize the difference between the urban élite and the poorer provincials, but also to create a Muslim subclass, a Muslim "other," now judged in the first instance according to appearance. These differences were aggravated further by declarations of the élite that clothing had nothing to do with religion, and therefore to be too fixated on clothing was to reveal the extent of one's delusion.[32] This was not what the common folk wanted to hear after centuries of having been told the opposite.

Unsurprisingly, then, dissent at the Hat Law sparked rioting by people, many of mixed ethnic backgrounds, fearing that the break with the past undermined religious order and, by extension, social and political order. For Islam was seen as the glue between the Kurds and the Turks. The disaffection was so rife in rural areas that it was easy to draw the conclusion that the law was a ploy, or a decoy, to bring the lower echelons of Turkish rural society to heel. As Nereid suggests, "The number of rebellions, arrests, imprisonments, and executions in the aftermath of the Hat Law might lead one to conclude that the rationale behind the hat legislation was to oppress and discipline Turkish society by forcing it to make its resistance visible and thus possible to localize and crush."[33] As she concludes, what the Hat Law disenabled was an essentialist reading of Islam, thereby displacing "essentiality or an origin to which you can return." In short, "There was no consistent, authentic, original past or traditional 'other' hidden by a superficial 'we'. The traditional 'other' was as multifaceted as the modern 'we'."[34]

Although the end of the fez gathered the most attention and incited the most emotion, this did not mean that the changes were limited to it. Rather transformation ramified to all parts of Turkish dress, from top to toe, with facial hair also becoming shorter or disappearing altogether. The campaign to conform to Western canons of dress had many immeasurable consequences. It alienated the rural and working classes whose contact and knowledge of the West was slender to non-existent, and it disrupted age-old traditions of weaving and tailoring. One such item was the *karadon*, the baggy pants, which in the summer were worn with a sleeveless shirt (*aba*), which was banned by authorities, polarizing members of the community in areas of both production and consumption.[35]

Headscarves, veils, and women's clothing

Since 9/11 the veil has assumed large, and some would say, disproportionate metonymic significance as a symbol of the difference between the values of the Christian West and the Islamic East. Seen in the most ideological light, it has become a powerful symbol of Islam putative oppression of women, as well as its cultural backwardness, and its tenacious weddedness to the remote past. What is far less known is that veiling, which for all and sundry is the outward symbol bar none of Islam, did not begin with Islam, existing well before the religion originated in the early seventh century, and practiced not only by Muslim women, but by Jewish and Christian women as well.[36] It can be traced back to Ancient Mesopotamia (3000 CE), through Ancient Greece and Rome, to the Persian-Sassanid dynasty (224–651 CE) and the Byzantine Empire (306–1453 CE).[37]

To the modern, liberal, and individualist Western eye, the veil appears to have quite a definite message, namely covering what ought not to be covered, for to deny the face is ostensibly to deny identity and identification. As Sahar Amer, in her detailed study of veiling, gnomically states: "Liberating Muslim women became a leitmotif of nineteenth-century European discussions about Muslim societies, and a key component of what has come to be known as the White Man's Burden."[38] For the simplistic dualism to veil or not to veil is itself a front for much more varied views and more nuanced circumstances. The Iraqi feminist Basima Bezirgan commented in the mid-1990s that: "Compared to the real issues that are involved between men and women in the Middle East today, the veil itself is unimportant."[39] Yet if it is inconsequential to some, it is for others what divides men and women, and their claims to equality. Huda Sharawi, founder of the Women's Union in Egypt, removed her veil in 1923 as an expression of her dissatisfaction.[40] Nonetheless, as Elizabeth and Robert Fernea point out, veil or no veil, the strictly observed role of women in society and the household in Islamic countries is largely preserved.[41] It is a pertinent symbol of female honor,

which must also be reciprocated by men who also wish to be known as honorable. Amer concludes that "veiling is not and has never been a neutral phenomenon." It has always been subject to "competing meanings and motivations at different times and in different places."[42] What is certain is that the veil remains an inflammatory symbol that has had one significant climax in France's outlawing of the veil in 2010. The guiding premise of the Constitution of the 5th republic was that France is a fundamentally secular state and systems of belief ought not to impinge upon the "community" as a whole.[43] As we know, beneath the rhetoric of French liberalism lay many discontinuous strata of pain and resentment in the aftermath of French colonialism, and the Algerian war, a still lingering presence in the minds of many.

It is a controversy that also helps to recall the discomfort that Turkish men experienced with having to forgo the fez, for the divestiture of both was to a great extent an imposed nakedness that exposed the interrelation of self, clothing, national identity, and religion. In both cases clothing and appearance played witness to the defense of a highly abstract invocation of fidelity to the state. One recurring argument for hijab, and the (forced) enclosure of women's bodies, is that it gave as much room for movement as it was an impediment, inasmuch as women remained anonymous, an invisibility that also had its advantages. It also managed the ability to conceal other forms of dress beneath it. But it was also in the nineteenth century that women began to change their style of clothing, especially indoors, for example moving away from the *gömlek* and the *salvar* toward the *entari*, a long dress that was in tune with the European look.

Concealment and the ambiguities that this engendered helped to nourish the imaginations of generations of artists, writers, and composers. The fetish over the harem is the first narrative port of call, and heavily commented upon, not least in the famous letters of Mary Wortley Montagu.[44] In her case, where she was able to penetrate the harem where men could not, her writings serve as invaluable documents to what for the Western man was another world and a most coveted sexual frontier. But these zones of supposition were not confined to heterosexual sensibility alone. In Virginia Woolf's *Orlando*, Turkey becomes the liminal zone of sexuality, where the eponymous protagonist transforms from woman to man. Clothing is a central modulator in this change, as it is represented by Woolf as having few differences between genders. But as Matthew Beeber notices, this is a misrepresentation of Ottoman dress, and something to which commentators of the novel have given scant attention. By figuring Turkish dress as largely being androgynous, he argues, Woolf mounts a veiled critique of the traditional Victorian image of the Orient as sexual and feminine.[45] While critics have addressed the issue of androgyny, they have not gone further to observe how incompatible its application is to actual Turkish fashion and dress.[46] One item in particular, baggy trousers, is used by Woolf to reveal this lack of difference.

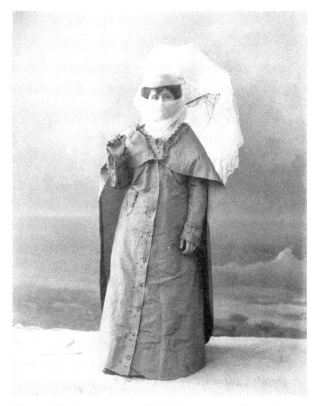

Figure 2 Turkish woman c. 1885. Photo by Adoc Photos/Corbis
via Getty images.

Yet, as Beeber argues, these are "a trope, a symbol of androgyny and sexual
freedom in the East, a symbol especially powerful in the imaginations of Victorian
women for whom the trousers might appear mannish in comparison to
burdensome crinolines."[47] Woolf's diaries from Constantinople nonetheless
identify the strong demarcations between the sexes, suggesting that the
misreading of fashion was motivated at dispelling reigning clichés by Victorians
of Ottoman fashions and mores.[48] Woolf was well acquainted with the writings of
Montagu, whose vision had become influential to British notions of the East. For
Montagu stressed the "liberties" of women's dress and movement, afforded by
dint of concealment. The "liberties" that Montagu spoke of were also interpreted
into a sexual realm, naturally enough. Yet Woolf was well aware that Montagu
contributed to the feminization of the Orient: Montagu's privileged and selective
outlook, portraying a far more relaxed role for women, elided the grimmer truth
that it was men who had mobility and it was in their interests to curtail the
movements of women.

True enough, the image of the Ottoman woman, covered from head to toe with only a small slit for the eyes, continues to be a prevailing one, and seductive not only for eliciting endless speculation, but for presenting such an easy generalization for representation and critique. However an important correction needs to be made at this juncture. For the idea that all Ottoman women were veiled in the nineteenth century is as sweeping a generalization as the brash Western equation of the hijab with women's oppression and Muslim tyranny. Ottoman women well into the early years of the Republic wore veils in different ways and situations, based on their class or their own cultural views. For example, the peasant women in Anatolia were not veiled but wore a headscarf and only concealed their lower face in the company of men with whom they were unfamiliar. Similarly, the Westernization of women's dress in the nineteenth century occurred at differing degrees depending on women's social station and whether urban or rural. The latter not only were limited in means, but were also less exposed, and less receptive, to outside trends and changes. Being mindful of the ethnic diversity of the Ottoman empire, different groups adapted at different rates: peoples who identified with Greece or Armenia, for example, accepted Western changes with greater rapidity than their Jewish or Muslim counterparts.[49] Reforms continued in fits and starts. Sultan Abdülamid, for example, banned women from wearing several items of clothing (the *carsaf*, *ferace*, and the *yasmak*) as he believed that they did not sufficiently comply with the requisite modesties of Islam.

Curiously, it was also Ottoman women's fashions that played a cardinal role in the liberation of European women from the corset and the stay. Ever since the eighteenth century the Ottoman empire had been highly conscious of European ways and how they differed or may have improved on their own. It was a preoccupation that accelerated in the mid-nineteenth century, in no small part fueled by the Sultan Mahmud's example, that Ottoman women began experimenting with Western fashions, which also included the corset. It was also by showing signs of influence from Paris that upper-class women could register their sophistication, and also distance themselves from the antiquated lower classes. Further, the rise of department stores at the end of the nineteenth century, and the greater circulation of goods together with advertising material ensured that Turkish women with the right means had a whetted appetite for European goods. During this period, it became common for upper-class women to wear a long flowing coat, the *ferace*, to have their faces barely covered, and to have replaced the *terlik*, or slippers, with boots with high heels. Meanwhile, by the end of the nineteenth century, lobbyists for Women's rights, the suffragettes, became synonymous with bloomerism. "It is remarkable," as Inal remarks, "that at the same time as the *salvar* and *entari* became a fashion of high society in Britain, it was simultaneously replaced by European dress among the elite women of the Ottoman Empire. The same type of clothing that symbolized authenticity,

Figure 3 Turkish woman c. 1885. Photo by Adoc Photos/
Corbis via Getty Images.

showing off and wealth in Britain represented the old and traditional Ottoman
society."[50] Abandoning the corset and wearing baggy pants was more than an
attempt at comfort, it represented an entire new perspective on the way society
should be organized. Later in 1911, after his *Thousand and Two Nights* party,
Paul Poiret would credit himself with having freed women from their sartorial
encumbrances, when in fact this had been occurring over decades, and in
no small part to the exchanges in influence between Ottoman and European
women.

 Women were banned from the veil in 1935, ten years after the proscription of
the fez. This cannot be seen in isolation, but rather as grouped among a series
of Atatürk's "civilizing" reforms, which included women's education and literacy
as well as political participation. Around the turn of the century the most popular
forms of clothing for middle and upper-class women were the *çarsaf* and the
peçe. However, like the fez, by the 1920s these garments became seen as
retrograde statements of a stagnation.[51] The *çarsaf* was a single, loose piece of
cloth that covered the whole body. But once cut in half, it could resemble

something of European taste. The upper garment formed something like a cape, and the lower body a skirt. As the skirt evolved, it became shorter and narrower, while the *peçe*, the transparent face veil, was replaced by the scarf (*esarp*). The stories of women's dress, up until the Republican reforms, are the vicissitudes of conservative perception as to the appropriate signs of modesty and devotion in women.

The debates surrounding the relationship between clothing and religion have already been traced above with regard to the fez, but with women's clothing the focus was elsewhere, since the codes of guardianship began with a woman's own body. Women who responded to the reforms were frequently met with violent responses such as being spat at, being stoned, or having knives drawn on them. Yet both the Balkan and First World Wars were significant catalysts that made more women participate in contemporary life where they were more visible and responsible. Earlier in the nineteenth century women worked in positions such as nurses, journalists, and teachers, but the shortage of male labor precipitated by the wars meant that the roles open to them expanded to those such as clerks and factory workers. In Istanbul their placement in menial labor extended outward to street sweeping. Women therefore played a sizeably greater part in public life. In 1915 an imperial decree made it admissible not to wear the veil during working hours. As their agency increased, so did their compulsion to express it, so that discarding the veil seemed perfectly natural, like relieving oneself of an anachronistic impediment. After the war, with social agitation fomented by the shame of defeat, the clamor for abandoning the veil for good gained momentum. More and more female activists declared the necessity of modernizing dress.

The promulgation of the Hat Law for male citizens eventuated in the headscarf replacing the veil as a signifier and safeguard of women's modesty. And while ardor of belief varied according to class, and whether one lived in a city or the country, tenacious binaries established themselves. The *çarsaf* and the *peçe* were viewed as upholding decency, tradition, and the correct position on religious belief; they were deemed by reformists as stultifying anachronisms. In turn, those advancing reform were cast as abetting moral decline and moving in a direction that dishonored Turkey's past. The rhetoric of tradition is seductive, since it implies that the glories of the past can only be regained through lip service to it. But certainly, despite the divide between men and women in Islam, the differences between the more modern men's clothing and that of women became more pronounced, suggesting an urgency to make dress more equitable, which is also to say more modern. Nonetheless, as Yilmaz suggests, "among large segments of society, women's dress, their visibility, education, and employment, and the regulation of male-female relations continued to be perceived through local, tribal and religious lenses."[52] The status of women's dress remained more fluid than the more policed male counterpart, and in many cases appeals for voluntary

abandonment of older forms of dress went unheeded. This escalated in mayors issuing more stringent edicts, but the effects were again uneven. This did not deter the Shah of Iran, Reza Shah Pahlavi, from embarking on an unveiling campaign after his visit to Turkey in 1934. But for him, too, propaganda proved ineffective, prompting him to enact in 1936 laws making it mandatory for women to unveil.

It was also around this time that the Turkish government invited intense debate about the *çarsaf* and the *peçe*. By this time, it was observed that women in the provinces, which amounted to about two-thirds of the Turkish population, wore neither. One question centered on why the relatively small fraction of women still refused to jettison the *peçe*, or headscarf, in particular. Was it an expression of women's distrust of men? Other arguments stated that clothes that concealed appearance were conducive to crime. A member of parliament, Hakki Tarik Us, was particularly voluble on the matter, waging an attack on conciliatory measures of voluntarism. Changing roles between men and women called for the *peçe*'s abolition, as it was a powerful medium that impeded such progress.[53] Others tended to the belief that Turkish reform was not reducible to clothing, and that more far-reaching perspectives could provide better results. What these various opinions did share, however, was that they were all propounded by men. It was a stark example of the bias that still tainted Atatürk's otherwise strong push for women's rights under the new regime. During his brief marriage (from 1923–1925) to Latife Hanim, a woman hailing from a wealthy family and with a European education, Atatürk was accompanied by her on his visits to Anatolia, where she appeared wearing modest European clothing and a headscarf. But Atatürk persistently appeared to officiate women's dress in the manner of the male counterpart, laying the vicissitudes of women's dress to those dictated by "fashion."[54] Gradually, by the early 1930s, the hat had begun to supplant scarves, although not without continued pressure on old religious beliefs, especially those held and enforced by men.

At the same time as these complex and fraught cultural upheavals in Turkey, the West was still content to cherish a stereotypical view of the former Ottoman Empire. The 1920s witnessed quite dramatic changes in women's dress, allowing for greater mobility. It was at this time that masquerade, now in the modernized term, "fancy dress," experienced a renaissance in popularity not only due to party culture but to the significant rise in various forms of media and entertainment, including cartoons, films, and the widening ambit of print media ranging from guidebooks to fashion glossies, which were already disseminated in ever-greater number before the War.[55] One of the more popular examples that could be bought off the rack at Harrod's department store was called "Turkish Delight." This was the only version with direct cultural inference: others in the line included "Merry the Bright" and "Queen of Hearts," as illustrated in the 1927 catalogue *Fancy Dress at Harrods*.[56] "Turkish Delight" consisted of a splayed feather head-decoration, repeated pleated riffles at the waist, loose-fitting striped pantaloons,

and shoes with an upward-turned tip. This is but one small instance of a multitude of cultural dissonances that, while ostensibly innocent, are prevalent until today. They are preponderant in the way in which artists are forced to broker their identity against false or misinformed assumptions about their country of origin. In the case of fancy dress in the 1920s, it did not sufficiently serve the Western imagination to look at what Turkey "really was." This oscillation between inner desire and compulsion and the pressure of external perception is an ongoing theme of this book.

Banning the headscarf

If Atatürk had demurred from securing a law against headscarves in his own time, it was finally put into motion in 1982. The ban was on wearing headscarves for religious purposes in universities and government offices, in other words in all "official" non-commercial institutions related to social service. This shortly led to a number of scandals. On July 31, 1984 the *Daily News* of Ankara published an image of three female students in academic dress, one wearing a turban. They had been celebrating their graduation in Medicine at the University of Ankara. The turbaned woman happened to be the top student, who traditionally delivered an address to her fellow graduates. In this case, owing to her head covering she was prohibited from doing so. In the previous week there had already been instances of women in universities falling afoul of the law: in Uludag University in Bursa four students were suspended after arriving in head coverings that were said to be "turban-style."[57] And a junior academic of Chemical Engineering of the Aegean University in Izmir proclaimed that she would resign if unable to wear her headscarf, adding, "This is My Philosophy of Life."[58] In an attempt to stave off mounting controversy, the rector replied that Dr. Koru, the academic in question, was at liberty to wear anything on her head when off-duty. The ongoing debate saw other women speak out in defense of the government laws, highlighting how polarized Turkey still was over the issue. By July 29, the Istanbul newspaper, *Milliyet*, which had been covering the saga, finally reported the University's announcement of the right to dismiss Dr. Koru.

The question still remains as to why these events raged potently in Turkey until as late as the 1980s. One reason Emelie Olson cites is in the vast ethnic diversity, and hence the variety of values and beliefs in Turkey. Just as the government used clothing to leverage its policies, people dissented in kind. "By 1980" states Olson, "Turkish society had become politicized to an extreme degree." There were numerous acts of violence and civil unrest:

> Confronted by this breakdown in public order, the authorities decided that the manipulation of dress as political symbol contributed to the tense situation.

The conspicuous and constant "signing" of religious and political views through dress and hair by extremists on all fronts was seen as both inflaming passions and making the "enemy" on both sides identifiable to snipers and assassins.[59]

The problems were historically deep seated. As the Turkish economy showed no great signs of prosperity, certain people would look back with nostalgia to what they saw as the prosperous Ottoman past. While not fully embraced by Western Europe, Turkish people were far from unified in their view of modernization, which singled them out as a Muslim nation from other neighbouring states that were once part of its dominion. In short, the dress reforms, as seen in the long term, came to be regarded by some as leading to Turkey's isolation. It was a complaint that could not be made with due decisiveness, however, as many of Atatürk's reforms had had positive results. For many modern Turkish people, they felt inserted into an uncertain space, parked indifferently but agonistically between Occident and Orient. At the end of the twentieth century, for many who looked ambivalently back and who also saw an unclear future, Turkey's rapid alteration was an example of what Bhabha (writing of Indian and African colonialism) sees as the compromise that comes with "mimicry." Bhabha's pun, "*Almost the same but not white*,"[60] is painfully pertinent to the Turkish experience, where emulation only amplifies the many aspects in which the many intricate acts of mimicry fall short.

The tensions that arose in the 1970s were also highly influenced by the women's movements in the West, and other racial protests that had gained momentum since the early 1960s. Turkish women used the headscarf as a way of registering their difference from both men and the West. By then it had a complex status, since its abandonment had been a sign of women's liberation. Yet it was increasingly seen as a partial liberation, organized by men. As Valorie Vojdik points out, "a certain group of women—young, urban, and typically daughters of migrants from the rural periphery—deliberately embraced the headscarf, challenging the secular elites as a political matter."[61] A salient issue in these challenges was that of what women saw as their inalienable human rights. By the new millennium, meaning and instrumenting of these rights had become convoluted from a global perspective. Turkey forbade the headscarf, yet Iran mandated it. The United States granted the right of choice to Islamic women, while France banned headscarves. In response to the French ban on schoolgirls' scarves enacted in 2004, in 2005 the Turkish government revisited their own law. They concluded that it was not in violation of human rights, but a restriction that protected the beliefs of all citizens by ensuring that religion was not made overly manifest.[62] Vojdik emphasizes that these overarching arguments on the part of the government mask the reality that it is a law that centres on masculine power over women's bodies. "The headscarf debates" illuminate "the reciprocal

relationship between the construction of the state and gender relations."[63] But such considerations should never elide the fact that the veil is a highly fluid sartorial trope. It cannot be considered as an instrument of Muslim male control, but must be seen as a cipher for what are often conflicting practices and beliefs. In surveying the way that contemporary artists deal with veiling, Amer finds that

> Muslim veiling clearly never refers to one singular type of practice, nor does it have one universal meaning or unique form of expression. Rather, veiling describes a multiplicity of experiences. It is controversial only because it is a visible marker whose meaning cannot be contained in or grasped with a single or simple explanation. The meaning of the veil can only be revealed through the exploration of its shading, its range of expressions, its contradictory practices.[64]

We might also make peace with the notion that the campaigns to "liberate" Muslim women from the veil and the scarf are past, state laws as in France notwithstanding. We must resist, it seems, reductive views about veiling and instead embrace it as a multivalent sign of both submission *and* resistance.

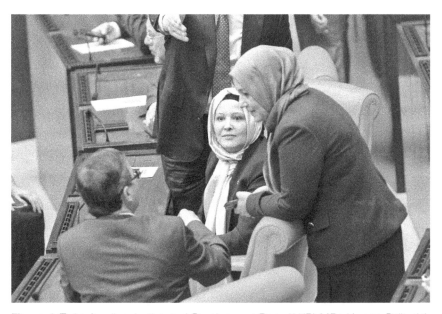

Figure 4 Turkey's ruling Justice and Development Party (AKP) MPs Nurcan Dalbudak (centre) and Sevde Beyazit Kacar (right) attend a general assembly at the Turkish Parliament wearing headscarves in Ankara on October 31, 2013. Four female lawmakers from Turkey's Islamic-rooted government attended a parliament session on October 31 wearing headscarves for the first time since a ban was lifted in the staunchly secular country. Photo: AFP PHOTO/ADEM ALTAN/AFP/Getty Images.

It would be feasible to conclude that the headscarf, and related head covering, worn for itself and not, say, as protection from the elements, has emerged as very much a political instrument pertinent to both the self and the state. Instead of protection from the elements, it is a barrier, a partition between male presumptions and women's private worlds, and symbolic protection from the regular ideological onslaughts from Western reproaches of Islam. It is a multivalent instrument. Where it was once linked to nostalgia and traditionalist intransigence, it is now an inflammatory device for women against imposture, the impositions in both words and actions of power against them.

3

THE GLOBAL
TURKISH ARTIST

Political unrest in Turkey has not stayed efforts on the cultural front, most prominently, the Istanbul Biennial, the large exhibition of international art founded in 1987. Now part of the biennale circuit that begins and ends with the Venice Biennale, Istanbul's event every two years has been significant in situating Turkish artists in an international milieu. It is perhaps the single biggest factor in the new concept of the globally active Turkish artist. While the Venice Biennale opened its doors in 1895, the Biennale phenomenon is very much a component of art and globalization, in which particular countries stake claim to active participation in international culture. Together with the Biennale of Sydney (which began in 1973), the Istanbul Biennial is one of the first of these biennales, which continue to be newly founded around the world with apparently irrepressible momentum. With the agonistic history of Turkey's Westernization in mind, the formation of the contemporary Turkish artist would appear to be a product of natural evolution, if not also culturally exigent. The oscillation between ideologies of cultural specificity and those of global fluidity and adaptability have necessitated an artist that is forced to define personal origins in media and in sites that are beyond the boundaries of these origins. Such conditions have created the culturally hybrid artist, a notion that we will see in later chapters, that is not without its compromises and difficulties.

There is more to compare the Sydney and Istanbul Biennales than their provenance, for both were keenly conscious of situating their own national art and artists in the international sphere, both aesthetically and historically. While predating Istanbul by almost fifteen years, the early Sydney Biennales were relatively modest affairs, but by 1990 a clear pattern in the curatorial rationales had established itself, which was a near obsession with the center–periphery debate. Harold Bloom's phrase, "the anxiety of influence," used for the way writers deal with powerful literary legacy, was reformulated for the perturbations of cultural inheritance, and the problems surrounding the so-called importation of style. Although placed according to different social, religious, and historical co-ordinates, art of Australia in the 1970s and 1980s was literally obsessed with

the perception of itself as a second-class culture, artistic ventriloquists of scripts devised on the other side of the globe. A short list of some of the thematic titles for the Biennales bears this out: *European Dialogue* (1979),[1] *Origins, Originality + Beyond* (1986),[2] *The Readymade Boomerang: Certain Relations in 20th Century Art* (1990),[3] and *The Boundary Rider* (1992/3).[4] It was also at this time that words such as "liminality," "interstitial," and "marginality" began to have critical currency, sometimes alas, to the detriment of already fraught artspeak jargon (what the art critic Richard Dorment would more caustically refer to as "pernicious drivel"). With its origin over a decade later, the artists and public of the Istanbul Biennial were spared the same level of obsessiveness in questions about a national art, an authentic national style, and artistic inclination. These were questions that began to wane by the 1990s when the rise of the Internet appeared to make cultures more diffuse and more porous. This is in no way to suggest that questions of nationality dissipated or were superannuated, they only shifted register toward the individual, so that "nationality" made the subtle transition to "identity."

The word "margins" can hardly cope at all with these identities anymore, because of virtual worlds, and because so many people profess to have more than one identity. The discourse of marginality is very much lodged within postmodern revisionism, and postcolonial theory. It is still valid as a shorthand but is still part of the epithets "hybridity" and "multiculturalism," which, steeped as they are in neoliberal good intentions, circle back to limited and limiting ways of describing the complexities of culture and the various ways in which individuals negotiate them. As Katherine Pratt Ewing argues, "the concept of hybridity is not a good model for analyzing how people caught between cultures actually negotiate identity, because it does not explain how individuals manage inconsistency through a variety of cultural and psychological strategies that generate multiple, contextualized identities."[5] She later avers "that an ideology based on multiculturalism and celebratory hybridity imagines homogeneous collective identities that hamper recognition of the actual heterogeneity."[6]

This is what makes the examining of a number of Turkish artists to have emerged since the 1990s a rewarding exercise, for the reason that the artists have no choice but to engage—which may also mean through disengagement— with Turkey as a Muslim nation, and therefore numerous stereotypes and assumptions are used to interpret the work. Many of the artists dealt with in this chapter are models of cultural pluralism: having trained in Europe and the United States, while maintaining an art practice indelibly tinged with Turkish experience, whatever that may be in their eyes. This also entails divergent visions, unmoored, ostensibly or not, from discernible cultural relationships, and therefore examples of the global worldview that is a hallmark of contemporary art. Since roughly the mid–1990s, there has been evidence of artists expressing their belonging to a global community that transcended historical state boundaries. For instance a

collective from Slovenia, NSK ("*Neue Slovensiche Kunst*" — "New Slovenian Art"), representing their country in the 1993 Venice Biennale, sought to undermine the principle of the Biennale itself, which is based on discrete national selections.[7] Writing for their catalogue, Zizek called for "a state without nation, a state which would no longer be founded on an ethnic community and its territory."[8] To some extent this statement has come to fruition, but also under the conditions of its opposite. For even if state boundaries are historic and porous, and continue to be contested and reclaimed (for instance Russia with Crimea, China and its ocean waters), nationality exists very much as a sign to be distributed according to the contrived global pie chart of representation in the name of international parity and the semblance of balanced representation.[9]

No mistaking it, a key characteristic of global curating is the expression, albeit in its nuanced form, of culture. The artist must somehow be a purveyor of his or her provenance and language, not only to satisfy Euroamerica's inexhaustible appetite for otherness, but to the extent to which they violate common codes and precepts about race, nation, and belonging. Writing about the "transnational artworld" germane to globalization, Noël Carroll argues that although transnationalism has always been a factor of trade and transaction between states and civilizations, what stands out about the present era is "a single, integrated, cosmopolitan institution of art, organized transnationally in such a way that the participants from wherever they hail, share converging or overlapping traditions and practices."[10] This is a disarmingly assuring statement that has the ring of truth. But it is within the landscape of similarity (or sameness), that exceptions and divergences tend to be exposed. For Turkey these oscillations are particularly pronounced, no less because its modernization had always sought the integration with the West. For those Turkish artists who participate in the global stage of art, a common thread are the many slippages that occur from assimilation, and integration, the proverbial, "yes . . . but." It is because of the history of attempted integration that the asymmetries between Turkey and its Western idealizations tend to be amplified.

Although artists from Egypt and other Arab countries began to enter the international sphere in the last decade of the twentieth century, artists from the Middle East received unprecedented visibility after 9/11. In cultural circles and from an artistic point of view the generic protagonist was a subject for a more searching critique, and especially those mounted on their own, the local artists', terms. It is a much-remarked fact that contemporary art has a voracious appetite for seeking, or seeming, to "understand" the aggressor and the other, in the effort to reintegrate difference — all the while knowing full well that the novelties of scale and attention in contemporary art thrive off difference and lip service to cultural revisionism. As I have written elsewhere, contemporary art is an industry that thrives off a meta-Orientalizing that is enframed as its ostensible opposite: integration. The anger, torment, and confusion in the wake of 9/11 set the art

establishment into a tailspin of its own, where an even-handed, liberal approach of understanding the Muslim world was played out knowing that uneasiness and ennui reigned underneath—therein the fascination when seen in Euroamerican terms.[11]

In many ways the state of affairs is understandable as it has to do with marketability. One of the marked results of 9/11 was, as Maymanah Farhat argues, to have the Western Orientalist interest "greatly intensified and . . . all the more audacious."[12] Farhat acknowledges that there was exposure of Middle Eastern Arab art in U.S. contexts, but they were always isolated, and for that, somewhat specialized and quarantined. Until 9/11 Arab artists had "been consistently shut out from the mainstream," finding themselves in "a notoriously exclusionary art scene."[13] Examples of artists who have risen to prominence in the last fifteen years are Emily Jacir, Walid Radd, and Ghada Amer (although Amer attributes the launch of her career to exhibitions before 9/11: to be discussed in the following chapter). While it is certain that the United States has been intently and carefully selective of much Middle Eastern art, there have also been efforts to find a constructive balance, but their success is dubious. Farhat cites exhibitions such as the Metropolitan Museum of Art's *Venice and the Islamic World* (2007), in which Islam is taken out of the narrow political frame of the moment, placing it against its complex, historical, pan-cultural roots. But the result is to precisely transport Islam back into the dreamland of the past, shorn of its contemporary ambivalences. Another is *Zones of Conflict* (2008), at the Pratt Institute of Art, which did the opposite, bringing Islam into the epicenter of world conflict, succumbing to "a sensationalist view of the Middle East." Meanwhile, with the United Arab Emirates on the ascent, Dubai has actively replicated the kinds of curatorial configurations shaped in the United States. While the artists dealt with below are not necessarily ones that have garnered success in the United States, they are certainly subject to the advantages after 9/11, but they know this to be a mixed blessing, as they must struggle with contradictory views of which they are seldom in control. For the way in which contemporary art from Middle Eastern, Islamic states is presented, arranged, looked at, and critiqued in many places not confined to Europe or the United States, there are many complex variables of expectation and ideology at work.

The artists and works have been chosen not necessarily according to often culturally reductive decisions made by curators of contemporary art, but rather for the extent to which they exemplify the contemporary and always evolving notion of the "third space." This is the space where cultural legacy and inheritance is not abjured, but rather exposed for its heterogeneity, and its constructive capacity to shape and re-imagine itself. These exemplify Chow's term of visualism in a multitude of ways, usually through destabilizing clichés. Along the way, many of these works bring to light unanticipated perspectives on groups, languages, and practices.

Ahmet Öğüt's poetic transpositions

In 2009 the still young artist (b. 1981) exhibited his installation, the *Exploded City* at the Turkish pavilion of the Venice Biennale. It was a seemingly benign panorama of endearing miniaturized buildings, all with a clean, colorful Legoland kind of uniformity that suggests the patience of good order. Closer inspection reveals that the buildings are situated on disconnected triangular concrete blocks of irregular height, which, in the Lilliputian scale, prevent communication between each cluster of building, all placed with precarious density against one another, abutted with very little breathing room, and certainly in disregard for any town planning. There are no parks or playgrounds, streets and roads are all but inferred. Where model cars and buses appear, they are poised on an edge, as if heading into nowhere, or some other hypothetical beyond. In short, the initial verisimilitude of the work gives way to the suspicion that these maquettes have been assembled as relics from other cities, their composition a ramshackle clutter. Perhaps the original charm that the work elicited is purposely misleading, as these structures and vehicles are the revenants, united in this limbo, ones that have all befallen disaster.

The text on the wall contains the list of their origins:

Exploded City's Buildings and Vehicles:

> **Madimak Hotel**, Sivas, July 2 1993
> **Europa Hotel**, Belfast, 1972–1994
> **HSBC Bank**, Istanbul, November 20 2003
> **Ferhadija Mosque**, Banja Luca, May 7 1993
> **Mostar Bridge**, Mostar, November 9 1993
> **Water Tower**, Vukovar, August–November 1991
> **Future TV Station Building**, Beirut, May 10 2008
> **National Library**, Sarajevo, August 25–26 1992
> **Post Office**, Prishtina, April 8 1999
> **Tikrit Museum**, Tikrit, March 27 2003
> **Beslan School**, North Osetya-Alania, September 1–2–3 2004
> **Alfred P. Murrah Federal Building**, Oklahoma, April 19 1995
> **Paddy's Pub**, Bali, October 12 2002
> **Maxim Restaurant**, Hayfa, September 4 2003
> **Palestine Authority Foreign Ministry**, Gaza, July 16 2006
> **Al Mamoon Exchange and Telecommunications Center**, Baghdad, July 2006
> **Club El Nogal**, Bogota, February 7 2003
> **Trident-Oberoi Hotel**, Mumbai, November 27 2008
> **United Nations Building**, Algiers, December 11 2007
> **Wedding house**, Kakaral July 1st 2002; Kandahar, November 6 2008

Islamic University of Gaza, December 29 2008
Clinic Center Dragisa Misovic, Belgrade, May 20 1999
Stagecoach Bus 30, London, July 7 2005
Commuter Train, Madrid, March 11 2004
Renault 19, Semdinli, November 9 2005
Truck Ford D1210, Susurluk, November 3 1996

These were all subject to violence and terrorism, all destroyed. The deadpan display with its schematic factuality, together with the sheer number, and their international sweep, makes for disturbing viewing.

The title, *Exploded City*, is a transposition of Italo Calvino's *Invisible Cities* (1972), in which Marco Polo describes fifty-five cities to the aging Kublai Khan. This was customary practice, where the emperor asked traveling merchants to describe the state of his vast emperor. But, in this case, Polo's narrations are all in fact about the same city, his native Venice. This can perhaps explain the gaps between Öğüt's buildings, and further reflection upon Calvino's story may suggest that the maquettes in *Exploded City* are now assembled together in an imaginary afterlife, as chilling and mute remnants of trauma and chaos.

In the accompanying text to the installation, the artist offers his own pastiche of Calvino's text, where he imagines himself a denizen of this place:

This city is from the future. It's called *The Exploded City*. Those who live there have emigrated from faraway lands, with dreams of traveling to the future. When they realized that there was no finding the future, they decided to build this city. It is said that hundreds of different languages, such as Ossetian, Bosnian, Albanian, Kurdish, Castilian, Irish, Turkish, Persian, Arabic, Urdu, Anglo-Frisian, and other Saami, Altai and Slavic languages are spoken in this city. These people who don't speak each other's language, instead of creating a *lingua franca*, have learned to communicate through looking into one another's eyes. Not before long, they taught me this eye language as well. In this city, all the other remaining languages are like a constant background noise. They actually resemble the besieging of the city by various types of birds.[14]

The artist concludes that he spent his "last day in *The Exploded City* at the empty *Tikrit Museum*, imagining the various codes of law from Mesopotamia, remains of monuments, inscriptions, and monumental sarcophagi surviving from ancient empires."[15] It is a haunting statement, not only in light of the devastation of the Syrian landscape that was soon to occur, but with what was occurring at the time when Öğüt first exhibited the work, with the permanent liquidation of ancient historical monuments and archaeological remains in Iraq and Afghanistan. Öğüt gives much to ponder, especially with some foreknowledge of Turkish history. For his own imaginary city is a cross-roads, like Istanbul-Constantinople, of cultures,

and therefore a nexus of histories and memories. It is also testament to the paradox that acts of restitution and memorialization where rendering visible only foreground everything that is lost and forgotten. It is a work that in a subtle way also engages with the forceful cliché that terrorism is synonymous with Islam's disaffection with the West, placing the condition as a universal problem of hatred.

A similar theme of the global hysteria over terrorism is reprised in a work the following year, *River Crossing Puzzle* (2010), an interactive installation at the *Galerie für Zeitgenössische Kunst* in Leipzig. This consisted of seven large cut-out type figures on movable white platforms. The wall text states the following mind-bending conundrum:

> A bomb disposal technician, a suspicious bag, a soldier, two security dogs, a suicide bomber, his wife in wheelchair and his daughter have to cross a river. They have discovered a small boat. The small boat can carry only two people or one person and one dog or item at a time. The suspicious bag cannot be left with anybody unless the bomb disposal technician is present. The suicide bomber cannot be left with any of the dogs unless the soldier is present. The soldier cannot be left with any of the suicide bomber's family members unless the suicide bomber is present. Only the soldier, suicide bomber, and bomb disposal technician know how to use the boat. How would they cross the river?

Viewers to the exhibit were invited to move the figures around in an effort to solve the problem. But, like most good interactive art, it does not require active interaction in order to convey its meaning, for to solve the problem is not to plumb the meaning of the work. Rather Öğüt appeared to be commenting on the way that everyday situations have been overlaid with suspicion, made into problems, where little is taken on face value and where people are made to feel part of situations that are beyond their control. Yet, just as in this seemingly innocent game, the interconnectedness of events also tends toward emphasizing our isolation and forced alienation, since in a climate of paranoia "everyone" is possibly a target or a perpetrator.

A significant portion of Öğüt's work consists of incidental pieces, performances, live events, and public intervention. *The Obscure Horizontality of a Blind Spot* was an outdoor intervention that was commissioned by Sofia Contemporary (Bulgaria) in 2013. This was a horizontal klek shop in an unfamiliar place, a red case with horizontal shelves placed above a cavity in the street where a participant "seller" would sit, his or her head appearing from the oblong aperture in the middle of the unit. Passers-by were encouraged to stop and inspect the wares and converse with the seller, or hawker, stationed within. Behind the quirkiness and humorousness of the work was a statement about the countless nameless (hence "blind spot") people on streets who sell random wares. These people are economically straightened, and usually migrants. Another performative piece of

the same year, *The Muscles Behind My Eyes Ache from the Strain*, featured the artist atop the Galata tower in Istanbul delivering an artist talk. An audience was invited to assemble on the Han Terrace nearby to witness a lip-reading specialist, Özgür Tekol, interpret what was being said from out of earshot. The Galata tower is in the Galata/Karaköy district, a small cry north of where the Golden Horn meets the Bosporus. Anyone knowing this detail could easily have understood that this work was a subtle and poetic interpretation of the many nationalities that have always made up Istanbul, which means that it is an intense site of constant translation. These linguistic transmissions, with what is gained and what is left behind, become metaphors for all manner of cultural exchanges, transpositions, and transfers.

Hatice Güleryüz's heteroglossias

Hatice Güleryüz (b. 1968) began her education at the Dokus Eyül University in Izmir, Turkey, before moving to Plymouth University in England, and finally studying at the Willem de Kooning Akademie in Rotterdam and conducting research at the Jan van Eyck Akademie in Maastricht. Her work is steeped in multiple experiences, also drawing on others who have had similar pasts with divergent paths.

Her practice is typical of artists who emerged in the 1990s, when digital technologies made art increasingly available across long distances, and when it first became important for certain works to exist across multiple spaces and formats—online, as installations, as documentation. As such, her work consists of film and video, as well as photography and drawing. Consonant with the variety of media, Gülerüz's work is also compelled toward multiple voices and subject positions. These provide strategies for looking at the many ways in which cultural identity is configured and positioned. This includes the expression of cultural identity through mechanisms that do not necessarily confirm or deny, but rather renounce belief and conviction.

A film from 2005, *Strange Intimacies*, begins with an extract from Serge Gainsbourg's "*Je t'aime moi non plus*," which is soon muffled by a street cacophony and the closely framed image of a generically monumental bronze cast of Atatürk revolving on an axis (the din dies out halfway through to leave his head gyrating in silence). Then it cuts to a shot panning across buildings on the outer suburbs of Istanbul to a voice-over of a young man with an American accent:

> On my first day, I was very excited to find out where my first place would be in Istanbul. And we're driving from the airport, and we go into the heart of the city, and we keep driving. We go over a bridge, and we keep driving, and we're about a half hour outside of Istanbul, and we come into Atachet here

and I realized, first of all, I'm not living where I thought I was. I'm nowhere near the blue mosque or Hagia Sophia, or any of that. Um, and I'm on this stretch of high-rise buildings that my grandmother used to live in, y'know, back in Fort Lauderdale, or Hollywood, Florida. And, I look out at them, and I think, "I'm in Turkey?" I mean, you look at these buildings, and you could be anywhere. I-I seriously think you could just pick up this piece of Earth and move it over to Miami, drop it down, and it would fit in perfectly. It would be fine. Um, I know there are Turks living across the street, and I know somewhere in the distance is a mosque because if I'm really quiet I might hear the call to prayer. But I don't believe that I'm in Turkey sometimes. I'm looking around here and I'm thinking, "where am I?" Y'know, "what is this?"[16]

Fade to black. The plain text: "I am constantly thinking, what are you afraid of? You have to somehow to find out who you are in this culture, adapt in some ways. It has been a struggle for me." This could be the artist speaking, but it is left purposely ambiguous, given the number of voices that the film entertains. The next screen announces: "It seems you have experienced nothing, but it has been a lot. It is invisible but real." Another purposely ambiguous statement, it conceivably bears upon countless and immeasurable aspects that make up the person you are. The final text at this point is deliberate bathos: "How many different sizes of yogurt are there?" A textual McGuffin, it refers to yogurt as a staple in the Turkish diet.

There follows a series of sequences of footage of various places in Istanbul, with commentaries from men and women in English in different accents, all of which have their different range of questioning about place and belonging. In different tempos, one stylized dialogue, another not, they all share the same issue with how Turkey compares to their country, and how the Turkey they now experience compares to their expectations. One female voice with an American accent speculates on her views about mobilizing Turkish women for political office, and the differences between views of women in Istanbul and those in smaller cities. Around the middle of the film an attractive woman with a tattoo on her left breast and wearing a blonde wig performs a lubricious dance in a non-descript apartment. A young German woman muses about the "omnipresence of Atatürk," where in Germany in the aftermath of the Second World War, such cultism is unthinkable. National heroes are past and literary such as Goethe and Schiller, but in the shadow of National Socialism it is impossible to entertain the connection between politics and idolatry. The intertext then reads, "I don't think I changed a lot. It just makes me try to find new ways to be myself again; because in my country I am just French." Later, another female with an American accent announces that "knowing Istanbul is impossible."[17] The comment recalls another by Zizek about the slippery symbolism of national identity, which is a combination of "I know what it is, and yet I cannot define it":

For example, in political discourse, the Master-Signifier "Our Nation" functions as this kind of empty signifier standing for the impossible fullness of meaning; its meaning is "imaginary" in the sense that its content is impossible to positivize—if you ask a member of the Nation to define of what his National identity consists, his ultimate answer will be, "I cannot explain, you must feel it, it is *it*, what lives are really about."[18]

In Turkey this conundrum is more on the surface than perhaps in other countries (such as Germany), despite or because of Atatürk, who stands (in) for symbolic national immutability.

The final sequences are taken from a train, with views of Hagia Sophia and the Bosporus, regularly interspersed with the back of men fishing on the bridge. The phrase "I am just French" rings as a leitmotif to this work, which tells through the voices of visitors to Istanbul the difficulties of Turkey being "just" anything, their encounters rife with contradiction. Complementary to the film is a book, not so much a catalogue but an autonomous artist book, with quotations like those above, photographs, and film stills.

As Johnny Golding states, Güleryüz's work is "Forever cast into the neither/nor regions of life,"[19] where it could be added, sexual identity is never far from cultural identity. This is something of a commonplace, but it needs continual recognition. As the Israeli-born moral philosopher Avishai Margalit maintains, "people with a need for a clear and rigid identity cannot afford to understand the other side, and see its humanity. This failure is not a cognitive failure but a failure of will."[20] Part documentary, part stream-of-consciousness, part memoir, Güleryüz's film returns us to the components of our aesthetic, cultural, and personal formation, and lets us see how fragile the architecture can be, and the extent to which our sense of (cultural) self is an active inner dialogue of comparison and affinity. The concerns of *Strange Intimacies* are a singular testament to the subtle and multifarious nature of contemporary Turkish identity, but also the way all subjectivities maintain contrasting and agonistic attitudes to the places of origin and to those they visit.

Servet Kocyigit's reconstructions

From the same generation as Güleryüz, Servet Kocyigit (b. 1971) also studied art in the Netherlands, at the Gerrit Rietveld Academy and the Atelier program (De Ateliers) in Amsterdam, where he spends his time when not in his native Istanbul. Upon his receipt of the Spilman Award for Excellence in Photography in 2016, the press statement declared that: "Many of Kocyigit's works deal with the different experiences of foreignness, immigration and identity construction, in an era where the difference between free movement and forced-movement is at the

base of the global human condition."[21] The work in question was *My Heart Was Not Made from Stone*, produced while on an artist residency in Johannesburg in mid–2016. This multilayered work involves the use of six "performers"—all six or just singly—in a selection of landscapes and sites (an example of what Claire Bishop has called "delegated performance").[22] In one image they are placed in a row, walking; in another, still, in a row, and seen from a distance. Others involve them holding or hanging doctored maps.

In his explanatory text to the work, the artist acknowledges Johannesburg and its surroundings as a place of cultural and racial diversity often resulting in conflict. "My research," Kocyigit states, "is based on the understanding of how we define a country, who claims the land, and when and how we draw the borders revolving around the feelings of belonging."[23] He observes that, as a migrant himself,

> the subjects of migration and art go hand in hand for me. Both migration and artistic praxis are far from a uniform or evenly shared experience. Mobility or migration, conditions that provide a niche from which to address issues of identity as well as belonging, challenge inherited notions of home, territory, and community in a world that is constantly shifting.[24]

The landscapes were "a mining site, a burnt site, a forest, rubble, a garbage dumpsite." The maps in some of the photographs are featured with stylized, intentional prominence. Kocyigit had brought large school maps with him and requested local artists to paint gems on them as symbols of the imposition of human desire (and greed) on the landscape. According to Kocyigit, "Mining is the perfect metaphor" because of the way it alters the landscape, while also forcing whole demographics to shift: "People have been pushed away from their lands or forced to labor in the mining sector. In a contradictory manner, it also created cities like Johannesburg."[25] Each performer is marked with a number on his bare chest of co-ordinates of his place of belonging. Images that are not of forbiddingly vast and roughly hewn mining sites have a tree as a centerpiece. Kocyigit explains its symbology as "the symbol of belonging, of being rooted, and grounded. It is a micro cosmos. It is a place where we meet and come together." And trees can also be uprooted and die. And when people meet they inevitably disband to meet again. Or perhaps never, due to calamity, chance, or death. As the title itself suggests, *My Heart Was Not Made from Stone* is a work that relays to us, not with any sentimentality at all, the oscillation between the forced or voluntary removal from place, and the many acts in which the meaning of place is reconstituted as an active exercise of community. Place as place—that is not an indeterminate any place whatever—is always a product of social invention and interaction. Since this is always a process whose tenets and components are always subject to revision and revisioning, the subject of belonging resists a logical template, which makes art a congenial form of expression.

Figure 5 Servet Kocyigit, *My Heart Was Not Made from Stone (South America)* (2016), 100220 cm, C-type print, courtesy the artist.

Although his work is not limited to it, a survey of Kocyigit's practice—which in addition to photography includes installation, sculpture, and two-dimensional works— reveals how dedicated he is to exploring the themes of nationhood and belonging along the lines of shifts, overlaps, and unaccountable modifications. His series *Maps*, also from 2016 comprises "paintings," or wall panels depicting land, coast, and sea made of different patterned fabrics. Landmasses are demarcated according to each pattern. All of them are against a turquoise blue ground, presumably the sea. In one panel the "land" consists of intricate and colorful patterns of the generically Oriental sort, another assembles variants of battle fatigue patterns. Some are painted over, bearing a symbol of a figure or ruin from antiquity, all of the "landmasses" are interspersed with buttons of various sizes joined by thread lines that suggest roadways or trade-routes. Exhibited at the Centre for Contemporary Art in Torun, Poland, in the catalogue essay Lora Sariaslan comments that these imaginary maps entail "intertwined themes of statelessness, citizenship and migration." Intensely political, Kocyigit "sees what frontiers have done to societies and what societies are doing to frontiers."[26] The juxtaposition of motley civilian patterns with those used for soldiers' uniforms highlights the unwelcome truth that the two are seldom if ever separate. Textiles are also an apt metaphor for the fluidity of cultural movement and of cultural exchange, since textiles were always in some way included in the trade routes since antiquity. We can also recall the paintings by Venetian artists like Carpaccio from the end of the fifteenth century in which the city is bedecked with sumptuous carpets and its citizens in rich silks and damasks. For in Sariaslan's words textiles "represent a confluence of messages" because they at once represent both personal and public interests. "Perhaps more than any art form, textiles amplify and even reveal the appreciation of the inherent fluidity of signs. In essence, the meaning of textiles can never be truly fixed."[27] While this is

Figure 6 Servet Kocyigit, *Gold Line 1* (2016), textile collage, embroidery on textile, paint, courtesy the artist.

perhaps an underdeveloped assertion, it applies to Kocyigit's aims, in which national belonging is never limited to site or soil, but first appears as representation.

Armed with the awareness of these two works, the process-based work *Kafka Rose*, commenced in 2013, is given added resonance. From a visual perspective, it involves a line of three tables, abutted together but unalike in style and height, covered entirely with books. These are from the artist's library. The project consists of Kocyigit assigning different scents to each book—making sense of the title, where Kafka has been equated to a rose scent. Synaesthesia— the apprehension by sensory data that activates a different sense, or sensory matrix—has always had an important role to play in the making of art and the way it is apprehended. It has clinical applications as well, which Arthur Rimbaud conjoined to the poetic when he made his now famous intent at uncovering the "unknown through the derailment of all the senses."[28] Equally as famous is Walter Pater's exhortation that "all art must aspire to the condition of music." European artists of the end of the nineteenth century would often refer to the "musicality of (or in) painting," meaning its Schopenhauerian and Paterian reach into an abstract, ineffable truth. Composers from early to late Romanticism sought to invoke quasi-cinematic vistas as in Beethoven's "Pastoral" 6th Symphony (1808), Richard Strauss' *Alpine Symphony* (1915), and the opening movement of Gustav Mahler's 4th Symphony (1900). The novel, especially the realist novel, is a highly visual genre, but not only visual, calling upon sounds and smells in an indefinable

Figure 7 Servet Kocyigit, *Kafka Rose* (ongoing multimedia work since 2013), tables, books, perfumes, and scents courtesy the artist.

way that, because of this indefinability, makes these scenic qualities so compelling and alluring.

Smell, the olfactory sense, is arguably even more evocative to our memory and imagination than music and sound, but this is also because it is far harder to harness into an intelligible structure other than that of association that is experiential, its essential qualities are subjective, attuned to time, memory, and experience. (It would be tempting to digress into Proust here but at the risk of losing the thread.) What *Kafka Rose* shares with the work described above, and other works besides, is that it too is concerned with border crossing, not only between the different faculties, but between different individuals. The addition of a complementary scent to the novel is an invitation to the next person to handle the book, a former reader or a prospective one, to enter into the sensory correspondence that the artist has initiated. Since there is no room for justification or verification, everything is in the hands of what is imaginatively transcribed.

A similar alchemy is described by Teju Cole about the writings of André Aciman's experiences after leaving his native Egypt:

> Visiting Egypt, he remembers how the smell from a certain falafel place in New York used to fill him with deep longing for the small falafel establishments he had known in Egypt. But, in the course of his memory, he also realizes that the falafel place in New York matches his dream of Egyptian falafel more closely than can Egyptian falafel itself.[29]

Kocyigit experiments with a range of chemical essences as a makeshift homebrew *parfumier* to arrive at his various olfactory agents that are then given their literary home. There is an "Oriental" reading that can be given to this that is not gratuitous, namely the creation of a garden of earthly delights, in which the senses are overloaded, something in the manner of the surfeit of exotic imagery in Flaubert's *Salammbô* (1862). But unlike conventional Orientalism, which is criticized as intrusive and limiting, Kocyigit's is precisely the opposite, an expansive and evocative invitation from one lover of literature to another. Imaginative worlds are conjoined in a speculative, reverberative space.

Halil Altindere's defamations

Unlike his contemporaries with their transnational, émigré and expatriate status, Halil Altindere (b. 1971 in Mardin) remains in Istanbul, his work devoted to the marginalization of groups due to the still prevailing repressive measures imposed by the Turkish government. Of Kurdish origin, Altindere recoils from nationalism, and is also vocal to those other artists who appeal to jingoism. At the same time, while acknowledging the internationalism that swept contemporary Turkish art

after the 1980s, he remains devout to Istanbul as the home metropolis where he can best produce his work. He confesses quizzicality at the more ordered Western cities and their "sterility" and their "controlled subculture" in relation to the chaos of Istanbul. There he feels a sense of responsibility: with genuine concern over Turkey and how it progresses into the new age.[30]

In broader strokes, his practice is in the ambit of Institutional Critique and Fluxus, taking the form of ironic interventions on state documents or symbols, to, more recently, video works about the dispossessed in Turkey. As with many artists whose manner of working is experimental, trans-disciplinary, and project-based, Altindere does not see himself as making art objects per se, but creating platforms for reflection and critique. As such, he is also the publisher of the magazine *art-ist, Contemporary Art Magazine*, and also engages in curatorial projects. After all, the conceptual political artist is in many ways a curator, a manipulator and stage-manager, of people, ideas, and objects. As the text on him from Pilot Gallery in Istanbul reads that work since the 2000s has focused on "subcultures, gender and out of the ordinary situations of everyday life."[31] This is reflected in two recent video works, *Wonderland* (2015) and *Homeland* (2016).

First exhibited in MoMA's PS1 in New York, *Wonderland* was a rap video involving the young males of Istanbul's Sulukule, an historic part of the city that since the Byzantine Empire has been home to Romani communities. However, since 2006 the communities have been increasingly under threat because of the building demolitions in the name of supposed urban renewal, the anodyne term given to forced urban displacement for the purpose of weakening groups that may pose a threat to government control. The video was staged by the hip-hop group *Tahribad-i isyan* ("The Rebellion"), voicing their disaffection about gentrification and marginalization. At certain points in the video they are being observed or stood off by police.

To a Turkish observer, the concerns of *Wonderland* are not limited to the suburb in which it is based, for many parts of Istanbul have been subject to intensive reorganization for commercial developing interests. As the explanatory blurb to the video states:

> In May 2013, protests were held in Istanbul's Taksim Square in reaction to plans to replace the park with a shopping mall and high-end residences. The protests developed into riots when a group began occupying Taksim Square in an effort to highlight issues such as freedom of assembly and freedom of expression, as well as more broadly defending the secularism of Turkey.[32]

The Prime Minister Recep Tayyip Erdogan followed this up with a stringent campaign of censoring social media and the Internet. By court order, web browsing data of individuals were seized, Twitter was blocked, and YouTube temporarily shut down. All of this was far from extraordinary in Turkey but is

Figures 8 and 9 Halil Altindere. Stills from *Wonderland*, color video, sound, 8'25". Courtesy the artist and Pilot Gallery, Istanbul.

seldom brought to international attention. The regular interruptions into individual freedoms serve as reminders of the instability of Turkish culture, and bring home the growing social inequalities, fomenting discontentment that regularly erupts in different forms. The restrictive measures are also reminders of how much Turkey has internalized the idea of despotism in both theory and in practice, as if extreme repression must be implemented at regular intervals lest Turkey lose sight of itself. Altindere's work, which speaks as much to the disenfranchised youth of outer-Manhattan New York, reveals just how complex and embattled the notion of freedom is in a country such as Turkey. This is especially so with digital global

networks, which mean that people's expectations are no longer limited to local demographics.

Altindere's work from the following year, presented at the Berlin Biennale, was another social commentary through a hip-hops lens, this time presented by the rapper Mohammad Abu Hajar, who was born in Syria but based in Berlin. With footage from both Germany and Turkey, *Homeland* was motivated by the Syrian refugee crisis, but extended to forced migration, past and present. The footage

Figures 10 and 11 Halil Altindere. Stills from *Homeland*, HD video, sound, 10'6". Vocals and lyrics Mohammad Abu Hajar, music Nguzunguzu. Commissioned and coproduced by the Berlin Biennale of Contemporary Art, with the support of the SAHA Association. Courtesy the artist and Pilot Gallery, Istanbul.

in Turkey is largely that of the many waterways that have served as trade pathways, but which have also historically seen the traffic of countless nameless travelers, traders, and runaways. One scene is of Turkish youths aged approximately between eight and twelve on a beach absurdly tying empty water bottles to their waists, the makeshift floating devices that stand for all the cheap and on-hand devices used to secure whatever safety that can be had.

In their respective ways, both Germany and Turkey have borne a large brunt of the spillage of refugees from Syria. They are tied in other ways over this crisis. In early March 2016 the Dutch Prime Minister Mark Rutte, together with the German Chancellor Angela Merkel, made an agreement with the then-prime minister of Turkey, Ahmet Davutoglu, which privately revised the 2015 agreement of resettling 22,500 refugees to accepting 150,000 to 200,000 per year.[33] About a year later Erdogan accused Merkel of Nazi practices over a dispute about electorally campaigning the vast Turkish resident population in Germany. In the process of placating Erdogan, Merkel was subsequently criticized and mocked for what was seen as a climax of appeasements that began during the refugee agreement of 2015, and were deemed, especially by the right, as a series of capitulations that earned her a staggering drop in approval.[34]

Today's salient issues of refugeeism have two philosophical poles. The first relates to the birth of civilizations themselves, and the need for borders and boundaries for the sake of self-protection. This instinct is a genetically human one, almost as fundamental as the need of a mother to protect her child. But to simplify the politics according to this detail is disingenuous in the extreme. For while refugees are part of the very fabric of civilization, endemic or a casualty of its inevitable expansion or contraction, refugeeism has a special if not unique status today in comparison with what it once was. One condition is the invisible indivisibility of a virtual sphere, the other is the very physical fact of escalating overpopulation, with the myriad pressures—on space, resources, the distribution of wealth, just to begin with—that this brings. In his book on the contemporary condition of refugeeism, Zizek makes several very prescient observations that are as relevant to Altindere's *Homeland* as they are to Koçigit's *My Heart Was Not Made from Stone*, made at the same time. One of these is especially pertinent:

> In our global world, commodities circulate freely, but not people: to reiterate, new forms of apartheid are emerging. The topic of porous walls, of the threat of being inundated by foreigners, is strictly immanent to global capitalism: it is an index of what is false about capitalist globalization. It is as if the refugees want to extend free global circulation from commodities to people. . . . The way the universe of capital relates to the freedom of movement of individuals is thus inherently contradictory: it needs "free" individuals as cheap labour forces, but it simultaneously needs to control their movement since it cannot afford the same freedom and rights for all people.[35]

This, if not all of the work of Altindere, is devoted to this intensely damaging problem; the contradictions that inhere in the false ideologies of what resemble state cohesion, where "belonging" dangerously topples into neighboring, noxious ideas about uniformity and control.

Homeland concludes with footage of Berlin's Tempelhof, a former airport but since September 2015 a refugee camp.[36] This is a canny step on the artist's behalf. Whether intended or not, it is a direct fillip to Erdogan's indiscreet "Nazi" accusation, since the Tempelhof airport, situated within Berlin itself, was radically reconstructed by the Nazis in the mid–1930s in anticipation of war. Redesigned by the prolific Nazi architect Ernst Sagebiel (who also designed Goering's air force ministry building not far from Berlin Gestapo headquarters), its shell limestone walls are stamped everywhere with Nazi authoritarianism and it still bears Nazi-related symbols. As if to heighten the loaded historic relevance of this site, the name "Tempelhof" harks back to the Middle Ages, when it was important land that belonged to the Knights Templar. Its transformation into a refugee camp is an ultimate step of sanctification in which the casualties of war are being in housed on a block of land where so much war was either planned or waged.

There is also a significant historic counterpart that this transformation of Tempelhof calls to mind. This is the Cinecittà, or "Cinema City," nine kilometers south of the center of Rome, which was a refugee camp between 1944 and 1950. Cinecittà was established by Mussolini as a hub for making, showing, and distributing films, which included costume dramas, operas, and of course propaganda. Until then Italy had no great film industry to speak of, and very swiftly Cinecittà became the fattened calf of the Italian Fascist's culture industry. As Noa Steimatsky relates, what was so ironic about the transformation of the Cinecittà into a camp was that its content had sedulously avoided any depiction of social privation. Simply put, barefoot children did not set foot on its grounds as consumers or as imagery. As she relates, it was such a change of fortunes for the site that many contemporaries recoiled from acknowledging it.[37] Well after its uncharacteristic repurposing, its history as a camp continued to haunt many Italians, like some traumatic blight. Tempelhof, which was closed in 2008 to public outcry, is feasibly also the object of the same feeling of symbolic violation, and yet in essence it is the very meaning as a place of war and of transit that has supplied the circumstances that it finds itself in now.

Transitoriness is defined as a state antithetical to belonging. Here one is between stable states, between homes. But one of the less savoury aspects of globalization has been identification of a new social group, which is expanding all the time. Now, third and fourth generations live in ghettos at the edges of Indian airports, surviving off their waste. In South America favelas are now a permanent demographic. The conditions in Palestine are deteriorating and the global community despairs of any solution. And since the 1990s millions of people have been living in non-spaces uncertain of their direction or their fate, which is well

out of their own hands. Historically Turkey has been a bridge between empires. But in its forced modernization the fluidity of borders—geographic, psychological, symbolic—is graven into the national consciousness. As this small selection of artists attest, the common thread that binds contemporary Turkish artists, in Turkey and elsewhere, is a state of being that encompasses many voices and many places, that home is a zone that we make that can later be remade, and remade again.

4
ART AND THE ISLAMIC FEMALE DIASPORA

But she lives; for great poets do not die; they are continuing presences; they need only the opportunity to walk among us in the flesh. This opportunity, as I think, it is now coming within your power to give her. For my belief is that if we live another century or so—I am talking of the common life which is the real life and not of the little separate lives which we live as individuals—and have five hundred a year each of us and rooms of our own; if we have the habit of freedom and the courage to write exactly what we think; if we escape a little from the common sitting-room and see human beings not in their relation to each other but in relation to reality; and sky, too, and the trees or whatever it may be in themselves.

VIRGINIA WOOLF, "A ROOM OF ONE'S OWN"[1]

This is something I never imagined doing, and which is usually odious to me: a personal testimonial in a book whose voice is supposed to follow conventions that are critically dispassionate (knowing forever that in the critical project this is never wholly reached, always "to come"). The subject of this chapter was shaped by a number of female students that I have taught over the years originating from the Middle East, including Saudi Arabia, Qatar, Iran and Iraq. Even if not in a conventional sense, they were all refugees. That is, refugees of repressive systems that were highly constrictive of what women were allowed to do and how they ought to conduct themselves. One thing that united them—even though over the years they did not know one another—what they had in common was reticence and reserve. I would soon learn that their silences fronted a great weight, from experiences from which they were still at pains to escape. As can only be expected, the art by these students was inexorably shaped by their experiences as women from Muslim countries, especially the strictures they were forced to observe, and innumerable impediments placed in their way in being able to express themselves. At every level they found themselves policed. Yet their worldview was one of extreme ambivalence,

*cherishing affection for their families and friends and many other things besides—
they were part of their pathology, an epigenetic bond. Yet the treatment of women
filled them with loathing and dread. In some cases, even in Australia, they were
unable to escape the controls and proscriptions inflicted on women, their residue
existing in the open obstructiveness with which consulate authorities expressed
their contempt of women, and in the limitations placed on their mobility. But the
differences in how they were treated only seemed to exacerbate the trepidation
and unease that had been built into their pathologies from a young age. It was from
these women that I was able to apprehend the complexity and urgency of the
Middle Eastern female diaspora, artists who are only able to express themselves,
and if so disposed, their national awareness of self, well beyond the boundaries of
a core of their being that is forever fragile and imperfect. For them artistic
explorations of home can only be made away from home. To have room of their
own, they must find it elsewhere.*

To describe the exilic condition, Edward Said proposes the term "contrapuntal"
to distinguish between others whose cultural awareness is more uniform. Instead,
"exiles are aware of at least two and this plurality of vision gives rise to an
awareness of simultaneous dimensions."[2] Add to this the modulation of what
can and cannot be afforded in one or another country. Writing from a male
perspective (and insulated by privileges of U.S. top-tier academia), Said works
under a generalist assumption. His position is not tempered by the added
reflection that the contrapuntal experience can have an inordinately different face
depending on the sexes, or of socio-economic mobility. If a critic like Said feels
the weight of Palestine from afar, a female artist from a country like Iran feels not
only the loadstone of her country but that of a woman in her country. It is a feeling
that is allowed to be more acute from protracted detachment from place, but it
is a clarity of vision that for many artists comes at a price or emotions such as
guilt and uncertainty. The disaster of 9/11 and its aftermath placed yet more
complications on people from Muslim states living abroad, especially in the
United States. As this book has touched on already, a symptom of the conflict
between states leads to a reductivism, a homogenization that acts as a covert
form of control. The rise of the female Islamic diaspora in art, as elsewhere, has
an inordinate effect in helping to stay sober about Western perceptions of Islam,
as well as broadening the circle for feminist debate. In wider terms, the Iranian
diaspora is only a recent subject of critical scrutiny that has gained momentum
in light of successive crises in the Middle East.[3]

 Art is arguably the best lens to view the condition of the diaspora, for the reason
that art demonstrates that the experiences are not the same, and attitudes vary.
Two artists, Shirin Neshat and Nasim Nasr, were born in Iran to middle-class families,
then came to study in the United States and Australia respectively. Ghada Amer
was born in Egypt, studied in France, and now resides in New York. Mona Hatoum

was born in Lebanon, identifies as Palestinian, and lives in London. With the exception of Nasr, these artists have a strong international presence, with a long trail of critical material behind them. This has been one factor in singling them out for discussion, but only one: each of them occupies a different place on the spectrum of the exilic sensibility. What all have in common is their sizeable contribution to art and its relationship to nationality and gender difference. They demonstrate the problems with what Spivak calls "universalist"[4] feminism, and what she decries as "the hasty gender-training undertaken by today's global feminists."[5] What all of these artists embody is the condition of Spivak's "double bind": women artists engaging with womanhood in different contexts and evaluated according to different aesthetic and ethical criteria than those on which much of their work is based. Spivak's double bind includes embracing a "white" literary canon while being a woman from a subaltern state of India. She speaks and celebrates the language of the imperialist. There is no immediate solution to this issue, and indeed to try to find one would be to contribute to the original problem, if there is one.

Further to the predicament that Spivak outlines is the lack of relative consensus concerning the term "Islamic feminism." For the title "Islamic feminist" can either stand for the more Westernized liberal model of (largely) expatriates who evaluate the conditions from the outside, or it could account for both the men and women within Iran (mostly since this is where most of the discourse circulates) who seek better conditions for women. One source of the disagreement with the term is that fundamentalist Islam is *ipso facto* a means of curtailing and demeaning women, making "Islamic feminism" a misnomer, even an oxymoron. Thus as Valentine Moghadam relates, those unsympathetic to the idea "maintain that the activities and goals of 'Islamic feminism' are circumscribed and compromised" and that little change will occur to "women's status as long as the Islamic Republic is in place."[6] She notes that within Iran feminism is moot and certainly not a word used in public. However "it should be possible to identify Islamic feminism as one feminism among many."[7] What the various debates surrounding the issue of Islam and feminism do expose is that globalization has revealed like never before the ways in which feminism varies and needs alteration according to context and culture. From the perspective of Islam, it appears that the position is multiple from the start.

Nonetheless, Islamic women, especially from the perspective of non-Islamic groups, are subject to several layers of stereotyping, first in the way that Islam objectifies women, particularly when in hijab where nothing is disclosed and where the state of being is itself abstracted. Muslim countries that enforce hijab strongly, such as Iran, have different categories, the more modernized and looser versions prone to receiving derogatory accusations of "improper veiling."[8] For women, hijab can also carry a multiplicity of meanings. It might be to show her religious affiliation, or, as Lynne Hume explains, "her affiliation, with, or protest against, a political party, her strong belief in the feminist movement or her

allegiance to her struggle against colonial regimes. However, it might be simply a means of protecting herself from being hassled outside her home."[9] The last justification is often cited in defense of wearing it.

Second, Islamic women are inevitably forced to endure the deeply ingrained Western assumptions about Islam and womanhood, so potent as to be inescapable, combining the unwonted sentiments of pity (for them) and contempt (for Islam and also to them if they appear to have "succumbed" to it). But it is also because of this that many female artists from Islamic countries practicing in the West have such a deep reservoir of material.[10] In her reading of stereotypes Rey Chow advises that the "dangerous potential" of stereotypes lies not in their "conventionality and formulaicness but rather in their capacity for creativity and originality."[11] This is not meant in a good sense, but more to show the way "stereotypes are capable of engendering realities that do not exist."[12] The energy that goes into their invention can be seductive and tenacious. Many artists such as those discussed below turn the insidious message and operations of stereotypes on their head, using the creative potential of cultural and racial stereotypes in what that exposes as its fictitiousness while envisioning new identities for themselves. In the latter the stereotype is not hidden but it is reclaimed. It is not resolved, but it is rendered as more mobile, open, and protean.

If we are to concentrate on Iran for the moment, it is worth noting that Iran has sought a stronger cultural representation in world events, pre-eminent among them being its participation in most Venice Biennales since 2003. Following this example are several female artists that have flourished and gained national and international recognition in recent years, including Monir Farmanfarmaian (b. 1924), Shadi Ghadiran (b. 1974), Shirin Fakhim (b. 1973), and Shirin Ali-Abadi (b. 1973). But it is the female artists who have chosen to develop their careers elsewhere that have received the greatest acclaim. In addition to Neshat, these include Parastou Foroohar (b. 1962), who is based in Germany, Ghazel (b. 1966), who lives in France, and Mandana Moghaddam, who identities both as Iranian and Swedish. In 2005 Moghaddam represented Iran in Venice. The work, *Chelgis II* ("*chel gis*," meaning "forty plaits of hair") was an enormous block of concrete (87″ × 75″ × 39″) suspended from the ceiling with ropes made from braided dark human hair and red ribbon. At the bottom of each four corners hung hair and ribbon tassels, suggesting that the fibers ran through the cement unit. According to the strict rules of hijab, women must reveal neither body nor hair; the hair in this work also references a Persian saying: "to hang by hair" is to face failure. Yet as Somayeh Noori Shirazi remarks about this work, "It is the opposite of this presumption that is presented in *Chelgis II*. Delicate hairs are gathered, woven, and united elegantly to hold up the heavy block." It remains unclear whether the braids support the heavy weight or are trapped within it.[13] The dourness of the work reflects Moghaddam's own history: after the fall of the Pahlavi monarchy in 1979, her father, a member of the Shah's army, was

executed, stigmatizing her entire family. In 1983 she fled Iran, and spent some time in Turkey before being granted asylum in Gothenburg, Sweden. Hers is but one example of many artists of that generation fleeing their country when faced with the violent upheavals that led to the establishment of Khomeini's theocratic regime. Much of their work is an effort of invocation that is steeped in questioning about a fragmented past that, although irretrievably, is still somehow impassably present in memories and in the words of loved ones and friends.

One of the chief characteristics of social and national identity is conflict. Not only does self-definition come from an assertion of what one is not, but with whom and with what groups are seen to encroach on that identity. These enemies and anomies may be real or not. States exist by virtue of threat and competition, while pretending to subvert these pressures. Bhabha discusses how conflict with enemies and outsiders is an important factor in the way communities hold together. But what if, he asks, this ideology is "split . . . so that the 'sign' of the social is condemned to slide ceaselessly from one position to another?"[14] The space between outside aggressors and internal assertion becomes the space in question; it is a space of constant negotiation. In many ways this is the space that the artists discussed below occupy. There is an antagonism to the plight of Islamic women but such feelings are interleaved with love, concern, and the need to heal. As Amy Malek has observed, the Iranians that have moved abroad since the revolution of 1979 have produced a very particular kind of work "that speaks to the liminality of their subject positions."[15] They question dominant Western views about Islam and Iran while also airing their own variances to their inherited traditions. It is hard to think of their work as outside of a fluctuating sense of ennui. And there is always the question of the artist's "home": where she belongs, and to and for whom she speaks. The answer is forever changing.[16] "Are these people in fact 'at home'" asks Aphrodite Navab, "or has home become foreign to them? Has this alienation propelled these artists to picture themselves together with readily identifiable, traditional markers of Iranian culture?"[17] What their case exposes is that one can be more at home by being elsewhere, and how that elsewhere indefinably draws the culture closer, and with it, its many markers and monikers.

Shirin Neshat: From darkness to dignity

Neshat explains how daunting the change effected by the Iranian revolution was to her, leaving her with a feeling of loss and disconnection. Growing up in Qazvin, in the 1960s and early 1970s, her childhood was happy and incident free. Like Nasr later, her father was a gifted physician who was broad minded and who encouraged his daughter to explore the world and to take risks.[18] Her comfortable

life was shattered by the rise of Khomeini, causing her and her siblings to travel to be educated in the United States. She returned in 1990, but to a much-changed Iran in which Islam was deeply entrenched. It was a journey she describes as Dorothy's trip over the rainbow, but in bleak reverse.

It was after her return that she became compelled to reinterpret and explore the new Iran. Made between 1993 and 1997, *The Women of Allah* was her first major suite of work. In her words in 1997, these works were an active means of "discovering and re-identifying with the new Iran." She continues: "On a more philosophical level, I am very interested in the lives of the women I characterize, particularly in how you can find liberation and strength in a situation that is so limited by authority, where the focus is on the collective and not the individual, and the ultimate struggle is simply to be yourself."[19]

The series of works at this time included black and white portraits of women in large cotton floral chadors, with their hands covering their mouth and nose, emphasizing only their eyes. The hands have been painted with decorative designs and Farsi script. Some images show women with guns, partly secreted beneath their chadors—a caustic and prophetic statement on precisely this fear that became central to the debate about the burka in France after 9/11. In *Speechless* (1996) a woman's face is cropped almost down the middle, covered in a filigree of script, and, jarringly, the barrel of a gun pokes out from the side underneath her cheekbone. In another image a woman in a black chador aims a revolver at the viewer, aimed high in front of her nose; her eyes remain censorious, calm, and alert.

Yet it is the script that covers the hands that saves these works from tipping into caricature. For those unable to read it, it would be safe to assume that it has connotations, but in fact they are lines from the Iranian poet Forough Farrokhzad (1935–1967), including one of her most famous poems, "I Feel Sorry for the Garden" in which a young girl bemoans the ruin of her family's garden and then wonders why those around her do not share in her sorrow.[20] Jasmin Darznik explains the importance of the garden as a motif in Iranian literature, which in the twentieth century became a metaphor for Iran itself. Although Farrokhzad wrote her poem well before the revolution, Neshat uses it as an expression of wistful regret. By inscribing such messages on women's bodies, Neshat's works signify, as Darznik comments, "not silence, but its opposite, self-expression." They are testimonials to "a striking female agency that does not deny historical repression of women in Iranian culture."[21] Using Farrokhzad is also a way of signaling cultural difference for "her work disrupts an idea of modernity that depends on the West for its inspiration and explication."[22] All the women are subject to some form of concealment in which reticence is in constant friction with defiance. They are also signifiers of placelessness, not only on the level of the exilic Iranian, but to the extent that the Islamic woman is always the intruder, which accounts for the need to cover her. For "chador" comes from the Turkish, *chadir*, meaning tent:

the chador is literally the refuge, the home of one who is not otherwise allowed to be in the world of men.[23]

Neshat notes how covering women from head to toe emphasizes the role that their eyes play: "In any Islamic country, the women on the street are almost completely hidden behind their veils, and yet they can communicate so much with the little they have exposed."[24] The designs on their hands are an encoded summary of the photographed woman's self, including her date of birth, the saint she identifies with, what she likes to engage in, or the names of her parents. She concludes with a pertinent comment:

> A lot of Iranians have asked me what I think my work would be if I lived in Iran now. Obviously an artist who lives in Iran and is concerned about the same issues in Iran might have a totally different reading of the state of women or the ideology of Muslim fundamentalism. So I'm very aware of my limitations.[25]

The point to be drawn here is the continually looming hypothetical question of responses from within a culture rather than from outside it, and with it mythic questions about the nature of authentic authorship. What is key is not the answer to this question as it cannot be answered, but the element of uncertainty, which relates to the limit when all the sureties about whom we are become exhausted.

This uncertainty, which is the ambiguity inherent in art, has been interpreted, however, as more troubling. Siamak Movahedi and Gohar Homayounpour contend that Neshat's work "is clearly ideological and subject to a polarized and heated" debate.[26] Her detractors see her as complicit in a neocolonialist project, presenting nameless exoticized women, once again, for the delectation of the Western gaze. They consider that her perpetuation of the objectification of women mutes her capacity to engage successfully in notions of gender construction and control.[27] But perhaps these objections, or hesitations, expose the very difficulties involved in the representation of gender, particularly as it applies to its restriction and circumscription. For to deal with the limitations placed on gender is to need such limitations to be played out within the image itself. As Movahedi and Homayounpour, in their essay on the chador, conclude, Muslim men are taught to hate women while idolizing their mothers: "They enter the world through the body of a woman but make their life project to control it by laws, structure it by dress codes, to condemn it for being the site of sexuality, to negate it as a lack, and to attack it as inferior."[28] These are strong words that not all, even Islamic women themselves, might agree with, yet their shrill tone highlights the difficulty that an artist faces. For in Neshat we see the conflict within the artistic decision-making process between balance and protest.

The Women of Allah photographic suite (1993–1997) was the work that brought Neshat her first wave of international recognition. Although inclined to a certain didacticism, Iftikhar Dadi has characterized them as "postcolonial

allegories" that bring to the fore "complex questions of cultural translation between seemingly incommensurate entities, the West and Muslim women."[29] Dadi acknowledges the attempt to represent Muslim women is fraught from the beginning, because they are a diverse group, yet he applauds "Neshat's canny recognition of the easy slippage between stock media imagery of revolutionary Iranian women as metonymic of all Muslim women." In other words, returning to Chow's deliberations on stereotypes, Neshat confronts stereotypes head on, knowing that this is the only way to combat them, dealing with them as stereotypes "as such" and making the viewer self-conscious about the need to stereotype and the willingness to accept them. Dadi argues that Neshat's work confronts the narratives of nation as allegory, which has the advantage of polysemy, multiple readings within a given structure. Dadi suggests that the photographs disclose the

> irreducible social differences between a universalized and globalized commodified order in which the figure of the woman carries a charge as a consumer and as an object of the spectacle, on the one hand, and an Iranian/ Islamic order where she symbolically carries a threat to the imagined global order yet where she also remains an object of (veiled) spectacle, on the other.[30]

This applies both to where the veil is mandated, as in Iran, or mandated against, as in Turkey or France. Either way the veil "becomes a spectacular marker of imagining a new utopian/dystopian community."[31] The veil is brazen control but the same time also ambiguous, as it can be read as a means by which women reclaim their difference, their retreat to privacy.[32] It is the cipher, par excellence, of gender and cultural division.

The trilogy of the video installations, *Turbulent* (1998), *Rapture* (1999), and *Fervor* (2000), that followed, secured Neshat's status as a major international artist. They were filmed in various locations such as Morocco, Mexico, and Turkey. As she states: "I go everywhere to make believe it is Iran."[33] While still in keeping with the black and white aesthetic of her previous work, these works are more subtle not only because of sound and the moving image itself, but because of their haunting qualities. *Turbulent* consists of two screens *en face*: it begins with a man in a pristine white shirt singing to the camera, with a gathering of men also in white shirts behind him. On the opposite screen is a figure all in black with her back to us, facing the same auditorium but empty. When the man completes his song, controlled and technically meticulous, the room on the other wall darkens, and the woman begins her own doleful song, a wordless funereal woman's lament, that gains in intensity. As the camera circles around her, the blackness appears to consume her except for her face and her gesticulating hands. All the while the man stands impassive, as if observing the woman whose sounds are like a torrent of repressed feeling. In the words of Melissa Ho: "She

Figures 12, 13, and 14 Shirin Neshat, *Rapture* (1999). Film stills. Photos by Larry Barns. Courtesy the artist and Gladstone Gallery, New York and Brussels.

unleashes a wailing, throbbing, otherworldly torrent of sound that leaves the male performer—and the gallery audience—staggered."[34] *Turbulent*'s point of departure is the prohibition placed on women performing in public, but its critical ambit is clearly aimed at the limits placed on all forms of female self-expression, and their psychological effects as a result of having thoughts and feelings consigned permanently to the prison of the home.

Both *Rapture* and *Fervor* follow the two-screen format. For *Rapture*, Neshat enlisted 200 actors, equally divided between women and men. Again the women are in black chadors, while the men are in black pants and white shirts. The men inhabit an empty fortress and engage in faux-medievalizing activities: engaging in combat, climbing the ramparts or surveying the landscape beyond. Meanwhile the women walk across an open plain, occasionally making wordless sounds. They then perform acts of religious devotion before heading to a beach where some pile into a small boat and make away, while the men wave at them from on high behind the fortified walls. As something of a synthesis to the trilogy, *Fervor* unites the bifurcated format of the former two. A man and woman walk in opposite directions on a curved country road, and pass, but in a manner so as to suggest some deeper connection between them. In the next scene they are at a gathering, but where the men and women are separated, listening to some male authority figure narrate the tale from the Koran (taken from the Old Testament) in which Zoleikha seduces Youssef. All the time the couple from the previous scene exchange furtive glances through a dark separating curtain. The speaker's exposition becomes more animated and ferocious, cursing the satanic seductions of women ("Curse upon Satan!"), repeating his malediction in an increasing frenzy. The woman rises in what seems to be objection. The man flinches and watches her leave. Both later pass again on a street, but the energy that once linked them is now lost, and they then diverge, the space between them thick with absence.[35] It is a romance at a mute distance that transpires in the realm of thoughts and that is transacted as a cloud of abstractions and hypotheses rather than recountable events. This is because the work is about the furtive emotions made possible by codes of sexual repression and segregation, as much as it is about what such codes prevent from occurring.

In speaking about this work, Neshat stated that she chose the title *Fervor* because it was a word that could be construed as either sexual or religious: "Again, I was pointing toward the clash between sexual and carnal desire versus social control."[36] He believes that Western observers found it harder to grasp than the previous two works. This may have something to do with the kind of contact to which Western women and men are used to:

The type of forbidden seduction that one experiences in that part of the world is of course very different from what one experiences here in the West. You're not supposed to make eye contact with the opposite sex. Every Iranian man

and woman understands the dilemma, the problematics, and yet there is the joy of a simple exchange in a gaze. This type of social and religious control tends to heighten desire and the sexual atmosphere. Therefore, when there is a modest exchange it is the most magical, sexual experience.[37]

Neshat suggests that *Fervor* represented a closure for her on "gender curiosity" that she had long had. And if the other works spoke of disparities between men and women, this work was not oppositional, but rather the desire that men and women share. Yet she does admit that "it is the woman that takes most of the heat." It is an imbalance that tends to provoke rather than quell the need for Neshat to defend all levels of female gender or sexuality. In the audio tour for her contribution (from the *The Women of Allah* series) to the 2006 exhibition at the MoMA, *Without Boundary*, she asserted that Muslim women are "the sexiest on the planet" because of the seduction borne from mystery.[38] No doubt, Neshat is playing up to the ubiquity of the harem as the metonym for the erotic in Orientalist culture, knowing that it is often best not to elide clichés, since they can only be destabilized if you advance on them head-on.

The dualities prevalent in these works, which would continue to be so in successive major pieces such as *Rapture*, are germane not only to the divisions of gender that Islam amplifies, but also Western secularism against theocratic Islamic fundamentalism, and those living within the artist herself. It is a bifurcation on a stark visual scale that, as Hamid Naficy states, "reproduces the duality, fragmentation and simultaneity of deterritorialized existence."[39] *Rapture* (2001), which is accompanied by a bracing score by Philip Glass, is another dramatic allegory of white-shirted men and black-chadored women, set in a desert. The men carry an enigmatic object to a space cleared by a circle of hunched women. A fire erupts across a triangular stone wall, then a girl appears, presumably some spirit of judgment or unity that prompts the thought that the vast differences between genders and nationalities vanish upon death—or perhaps not since the cultural rituals of death persist. In her reflections on the ways in which Neshat draws on mythology in her work, Manya Saadi-Nejd explains that

In this film, Neshat leaves the sociological themes of her earlier work and concentrates instead on expressing a cyclical philosophical message of death and return. The final conflagration thus has a positive meaning, recalling the Zoroastrian notion of fire as a purifying and illuminating force which assists the sun in bringing about rebirth. In this film, the portrayal of abstract, unreal mythological themes to express philosophical notions about the cycle of life and death is obvious.[40]

The mythological impulse, and an historic quality to this work—that it exists now as a result of the persistence of ritual over decades or much longer—lifts the

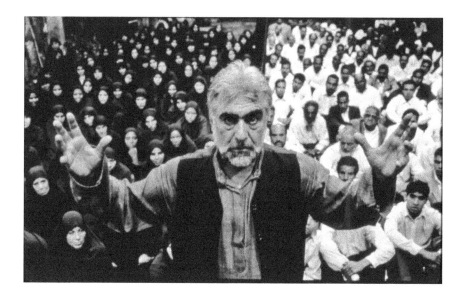

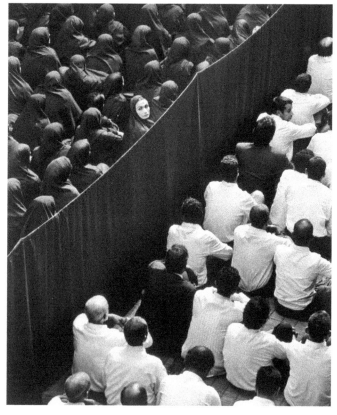

Figures 15 and 16 Shirin Neshat, *Fervor* (1999). Film stills. Photos by Larry Barns. Courtesy the artist and Gladstone Gallery, New York and Brussels.

narrative beyond the minutiae of contemporary events (since it would inevitably, and inexorably, have been read against the backdrop of 9/11), and outside of the ambit of the "modern" and progressive West.[41] The passage of transformation, or transubstantiation, that *Rapture* allegorizes, points to the fragility of gender and cultural boundaries, not despite their enforcement but by dint of them. Neshat's films share, along with a number of filmmakers, a consciousness that divisions give way to more fluid relations. Albeit from vastly different perspectives, in *Rapture* men and women partake in the same ritual, and the ritual is only as such because of original division.[42]

The Book of Kings (2010) was inspired by the eruptions of violence in Tehran after what was clearly egregious electoral fraud aimed to secure Mahmoud Ahmedinejad's presidential office, the most violent and widespread since the 1979 revolution. They subsequently came to be known as the Green Movement, named after the color associated with the Mohammad the prophet of Islam as well as the electoral colors of the defeated opponent, Mir-Hossein Mussavi. One of the many notable aspects of these protests was the presence of women, something that Neshat was quick to recognize. Shortly following these events in Iran came a series of upheavals in Tunisia and Egypt, known as the "Arab Spring," tumults that caused as much hope as concern at the time, but as has since been shown were not the revolutions that had first been anticipated.

As with her earliest work, Neshat concentrated on a literary text, in this case one of the most significant to Persian identity, Abolqasem Ferdowsi's *Shahnameh* (c. 977–1010), or "Book of Kings," a verse epic on rhyming couplets recounting the reigns of fifty kings and queens since the beginning of the world until the seventh century. As Neshat herself relates, "While the *Shahnameh* captures the rise and fall of ancient dynasties, my work, *The Book of Kings*, focuses on contemporary narratives of political upheavals, revolutions, patriotism, and the falls of tyrants."[43] The photographs are broken into three parts, reflecting segments of society: the masses, the patriots, and the villains. In her own words:

The masses comprise forty-five individual portraits of ordinary people, with fine veils of words inscribed across their faces, which express a range of emotions, including anxiety, resignation, defiance, and fear.

The patriots pose with their hands over their hearts, a universal symbol of patriotism, demonstrating they are willing to make any sacrifice for political change. With gazes suggesting a sense of conviction, pride, defiance, and bravery, their faces are covered with bolder calligraphy, written in columns formatted like the verses in the traditional *Shahnameh*.

The three villains, displayed in life-sized, full-body portraits, represent political or religious figures who control and dominate the destiny of others. Their torsos feature images of violent battle scenes found in illustrations from

the *Shahnameh*, showing both the might of a warrior and the bloody outcome of battle.[44]

The net result is one of unmitigated affect. Each individual stares at us with an unflinching sincerity that borders on piety. There is an ineffable benevolence to all of the figures, even the "villains" who are emblazoned with graphic scenes illustrating *Shahnameh*, the only color being the small bursts of run where there is bloodshed. They stare out at us with a frankness that elicits our own sympathy, as if to communicate that villainy is itself an unavoidable burden and integral to the cycle of life and social upheaval. They are unified in their dignity.

Neshat has now established herself as a principal cultural figure that has addressed postcolonial bias, female representation, and clichés surrounding gender and religion. She is very particular about her methods and her message, not wanting to stir pity for Muslim women: "I'm not saying that they are not repressed but you cannot diminish people to nothing. . . . I am not an activist. I am not a feminist. I am a woman artist from Iran, living here [in New York]."[45] It is a declaration whose simplicity masks a far greater complexity.

Figure 17 Shirin Neshat, *Divine Rebellion*, from *The Book of Kings* series (2012). Acrylic on LE silver gelatin print, 62″ × 49″ (157.5 × 124.5 cm). Copyright the artist and Gladstone Gallery, New York and Brussels.

In his praise of the artist, Hamid Dabashi writes:

Shirin Neshat is singularly responsible for that hermetically sealed culture, deflated its inflated self-absorption, and dared it to "step outside" from the self-suffocating air of its own environment, out into the open air of a public space globalized beyond a particular politics of power or a marked aesthetics of resistance to that power, where the categorical differences between private realities and public truth can be settled in completely different terms.[46]

Ghada Amer: The provocation of pleasure

When asked in 2002 about what culture she identifies with, Ghada Amer replied: "I do not value any culture in particular, but rather what life brings to me with its experiences." She subsequently adds that "one moves and travels more than ever. Today's world is characterized by its ability to reveal more easily these displacements of people, with its cultural moves and encounters. It is important to recognize these cross-cultural encounters, to understand these economic shifts and to think about our ways of talking about these cultures."[47] Amer later stated emphatically that she "hated being called Egyptian, I never said I was Egyptian."[48] Indeed if she could be "boxed" as a white male artist, she would like that. In other words Amer is attempting to flee limiting rubrics; it is not a renunciation based on aversion or avoidance. But this stated slippage raises some very important, and for the contemporary moment, irrepressible questions facing artists—including their viewing public as well as curators, gallerists, and collectors—which is the ineluctability of the material substance of place, context, history, and language, and what values subtend from them. In a word, "culture."

Amer and her three sisters moved to France in 1974 when she was eleven years old. Her father encouraged his daughters intellectually, and Amer first studied in Nice and then in Paris. Her experiences in France in many ways shaped the artist she was to become. For instead of a woman from an Islamic country feeling the pressure of male control, she felt it in a country that prided itself on its secularism, or laicity. As a student of painting in both Nice and Paris, she was excluded from classes reserved for men, which led her to eschew for a time the traditional ("male") material of paint in favor of embroidery techniques taught to her mother and her grandmother. Despite repeated efforts, she was never granted French citizenship, something that caused her great upset at the time. Excluded from what was deemed men's business and from being French, she emigrated to the United States in 1995, residing in New York.

It was at this time that she was beginning to achieve success. Success in this case was not borne from the fascination and mixed feelings about the Middle East after 9/11, but, as Amer argues, in the wake of the huge and highly influential

1989 exhibition in Paris, *Magiciens de la terre* ("Magicians of the World"). Arguably a watershed in art and globalization, the curator, Jean-Hubert Martin sought to address what he rightly viewed as the ethnocentric bias of the Euro-American curatorium, that is, the body responsible for the biggest and most prominent exhibitions in the world. He observed that around 80 percent of artists around the world remained under-represented, or left to seem as if they did not exist at all. Fifty European and American artists were placed alongside fifty who were counted as sitting at the margin. There was no other thematic element, except that the artists were to be living. As would be expected, the exhibition drew criticism, such as its apparent randomness, the opacity of the unfamiliar, and the inevitable issue of decontextualization, from which it became difficult to rationalize motive. Some juxtapositions were also jarring, and potentially misleading.[49] All this notwithstanding, it was a benchmarking exhibition, that continues to be cited[50] since it brought precisely many of the above questions to the fore, and elevated the interminably insoluble issues of foreignness, ethnic difference, and so on, to the fore. As a result, artists who would otherwise be deemed unworthy of notice, soon found themselves curated into exhibitions, and the subject of critical scrutiny. Amer, who did not participate in the show in question, was one such artist.

Her earliest work, using embroidery, eventuated in her being turned away after her first entrance examination to the Masters course in Paris. Admitting later that these works lacked mastery, she turned to her earliest experiences in art making, which was to copy cartoons, and to consider the female nude.[51] This was because female sexuality from her country of birth was a taboo, but also a result of reading a magazine article in 1988 about veiled women that, she said, "really shattered me." By the early 1990s Amer had established themes that would remain constants for the rest of her career: love, femininity, and sexuality. She alternates between using graphic imagery of women's bodies and text. The chief material characteristic of her paintings is the use of thread and yarn. The momentum for articulating issues of femininity and the materials to achieve this was raised when she visited the School of the Museum of Fine Arts in Boston in 1987 in which she found that feminism and issues about women were discussed with a freedom that she had not experienced in France. And after that she became "fascinated" with Rosemary Trockel, especially the textile and embroidered works.[52] She would later comment on how moving from one culture to the next made her highly sensitive to the differences in the ways in which people see and relate to one another. "It's not a question of being tolerant, you feel it in your skin. You have to be flexible and to be able to shift your norms."[53] This she has done more than once, and it has enabled her to reflect on women's experiences more acutely and from a more global perspective.

It is all too easy to deliver the feminist stamp to Amer's work, but her relationship to feminism is a complex and nuanced one, just as is her attitude to race and

culture. What she appears to resist in feminism is not only its potential dogmatism, but indeed any ready label that limits her work, anything that reduces her work to confining categories. And yet she is refreshingly realistic about the status of women, and ethnic women, in the fashionable marketplace of contemporary art in which identity is trafficked as taxonomic markers. She admits that

> As a woman, I must admit that it is not always easy because I feel that women must talk above all about themselves. In order for female artists to be recognized and to succeed, they must represent women. Moreover, it is more or less the fashion these days to be interested in the Other, the stranger, the minority. Therefore, to talk about oneself as a woman and as a foreigner means raising issues and topics that suit today's fashion, all the while remembering that women must fight against the majority. Once again, women are forced to fight against the mainstream, and this fight is far from being over.[54]

The "fight" she undertakes is not defensive but aggressive through the use of what for many feminists is also a taboo, namely pornography.

Pornography is as almost as old as the history of representation, from the erotic wall paintings and priapic ceramic figures of antiquity to the overflow of coarse imagery in the eighteenth century, now climaxing with the Internet. As a form of signification it is distinct. Dictionary definitions fall short of the mark in this regard, since "pornographic" is now a term used well beyond representations of nudity and copulation to designate a starkly voyeuristic image, visual or verbal. Its main attribute is the resistance of the pornographic image to metaphor; it is not a shifting signifier, it is simply of itself, since the way the pornographic image communicates is in the capacity of a tool for excitation, not interpretation. To critique a pornographic image is ultimately to critique pornography itself, because the pornographic image is never alone, it is a cipher. It is these reasons that make using pornography in a work of art so difficult, so forbidding. Yet it is precisely the obduracy of pornography's signifying power that makes it so effective in Amer's hands. As David Frankel writes in a 2002 review of her work: "Quite rigorous feminist investigation into the use of such [pornographic] imagery had led to quite vigorous proscriptions; these Amer broke, while at the same time skirting the problems of voyeuristic objectification by obscuring her nudes under another layer of stitches imitating the drips and spills of Abstract Expressionist painting."[55] In Amer's work pornography is used, among other things, to confront the enforced concealment of women in Muslim countries, and the uneven attitude to female sexuality in general. These images are far from tawdry and breathe with a refined sense of purpose in which we know not to alight simply upon the obvious. Given that classical nudes are a male tradition, Amer's pornographic nudes are stand-ins for the absence of a coherent and present tradition of female sexual expression.

A recurring approach is to repeat the same motif—in a grid, in rows, or in interleaved combinations to present a new abstract pattern—rendering them with or together with thread, embroidering or encrusting the bodies, or hanging over or across it, like fine hair, or a veil. As Candice Breitz remarks, "the individual coherence of the pornographs (the objects of desire) is shattered, since Amer renders their poses generic, by replicating them over and over again, not only in the same piece but throughout the entire series."[56] This also results in destabilizing the integrity of the image, draining its use-value (to stimulate and satisfy desire). Paintings from the late 1990s bring the bodies to the brink of obscurity, and the repetition is mitigated by violent splashes of paint, or else by a skein of fine lines created from dribbling the paint from the top down. The paint and thread on the graphic outline of the figures act as a kind of concealing-revealing, obscuring the bodies and thereby rendering them more present, analogous to the way that the act of veiling enhances desire by emphasizing what is no longer available for view.

The works from 2006 see the graphic outlines become more bold and less repetitious, or else become even more repetitious with a hallucinatory filigree

Figure 18 Ghada Amer, *Noah Forever* (2009). Acrylic, embroidery, and gel medium on canvas. 36″ × 42″ (91.4 × 106.7 cm). Courtesy the artist and Cheim & Read, New York.

surface (as in *Checkers*, 2006) The layered outlines are reminiscent of the later Francis Picabia, who was also devoted to a strange, retrograde pornography in his treatment of women. *Noah Forever* (2009) shows a foreshortened woman's figure, uncontained by the dimensions of the canvas, in a pose that looks like feigned ecstasy while exposing her pubis. There are overlays in red and purple, of what appear to be a couple kissing. The thread reaching across the image in uneven, almost brutal distribution, like horizontal scratches across the surface, bringing this theater of desire to a screaming pitch. It does not matter whether this desire is authentic or not, what matters is the intensity of its staging. It is much as the way that sex workers and pornographic actresses are known for the extent of their overacting than over any need to make it seem real, as if drawing attention to the simulation is more enticing. In many ways Amer engages in a language about a language which suggests a way of feminine thinking and acting that, while imposed with male language systems, use it and enact it in different, even subversive, ways.[57] As Chika Okeke-Agulu recognizes, the figures in Amer's work are almost exclusively female: "in other words, it is world existing beyond the reach of patriarchal control and influence."[58] By extension, the exclusion of men suggests, actually or metaphorically, a pseudo-lesbian universe, one where men are contingent, unnecessary.

Not limited to painting, Amer's practice extends to outdoor sculptures and garden interventions, as well as sculpture, performance, and video. The outdoor work is largely text-based. For one of her earliest of these, *Women's Qualities* (2000) started with the artist asking people passing by the Metropolitan Art Museum in Pusan, South Korea, what they saw as women's best qualities. The most common resultant words included "docile," "sweet," and "virgin," which she then had transposed as a row of eight flower beds shaped into the words.[59] The next year in a public walkway in Barcelona, she placed a procession of red letters, bays filled with sand, that read in Spanish, "Today 70% of the poor in the world are women," which was also the work's title. From the public to the intimate, *S'Il pleuvait de larmes* ("If it rained tears") (2004) occupied a small garden inside the monastery in Certosa San Lorenzo in Padua. Tracing the floor plan of the original garden, four garden bays, and a circle at the base of the wall where the fountain once had been, the barriers reproduced the poem by Boris Vian, from which the title came, telling of destruction and war.[60]

Combining sculpture and performance, *The Reign of Terror* (2005) at the Davis Museum in Wellesley, Massachusetts, involved taking over the cafeteria in the lobby. The walls were covered with wallpaper of mostly rich puce, and of a nineteenth-century style pattern, symbolizing British colonialism. The paper contained a range of English definitions of "terrorism," while the paper plates, cups, and bowls, and the tray liners, on which the visitors ate, were all printed with the line, "*Terrorism* is not indexed in Arabic dictionaries." The same wallpaper was used in an installation in Malin, *Le Salon Courbé* (literally "The Bent Lounge

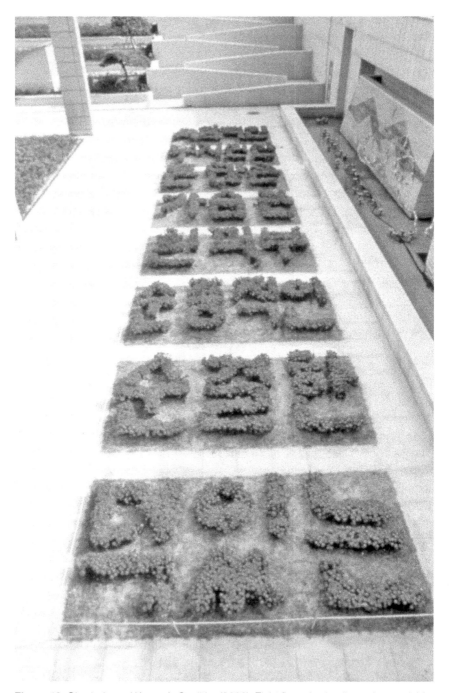

Figure 19 Ghada Amer, *Women's Qualities* (2000). Eight flowerbeds, dimensions variable. Courtesy the artist and Cheim & Read, New York.

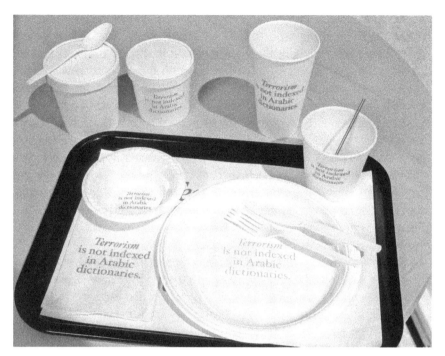

Figure 20 Ghada Amer, *The Reign of Terror* (2005). Printed cafeteria cups, plates, and paper tray liners; dimensions variable. Courtesy the artist and Cheim & Read, New York.

Room," 2007), but it was combined with three Louis XV style chairs that had been laced with scarlet thread that called to mind veins and capillaries on the surface of skin. The word "*courbé*" ("bent") comes from the term used for this kind of furniture, symbolizing the old prosperous Europe, found in wealthy Egyptian houses. As Maura Reilly then observes, "as with all of Amer's works, a pleasurable exterior contains hidden thorns. The traditional carpet [between the chairs] was inscribed in Arabic with the single Arabic definition of 'terrorism'."[61] What on first sight looks like an ode to luxury turns into a grotesque tableau in which layers of fakery conjoin into violence.

This play of rupture and disturbance is a constant force in Amer's work, just as how it is deployed and situated. It is a critique by osmotic seepage. In many cases the viewer finds him or herself in *medias res* before it is too late. As Fereshteh Daftari smartly puts it, Amer "strikes her blows from the cocoon of tradition." When employing language in her embroidery, it is "without espousing its innocence, and invokes the canon of calligraphy while narrating what remains unspeakable and what calligraphers would find unwritable. Subversion escalates in her work from the aesthetic to the cultural."[62] As opposed to the frank or inappropriate comment by a child who has yet to be taught a linguistic filter,

Amer's work operates through a number of filters, such that the viewer is made to feel uncomfortably conscious of them. But uncomfortable does not mean guilt. Rather Amer's work is about pleasure and thus guilty pleasures and the pleasures we strive to avoid—usually spurred on by religious abstinence. As Laura Auricchio relates, "The perhaps guilty enjoyment that we feel before Amer's autoerotic women may hide in a more general discomfort with the very notion of pleasure."[63] This pleasure resides not in a return to innocence, on the contrary it is very adult, very aware, but normally very silent. Marie-Christine Eyene reads Amer's work as reclamation of female pleasure. Its Muslim orientation is inevitable since Islam is so much about its denial. Yet she also concludes that the Christian immaculate conception is "the first Catholic dogma to refuse women the right to engage (jouir) in pleasures of the flesh."[64] The denial of female pleasure is written into the loftiest of doctrines, making its denial a condition of religious transcendence. It is a dire thought.

More recent paintings, the series Rainbow Girls, in many ways synthesize the linear figure work with the language work. Once again the canvases are overlaid with thread, but here in nervous, plentiful tendrils and tangles. The figures underneath are all but hidden, the threads imitating the curlicues of Arabic writing. Having begun with figurative forms, the surfaces are then made into a material scribble that gives the impression that it is searching for a form, a voice, or a language to return to. One source for work such as this can be found in Koranic decorations that adorn the Kufic poetry of the eleventh century, although these are far from having erotic connotations. As Robert Pincus-Witten writes in a review of this work,

> There are but two of many "threads" in Amer's oeuvre. Threads is a world of multiple meanings—it may be an idiom for "clothing," the constituent element of the structure of cloth, or that which binds you to your ancestry—all famously explored by the artist. . . . Despite Amer's fame, viewers are still surprised when chancing upon these erogenous images, which are, or were, often lost in disgusting, dangling threads, a tangle that itself also served as a sign of a highly fetishized—both negatively and positively—taboo substance: pubic hair. That Amer is Cairene only intensifies the radical effect of her subject; quite like Shirin Neshat, she is a standard-bearer of a certain anti-patriarchal conviction.[65]

These words, eloquent as they are, bring us to the beginning of this discussion on Amer and the agonistics of identification. On one hand, to the tacit irritation of the artist, she is made to circle back to Egypt. (As Auricchio notes, "Amer's concerns about the stultifying effect of a 'postcolonial' label echo anxieties voiced by several contemporary postcolonial theorists about the resurrection of the postcolonial 'hybrid as a figure of fascination'.")[66] On the other, she is

recognized for flouting the many still regnant unspoken prejudices imposed by men, and which many women internalize.

And it is for this reason that it is worth returning to the subject of Egypt, because of its troubled society and the ways in which these troubles become the burdens of women as keepers of the household, and as the intrusions on themselves as keepers of their own bodies. At the time of writing, the brief flush of hope that greeted the fall of Mubarak has faded well and truly. After the brief term of Mohammed Morsi, the current regime of Abdel Fattah el-Sisi has tightened its grip, together with the endorsement of U.S. President Trump. Having failed to fight terror or to revive the economy, he has labored to repress public dissent by policing and shrinking the free spaces of social media. Amer acknowledges that art cannot directly instrument political change, although it can increase awareness. Her work is charged fillip to the curtailments of women, Muslim or not. It is work that is passionately brash, which is without embarrassment or apology. It is an example from which women can draw sustenance and strength.

Nasim Nasr: Layered destinies

Nasim Nasr is an artist who knows the extent to which she is enframed by her culture in a place like Australia. She is keenly conscious of the advantages that accrue to this position—the sympathy that comes from curiosity or compensatory guilt—which merely make up one face of the same coin that also limits her. In Australia, she is never simply an artist; Nasr is an *Iranian* artist or *Iranian-*Australian, if she is lucky. The screen of cultural difference, Globalization's veil of Maya, is her only term of expression. To understand Nasr's work is therefore not to try to understand Iran per se, but to see how we understand Iran. By and large the Western grasp of Islam is shorn of subtlety.

The intellectual neo-liberal trend since 9/11 is strikingly consistent: writers seeking to show that Muslims are just like you and me, that there is a "good Islam," and a "bad Islam." We are told to decry the fundamentalists and to cherish the rest, as if society exists according to simple demarcations. This is pop revisionism at its worst, which suppresses the unassailable fact that Christianity has caused more wars and deaths than any other religion in history. The beguiling aspect of Nasr's work is that it is partisan to neither point of view. Her relationship to her country of birth, Iran, is complex to say the least. Iran is stamped on her complexion, her accent, and her memory, and yet it is also, for her, a place of suppression and humiliation. Technically speaking she was only able to produce art since her arrival to Australia in 2009. Before that she was severely curtailed in what she was able to represent owing to the strict Iranian laws on what is admissible for representation. Proscription on representation is

as old as Islam itself (which is why we must turn to its decorative arts such as carpets and weaponry as forms of expression), but there are increasingly more people of Islam, as with Nasr, who question the validity of these laws, and suspect them of being but one means of a more intricate system of political power. Nasr's "coming out," or what she calls her rebirth, is much of a piece with artists of other countries, China in particular, who were only able to discover their own voice outside of their country of birth. But a question that remains hanging is the extent to which this voice, which is pre-eminently a cultural voice, is "their own." This is the paradox of cultural expression (cultural quantity) in art: it must in some regard be denounced, or displaced for it to be expressed. One cannot express Iran in Iran as sharply as one can in Australia. The question of her own placement within such zones of divergence is something that Nasr's work vigilantly addresses.

One of the earliest Australian works is *Cyprus and Suppress* (2009), photographs of the artist's sister's naked form behind a frosted screen, with the only clear feature a *buta* shape on what appears to be a tattooed palm pressed against the glass. The image is deliberately seductive, and deliberately cryptic. After the immediacy of seduction, we are confronted with something more discreet and encoded. The screen is the Orientalist screen that hides the harem, in the sense that "harem" is metonymic of the sanctified region of prohibition, what is kept from the gaze, the zone beyond the understanding of Christian-Western consciousness. It is also the place where the Muslim woman can finally unclothe, free from being on show—but in Nasr's case the only place where she had formerly been able to make art that could never be shown, since her preferred motif was the nude female form.

As mentioned earlier, the *buta* is the original name for the paisley motif that originated in Persia and India, and that was marketed, elaborated, and 'improved' in the Scottish town whence it gets its popular name. As a symbol it is now very much an example of a culturally interwoven statement that the artist uses as an embodiment of the culturally hyphenated condition. On one hand it is quintessentially Oriental, its sinuous form having all the connotations of a world of sensuous pleasures—not as well how the curvilinear forms are commonly referred to as "arabesque." They are also symbols in the Middle East and India of ancient traditions. It is an armature for all manner of decorative variation. Yet it is also a motif that became creatively absorbed in the high age of British imperialism, when its industrial power could outdo its colonial counterparts in production and design whilst retaining all the signifiers, now unmoored to their origin, of exotic mystique. Thus Nasr's use of the *buta* is purposely ambiguous, contradictory, implying a continuously unresolved act of cultural reclamation.

Standing behind the frosted screen is both liberation and repression—which is also the completest definition of the burqa in which freedom and containment

are the same. This is also why the burqa has now become the most concrete visualization of the contemporary Muslim condition—the "Muslim problem"—to Euro-American eyes. It is the sign of difference, or violence, injustice, and everything that is concealed from Western knowledge. As the sign of indignation and suspicion, it perpetuates the symbol of the lasting symbology of the harem but now it is darkened, tarnished by terror; desire has been replaced by fear.

In the performance *Women in Shadow* on June 24, 2011 at the Australian Experimental Art Foundation (AEAF) in Adelaide, an allocated number of guests were ushered into a room that had been arranged to look like a fashion event. Men and women were instructed to sit divided, just as they are in Iran. Once assembled, they were the audience to a procession of eight women in chadors. When we ask about the West's antipathy to burqas we have to go somewhere deep into the Christian psyche and to the history of revelation. Islam's idea of revelation has to do with prophets, but never the equivalent of Christ himself. Muhammad was the messenger of God, not his worldly scion. To a degree, burqas reignite this ancient anxiety fear, they emphasize the state of something hidden. The hysteria it can spawn reached a somewhat understandable but still irrational pitch after 9/11. Exacerbated by the "Danish cartoon controversy" of July 2005, in the more suspicious and ignorant circles, burqas and turbans (more accurately in Iran these are known as *amameh*)—the *reductio ad absurdum* of Middle Eastern clothing—were marked out as indicators of terrorist lawlessness.

The status of what Emma Tarlo calls "visibly Muslim"[67] becomes a problem, however, when the non-Islamic state expects a certain degree of conformity and assimilation from its citizens. The burqa is perennially the locus where the stark differences between cultural values become apparent. For assimilation means something to one country that it doesn't in another. This usually begins with learning the language but the ideas of "shared" and "common" values are always liable to experience friction with democratic values of tolerance and multiculturalism.

Again, Nasr's work was purposely ambiguous. A statement of contradiction asserted as a plain statement: the non-fashion of the chador articulated through three ciphers in a context of the fashion catwalk where change, choice, commodity, and sex are legion. But while the statement was plain it was not neutral. At the end of the performance, the women produced plastic bags containing live gold fish, Persian symbols of rebirth. Nasr was using the fish as opposed to the female form to signify escape. In this regard, she was true to her Iranian roots in not shaming other women or evincing disrespect to those who cherish hijab as central to their faith and their privacy. For in effect the chador cannot be escaped either as a cultural quantity or for those who have experienced it, since it is an outward sign of a deeply internalized principle. *Unveiling the Veil* (2010) is a ten-minute video in which we see only the eyes which, when wearing the chador, are the only part of the body that remains uncovered. Slowly, the

artist begins to weep. Then with wetted hands touches the eyes to make the eye makeup run down her face, leaving a vulnerable smear.

Against the background of her other work we can see that the comment is clearly and movingly made: removing the chador, renouncing the draconian Islamic law of Iran by coming to Australia, is a reawakening that comes at a price. Like all exile, voluntary or not, one must shoulder the task of constantly making a home as opposed to having the luxury of claiming one. Nasr's work treads the line between resentment and respect. Art is the best medium for this, for it is the only form in which contradictions can inhabit comfortably, so long as they are articulated beautifully.

In 2009 Nasr also produced a series of photographs, *Liberation*, of herself in full hijab at the edge of an ocean—more specifically it is a legal nude beach, to give the work greater emphasis. She looms spectrally, nearly a silhouette. There is none of the levity or ebullience that might be expected from a work of this title. Instead the images are deeply ambivalent. They seem to tell a story of a woman who has left her loved one, and is now unsure of whether this was the right choice, but who finds solace in the beauty that resides in melancholy. In other words, the non-Iran (in this case Australian) audience ought not to feel triumphant or to claim this artist as their own (as all countries are wont to do with migrants, especially sportsmen, who are successful). And this is what makes this culturally inscribed so unconventional.

Exploring the proximity of joy and grief is the 2013 video work, *Beshkan* ("Breakdown"). Calling to mind the film works of Samuel Beckett, which isolated the lips from the rest of the body, this work is only of several pairs of hands hovering against a large, inscrutable black ground. The hands ritualize the "Persian snap," or *beshkan*, whose Western equivalent is the theatrical gesture of cracking or clicking one's fingers before attempting some important task. In Middle Eastern countries, *beshkan* is enacted as a celebratory act, after good news, or partaking in a happy family event. But no sooner as these hands are separated from their bodies, and from the events to which they supposedly respond, they quickly assume a sinister aspect, eliciting sorrow, not joy. The "dance" of the fingers as the artist calls it,[68] becomes a harrowing act of hand-wringing, the snapping alluding to self-harm. Are these exiles deprived of voice and community, whose only recourse is a simple bodily act as if deprived of everything including the capacity to speak? Or is this an innocent, childish game unrecognizable to the average Westerner?

The right to speak from an historical perspective in Iran is the subject of the photographic suite, *Zaeefeh* (*Wretchedness*, 2015). Traditionally, *Zaeefeh* was the name conferred by the Shahs to their wives: the weak ones, with abilities inferior to men. The word crept into everyday speech for men to call their wives at home. It persists today in non-urban areas when men want to humiliate women. The photographs are hazy images of nineteenth-century Shahs, overlaid

Figure 21 Nasim Nasr, *Zaeefeh* (2015), giclée archival digital print on Hahnemulle etching paper. Courtesy the artist.

with writing. As with Neshat, Nasr invokes the words of Forogh Farrokhzad whose poems mentioned women's purported weaknesses and incapacities. In addition to quoting from Farrokhzad's poem, "Another Birth," Nasr quotes Sadeg Hedayat's *Blind Owl*, a story also banned in Iran. In this work, Nasr aims the word back at the Shahs themselves, who displayed poor leadership and assisted in Persia's decline through craven acts such as selling off the empire's wealth and sovereign rights to the imperial powers. Anne Marsh comments that "the writings are etched onto the skin of history, but the scale of the photographs creates pixilation, which blurs the image, making it unrecognizable. Nasr prefers this poetic aesthetic, one that pulls back from a didactic message."[69]

Writing on a photography and video work (*Forty Pages*, 2016), in which the artist's face is sequentially covered in official stamps to express the state of travel and transitoriness, John Neylon asks: "'Is this my destiny', this series at face value appears to ask, 'to be someone defined and subjugated by not only institutionalized power but also "us" and "them" community mindsets?'"[70] The

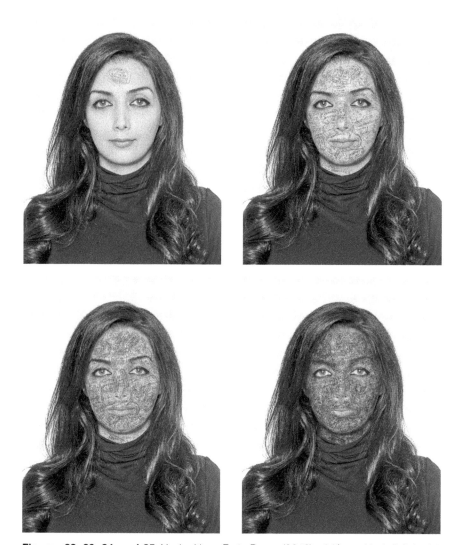

Figures 22, 23, 24, and 25 Nasim Nasr, *Forty Pages* (2016), giclée archival digital print on 320 gsm white cotton smooth. Courtesy the artist.

question is of course unanswerable since it sits somewhere in the middle, the transorientalist space of oscillation and interleaving.

Beneath Nasr's resolutely crisp and compelling aesthetic lurk folds of discordant meaning and awareness that is the lot of any sensitive, reflective exile. Culturally, ideologically, her work is a room of mirrors in which personal intent is constantly trying to emerge, reborn, from the vapid web of cliché.

Mona Hatoum: Forever in transit

The exile has a special privilege, which is the luxury to be able to reflect with melancholy relish on a place departed and a time lost. He or she can point to that elsewhere, irrespective of how fictional it may be. The displacement creates a space of permanent reverie. But what of people who are displaced from the very beginning and where the only familiarity is with rootlessness? This is perhaps the best way to define the work of Mona Hatoum, whose position is in the occupation of several positions at once, and the movement between them.

In a series from 2002 to 2013 under the title *Routes*, Hatoum took the maps from various airlines and colored spaces between intersecting flight paths, superimposing a new decorative, abstract geometric layer over countries and continents. This work suggested that the geographic boundaries on a map were now redundant, with the new borders created by the movements of people, a vastly intricate and unfathomable configuration of change and transition. Ila Sheren comments that "Mona Hatoum's works describe a . . . disjunctive scenario in which the comforts and familiarity of 'home' can never be attained."[71] She exemplifies a global condition that Sheren guardedly calls "post-border."[72] For migration is a central leitmotif to Hatoum's work that exists on several levels, be it forced, temporary, or voluntary. It also mirrors the constant movement of global artists, who have become nomads from festival to festival, biennial to biennial.

One of her earliest works, *Measures of Distance* (1988), engages the theme of displacement together with family and femininity. The images, which change periodically but slowly, are of colored photographs the artist had taken of her mother while showering, the body a blurred ghost behind a screen. Details of bare breasts toward the middle of the piece become a little more distinct, and further on sharper lineaments of her body. These have been overlaid with another screen of script from her mother's hand from letters in Arabic she had written to her daughter. The sound is Hatoum reciting an English translation of the letters. Another sound layer rises at certain times, which is of Hatoum and her mother conversing in Arabic. The initial words mention the process of the work's making ("You asked me in your last letter if you can use my pictures in your work"), which quickly leads to private details related to womanhood ("Go ahead and use them, but don't mention a thing about it to your father"). This is interrupted by an anecdote about how the father woke from a nap and found his daughter taking photos of her mother's naked body in the shower. And later: "My dear Mona, I long to see you my little one," laughing and chortling from earlier transitions to a reticent ache over the difficulties of distance. The mother explains the difficulties of sending letters while the war in Beirut is raging, exacerbated by concerns over the ongoing Lebanese civil war. As the images become more legible, the face remains darkened, not necessarily out of modesty or for the need for anonymity, but to make the body's vulnerability more generic, as if speaking for the

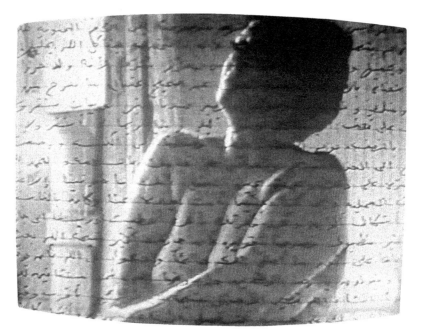

Figure 26 Mona Hatoum, *Measures of Distance* (1988), color video with sound, 15'35". Western Front video production, Vancouver, 1988. Courtesy the artist.

defenselessness of all those caught in the crossfire of conflict. "Before we ended up in Lebanon, we were living on our own land; in a village with all our family and friends around us, always ready to lend us a hand. We felt happy and secure and it was paradise compared to where we are now."[73] The image of the mother showering has begun to recede. "I'm not just talking about the land and property we left behind, but with that our identity and our sense of pride in who we are went out of the window." Pause. More talking in Arabic in the background. "Yes of course, I suppose this must have affected you as well. Because being born in exile, in a country that does not want you, is no fun at all." The Arabic chatting in the background and the English voiceovers, symbolizing two worlds and also mother and daughter, fold in on one another in counterpoint. "The linguistic play," remarks Ella Shohat, "also marks the distance between mother and daughter, while their separation instantiates the fragmented existence of a nation."[74] Shohat points out that this film is highly unconventional on the level of both intimate conversation and the manner in which it is delivered, with so much naked flesh. "Paradoxically, the exile's distance from the Middle East authorizes the exposure of intimacy." But this distance also applies to the non-Arabic speaker viewers, who are presumed to be the majority. "For such 'foreign' spectators," notes Siona Wilson, "this sound is abstract; it marks the viewer as an outsider to this intimate mother-daughter relationship. But it also animates the abstract quality in

voice as such."[75] This is the voice as disembodied entity, as displaced and foreign element to bodily matter.

The work ends with the artist reading over a black screen reciting her mother's continuing frustrations in trying to reach her daughter. By the end, the sadness is palpable. It exhorts empathy and is so poignant because of its factuality, of it simply having been said and the people simply being there, the communication not being a plea to others but a reaching out to closest relations, the commonest of exchanges. This reaching out is constantly thwarted, amplifying the sense of deracination for both addresser and addressee.[76] It is a foundational work for the artist, if only because she would not continue to deal so explicitly with herself or on the same terms, preferring a more oblique approach.

Yet *Measures of Distance* does give a fair sense of what lies beneath the works to come, in particular the role and meaning of home: home as a place of arrival as in homecoming, home as the reminiscence of childhood to which we all wish to return but cannot, and home as a zone of disorder and fragmentation, the battery of memories that we are constantly trying to reassemble into adequate order. This is evident in Hatoum's use of maps, which in her hands the science of cartography flounders under the weight of reductive abstraction. The abstracted form becomes the analogy of the alienation from home. And the many maps in her practice can, in retrospect, be interpreted as an obsessive searching for what cannot be found. Najat Rahman comments that "Evocations abound in her art here and elsewhere of globes, cities, maps—fragile maps, maps that swing, maps of cities, maps that disappear, the precarious ensuing from maps, subjective mapping as a way to contest official maps with the creative act."[77] Hatoum's maps perform a contradictory movement of attainment of non-arrival, they announce and perform the itinerary of displacement.

The meeting of the cartographic and the somatic is borne out in one of Hatoum's most mysterious works, *Corps étranger* ("foreign body"), a video installation involving a cylindrical container with two openings and a circular video projection on the floor.[78] The images were of the artist's own body parts seen from up close, picking up on the minutiae of the inside and outside of a body—intestinal tract, follicles, eyeballs—and in ways that make the body, as the title suggests, foreign. Significantly, the word "strange" (*étrange*) was not used in the title, since the work evidently dealt with the way in which the most familiar thing to us, with a change of perspective, can be made foreign to us. In parallel to works about journeys over borders, this is a journey over the body's intimate topography, transforming it into a planet on its own with its own barriers, thresholds, surfaces, peaks, and troughs. Stephen Monteiro analyzes this work as a reflection on both medical imaging and pornography, and their "methods of restricting and regulating access to the images they produce." Moreover the work's "medicalized gaze pushes to an extreme pornography's increasingly 'clinical' and 'abject' gaze."[79] Hatoum's work, notes Marisa Yu, "encompasses a

Figure 27 Mona Hatoum, *Corps étranger* (1994), video installation with cylindrical wooden structure, video projector and player, amplifier and four speakers, 350 × 300 × 300 cm. Installation view at Centre Pompidou, Paris. Courtesy the artist and Centre Pompidou, Mnam-CCI.

paradoxical aspect of being both beautiful and repulsive."[80] Ursula Panhas-Bühler writes of the work that it is "a visceral journey: an excursion into the morphological unknown of the interior . . . an audio-visual journal of an inner beyond in which all symbolic detachment meets its limits."[81] This is the somatic uncanny: biologically familiar yet disconcertingly strange, an instance of rendering the self strange through technical intervention.[82] Like pornography, we are conscious of our removal from it, while making us conscious of the distribution of different regimes of power: that of the voyeur but also of those with the power to produce something to be seen.[83]

These observations may be extended to the "pornographic" treatment of world news and catastrophe in which the exhortation for concern is drowned in the voyeuristic lure of the lurid, where imaging of tragedy is a grotesque end in itself. Seen in this light, news is always a microscopic distortion of the myriad surface of events, as such always a distortion. Monteiro adds: "The work's relationship to issues of exile, geo-political imbalance and state violence is present in its title."[84] It is a work that is distinctive for, among other things, the way it differs and stretches the approach of artists with which Hatoum is grouped. For Randall Halle contends that she is one of a grouping of artists and filmmakers "troubled by an experience of domestic, local and/or state exclusion based on their background," preoccupations that drive them toward the "subjective and the representational," a drive toward diegetic content, over the "structural and material."[85] But with *Corps étranger* this could not be further from the truth: with a little knowledge of the artist's larger project, it effectively combines the subjective with the structural, its power deriving from its abstractions.

From here on there would continue to be dialogue between the deeply visceral and the political, suggesting, among other things, that political situations or their effects are not external to people's bodies, rather the bodies live out their effects in unexpected and inexpressible ways. *Recollection* (1995) involved a small wooden table at the end of a room, a cake of soap filled with hair, a small loom with woven hair, and countless small balls of hair strewn all over the floor. They looked like insects-cum feces, perverse detritus. "The physical encounter with the inert detritus of Hatoum's body," states Deborah Cherry, "could prompt questions about presence and absence, and disturb memories, from the intimately pleasurable to the traumatic."[86] Or, in the words of Mignon Nixon, the excess of bodily detritus in this work was a way of enacting touch, "and with its associated chain of cobwebs, dust, and mourning, it was a haunted touch, the room's atmosphere of loss memorialized in the fetishistic ritual of gathering and weaving locks of hair."[87] For the simple act of gathering hair from the floor that has fallen after brushing has always a certain elegiac quality, and a delicate but decisive foretaste of our own mortality. A related work from 1993, *Jardin public*, is of a brown wrought iron chair of the kind strewn about the Luxembourg gardens in Paris, and slightly off center is a triangle of brown hair, situated where the pubis would be when seated. The "l" in the title artfully remains, making the viewer complicit in the pun, the "l" acting like an interloper, and the viewer a guilty voyeur.

These works were produced at a time when discussion of the feminine with regard to abjection was in circulation, influenced considerably by the translation of Julia Kristeva's *Powers of Horror: An Essay on Abjection* the decade before.[88] Christine Ross, commenting on *Corps étranger*, explains how it explores abjection, alienation, and disgust in relation to the female other:

The woman, the Palestinian, the visceral or dysfunctional body, that it, what *has to be abjected* by the Western subject to construct his or her identity, is now in the viewer's space, externalized, in proximity, indicating how the "difference" or the "distance" between the I and the other, the mind and the body, the healthy and the ill, is not so clear or predictable anymore. One is not in complete control of the situation. This is what disease is about; the body acts independently of your will, even from your consciousness.[89]

Add to this the predicament of statelessness and exile; the permanent state of cultural dis-ease.

One of the most elegant, but unsettling, objects by Hatoum is *Keffieh* (1993–1999), a textile made of cotton and human hair. Its delicate filigree is interrupted by fibers that stray between the weave and randomly escape the confines of the square shape. A keffieh is the traditional Palestinian headscarf with a fishnet pattern worn by men that became a symbol of their solidarity that gained

Figure 28 Mona Hatoum, *Keffieh* (1993–1999). Human hair on cotton fabric, dimensions variable. Courtesy the artist and White Cube. Photo: Hugo Glendenning.

momentum after the Oslo accords of 1993. For Hatoum this work enacted "quiet protest" in which hair, normally a symbol of the feminine in her work is used within a "potent symbol of Arab resistance . . . a symbol of struggle with a definite macho aura."[90] In his detailed examination of this work, Jaleh Mansoor presciently observes that the conspicuous grid in the fabric can amenably be read as the tissue of opposition between Palestine and Israel.[91] She draws attention to the recurrence of the grid motif in her work, which, among other things, can signify "internal stasis" of the Israeli–Palestinian conflict. The endless repetition of the grid—even contained it can suggest endless expansion—links to the irresolution of contradiction, as well as the dependence on each contrary to this irresolution.[92] Another powerful deployment of the grid occurs in *Interior Landscape* (2008), a bare bedframe with only a single pillow, whose support is a grid of barbed wire in place of where the springs should be. Sewn into the pillow, with the threads of her own hair, is the contour of the historical map of Palestine. Mansoor observes: "While the shape of a 'country' is usually that of a nation-state, here, the spectral state of a non-state is metonymically articulated by the remnants of the frailty of the body, in particular the body without rights or citizenship."[93] She contends that Hatoum maintains a nuanced position to her status as a woman artist who identified as Palestinian, despite the constant pitfalls of the "Middle Eastern woman artist" label. Hers is "an inflected subject position often regarded as unstable." Further: "Hatoum does not, as is so often the case in Western doxa, collapse Islam's dictates with the Palestinian struggle, and she insists on the disarticulation of the two."[94] Clearly the need to deflect typologies, which quarantine and deactivate a cause, is part of the cause itself, and therefore inherent to the content of the artist's work. Mansoor concludes that Hatoum's work is devoted of "the problem of biopolitics" in which power structures ensure that any subject cannot be free of "Biological determination."[95] In this regard Hatoum exposes a paradox, namely that the epithet of feminist is germane to such determination but all the while necessary, even if the power machines thrive off such forms of resistance. The gender deadlock mirrors that of the Israeli–Palestine situation.

Hatoum's 2000 exhibition at the Tate Britain was entitled, *Mona Hatoum: The Entire World as a Foreign Land*, a line taken from Edward Said. Hatoum had been discussing exile and home with him, and the paradox of "home" is that it can feel like a prison. "Said wrote of her "*defiant* memory facing itself . . . unwilling to let go of the past."[96] Home is a distant anchor long cast from an unmoored boat. Almost two decades hence, this title can in many ways be taken as a coda for Hatoum's œuvre. The feeling of permanent foreignness and deracination is something that more and more people face in the present era, either from ecological disaster, political upheaval or, indeed, from social media wherein an unmanageable sum of "friends" and "likes" only exacerbates one's alienation. The agonism in Hatoum's work is simultaneously geographic,

spiritual, and bodily. Her works are about the longing for contact, for touch. And even when that touch is made, it can too often be misunderstood. Thus Hatoum's language is of standing between two languages in the eternal act of translation.

It is perhaps this occupation of multiple spaces of custom, body, and worldview that unites all of the artists discussed here.

5

"CHINA," OR CONTEMPORARY CHINOISERIE

When the Metropolitan Gala opened on "the first Monday in May" in 2015 its exhibition met with an oddly extreme combination of responses, sometimes within the same person. *China: Through the Looking Glass* was undeniably a technical feat of curatorship and staging, dazzling on every level. Combining fashion, art, and film, it explored the many ways in which China and "Chineseness" has been evoked, troped, and shaped through these forms. While visually sumptuous, it nonetheless rankled cultural sensitivities, precisely because it used the imagery and style associated with China as manipulable, unconstrained to China itself. The exhibition, in other words, played loose with culture. It was the obverse of what culturally responsible curatorship is thought to have been, namely authentic, and respectfully objective. Instead, China was turned into "China," an infinitely pliable set of qualities available to all. In a word, the exhibition exploded myths of cultural essentialism, while exposing how widespread such beliefs are cherished. This was especially remarkable given the rich diet of China that has been dealt the Euro-American public at levels of the media, not least in films and television dramas. The epic film from the Italian-born Bernardo Bertolucci, *The Last Emperor* (1987), excerpted in the exhibition, has had a profound and lasting influence on Chinese cinema. A recent example of television is the series *Marco Polo*, which is replete with cultural confusions, beginning with the premise itself of a cultural interloper from Europe. And the filmic trilogy involving the martial arts hero "Ip Man" is steeped to the point of uncanniness in other boxing films such as *Rocky*. Such conjunctions do not amount to violations or intrusions, but rather examples that reveal how the cultural image of China is a product of far more than China "itself." Similarly, Chinese contemporary art is something with a pan-national genesis, a co-created entity between China and the West. Historically speaking, China occupies a special space in the evolution of cultural manufacture in which geographical China and the idea of China ("China") occupy two discernibly separate, if overlapping, spaces. Paradoxically

this parallel between reality and image is a result of such a strong impression of what China "is." This conundrum, this empty center of truth, together with an unerringly vivid image of cultural identity, is quintessentially transorientalist, as was the exhibition's many folds and byways of influence and example.

"China" is a room of mirrors

As the reviewer from the *Washington Post* commented: "The designers, more often than not, never intended their garments to be commentaries on politics, human rights or the complexity of East-West trade negotiations. They wanted them to make people dream."[1] Precisely: and yet rather than this being an exception to any rule, the relationships that the exhibition struck was how all national identity is a dream. It can be a sumptuous and pleasurable one, or an achingly wishful one, as we saw in the case of Hatoum and Palestine in the previous chapter. The review for the *New York Times* was more trenchant, stating that the exhibition was "just fashion business as usual, the product of a culture that speaks a language of overkill."[2] (The writer, Holland Cotter, had clearly not thought to revisit the work of Jeff Koons or Damien Hirst.) Cotter cites what he sees as an example of dissonant appropriation, a Dior cocktail dress decorated with an inscription from an eighth-century stele that is of "an unromantic report on intestinal distress."[3] But maybe this instance of what could be deemed travesty is at the very nub of the ways in which translation takes place, on the surface, unmoored from philological niceties. His verdict is that marriage of art and fashion (and film) only reveals the shortcoming of the critical functions that fashion can perform, with "art reduced to being a prop in a fashion shoot."[4] By all accounts Cotter joined a number of critics whose appraisal appeared not to have digested many of the messages from the catalogue. Andrew Bolton, the exhibition's curator, explains that "*China: Through the Looking Glass* is not about China per se but about a China that exists as a collective fantasy. It is about cultural interaction, the circuits of exchange through which certain images and objects have migrated across geographic boundaries."[5] These flows occur in many, and frequently incalculable, ways such that an inauspicious sign is made adaptable not for its semantic content but for its aesthetic appeal.

Part of the rationale for the exhibition was to celebrate the centenary of the department of Asian art; another, more informally, was to break the shadow of the extraordinary success of the Alexander McQueen retrospective, *Alexander McQueen: Savage Beauty*, in 2011. Another consideration was more presiding, given China's phenomenal rise as a super-power in the last twenty years. The exhibition was larger than any other of the Costume Institute's to date, flowing beyond their own lower floor to the Asian galleries on the second floor. Writing on the occasion of the exhibition's closing, Allison McNearney remarks that the

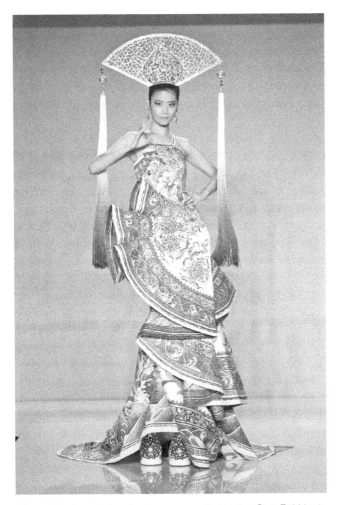

Figure 29 A model walks the runway during the Guo Pei Haute Couture show at the Fashion 4 Development's 5th annual Official First Ladies luncheon at The Pierre Hotel on September 28, 2015 in New York City. Photo by Neilson Barnard/Getty Images for Fashion 4 Development.

exhibition's overall effect is "akin to the sensory overload of a theme park,"[6] filled sound, moving images, sumptuous settings of breathtaking technical mastery, gorgeous objects, and, of course the fashion items themselves. The Metropolitan's curator of Asian art, Maxwell Hearn, stated that it was the aim of the Asian galleries, and in this case the Chinese galleries, "to show Chinese art from the perspective of the Chinese themselves. It's not Disneyland."[7] The exhibition was an avowed shift in perspective, while also trying to avoid the "Disney" effect. Each room had a different atmosphere with corresponding films and fashion.

Very little was spared: Chinoiserie wallpaper, calligraphy, perfume, the Manchu robe, the *qipao*, porcelain. One breathtaking room saw the Asian gallery's Chinese garden transformed into what was made to appear like a pool, or a massive lacquered surface by laying celadon on the floor, making the objects float against their shimmering reflection. Among the more popular, the porcelain room featured examples of dresses in white and blue, inspired by Chinese porcelain.

When Jean-Paul Gaultier inspected one of these gowns he immediately exclaimed that it must be by Galliano, then was astonished to find it was by the Chinese-born Guo Pei, who also designed Rihanna's gown, the most opulent, for the gala opening of the exhibition.[8] There is more to Gaultier's mistake than a case of casual misrecognition, for Chinese porcelain, china as it is known, is a tale of stylistic miscegenation on a grand scale. It is a case that is best illustrated with the design most universally associated with the Willow pattern as mentioned earlier in the Introduction. An earlier example, which the now ubiquitous Willow pattern fed off in an indirect way, was the mixed genesis of the Tree of Life motif. Its history goes as far back as Tudor England, which saw the first great interest in "China fashion," a term that indiscriminately meant all floral patterns. Such designs, which would come to be associated with chintz, began in England, working from impressions inspired by designs imported from the East, but not limited to China. These were printed in India and modified there as a result of a domestic visual vocabulary, one that anticipated English taste, which was beneficial to please. In response to English demands, Indian textile designers and workers elaborated on the Tree of Life pattern, which was then taken up by the Chinese in the eighteenth century, who then quickly made versions of their own. Writing in the exhibition catalogue, the present author adds: "To recapitulate: 'Chinese' designs invented in England were then reformulated in India to be taken up later by the Chinese. Amusing but true, this case is a more accurate illustration of how Orientalism is 'made up' in both senses of the phrase."[9] What Gaultier in his meanderings in the exhibition took to be a typically Orientalist gown—Galliano's chinoiserie—was an understandable and pardonable error, and a case of the transorientalist transaction: Guo's take on a designer like Galliano's take on designs that may or may not have originated in China. A shorter version of this is to say that Chinese (trans)orientalism is a take on itself, riffing on its own fantasy.[10]

While dominated by recent fashion pieces, *China: Through the Looking Glass* was an exhibition steeped in all the disturbances and cultural interleavings that are chinoiserie itself. China styling emerged gradually with increasing populations, thereby increasing trade routes, and the flush of goods brought from naval trade. The relationship to the styles adapted from far and distant lands is there in the word "chinoiserie," which may be related to English terms like "medievalizing" when used to refer to the adaptation of the Middle Ages from the middle of the nineteenth century onward. This meant a range of motifs, signifiers, and allusions

that were more or less related to a point of origin, but just as much related to the process of interpretation and invention itself. As it is often said, the Middle Ages was invented in the nineteenth century, it was later re-invented and invented again by Hollywood and pulp romances in the next century. A related term used in seventeenth-century France for the cult of Cathay was *lachinage—la Chine-age*—literally "Chinese-ifying" or "play on China." Chinoiserie was from the start a generic term for what connoted what was not Western, notwithstanding that the West was the larger participant in gesturing and giving an image to this outside. For the exotic, after all, is what is not proximate, it is distant, delectable, and in its narrative mythology, ungraspable. It is therefore impossible to tell whether chinoiserie originated in China or in Europe because it started from both at once. It was generated out of competition between the two (and more) perspectives. We must ask, then, why this common origin has paled in emphasis and the gradually mounting sense of fear and annoyance over the misplaced origins, and the pedantry over the cultural truth that has occurred almost principally in Europe and the United States. Most probably it has to do with the realization that not such authenticity is obtainable, and it is best to transmit such anxieties once more against the backdrop of the cultural other.

Another concern was the historical and ideological limitations that the exhibition, despite or perhaps because of its abundance, brought to the fore. As Harold Koda acknowledges that: "Paradoxically, chinoiserie's prescribed and relatively limited aesthetic vocabulary, whether exploited by the Chinese or the non-Chinese, is directly related to its communicative power. It is because of these omissions and elisions in its system of reductive signs that fashion so compellingly conveys China's unwieldy and complex reality." In other words, chinoiserie is a universe unto itself whose relatively small language has the capability of communicating itself widely, which in turn admits of greater variation—a stylistic Esperanto that is easy to grasp, and amenable to modifications. But these limitations make chinoiserie vulnerable to criticism from the very start. In her review of the exhibition catalogue, Rachel Silberstein asks why the persistence of black and red, of dragons, pagodas, phoenixes, porcelain blue and white, silk and so on?

> And given that what the exhibition and its catalogue reference is an aesthetic of early modern China informed by commercial processes of trade and export—which evolved in a process of self-selection that was guided by Western taste and, hence, was founded upon increasing contact and knowledge—why the insistence on China as fundamentally unknowable?[11]

She remains uncomfortable the aspect of Orientalism as the cipher for fantasy, since it elides the more noxious aspects. She concludes that the exhibition persists in "an apolitical and ahistorical vacuum absent of race and class

encounters" that once again prioritizes the Western grasp of Chinese styling. It gives very little space for how Chinese designers have made sense of this against a "claustrophobic" position maneuvered according to Western definitions.[12] This is a valid argument, but easily made, and tilted toward an anthropological worldview. It also presumes that there is some correct core of identity that provides some alternative to the generic straw man of Western oppression. Yet, as this book has shown already, and will continue to show, the answer is, alas, not so clear-cut, and the morality in the argument not so tenable. To take the example out of the Chinese arena, as we will see later, many Australian Aboriginal artists and designers have taken possession of the dot motif, despite it being specific to the Western Desert region. Is this a case for cultural impoverishment? Or is it repossession? It depends on the degree of one's ideological investment in a motif or a style. Ideological readings will always come to grief, because with chinoiserie ideology is effectively left at the door.[13] Another path to explore this is through the filmic representations of China by Chinese and non-Chinese.

Filmic projections and interjections

In her short essay on Sofia Coppola's *Lost in Translation* (2003), Homay King notes the fraught nature of its reception by the Japanese, who were dismayed at the two-dimensional depiction of the Japanese against the two lead actors, Bill Murray and Scarlett Johansson. (This did not prevent the film picking up an Oscar for best screenplay.) As King explains, the film is not an attempt at an accurate representation of Tokyo and its denizens, but rather Western perceptions of it, as embodied in the two main characters. Yet whether this is the perception of the director, the characters, or of a now conventional Hollywood vision of the East remains unresolved. For at any rate this point of view is stultifyingly clichéd: the Orient is feminized, and its agents are either inferior or threatening, "cloaked in artifice," and so incommensurate to their Western counterparts.[14] "Such myths," King affirms,

> Can be traced to historical factors such as the Opium Wars, nineteenth century immigration patterns from China, the traumas of World War II, the Korean War, and the Vietnam War. But they also fulfil a psychical need, a projection whereby Hollywood's Tokyos and Chinatowns become a kind of cinematic dumping ground for anything that defies Western comprehension.[15]

One need only think of the Polanski neo-noir classic, *Chinatown* (1974), in which the title and the place for which it stands are metonymic of all that is incomprehensible and dissolute in the lives of the main protagonists.[16] In *Lost in Translation*, the net effect is confusion, drollery in which the irony stated in the

title succumbs to predictability. But, as King allows, all of the film's difficulties might lead to a conclusion that the cliché and the real world are not two domains, but intertwined, and "this is what *Lost in Translation* can teach us: that an authentic essence can never be distinguished from the barrage of signifiers that are slathered onto it."[17] The challenge is how to configure this relationship.

King would enlarge on the complex configuration of cultures and cross-cultural representations, in which she develops notions such as the "Shanghai Gesture" and the "enigmatic signifier,"[18] a term she borrows from the psychoanalytic theories of Jean Laplanche. "Unlike a riddle, to which there is a correct answer or solution if only one can reason it out, and unlike a mystery, which lacks a specific answer but does have an explanation in the theological or supernatural realm, the Laplanchean enigma has no answer at all."[19] This is because these signifiers are generated in the course of language acquisition and perceptual awareness, processes that are never complete or resolved, generating "remainders" that reside in the unconscious. It is a source of confusion but also fascination and desire. King goes into detail about the way that Laplanche has been a useful source in understanding the imbrication of the other in the constitution of the self. What is feared in the other is a reflection of one's own anxieties over the imprecise constitution of the self, and it is this imprecision, enshrined in the enigma that underscores subjectivity. When applied to the orient, such observations help to understand how essential it is to Western identity, wherein its otherness gives the semblance of Western autonomy.

In film, the "enigmatic signifier" is especially applicable to the representation of the East, observable in particular objects. In the Hollywood noirs of the 1940s these take the form of "eastern curios—jade necklaces, delicate snuff bottles, bits of calligraphy on rice paper—seem to appear only to invoke a vague inscrutability."[20] In many ways King's enigmatic signifiers are analogous to Alfred Hitchcock's "McGuffin," gestures or objects that appear imbued with a particular significance, but which lead nowhere, their purpose to add to the air of intrigue and apprehension. For King the East complements the way in which film introduces us to foreign people and places, and "designers who quote Chinese aesthetics are often citing cinema, not reality."[21] Filmic Chinatowns are sites of fantasy, and a star like Anna May Wong becomes a cipher for the unknown, "an enigmatic signifier in her own right."[22] The fabricated nature of styles and references, and the venerable history of pan-national appropriation and influence, allows for a supple and free-wheeling interchange between Chinese and non-Chinese cinema:

> The result is a virtual China that combines anachronistic allusions to disparate times and places into a grand pastiche and, largely unwittingly, quotes centuries' worth of cross-cultural exchanges. The interchanges themselves have often been distorted by misinterpretation during the course of their journeys, with the original models lost in translation, *if they ever existed at all*.[23]

On the level of veracity, the China, or Chinas, in film are commensurate to what Hollywood Westerns of the John Ford era were to the real West. Another analogy could be the 2016 television series *Westworld*, developed from the 1973 film of the same name.[24] Here very rich people can enter into an enormous theme park populated with lifelike automata who, being non-human, can be subjected to anything, however distasteful the humans who deliver it to them wish it to be. A simulacral conjunction of heaven and hell, the "West" that the participants enter into is a *filmic* West, full of leather-clad villains with rakish moustaches and motley strumpets with brilliant white teeth.

In this itinerary of tangled influences and allegiances, Bertolucci's *The Last Emperor* comes up for regular discussion by critics and scholars. For although not the first, this film is a signal example of the culturally interleavened nature of Chinese film. Yes, it is also widely agreed that *The Last Emperor* indulges in a great deal of Orientalizing, with all the simplifications that follow from that. The film tells the story of Pu Yi who comes to the throne at the age of three, his extraordinarily sheltered life in the Forbidden City sequestered from the outside world, his experiences in the Republican era and the Cultural Revolution ending with his fall to a proletarian existence as a gardener. Consonant with King's readings of oriental signifiers, Rey Chow analyses the film as a seminal instance of feminizing the orient, with Pu Yi as its avatar, around which a series of feminine, castrated figures (eunuchs) or feminized impulses circulate.[25] Chow sees it as both telling and problematic that the film garnered numerous Oscars, but none for acting. Not to be confused with blatant racism, this omission had much to do with the recognition of the actor outside of the film as an individual and a celebrity, and his or her ability to portray another person convincingly. The Chinese actors were already other, effectively opening an unresolved space for judgment.[26] Later she asks: "What happens when a Chinese person sees *The Last Emperor*?"[27] The answer brings to the fore the exclusion of the ethnic spectator from the equation, such that he or she must occupy more than one position at once, and be made aware of being an ethnic spectator as such. By making the spectator conscious of occupying several positions at once is thereby to recall the idea of the imagined community, and the multivalent ways that individuals intercalate themselves into culture.[28] These amount to "identificatory acts." Someone can partake in the spectacle of "China" without much objection, but also feel Chinese without partaking Orientalist constructs and preferences. But it is responses like these that are marginalized within Western frameworks of viewing and perception; that is, the ethnic and feminized spectator "as image as well as gaze."[29]

From the time of its showing, *The Last Emperor* would maintain a strong hold on Chinese filmmakers, eminent among them Chen Kaige, best known for *Temptress Moon* (1996). Chen was in fact an extra in Bertolucci's movie, playing an anonymous guard. The debt to *The Last Emperor* is great, from the art direction, to the way the narrative is set up. *Temptress Moon* also begins in 1911

Figure 30 Chinese actors Wu Tao (centre) and Joan Chen (right) on the set of *The Last Emperor*, directed by Bernardo Bertolucci, 1987. Photo by CHRISTOPHE D YVOIRE/ Sygma via Getty Images.

with the Revolution, and the story starts with the main character's childhood. Film as a play of narrative constructs that is based in degrees of verisimilitude gives the filmmaker extensive license to play actuality, such as it is, with myth, and as many forms of other constructs made available to him. The free play of cultural image that is writ large in the Orientalist program is fertile soil for Chinese directors. Chow states further: "As these others' gazes beckon in their orientalist, exoticizing, and/or meticulously historical modes, the homecoming that is filmmaking inevitably becomes a process of citation and re-viewing and—even as one manages to produce a fresh collage of perspectives—of being (re) seduced with the sight/sites of others."[30] Compare this statement with that of King, this time from the Western perspective:

> The Western fascination with the "Orient" in such instances, might not be merely the result of a fetishistic curiosity or xenophobic projection, although those attitudes can be detected in certain texts and films. Rather, it might stem from the uncanny realization that one's own culture is a mosaic of fragments that arrived, once upon a time, from elsewhere.[31]

Both statements seek to guide the attitudes to culture and cultural production away from Saidian censure. They eloquently call on nuanced criteria that elevate films (and other cultural products by extension) away from the reflex of

defensiveness against deceit and exploitation, toward realistic models for appraising mediums that are perforce intertextual and transcultural. If not, a postcolonial analysis will quickly run aground, powered by its own ideology, its over-vigilance and "iconophobia," as Chow puts it, that diligently detects signs of cultural stereotyping, but this notwithstanding directors such as Zhang Yimou, who in some films confront potential impasses in this ideological predicament.[32] What these efforts do expose is an infinitely mediatized world, in which recourse to a "real" place, in this case China, is increasingly shown to be mythic. For the conventions of filmic language are inscribed with "transmigrations and transmutations." Efforts to be different have success that is only relative, and their difference tends to refer back to tried themes and tested expectations. For they are all of a piece with "a dominant global regime of value making that is as utterly ruthless as it is creative."[33]

In a recent essay, "China as Documentary," Chow speculates on notions of authenticity and accuracy in the documentary genre between insiders and outsiders. It is no doubt a question with an imperfect answer, but as she makes clear, it is "[t]he gap between these positions that interests me."[34] Focusing on the films of Jia Zhanke, Chow notes that what is distinctive is that they do not rely on the presumption or observance of some objective past, instead the past is conceived "as a (re) collection, one that curates materials in fragmented form from different media." Jia's preoccupations are not with the "real" in any conventional or ideal sense but rather "a new kind of conceptual project: a project of imagining modern China not simply as a land, a nation or a people, but first and foremost as medial information."[35] Hence this is China constantly being remade before our eyes over the channels of YouTube, social media, and so on, channels that are never fully controllable.

Ip Man: Kinship from conflict

Well into the 1980s, to mention martial arts in cinema was to invoke the name of Bruce Lee. His influence was immeasurable. Before Lee (Lee Jun-fan), who died at the age of 32 in 1971, martial arts were part of Asian arcana, and mystic disciplines, a perception only confirmed by the celebrated television series *Kung Fu* (1972–1975), starring the Hollywood-born actor David Carradine (Lee auditioned for the part but did not get it). But shortly after, with action actors such as Chuck Norris no longer mimicking anything Asian, martial arts entered the mainstream. Here is not to enumerate on the films and the now sizeable literature on the subject. Suffice to say that it would be hard to find a contemporary action film that does not have sequences involving martial arts, especially now that police and armed forces across the world have integrated martial arts into their training programs.

A climax of the tradition that Lee inaugurated is perhaps with Tarantino's *Kill Bill*, which Paul Bowman considers "as amounting to Bruce Lee finally getting a kind of symbolic revenge on David Carradine."[36] Set to the music of *The Green Hornet*, Uma Thurman wears a yellow outfit reminiscent of the one Lee wore in *Game of Death* (1972), which remains incomplete because of his early death. "Bill" is played by Carradine himself, who plays the same kind of long lute that his character Cain carried in *Kung Fu*. Bowman argues that Lee opened up a new type of male oriental space. Hitherto there had been many kinds of loose and fanciful appropriations of the Asia that met the ends of the film as opposed to paying any heed whatsoever to the actual culture to which the tropes supposedly referred. Unlike the gunslinger who relied on his prosthesis, the firearm to make his mark, Lee offered "perfectly self-reliant grace."[37] Lee's legacy coincided with the globalization of cinema and, as Bowman notices, the term "martial arts" is as "slippery" as that of "globalization" itself, both in showing the effects of untraceable cultural intersections and intercessions.[38] The amalgamation of different martial arts disciplines in Asia and in the West has made claims to authentic origins of certain styles unmanageable.[39]

There is one series of recent Chinese films that stands out in a genre in which cross-cultural exchange is at the root of its formation and meaning. This is the martial arts trilogy, *Ip Man*, loose biopics based on Yip Man, the Wing Chun master with whom Lee began to learn at age sixteen in 1957. The films stand out not only for their box office and fan-base success, but also because they reprise the question that Chow advances as to the feminization of China and noting that her critique is centered on a film whose main protagonist is a man. Lee and his epigones were ruthlessly unequivocal on where they stood on the (clichéd) spectrum of male identity. However, as if contrasting a legacy of some fifty years of the display of male strength and skill and passing through the era of the pumped he-men of Stallone and Schwarzenegger, Ip Man has all the traits the traditional post-Lee filmic hero deplores. He is svelte, pacifistic and retiring. To some extent Carradine's character Cain was this as well, his reticence masking hidden strengths, however his character was itinerant, while Ip Man in his maturity lives a modest, near bourgeois existence. Yet these traits, antithetical to the thuggery of toughness, are key to his magnetism, for it seems to imply that not hypertrophied strength, but skill and ethical forethought bring victory and success. What is also striking in this contrast to tradition is the way that several *Ip Man* films, among the best known and successful, freely pastiche narratives from Stallone's *Rocky* series, especially the early ones that were seminal in sedimenting the boxing film genre (as opposed to the martial arts genre). For one of the strengths of the best of the *Rocky* movies has been the centrality of "home" values of kinship to family and country. Rocky, like Ip Man, is an outsider with a strong moral compass, a faithful husband, father, and friend. His seemingly unwavering morality is a large portion of the appeal of the *Ip Man* film series. The

films are recent instances of what Chow calls "sentimentalism," a hallmark she attributes to Chinese film, something to be turned to shortly.

In what can be called an intertextual triangle, the other strong debt that the *Ip Man* films have is to Bruce Lee, not only because he is aligned to Ip as his most famous student, but for all that Lee has come to represent. As Bowman emphasizes, the significance of "the extent to which all of the characters and all of the films are irreducibly entangled with, indebted to, constituted by, and structured through Bruce Lee, in a condensed and displaced form."[40] The authenticity to which the *Ip Man* films lay claim is built on a different edifice, or more than one, so that the cross-cultural relationships are intricate and many no longer traceable.[41]

In 2002, Wong Kar-wai, director of *In the Mood for Love* (2000), announced his intention to embark on the *Ip Man* project, but his project stalled. Producer Raymond Wong, with the director Wilson Yip, completed the first of the series in 2008, followed by its sequels shortly after in 2010, catapulting the lead actor, Donnie Yen, into international stardom. (To those unfamiliar with the series, Yen entered the mainstream stage in *Stars Wars: Rogue One* (2016) as Chirrit Îmwe, his own version of the oriental blind martial arts master.) At the same time as the release of the first in the series, Yu Chenghui played Ip Man in the television series on Bruce Lee. Concurrent again with the second Ip Man movie in 2010 there also appeared the prequel, *The Legend is Born: Ip Man*, directed by Herman Yau, starring the hitherto unknown martial artist Dennis To Tu-huang, who fights ninjas in an occupied China. In 2013 an ambitious fifty-episode television series on Ip Man aired in mainland China with Wilson Yip consulting and the American born Kevin Cheng Ka-wing starring. There also appeared *Ip Man: The Final Fight*, two years before the third in the Wilson Yips' trilogy, and with Ip Man's son, Ip Chun, as one of the consultants. Anthony Wong replaces Donnie Yen, and plays Ip after he has departed China for Hong Kong, to witness, as Grady Hendrix explains, "Hong Kong's labor movement, the anti-colonial riots of the late Sixties, and the dislocating of the inhabitants of poorer neighborhoods amid the rapid transformation of Hong Kong into an international city."[42] The film is arguably the most political and also an unexpectedly searching narrative that destabilizes the martial arts genre. For in the film, Ip Man is regularly faced with his own powerlessness in the face of poverty, corruption, and unrest, issues for which his fighting skills are of no use. While there are plenty of spellbinding action scenes, the "final fight" turns out not to be one of combat, but of sickness and mortality. Toward the end of the film Ip Man sits by the side of a friend who is dying from cancer, hence the final fight has nothing to do with contest or victory, but with how much dignity can be seized from imminent death.[43]

To return to the trilogy, their success is attributable to a number of factors, one theme being the quietly benign, almost sweet, integrity that Yen projects on

screen. But it also has to do with the *déjà vu* nature of the plotlines of the last two, as if Ip Man has been overlaid onto Rocky in a palimpsestic manner. The alterations and differences are enough to lend the films a sense of their own autonomy while also keeping the underlying narrative schemata intact. In the first of the series, Ip is an independently wealthy Wing Chun master in Foshan who leads a retiring life, but who comes to prominence by defeating a Northern Chinese martial artist, Jin Shanzhao. At this early point, the victory sets up the regional-nationalist leitmotif of the film series, in which Ip is a defender of his family, which is an extension of his community. Although Rocky starts off as poor, by the middle of the film there is an unmistakable relationship between his own plight and that of the everyday man. His determination is no less that of the American free will and manifest destiny. For Ip, his probity is tested to the greatest extent when the Japanese invade Foshan in 1937, claiming his house as their headquarters. The General, Miura, also happens to be a karate master. He sets up an arena where Chinese martial artists can compete against the Japanese military trainees. The offering for the Chinese if they win is a mere bag of rice. The symbolism of Japanese imperial ambitions and cruelty, and their conviction of their own superiority, hardly bears mention. After Ip's friend Liu is killed by a Japanese officer for losing against three Japanese opponents, Ip in a fit of rage demands a challenge against ten karateka, whom he mercilessly defeats. The film ends with Ip fighting and beating Miura, which ultimately leads to a rebellion against the Japanese. Although not wholly victorious, Ip secures the dignity of the Chinese.

In contrast to the actual turn of events, this conclusion is more than just a slight retouching. Ip is cast as a hero whose discipline is put at the service of his patriotism. But in reality Ip did not leave mainland China for Hong Kong because of Japanese occupation in the Sino-Japanese War, but rather to escape the onset of Communism. The vexed issue of Communism, which may have made the film unattractive to some, is carefully pushed to the side, using the still alive antipathy of the Chinese for Japanese exceptionalism as the narrative scapegoat.

Ip Man 2 takes up with Ip in Hong Kong in the 1940s after they have escaped Foshan. Ip lives with his family in straitened conditions, and is having difficulty in finding students, until he is challenged and easily defeats a young thug, Wong Leung. Although humiliated, Wong relents and returns with his friends to learn with Ip, who establishes a modest but prospering school of Wing Chun. Ip and his school soon raise the attention of Hung Ga students. After a series of conflicts, the head of the Hong Kong martial artists' coalition, Hung Chun-nam, bids that Ip perform at a special fighting ceremony to prove his mettle. Ip easily defeats his challenges and ends up facing Hung himself. The encounter is abruptly cut short when Ip protects Hung's son, who enters suddenly, from being accidentally hit by Hung himself. Somewhat reconciled to Ip, Hung invites him to a boxing match he has helped to set up with the British.

It is at this point that we know that the subtext has moved from Japanese imperialism to British. For the star of the event is Taylor "The Twister" Miller (Darren Shalavi), an objectionably feckless, merciless, and racist character who attacks the students, causing Hung to defend them and the reputation of his school, and by extension the Chinese in Hong Kong. Miller is taller than his counterparts, who are also no match for his musculature. In short, he is the embodiment of imperial Britain's arrogance and brute strength. In his challenge, Hung does well at the beginning of the fight owing to his superior skills, but he is no longer young and quickly loses the upper hand when he is stunned by a severe blow to the head. Debilitated by his asthma, and unwilling to concede defeat out of deference to his people, Twister pummels Hung to death. This turn of events is a facsimile of *Rocky IV*: the erstwhile rival cum-friend Apollo Creed perishing at the hands of the brutal Ivan Drago (Dolph Lundgren). Like Miller, Drago is more than a champion unto himself, but a representative of the superiority of his home country. As with the *Rocky* films, the final fight of *Ip Man 2* is very carefully choreographed. And like Rocky, the dramatic build-up is such that Ip comes within a hair's breadth of failure; he rises from insurmountable odds because he has "heart," a term used in boxing for humility and having the gumption and perseverance commensurate to your skill, the quality in which physical skill and prowess are conjoined with human will. Rocky's defeat of Drago is the United States' address against Soviet Russia, while Ip registers the superiority of the Chinese to their British occupiers. Both succeed, victorious at poor odds and under hostile conditions: Rocky must fight on Soviet ground, while for Ip, even if surrounded by his Chinese brethren, it is the British colonialists who hold the strings. Following the victory of Rocky and Ip Man, there are cuts to the celebratory responses of their families, emphasizing that their efforts are rooted in the fight in defense of love and family. At the end of the Ip Man film he is introduced to a young man named Bruce Lee.

The final film in the Ip Man trilogy has undertones of *Rocky V*, in which both Ip and Rocky take charge of mentoring a fighter who at the end betrays and turns on them. For Rocky it is Tommy Gunn, for Ip it is Cheun Fung. In Stallone's final instalment, *Rocky Balboa* (intended as such before the making of *Creed*), Rocky's wife has died and his mourning of her defines the emotional gravity of the film. In *Ip Man 3*, although the Ip's fights and tribulations abound, the emotional center comes from his wife, Wing-sing, who has been diagnosed with stomach cancer. Her critical condition causes Ip not to attend a challenge between him and Cheung, leaving him open to a loss of honor. But Wing-sing intervenes and schedules another fight. Ip wins, and by extension not only because of his skill but out of deference to his wife's gesture, to her good name, and as a valedictory action to her imminent death.

The imbrication of family and state in the *Ip Man* trilogy is as pronounced as it is in the *Rocky* films, which reach an apogee with the fourth in the series. The role

of sport is one of discipline that defines the fruit of work for the underclass and the underdog. The struggle of the fighter is a model of the worker's struggle, and his commitment to his craft is a parable of the honesty of the common man. Ip's repositioning in Hong Kong is a mine for nostalgic capital. For to be displaced from the motherland of China allows for a generalist romanticizing that can also sidestep some more pressing issues, since, as Bowman advises, "the stakes of criticising China become higher."[44] For this reason, China in these films remains a distant and benign symbol of "the land, the family, the values and the folk." This accounts for the state of wistful longing, and the feeling of unerring moral rectitude of the *Ip Man* films. (The presence of boxing is reasserted in *Ip Man* 3 with the cameo of Mike Tyson who challenges Ip to a three-minute fight from which Ip just manages to survive, ensuring that the eminence of both disciplines of boxing and Wing Chun is preserved.) While nourished by the Western boxing genre, and, as has already been said, the films of Bruce Lee, they also represent a homecoming for Bruce Lee (who is written into them). It is, as Bowman, describes, "a 're'-patriation (for the first time) that is intimately intertwined with the repatriation (as if for the first time) of Hong Kong, rewriting itself, cinematically."[45]

This dramatic transition in which the deeply personal is combined with the political and patriotic is what makes homecoming such a strong notion to characterize much of Chinese film. For as well as nurturing the instincts of home and state, more subtly it suggests that Chinese film itself has returned home after

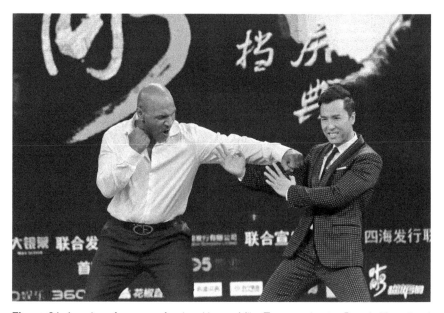

Figure 31 American former professional boxer Mike Tyson and actor Donnie Yen attend the premiere of the film *Ip Man 3* directed by Wilson Yip on March 1, 2016 in Beijing, China. Photo by VCG/VCG via Getty Images.

an embattled but necessary coming of age through Western and other influences. It is a staged authenticity whose emotional effects hide the many filters it has to undergo. Recall Chow's words cited earlier about the homecoming of cinema, and the process of citation that inevitably includes Orientalist ways of seeing, and the extent to which the multiplicity of perspectives is rewoven into something both enchanting but also deeply proximate and "real." The sense of proximity of filmic homecoming is made more seductive and therefore more convincing through what Chow refers to as "sentimentalism." Her term derives from *wenqing zhuyi*, literally "warm sentiment-ism."[46] While "sentiment" has its own associative baggage, the inclusion of warmth carries with it "affiliate notions of being mild, tender, tolerant, obliging and forbearing" all traits that were targeting by communists as weak and bourgeois.[47] This encompasses homecoming since *wenqing* accommodates what is comforting, nurturing, and homely and by definition excludes what is "believed to be antagonistic, dangerous, and evil."[48] Since home and family are one and the same, "*at the heart of Chinese sentimentalism lies the idealization of filiality*."[49] To return to Ip Man, what is compelling from a theoretical perspective is how much is made possible through a series of displacements and detachments. They are physical in his and his family's expatriation to Hong Kong, they are fictional in that the reasons for the expatriation have been rewritten, and they have to do with the ways in which the films either noticeably depart from or repeat other films and filmmakers to which they owe a special debt (Lee, Stallone). In short, the homecoming is only made possible from a long and circuitous route, but more paradoxically, through staying away.

Marco Polo: Discovery and displacement

It is this strange paradoxical doubling in which home is claimed subject to a series of fabrications that can neither be justified or tested, that makes it worth concluding with the short-lived television series *Marco Polo* that aired on Netflix in December 2014, therefore roughly coincident with *China: Through the Looking Glass*. (The second season appeared in July 2016, but was not renewed due to a sizeable financial loss.) For a production intended for a Western audience, and/or audiences schooled and expectant of a Western filmic diet, the historical figure of Marco Polo seems an obvious choice: The past is distant enough to draw as much license as is needed, and the narrative can be told from a white man's point of view. Moreover, Marco Polo is also an able and fertile cipher for reinterpreting the present through the past, especially when it comes to East–West filiation and conciliation. Although seen from a Westerner's eyes, the filiation and the new homecoming is supposedly on non-Western terms. All of this is nothing new, although the *Marco Polo* television series tends to bring these

relationships to the surface. What, then, remains to be asked, for the sake of this chapter at least, is how do the criticisms that this series elicited measure against those of the *China: Through the Looking Glass* exhibition? When can reservations about cultural appropriation said to be not of a piece?

Upon its release, the series was quickly met with a number of querulous responses. Writing just after its release in 2014, Lenika Cruz disparages the series as a poor copy of the best HBO dramas that perpetuates the "white-guy-in-Asia adventure" that makes an Orientalist point of view inevitable. Yet she concedes the predominance of Asian and Asian-Americans in lead roles over non-Asians.[50] Neil Genzlinger, writing in the *New York Times*, questioned the "dismissive" treatment of the show's female cast, while others criticized its uneven plotline and overripe faux-archaic dialogue.[51] Overall, the critical response to the representation of China paled in regard to its ability to be compelling. The advantage that the series seems not to have successfully exploited is the theme of discovery, and the possibilities that discovery brings for all involved. Marco Polo is depicted as being initiated into Chinese ways enough to lay the ground for the narrative of initiation, but it is not one of assimilation, as he must retain his position as cultural foil, and isolated central figure.

Apart from the obvious differences, the usefulness of the comparison lies in the role of verisimilitude in each, the exhibition and the film series. Fidelity to facts was a critical issue for both. In filmic (and televisual) adaptations, bending facts is forgiven if it is for the sake of ensuring the credibility of characters or for the maintenance of a still credible plot. Alterations are subject to open aesthetic judgment. However, *China: Through the Looking Glass*, perhaps more strongly than intended, shattered such protocols, by emphasizing what fashion has always done. Questions about establishing credible and ethical standards of cultural appropriation continue to circulate, as they always will, as they are in large part of ideological pathologies and reflexes that will not be dimmed. But such questions are arguably the wrong ones to be pitching. For the matter is more aesthetic than ideological. The real problem with *Marco Polo* is that it was found wanting as a convincing television series. It may be misplaced to embark on cavil as to whether Galliano (putting aside his unsavory political comments, if we can) should or should not make new fashion creations based on Chinoiserie themes, rather the issue is whether or not he does this well, which he surely does. An example such as his then assists, as we found in the mistake that Gaultier made while walking through the exhibition for the first time, in "Chinese" inspiration for Chinese designers. The real China can exist almost everywhere it is well achieved.

It is worth ending on this note, and to repeat the question: "Where is the real China?" What "China," as opposed to China as a set of facts such as they may be, shows us is that the realist-pragmatist answer to this question can hardly suffice, that is, that the real China exists in some ancient territory, of rice fields, or

peasants and workers who have been toiling in the same place for countless generations, and so on. Such images are themselves mythic, ideological, and, indeed, cloyingly filmic. This chapter was written only shortly after the premature death of China's Nobel Peace Prize laureate, the post, activist, and critic Liu Xiaobo on July 13, 2017, whose views are little known in China because of mass censorship. For most mainland Chinese, he never existed. When awarded the prize in 2010, it was given to an empty chair. "Honoured with diploma and medal," writes Trinh, "his vacant seat at the podium was said to resonate powerfully with the distinguished international audience attending the award ceremony, despite a campaign by Chinese government urging representatives from diverse nations to boycott the event."[52] Henceforth, the distinguished shame of the ceremony gave birth to a new and ominous term, "empty chair," metonymic of the void of China's egregious failures to answer to its countless false justices in the preservation of a precarious status quo. The "empty chair" resonates in the name of those expelled and silent, and for everything violently hidden from view.

Another important literary figure writing today is Yu Hua, much of whose work is banned in China but known around the world and translated into almost every major language. In a review of a recent book, *Seventh Day*, Ian Johnson concludes that the novel "touches on how many Chinese are coming to understand their history." Their passage in one, like the novel's protagonist, "stumbling back into a blurry, hazy history where fact and fiction are hard to separate."[53] These vexed circumstances are perhaps more exigent than those comparatively quainter qualms over the entitlements of cultural appropriation, as they are the result of a long and wide ethical chasm. Perhaps we need more, not less, enchantment in order to bring a liveable and humane China into closer proximity. Perhaps inventive creation, as opposed to what is correct, with all the mundanity that the word implies, can assist in a favorable homecoming.

6

JAPANESE RECREATIONS: BETWEEN KAWAKUBO AND COSPLAY

Is it possible to change to a Japanese who is not Japanese?

<div align="right">OE KENZABURO[1]</div>

When Roland Barthes' *Empire of Signs* was published in 1970, and on its English translation in 1982, it was given a mixed reception. This may have been in part to do with Said's *Orientalism* having appeared four years earlier than the English version, and sensitivities to cultural appropriation being intense. It is easier to dismiss Barthes' book as another example of a white man's Orientalizing, thereby reducing its very premise to a rebuke. For Barthes' intention was to find in Japan an antidote to the West's penchant for endlessly accreting sign systems. In Japan, and particularly in Zen, Barthes sees a reprieve from the noise of Western culture, calling it a place of transition, hesitation, in which material things are placed in the service of effortlessness and weightlessness. "Japan," Barthes confesses, "has afforded him a situation of writing" which is an "emptiness" and "the exemption from all meaning."[2] In short, for Barthes, "Japan" begins as a set of signs whose very purpose is to precipitate a lapse of signification. "Japan," then, becomes a metonym for this process. What Barthes cannily located was the trait with Japanese culture for seeking out the space between. While there are a multitude of things that are incontestably Japanese, there is also an observable trait since the modernization of the Meiji Period at the end of the nineteenth century to bring the West into juxtaposition with itself. Arguably whatever may be deemed unquestionably "Japanese" is seen as such in contrast to what is not, and for the sake of describing an in-between space. Two examples bear this out: the work of Rei Kawakubo (of Comme des Garçons) and the contemporary phenomenon of cosplay. But first a gloss on the modernization of Japan.

Meiji and modernization

Japan still retains many aspects of its pre-modern history in which it maintained isolation relative to other countries. Up until today, no foreigner, regardless of contribution or affiliation, may become a citizen. Isolationism was especially in force from 1639 with the *sakoku* or "closed country" policy, and reigned until the fall of the Edo period in 1868 and the beginning of the Meiji Reformation. A little earlier in 1854 Japan had begun to open its doors when Commodore Matthew Perry and his "Black Ships" enforced the Convention of Kanagawa. This led to the fall of the Tokugawa shogunate and the founding of a centralized state under the Emperor Meiji. With new infrastructure and foreign policy, Japan seized the opportunity for imperial expansion. Japan took control of Taiwan, Korea, and southern Sakhalin following the victories in the First Sino–Japanese War (1894–1895) and the Russo–Japanese War (1904–1905). It would continue this expansion after siding with the Allies in the First World War, later losing them after the crushing defeat of the Second World War. Japan's foreign policy ambitions since the second half of the nineteenth century were deeply ingrained with the need not only to emulate Western imperialism, but to carve out its own space as an "Oriental" nation that stood out from others, an important part of which was to make other countries submit to Japan's own Orientalizing. As Dorinne Kondo puts it, "Western Orientalizing, counter-Orientalisms, self-Orientalizing, Orientalism directed at other Asian countries: the interweavings of such constitutive contradictions produce 'Japan'."[3] Artificiality, stylization, fashioning, are overarching in Japanese culture, in which constructive mediation is deemed essential to one's relationship to the world. Evidently the same process was being conferred to culture-building.

Japan's expansion into other countries and cultures had a paradoxical effect, which was to engender an eclectic culture which, at the same time, had a stiff, almost pig-headed, sense of its own uniqueness. As Ihab Hassan writes in his ruminations on Japan, *Between the Eagle and the Sun*, which amounts to a reply or complement to Barthes' book:

> The myth of Japanese uniqueness, however, is far more complex than Japanese isolation, racism, xenophobia would suggest. For the myth rests on contradictory ideas of uniqueness, which often contains its own anxieties. Thus Japan's insistence on its distinctiveness may also betray its old identity problem, reverting to massive borrowings from China in the seventh century, continuing through massive appropriations from the Meiji Restoration. The paradoxes persist.[4]

Japan, he goes on to add, succeeded in Westernizing to an unprecedented degree, culminating in the economic boom of the 1980s made possible of the

design and manufacture of technologies that were rooted and consumed in the West. (It might also be contrasted to the less successful and troubled history of Westernization that took place in Turkey.) Hassan contends that "Japan's vaunted doubleness, at once Asian and Western . . . is a different form of uniqueness . . . a postmodern form, double coded, uninterested in 'purity'."[5] It is non-purity that asserts itself through continuous references to relics of a pure past, and through its constant reconstruction. Indeed it is double movement that is immanent to the Japanese aesthetic: after seeing that his son had swept the path to his tea house too clean, the tea master Rikyu returned a scattering of autumn leaves over the path to his teahouse.[6]

The duality within Japanese modernization is best illustrated in the attitudes to dress that persist to this day. The Meiji period made foreign goods of all kinds more accessible to everyday people, which included Western dress, which was both affordable and less restrictive than the traditional work kimono worn by rural men and women. In pre-modern Japan, the gendered differences in clothing were far less pronounced, while modern Japan encouraged women to wear kimono and men to wear suits. It also stipulated Western clothing, *yofuku*, and attire, *wafuku*, for weddings, funerals, and the like. (When the Duke of Edinburgh visited in 1869, the Imperial Court received him wearing formal Western dress. In the next year naval cadets were made to wear uniforms inspired by the British, while the army were inspired by the French. In 1971, policemen and mailmen were Westernized in their dress, and in 1872 so were rail workers.)[7]

This change also affected the understanding of the kimono in Japan from something of a universal garment to a decorative one reserved for ceremonial occasions. In the Meiji and Taisho eras these sartorial designations became quite intricate and stratified, especially when applied to geishas, with variations between formal party wear to more everyday wear. The ability to cope and comply with these variations was an index of one's status in being able to afford them and also to have the discipline to comply with them, which included seasonal modifications as well.[8] Complying and discerning carried its own reciprocal prestige, as Liza Dalby affirms: "A practiced eye could distinguish geisha from amateur even if each wore the same outfit. The same holds today."[9] The love of such intricate codes suggested a return to a ceremonial past, albeit that many of these codes were very much of post-Meiji making. One source of such zeal was in the prosperity leading up to the First World War, which fostered invention and revival, and the two intertwined.

Thus, in contemporary Japan, the kimono is not only ceremonial dress, but also for those who have learned its protocols. Kimono dressing is a matter of esoteric knowledge, passed down by specialists teaching in specialized kimono schools. In the words of Ofra Goldstein-Gidoni, "With modern kimono, like other inventions of tradition in modern Japan, what is Western plays a significant role.

It is conceived in large collective terms that make it absolutely and systematically different from the Japanese. Both the Western and the Japanese are referred to as cultural and discursive constructs rather than as objective realities."[10] This dialectical play is crucial to the way in which Japan created its Japaneseness that appeared to leave tradition intact without forgoing the benefits of Western progress. It was during the modernization period that the difference between what was Western (*yo*) and what was Japanese (*wa*) was articulated and justified.

State interventions into dress were not unusual in Japan but hitherto they had been oriented toward distinctions of class. The strategies in the Meiji period were far more sweeping, amounting to the men encouraged to wear Western clothing—which also meant cropping the hair and dispensing with the sidelicks and topknots that hailed from the samurai—and the women to wear traditional dress. There were fines for men who did not follow the new regulations, as well as commendations for those who deported themselves well.[11] In the early Meiji period however, it was still a familiar sight to see men dressed in a suit but wearing a pair of traditional sandals known as *geta*.[12] One important factor in the wholesale civilian acceptance of Western dress came when military dress became Westernized.[13]

Overall, the implications of this gendered partition were profound. From a symbolic perspective, the men were to be the travelers and ambassadors, bringing back the fruits of the West, while the women were the guardians of the home, safeguarding what was unique about Japan. Western utility was compared against the Japanese traits of beauty, respect, and harmony. The kimono was directly related to ideas of harmony in nature, and women were its purveyors. The coming-of-age ceremony that occurs when entering one's twentieth year ensures that these distinctions are at the core of social fabric: for the men it is a straightforward matter of buying a suit; for the women the process is highly elaborate, involving accessories, photographs, and, of course, the kimono. As Goldstein-Gidoni adds, the ritual is steeped in significance, and rule-bound: "Japanese women regard their own ignorance in the 'secrets' of kimono dressing as an embarrassing flaw in proper etiquette and femininity."[14] As one would expect, the quality of the daughter's kimono is a critical reflection of social status. The initiation ceremony has the kimono as the instrument to Japanese female rectitude, for her to become the "good wife, wise mother." (Until relatively recently, something of a universal touchstone for the Japanese role-modeling had been the Japanese Royal Family, which was upheld as a living symbol of Japanese lineage.)[15] Donning the kimono properly—with its elaborate additions of padding to create a smoothly cylindrical silhouette—was synonymous with cultivating the desirable woman—and a Japanese woman at that.[16] The geisha and the kimono have a firm hold on the Japanese imagination to this day, to the extent that they amount to talismanic national symbols.[17] Goldstein-Gidoni concludes that "the

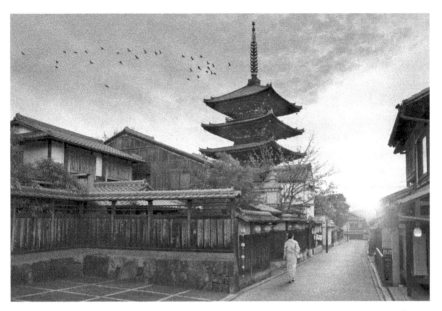

Figure 32 Yasaka Pagoda and Sannen Zaka Street in the Morning, Kyoto, Japan. Photo by Patrick Foto/Getty Images.

almost obsessive occupation of the Japanese with self-definition has reached the point of self-Orientalism and self-exoticism."[18]

This is maintained through keeping the differences at sway within the culture itself, that is, that the "West" is enacted as well, which is the province of men. Japan can be said to exist as a byproduct of the dualities it has labored to construct for itself: man–woman and "West"–"Japan." By way of another example, Japan is active in melding English words with their own grammatical and cognate conventions, or spelling them phonetically when sounded with a Japanese accent. This is what Hassan calls "Japlish." The results can be amusing and bemusing to foreigners.

> Japanese often use foreign words like free-floating signifiers, meaning anything, unless the letter *o* or *u* is tacked at the end of the word, as in *aisu-kurrimu*, *happy-endo*, *faito* (fight), *tafu* (tough), *kissu, rabu hoteru* (love hotel), *tarento, feminisuto*, which Japanizes the word, turning it into "real" language; then the Japanese use the word, as if it had sprung from the Yamato earth.[19]

It would be hard to find a better entrée and summary of the manner in which modern Japan has recreated itself. It is fluid, almost parasitic, adaptation that is then enshrined in essentialism through recursiveness and national self-entitlement.

"Japanese" fashion

The issue of Japanese fashion as the term is maintained and circulated in contemporary fashion in Euro-America as well as in South-East Asia, and Japan itself, continues to be a very vexed issue. This is not only because of the generalities and stereotyped expectations that it confers, nor to do with an acknowledgment of a noticeable difference. It is also to do with the way a multiplicity of qualities and approaches are lumped together, many of them inferred *a posteriori*, after the fact, as "Japanese." The phenomenon of Japanese fashion, which must include the many debates that surround it in addition to the material objects themselves, is a cardinal instance of a transorientalist reciprocal movement, in which cultural origin in time and tradition run reciprocally with cultural creation and interpretation. And it brings to light, simply, what occurs after arbitrary attribution, the power of naming of something as belonging to a place and its attendant history.

The tenacity of Japanese fashion as an idea and an epithet is due largely to the fact that it originated in Paris. Because of this it is immediately classed as something different from ethnic dress, since in retrospect it can be read as an intentional formulation that posed alternatives to Western tailoring and silhouette, alternatives that were then naturally given a cultural code. The first major designer to begin his career in Paris was Kenzo Takada, followed by Kawakubo, Issey Miyake, Yohji Yanomoto, and Hanae Mori. The next generation of designers included Junya Watanabe, Matsaki Matsunisha, Hirochi Nakano, and Yuji Yamada. Yuniya Kawamura, in her book, *The Japanese Revolution in Paris Fashion*, makes a great deal of what attracted Paris to the first wave of designers in particular, as an epicenter of taste that had been established since the reign of Louis XIV.[20] France, as a purveyor of aesthetic refinement and luxury, has long been a fascination to Japan, which includes among others the prestige that the upper middle classes see in being able to speak French.

The other reason was more logistical, and again based in the highly gendered partitioning of Japanese culture. When in 1959, at the age of twenty Kenzo wished to embark on a career in fashion design, he struggled to find a school of design that would admit male students. Finally, he found the Bunka school of design in Tokyo where he became caught up in stories of his mentor and teacher, Chie Kioke, who had recently returned from studying at the *L'École de la Chambre Syndicale* in Paris.[21] Kenzo was also aware of the influence that Paris fashions had on Japanese designers in Japan, which made the transition a sensible one. Kenzo's flair was in combining fabrics, pattern, and color, making for highly eclectic ensembles that used Western prints (many of them that had grown out of the long history of trade with India and China), folkloric designs, and Japanese fabrics. As Kawamura observes, Kenzo, seeing the profitability of the brokering

race, quickly "realized that the "exotic" elements were attractive to the French public, so he began to look elsewhere for other ethnic cultures. He also used straight lines and square shapes, which are derived from kimono that do not have any curves."[22] As modern Japan would use non-Japanese words as their own with increasing promiscuity, Kenzo did the same with fabrics and designs. He is given credit for "such recent trends as kimono sleeves, the layered look, folklore fashion, winter cotton, the explosion of bright colors, vests, baggy pants, and workers' clothes." The Kenzo-sown seedbed of contemporary Japanese fashion meant an approach to color that perpetuated the longstanding association with bright colors and the orient, forms that ran counter to what had been desirable, and with an unapologetic license for cultural appropriation. He was the non-European in his own Orientalizing, plundering the West and delivering it back for Western approval. All of this was executed in an eye-opening but not too challenging way, which prepared for the more radical experiments of Miyake, Kawakubo, and Yamamoto to follow.

The innovations of these designers, which now have a strong and growing literature, only enforced the "Japanese" label. It was one with which all of the designers felt uncomfortable. For while they knew that it meant acceleration to observability, they were justifiably sensitive to the limitations that it bestowed in equal measure. Kondo remarks how Miyake, for example, complained that naming him as Japanese limited his claims to be universal, running the risk of reducing him to a fad. While relishing the success, he was also distrustful of the rise of Western interest in new Japanese design, apprehensive that such patterns are followed by a decline in interest that is just as swift.[23] As Kondo reflects,

> Miyake's claim on universality reproduces the contradictions animating Japanese identity formation from the 1970s. On the one hand, his appeal for universality fuels the forces of consumer capitalism. "Universality" means clothing that will sell anywhere in the world. . . . On the other hand, "universality" reaches for recognition outside essentialized Japanese identity. Here the salient feature is racial marking, which preserves the unmarked category of universality for "white." Who, after all, is allowed the designation "designer," not "Japanese designer." Miyake's move toward universality on this level is a common, if problematic, move to escape ghettoization.[24]

Miyake's dilemma is another version of the Michael Jackson syndrome, that creates its own kind of blackness while also ensuring an unmissable amount of whiteness as insurance against obscurity. One result is that "Japan," in fashion and other practices as they approached the end of the millennium, has evolved to be a floating signifier that embraces precisely this contradictory position, which is recognition and evasion both at once.

Kawakubo: "I want to be forgotten"[25]

"I want to be forgotten" seems a fairly disingenuous proclamation by a designer that is so ambitious and with such wide global influence, which means that her influence and example will last well beyond her lifetime. However it is a comment that is in character for Kawakubo, who is well known for her evasiveness, which spreads to many things, from her reluctance to be in the limelight, her intolerance of what is not within her ethical and aesthetic worldview—and her aversion to being called a Japanese designer. But the desire to avoid designation has the effect of the drawing attention to the same. Moreover, it is a disavowal that is based in what is perhaps an over-presumption, of over-attribution, of ascribing the creative output to a series of cultural essentialisms—when to be associated with the country of origin may only need be that.

But just in surveying her earliest collections, it is hard not to devise narratives of attribution. In *Holes* (autumn/winter 1982–83), Kawakubo was one of the first designers—the other salient one was Vivienne Westwood—to introduce wear, stress, and depredation into the syntax of the garment. Westwood's early work frequently repurposed old garments, and her collaboration with Malcolm McLaren and punk gave her garments a brutal quality that ran counter to what was considered decent and acceptable. Kawakubo, for her part, brought the language of damage and destruction into garments that otherwise stood for style, as opposed to the anti-style of Westwood's punk. Formerly the habitus and expectation of high fashion was the best tailoring and the best fabrics. A garment that showed signs of wear was properly discarded, this being the luxury and imperative of class. Kawakubo may have still been using expensive fabric, but was subjecting it to stress that suggested degradation. The garments were also baggy or wrapped, in defiance of Western tailoring. Sagging, draping wrapping, together with raggy textures were all in the next collection, *Patchworks and X* (spring/summer 1983). *Gloves, Skirts, Quilted Big Coats* (autumn/winter 1983–84) included fabrics of uneven wefts that were also torn and ragged. The wrapping and layering of the body was strongly suggestive of makeshift streetwear, down to the way that homeless people wear clothes of different sizes and torn clothes like bandages. With wear and improvisation at the heart of the garment's meaning, Kawakubo designated the body wearing it as fundamentally traumatic, since she came after a former nameless (and absent) wearer. These collections were also exclusively black.

These references to ruins, hiatuses, and ghosts of history—which also rendered her sympathetic to interpretations aligned to the philosophy of Jacques Derrida and deconstruction[26]—inevitably courted associations with postwar Japan. The aesthetics of destruction, allusions to the remnant and to improvisation due to deprivation, could easily be read together with the Japan in the legacy of the cataclysms of Hiroshima and Nagasaki. As renditions of a "post-Holocaust

clothing," Kawakubo's collections from the early 1980s are compelling. A resounding theoretical refrain in the 1970s and 1980s—when succeeding generations of artists, thinkers, and scholars were dealing with expressions of war guilt—was Theodor Adorno's gnomic statement toward the end of his essay "Cultural Criticism and Society" that "To write poetry after Auschwitz is barbaric."[27] It is a statement that summed up the ambivalence toward the purpose of art and beauty in its pursuit of truth. The unutterable atrocities after the Second World War left little space for escapist or lyric poetry, and the ruins of the landscape across Europe and in East Asia made a return to pre-war innocence impossible, if not unconscionable. It was also from the protest era of the 1960s onward that artists were rethinking traditional modes of approaching art and the art object, and therefore traditional canons of the beautiful. As a direct result of the new subcultural styles of punk and glam, in the 1980s "grunge" became a dominant aesthetic in art and design. It was an art of detritus that abjured charm. Despite all denial or attempt to sidestep these associations, they are inescapable.

In her important earlier study, Spivak in her *Critique of Postcolonial Reason* (1999), devotes a large portion of her chapter "Culture" on Kawakubo, as she rightly sees clothing, as with architecture, as "privileged arenas of inscription." Spivak writes: "How very different she is, how *Japanese*. Yet, the authoritative cultural discourse that defines her and indeed defines Japan is placed in Euroamerican cultural history."[28] She notes that Kawakubo was born in Tokyo in 1943, so was an infant when the bombs flattened Nagasaki, yet also cites a Kawakubo comment that he "felt it important, not to be confined by tradition or custom or geography." Yet, as Spivak asks, "How does a 1943-born Japanese buy such freedom?"[29] One answer lies in the "march of capitalism" itself, which produces "plausible stories so that business can go on as usual."[30] In other words, Kawakubo's plea not to be culturally marked is motivated by a market that expects such a plea, and that, to some extent, accommodates it for its own self-interest. Kawakubo is thus not Japanese as such, but Japanese broaching the neutral space—which is to say, very modern Japanese. Spivak, in her impassioned critique, remains skeptical of Kawakubo's claim to being a "minimalist," as a means of refuge from the complex culture positions that are before our eyes. "If Britain sucks Empire from Rome, *Comme des Garçons* sucks style from France. France is to fashion what Japan is to otherness. The subject remains Europe."[31] For Spivak, who holds to the subject being "historically and therefore geopolitically inscribed,"[32] Kawakubo's attempted elusiveness can have grave political consequences because "it often allows an other woman to disappear."[33] The smoothing out is ideologically suspect because it finds itself complicit with commodity capitalism that welcomes the variability in the name of redirecting anything in the direction of profit.[34]

Kawakubo's comments about her inspiration, where her ideas come from, are similarly obscure. Her sources are somehow *ex nihilo*, an artistic immaculate

conception. For instance, in 2012 she stated: "I have no inspiration. I never do. I am maybe triggered by something somewhere sometime, but I am not conscious of it. I start without any theme and I grope in the dark as I proceed."[35] Rather, late in her career she maintains a form of authorship that is romantic and modernist, as emanating from the wellspring of subjectivity:

> External stimulus has not played a major part in recent collections. When you've been making clothes for over forty years, things that you happen to see and hear are not sufficient stimulus. They are no longer of use to me. Instead design is a process of finding something by starting from nothing at all. Creation is a fight with yourself.[36]

Genuine as they may be, it is relevant to turn to the concept of the intentional fallacy espoused by I.A. Richards and the New Criticism here, in that the artist is not necessarily the best critical witness to his or her work. The ostensible inscrutability of these remarks creates the possibility of unmooring certain strategies from their source, which of course need not all be traceable to "Japan." But it seems that Kawakubo wants to go further than that to be thought of as a creative mind who has shorn herself clean of cultural baggage. Her alibi to this is her husband and CEO of Comme des Garçons, Adrian Joffe, who affirms that Kawakubo

> never gave herself any ethnic boundaries. . . . From the beginning, she dispensed with any preconceived notions about western and Eastern social mores and cultures, all of these things are irrelevant to her world. . . . She deliberately casts away all questions of upbringing, nationality, sociology and the like. So many times it comes from just a feeling, an emotion, not a concrete reference.[37]

Reams could and have been written about the problematic nature of these claims: the conviction that an artist can be a cultural tabula rasa, the deletion of personal provenance from the equation, and the invocation of the modernist myth of artistic inspiration in the wellspring of the soul. It is a point of view that makes Spivak's critique much more trenchant. It is also highly cynical, for in cleansing culture of any reference other than the act of creation itself, it also absolves the consumer of any reflective judgment.

Among many, here are two collections in which historical and cultural references are plain to see, notwithstanding rhetorical efforts to downplay them. One is what remains the most controversial of Kawakubo's collections, *Body Meets Dress—Dress Meets Body* (spring/summer 1997), colloquially known as the "Lumps and Bumps" collection for the way the body's natural line is interrupted by bumps in unconventional places. As Andrew Bolton, the curator of the Kawakubo retrospective at the Metropolitan Museum of Art in 2017,

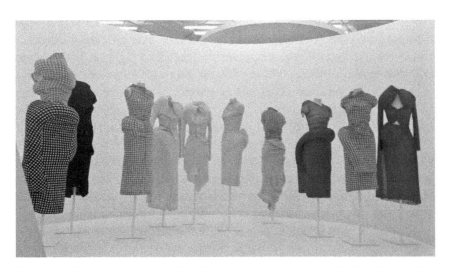

Figure 33 Fashion designer Rei Kawakubo's dresses present during The Metropolitan Museum of Art Costume Institutes' 2017 exhibition as an honored guest in New York, United States on May 2, 2017. Photo by Selcuk Acar/Anadolu Agency/Getty Images.

relates, the protuberances from goose down feathers "completely disfigured the body: so it was a celebration of deformity, which was challenging with these normative conventions of beauty . . . they still stand out as one of the most provocative collections, more so because it was often done in very child-like and sweet bubble-gum pink gingham."[38] Commenting on the same collection, the painter David Salle mentions latent expressions of "cruelty" in such designs,[39] and "[n]ever has pink-checked gingham, gathered and pulled tight over a nonanatomical protrusion, looked so uncompromising."[40] He also observes a connection between the Japanese obsession with packaging, and the "not-so-minor art form called tsutsumi, of which there are different schools and myriad forms."[41]

Yet another genealogical point in the now notorious "Lumps and Bumps" collection is again kimono, in which the body is often radically reshaped through padding the body front and back. For essential to the kimono dressing ceremony is the process of "correction" (*hosei*) in which the young woman's body was affixed with towels, gauze, and other materials to devise an ideal female form. Thin women were enlarged with extra towels, the breasts of other women were flattened, and if women had a noticeable irregularity elsewhere then it was suitably "corrected." The body was then closely wrapped and tied, followed by the kimono with the sash (*obi*) providing the final security, which was secured with all the strength of the women assisting.[42] Dispensing with the elaborate binding and the rest of the encoded ritual, Kawakubo was simply turning the smooth surface of the kimono on its head, "deconstructing" the convention by redeploying padding for making an irregularly bumpy and irreverently striated form.

If all of Kawakubo's work is eclectic to some degree, gathering from a range of sources and ideas so diverse they are hard to trace, there are certain collections that show this inclination in an especially "Japanese" light. In her *Cubisme* collection (spring/summer 2007) the angular, geometric fragmentation germane to synthetic cubism was unmistakably inflected with a Lolita kind of *kawaii* ("cute") that, at the time of the collection's conception, had become an unmissable presence of Japanese street style, and beyond. The ensemble was a paragon of post-millennial East-meets-West, and a reminder of how modernist fashions, including those by avant-garde artists, continue to be a source of inspiration for everyday wear, in dress-ups, through to film costume. At the launch of the collection, the models were in generic whiteface, which rendered them part clown, part cyborg, like characters from anime or from illustrated science fiction. The garments were limited to red, black, and white, with some of the layered white tulle dresses stamped with large, opaque red dots, in this context hard not to be construed as references to the Japanese flag. Other skirts, also of flared tulle, like a vernacular reference to Dior's "new look," were all blood red. Large belts slung on the torso over the breasts created a language of bracing and enclosure, but also connoted the flattening of the breasts in kimono. The tops were a mish-mash of the prim (one had a rounded school-girl collar, red on white) and the pulverized, shards of clothes like clippings from the fitting floor, reaffixed

Figure 34 A hall exhibiting the work of Japanese fashion designer Rei Kawakubo is shown to the media on May 1, 2017, prior to the public opening of the Metropolitan Museum of Art's spring Costume Institute exhibition "Rei Kawakubo/Comme des Garcons: Art of the In-Between" in New York. The exhibition ran through September 4. Photo by Kyodo News via Getty Images.

in random asymmetry. When sleeved, the arms were still visible under the translucent gauze or tulle, in one the coyness of this effect undermined by a second sleeve that resembled the outer armor of a robot. All the models were similarly shod in closed flat shoes with socks, all of which drew from the classic brogue. The sartorial semantics of safety and decorum are a typical ploy of the Lolita look of false modesty, the ironic mask for coquetry.

Nabokov meets Nippon: Lolita and cosplay

Lolitas and cosplayers are names for the various approaches to identity recreation that developed out of the fandom cultures of the 1990s largely between Japan and the United States. They both entail dressing up: cosplayers for particular events, while Lolitas assume a more lasting persona, imbuing a distinctively girlish aesthetic into their daily appearance and into aspects of their life and their immediate surrounding. Although invoking the eponymous novel by Vladimir Nabokov, Lolitas maintain that their identity play is not strictly defined by it. The ways in which it has been interpreted owe a great deal to the adaptive principles of contemporary Japan. What the Lolita and cosplay have in common—despite the many testimonials amongst them to maintain a clear qualitative distinction—is that they are highly encoded forms of costuming that have become an established practice of identity creation and communication. Cosplay in particular is a living example of the powers of reciprocal exchange between American comic culture as it grew out of the mid-twentieth century, and Japanese popular culture such as manga and anime.

The very origins of the word "cosplay" bear out the intricacy of its dual origin. For it can be taken to be the truncated form of "costume play," but it also originates in the Japanese, *kosupure*, used by Takahashi Nobuyuki after attending World-Con, a sci-fi convention in Los Angeles in 1984. Founder of the anime publishing company, Studio Hard, Takahashi was impressed by the number of the people dressed up and the quality of their costumes, which indicated that they were clearly in competition with one another. He took this experience back to Japan and encouraged his readers to realize the characters that they identified in print by dressing up as them. Alternative histories state that science fiction events began to appear in Japan in the 1970s, and were given subsequent momentum by the science fiction counterparts in the United States. Other decisive markers were the series *Mobile Suit Gundam* (1979) and *Ursei Yatsura* (1980), many of whose characters were scantily and suggestively clad. Fans imitating them in these early years incited complaints of indecency, with the result that in the Comic Market of 1983 they were confined to the edge of the convention hall, a measure that lent to the perception of cosplay as a socially

marginal practice.[43] A further impetus to the cosplay movement was the show *Captain Tsubasa* (1984), which featured a soccer team in exotic sci-fi cosplay-style uniforms.

Costuming was very much a post-Second World War release by the generation that had not witnessed the war. Public parades of costuming had already begun in the United States in the 1960s. It was one of many indications of the great economic surge that the United States enjoyed at the time. Not yet called cosplay, the influence of comic cultures (such as independent comic stands that would become independent stores), and the introduction of color television would see a widening fan base that would dress up as Batman in the 1960s, and, in the 1970s, their favorite characters from *Star Trek* (Dr Spock was a favorite, to William Shatner's chagrin). It is argued that this popularity and visibility of dressing up in North America gave Japanese fans the impetus in the 1980s to dress as their preferred manga heroes, while others attribute the origins of cosplay to Japan.[44]

The use of the original word *kosupre* was to distinguish it from the loaded meanings of others, such as subtle meanings pregnant in the Japanese equivalent of the word "masquerade," which means "aristocratic costume party." To surmount this problem Takahashi coined his own phrase, "costume play," which was later truncated to "cosplay." Participants were by extension "cosplayers."[45] By this time manga had already begun to have a considerable effect on North American markets. Japanese fans also referred to themselves as *otaku*, a special devotee of a fictional line and aesthetic. They and their North American counterparts began to intermingle with growing frequency, such that the styles and characters they were devoted to, the comics and animation themselves, also reflected such cross-pollination.

Since the 1980s, the conventions have been organized like any other major conference that has existed in academe, except they were oriented toward popular culture. They had focus activities, panels, special "delegates," which were usually the celebrities that played a character or did the voice-over, video rooms, and organized performances. Prizes were offered for costumes, and there were numerous stands selling related merchandise. It was also an appropriate market for launching up-coming films, television series, computer games, and, later, websites and other related Internet platforms. These now highly structured gatherings have become a significant means by which cosplayers communicate with one another. They are literally sites for action and exchange in which the participants share a common language and common goals. With Internet culture, they are a way of giving material focus to what exists simultaneously on a virtual scale.

But while almost, if not all, aspects of culture have some dimension owing to the Internet, the other reason for the extraordinary popularity of cosplay is the immeasurable success of Japanese popular culture. Its rise since the 1990s runs

together, as if in concert, with that of cosplay. Manga, anime, and video games now comprise a sizeable part of the Japanese export economy. This includes all possible forms of merchandizing, including books and magazines, figurines, clothing, and accessories (bags, shoes, watches, and so on). One of the reasons for the appeal of manga cartoons, what Susan Napier calls the "only major non-Western form of global popular culture," is that it presented credible, rounded characters as opposed to the compared vapidity of Western characters that were "too stereotypically good or bad, strong or weak."[46] The ability for youth to empathize with manga and anime characters made the transition to becoming the characters easy and somewhat natural.

But the popularity is not confined to the capacity for readers and users to emote to characters, it is also due to Japan's success in creating seductive hybrids with a wide range of appeal, usually occupying the gradient of "cute" (kawaii). In 2002 a survey found that more American children preferred and recognized Nintendo's cuddly Italian plumber, Mario, than the once universal Mickey Mouse.[47] This is not to forget Hello Kitty the character and the brand, which began as a vinyl coin purse in 1975. Since then it has become the quintessence of kawaii, and generates around seven billion dollars a year. Hello Kitty embodies a particularly Japanese aesthetic and economic condition that leads Douglas McGray to assert that: "Hello Kitty is Western so she will sell in Japan. She is Japanese, so she will sell in the West."[48] Another massive franchise is Pokémon, with its recognizably cute creatures, villainous or benign. They occupy a place of Western folklore tinged with sci-fi chinoiserie. The same may extend to the appearance of manga characters, who share many Western-Aryan traits but in an unmistakably non-Western, sci-fi oriental way. It is yet another very material case of what Spivak writes of Kawakubo that she is "the same-yet-not-the-same, different-but-not-different."[49] In a similar vein, and counter to the earlier argument as to the appeal of manga over American comics, Koichi Iwabuchi has referred to Japan's penchant for having it both ways as effecting mukokuseki, or "statelessness." Iwabuchi believes that Japan makes "culturally odorless products." They occupy an odd place, for while we recognize them as Japanese, that is where it stops, for they are conveniently unmoored from a precise point of cultural reference.[50] They provoke a soft sense of yearning that is not the real Japan, it is "an animated, virtual Japan."[51] On the other hand, Jacqueline Berndt defends the ambiguity of "mangaesque faces [as they] appear to be transcultural platforms rather than the manifestations of Japanese Occidentalism or representations of Japan's obliviousness to its past as an invader and colonizer in Asia."[52]

The racializing of manga and anime characters continues to be a source of much debate, especially given that they are strikingly ambiguous from the very start, and the looks also tend to vary. If a conclusion can be reached, it is that Japanese manga and anime attempt to universalize their heroes, assimilate them into the Western codex, while also leaving a foot in their culture of origin. "This

points to the Japanese context" as Berndt concludes, "in a two-fold way: first, with respect to representational conventions which undermine straight content-oriented readings and second, with respect to the more general significance of race and racialization."[53] After all, manga discourse as such is not preoccupied with race or ethnicity, which are more concerns of scholars and other commentators in America. Indeed, as Berndt argues, some critiques from these sources may be prey to an Occidentalist error of reading manga's perceived "statelessness" as white.[54] While some err to the view that modern Japan embraced certain Western notions of race and racism, "others highlight that in modern Japan, caste-based discrimination outweighed race-based discrimination." In an eminently posthuman twist, the discrimination that occurs in manga and anime is less based on race and is directed more as species.[55] "Speciesism" as an avatar of caste sees different creatures vie for supremacy. It is a convenient displacement into the unverifiable making any discussion of racial dynamics collapse under the weight of a whole lot of imaginary animals. In so doing, Japan's national image as a culture of the future is continuously and subliminally asserted.[56]

For all of this, economically the strategy of making exoticism familiar—a neutered Orientalism—has had immeasurable success. Some early statistics give a sense of manga's popularity and reach. In 2003 the Japanese Ministry of Economy, Trade and Industry reported that an estimated 65 percent of the production of animated cartoons was in Japan, with sales in the realm of USD 17 billion.[57] Japan also leads the world in the sales of comics, which are not only avidly consumed in the United States but throughout Southeast Asia, and beyond.[58] Manga and anime, which now form a sizeable proportion of the Japanese economy, are critical instances of Japan's soft power. And as the West continues to consume it, they of course affirm, both materially and symbolically, the significance of Japanese culture. By being fabrications in more than one sense, through manga and anime, Japan can, in turn, carefully regulate and curate its identity. This means how it can influence domestic consumers, and how it can continue to affect the way Japaneseness is perceived outside of its borders, however fluid such borders continue to be.

Unsurprisingly, the extraordinary reach and success of manga has spawned numerous non-Japanese imitations, which are called Original English Language (OEL) manga, Euromanga, or Amerimanga. These are commonly viewed as poor copies of the original, however Anthony Pym has argued that they are evidence of "interculture," the overlapping of cultures to create a discrete new entity—much in the manner of what has been called symbolic convergence.[59] Essentially the Euroamerican reinterpretations of manga are examples of transoriental multiple movement, beginning somewhere with modern Japan's interpretation and appropriation of American popular culture icons and cartoons, that is then consumed and reinterpreted by the West. Through imitation, which is a form of homage, the instatement of a third space also solidifies the Japanese

manga (in this instance) as the definite point of origin. Nor is Japan immune from the same tendency, with more cultural overlaps in the manga-ization of *Star Trek* and *X-Men*. Cathy Sell elaborates on the notion of interculture with another term, "polysystem," to define a configuration with multiple points of origin, and one that is continually mutating. She remarks that "as the established space begins to form an identity of its own, these additional elements also begin to evolve within the interculture. Cosplay is an illustrative example of this."[60] She continues:

> Through the activities of translation groups, cosplayers and anime clubs and the like, we can see that social interaction is intrinsic to manga and anime subculture. It helps to establish the intercultural space and fosters further cultural developments. This "between" space within which they interact provides not only the venue for a readership to develop and encourages greater interest in the source material, facilitating the translation of more texts, but also allows the creation of new material inspired by the translated corpus and the surrounding interculture that has arisen.[61]

One could also add that manga, anime, and cosplay have been the biggest drivers in reviving the international reintegration of Japan after its dishonorable record in the Second World War. The past has become obscured by a thick screen of adolescent fantasy. Or, to put it another way, the popular culture industry in Japan has been the single biggest factor in keeping Japan popular.[62]

The financially prosperous 1980s in Japan brought into force new forms of labor power and new sensibilities, including *freeters* and *otaku*. *Freeter* is another example of Japanese portmanteau neologism, being a cognate of "free" and the German word for worker, *Arbeiter*, in this instance to denote the rising sector of freelance workers. Even if the professional areas of graphic arts and digital design, which fed off contract labor, were not their careers of choice, the decision to opt out of being a "salary man" for more flexibility gave freelance workers more leisure time, which included their own creative pursuits.[63] Another slang term from the 1980s, *otaku*, referred to "nerds" who devoted as many of their waking hours as they could to video games, manga, and anime. The negativity of the word *otaku* as misfit, nerd, or outsider would soon dissipate with the recognition that he was an active participant in popular culture. Otaku was also initially stigmatized with connotations of withdrawal from the responsibilities of family and work for the sake of escapism and pleasure. "Today," as Nissim Kadosh Otmazgin affirms, "this term is generally applied to youngsters driven by a strong interest in contemporary culture and lifestyles, or to those who choose to facilitate social connections through specific, nonmainstream cultural practices such as cosplay."[64] However, cosplay is becoming more and more mainstream, not only with the growing number of players, but also those who may not play but know about it as a practice and as a contemporary form of expression and social

engagement. In Japan, commentators continue to be divided in their views of the Japaneseness of *otaku* culture: detractors consider it a diluted and mutated Americanization, and a symptom of a need to ingratiate itself with the American.[65] It is curious that something deemed so Japanese from outside Japan itself can be viewed as a tool of deception.

Seen in retrospect, the dual birth of cosplay in the United States and Japan seems like a foregone conclusion, given that both societies are highly technologized, an effect of which is an entertainment industry that is entrenched in daily life. The "fandom" of cosplay is not to be seen solely as a cultish response by consumers, but is far more physical and psychological. It suggests that everyday people can participate in the fantasy universe, commensurate with some superhero origin stories that tell of ordinary outsiders who become transformed. And this notion of transformation implies that cosplay is not conventional masquerade, where an individual remains that individual but who is just playing a role. Cosplay is far more serious, and aligned with the *otaku* sensibility as the operation of someone other. The psychic transference germane to cosplay is fueled by a will that has become used to vicarious play through video games and other virtual realities. Hundreds if not thousands of hours are lavished on this imaginary embodiment, which includes conceiving costumes (as variants and not always copies of the heroes people may mimic), and devoting attention to the way these costumes are designed and crafted. While costumes of varying levels of quality can be bought in shops or online, dedicated cosplayers tend to lavish enormous amounts of attention on making their own costumes, or of overseeing their making. As Therèsa Winge explains,

> Cosplayers exist at various places along a cosplay continuum, which is based on their level of commitment. At one end are cosplayers content with dressing (e.g., wig, makeup, and costume) as their chosen character and attending conventions and events for socializing and having fun. At the other end are those cosplayers obsessed with a given character, re-creating that character with meticulous attention to detail and performing as that character as often as time and money will allow. Between these two extremes there are cosplayers who research, study, and practice their characters and participate in cosplay events, such as masquerade and karaoke. Regardless of his or her place on the cosplay continuum, each cosplayer has an extraordinary level of dedication and commitment to the depiction of the chosen character, based on individual objectives that may include, but are not limited to, the following criteria: humor, accurate depiction, and casual participation.[66]

From this we can conclude that cosplay is not your typical play, but rather a subcultural context of a very unusual and distinctive bent, which for some people is a way of life.

In this regard, cosplay is very much a symptom, or better, a component, to the virtual identities that exist across the Internet. Selfie cultures also suggest that costumes and make-up will always place the photographic representation at a higher premium than the lived image, since it is the electronic image that can be more lastingly transacted.[67] At this juncture it may be useful to dispense with the presumption that there is a real identity behind the constructed one, as if there was some vestigial human truth behind the mask. Rather, it is a transformation in which the self becomes the self. While this had been the case before, virtual identities have made this a normal form of social and psychological conditioning. As is so often commented, the selves that exist on social media sites such as Facebook and Twitter, let alone the myriad dating sites, are particular projections of a self that the individual deems desirable and reflects the kinds of personalities and types they wish to attract. These worlds present wish-worlds that have escaped from workaday reality.

The seriousness of the cosplaying multiverse is reflected in numerous conventions around the world. In Japan the Ministry of Foreign Affairs plays an active part in partnering with other organizations to host initiatives that support Japanese popular culture. For example, in 2003 it teamed with tourism-related organizations in Nagoya for the "World Cosplay Championships" to judge the best cosplay outfits. The same convention in 2009 was attended by fifteen countries, from Italy to Singapore, Spain to Thailand. Other countries where fan culture is especially dominant include tech-based economies like Korea and Taiwan.[68] In 2006 the ministry initiated the International Manga Prize, which it intended to be deemed the manga equivalent of the Nobel Prize.[69] Fan-created manga, or *doujin* events, take place all over Japan; the largest is Comic Market, which, in 2006 had visitor numbers of some 430,000 over the three days it was held. Of these there were 10,280 female and 2,170 male cosplayers (these numbers were tabulated only according to those who used the official changing rooms).[70] Also in 2003, the same year as the World Cosplay Championships, Anime Boston was founded, the largest Japanese anime convention in the northeast United States. That a three-day festival in the United States is given to a cultural product not their own is no less than remarkable. It also points not only to the exertion and success of Japan's marketing of itself abroad, but also to the way such conventions reflect, as Susan Napier contends, how "performance remained an important key to how [Japan] was perceived."[71] As we saw earlier, this has a long history that dates back to the middle of the nineteenth century. The thirst for Japanese popular culture in American markets can be perceived as a mutated form of new millennial Orientalism, which is nourished by Japan being complicit in its own Orientalizing, a reciprocal relationship that is, hence, transoriental.

To argue that anime characters are more "real" than those from Western comics is a moot and emotional point for some such as the Batman die-hards.

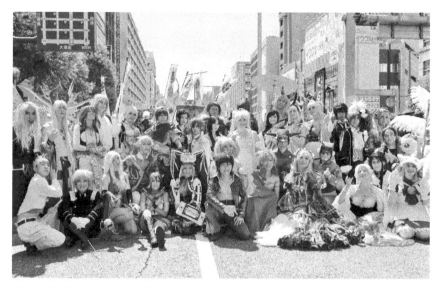

Figure 35 Forty cosplayers from twenty nations pose in a photo session during the 2013 World Cosplay Summit in Nagoya on August 3, 2013. The forty cosplayers will compete in the World Cosplay Championships. Photo JIJI PRESS/AFP/Getty Images.

Yet what remains incontestable is the dominance of Japanese characters in the relevant conventions, irrespective of where they occur, Japan or the United States, Singapore or New Zealand. True enough, Batman retains his certain ubiquity, and there will be characters from colossally successful franchises such as *Harry Potter*, *Lord of the Rings*, *Star Wars*, *Pirates of the Caribbean*, and *Game of Thrones*, but more plentiful are motley ninjas from *Naruto* and the mechanics and pilots from *Neon Genesis Evangelion*. The manga look has been adopted by numerous young women, and the instances of plastic surgery for larger eyes and bulbous breasts is on the rise. One of the celebrated "human Barbies," or living dolls,[72] is the Ukranian Valeria Lukyanova who looks so much like a manga character that she was cast as a doll in a horror film in 2016.[73] The sci-fi look is also conducive to improvisation from face painting to outlandishly colored hair, all favorites of their female-dominated delegates.

One of the many results of the populous female cosplay communities has been the confidence to experiment, one striking tendency being to dress as male characters. And cross-dressing is not the exception, it is indeed more like the rule. As Daisuke Okabe relates, in cosplay, those "who look good as men are highly rated by the community."[74] Yet practices such as these are not aimed at replicating masculinity or as expressions of dissatisfaction with their own gender. Rather, "cross-dressing requires the cosplayer to be beautiful while also portraying the male character in question."[75] The kind of masculinity they explore is more parodic, and exaggerated as found in dragging, thus the "men mimicked by

cross-dressing cosplayers is a copy without an original."[76] It may also be instructive to recall that the first geishas, as they appeared in the eighteenth century, were men, who entertained the other men waiting to see a courtesan (*oiran*).

To return briefly to Kawakubo's *Cubisme* collection, the garments bring into collision jagged, jarring, and asymmetrical surfaces with an uncanny "girly" look that in Japan, and by fans who follow such a look, is known as *shojo*. Kawakubo's love of aesthetically irreverent juxtapositions is typically put at the service of realigning the meaning and the contours of female dress, in this case "girliness" (*shojo-sei*) is played down by the harsh lines and the use of over-large accessories like belts. But the closed and flat-bottomed shoes ensure that the references in the collection are firmly anchored in *shojo*, which is more universally known as Lolita. Like their cosplay counterpart—from which they also aggressively distance themselves as something qualitatively and philosophically different—Lolitas are conceived in an intercultural space.

As will be recalled, Lolita is an under-aged coquette who is the sexual muse to the hapless Humbert Humbert, who in many ways is Nabokov's symbolic cipher for inappropriate desire. The "Lolita" type that arises from this story is conceivably a figure that exudes youthfulness, that incites desire, and who also enshrines perversity. Although Lolitas and their commentators have been quick to refute the connection with the "Lolita evidence," there is nevertheless enough aesthetic evidenced to make it, albeit in the broadest sense.[77] Another aesthetic touchstone is the dress of Victorian upper-middle class girls. Blurring documentary fact and period illustration, this is the girl as found in the representation of Alice by John Tenniel in his original illustrations for Lewis Carroll's *Alice in Wonderland*. This reference does nothing to dull the covert sexuality implicit in the adoption of the term "Lolita."[78] History has, apocryphally or not, ascribed to Charles Dodgson (aka Lewis Carroll) some tarnished and unwholesome motives in his attitude to children (he was inclined to draw and photograph children in the nude).[79] Yet another source of Lolita styling is in Rococo-inspired fashions. However if Rococo enters into a dialogue with femininity and fashion, it cannot escape one of sexuality, given the endless seductions of the paintings of the period.

The more lascivious connotations have been mitigated by tempering the inflections of Hello Kitty and manga. A Lolita has a mincing, contrived grace that places "girliness" (*shojo-sei*) on a fetishized pedestal, making parallels to dolls unavoidable. Just as Lolitas are often inclined to make reference to emulating porcelain dolls, the Lolita appearance is one extracted from the past while simultaneously projected into an animated comic-con future of visual excess and high-key color (when the Lolita is not Goth black). Winge identifies the Lolita as a "transnational object." As with any subculture it borrows, it consumes a cross-section of elements in a way that is in constant renewal. It is an aesthetic that began with borrowing and selecting from Western culture, in this case redefining Victorian-style dress such that it became repossessed as Japanese. "The

Victorian-era dolls and dress were removed from their original Western context, which allowed their assimilation and incorporation into Japanese culture as the Lolita aesthetic."[80]

The notion of becoming-doll is key to understanding the Lolita identity. For what cannot be overstated is that to dress as a Lolita is not the same as dressing up. The process of becoming Lolita transmutes traditional notions of self and fashion, for one does not dress up as Lolita, one becomes her.[81] As an identificatory process of diversion and empowerment, the character type is not so much a shell but rather the participant enacts the equivalent of a transubstantiation so as to be able to give life to parts of her that have been dormant or disallowed. The way Lolita—to use the word metonymically like kimono or hijab—toys with sexual content is highly conducive to the encoded and covert ways of sexual expression in Japanese society. Even when Lolitas protest that they are not eliciting sexual attention, they continue to be observed closely by Japanese men.[82] To this extent, Lolita, despite now being a worldwide practice, must also be understood as a very particular Japanese approach to dragging.[83] This self-recreation through an ambiguous stylistic subterfuge that combined Western nostalgia with Japanese futuristic fantasy is an enactment on the self of Japan's many cultural reformulations since the nineteenth century. As Winge observes,

> Within Japanese culture, Lolitas occupy a subcultural space where young women and men are empowered by the Lolita aesthetic to present themselves anachronistically in order to escape the trappings of adult life and with it the culture's dominant ideologies. But while they exist on the margins of Japanese culture, Lolitas also have had an impact on global popular culture: their traces are surfacing at global cosplay events, in American music videos, and even in the streets of New York City. This exposure has led to much scrutiny of the name and the style, as well as some unintended associations and appropriations, such as Gwen Stefani's Harajuku girls.[84]

But the ethos of escapism, metaphor, and fancy is now so firmly ingrained into Japanese culture that it has become a viable, if not necessary, means of communication.

Lolitas originated in the *kawaii* culture in Japan from the 1970s and by the following decade had begun to occupy aspects of children's imagination, not confined to what they consumed or observed but to choices of dress and behavior. The 1980s also marked the appearance of visual style or *vijuaru kei* or visual-*kei* rock bands that explored their own interpretations of British glam rock and "New Romanticism," using experimental make-up and dolling up in costumes in which the presence of Lolita was never too remote. Drawing from the increasingly voguish dress-up culture at home, in the 1990s the band Malice

Mizer combined looks from David Bowie's Ziggy Stardust, Adam Ant, and Kiss, presenting themselves as a form of Goth masquerade. One member (Közi) was a Venetian harlequin jester, another a Louis XIV clone, while the female member, Mana, dressed as Lolita, with bonnet and frills. Mana would not only present herself as such on stage but would also pose for magazine photographs. Bands such as Malice Mizer and X Japan fed the appetite for Lolita and Goth that would coalesce in the periodical *Gothic and Lolita Bible*. From thereon, Lolitas—classic, sweet, and cute, or more on the Gothic spectrum—would continue to permeate all imaginable forms of Japanese popular culture, including numerous manga and anime series. Just how deeply Lolitas had seeped into so many parts of Japanese life and imagination is testified to by the fact that the craze also has its masculinized incarnations. These came in roughly two forms. One was an *oji*, which followed a Victorian boy's dress with britches and long socks, a cap, and vest or jacket in luxury fabrics such as satin or velvet. The other was a female as an *oji*, effectively a tomboy Lolita hybrid, a girl dressing as a girl who wants to be or to look like a boy, but a boy who is in thrall to a girl type.

In many ways the Lolita is the natural development of the *otaku* mentality and culture. It is a persona that is an overt and socially ritualized escapism that, while once considered peculiar and eccentric, is at turns valued, desired, or accepted by most Japanese. Moreover, Lolitas now have become their own communities, physical and online. While Lolita is frequently referred to as "Loli cosplay," many Lolitas are adamant about differentiating themselves from cosplay cultures, not only in their philosophies and self-presentation, but also insofar as the Lolita is a more or less permanent identification as opposed to a character that is periodically adopted as a lubricant to social interaction at designated events. And while always varied and varying, the Lolita presents as a far more homogenous and therefore graspable and commodifiable entity, which has caused its subcultural status to be diluted by its entry into the mainstream, as seen in the mass marketing of Lolita styling with is related *kawaii* counterparts in America and Britain.[85]

Seen from another angle, the commodification of Lolita has also helped her seepage into more segments of culture. The sanitized appeal of *shojo*, as Frenchy Lunning argues, has an airily vacuous quality that "at the same time allows her [Lolita] to monopolize commercial constructions and advertising."[86] It is Lolita's ostensible powerlessness that makes her a "Trojan horse." For it is this very lack of a threat that has gained her admission to patriarchy, Lunning avers, which is unaware that a gamut of other queer identities follow in her path: "Having gained admittance, she has stealthily brought her siblings—the adult female heroines of gaming, the gay guys of *yaoi*, and the transgendered hero/heroines of manga—all as subjects in her family of forms." It is Lolita's particular constructedness that roots her in postmodern Japan. It is a Japan in which male roles and privilege still hold sway. Yet it is her ability to meld transnationally, into

Euroamerica that is a decoy to her ability to infiltrate high guarded zones of gender and conduct, causing them to be destabilized by her own artificiality and the queerness of her entourage. This is a position also interrogated by Isaac Gagné who looks at Lolita's presence in mass media such as television. Here Lolitas introduce a series of idiosyncrasies of speech and action that are presented as normal and as always having been around. It is a form of play in which young Japanese women can explore feminized and hyperfeminized forms of expression, as well as reshaping these expressions, that may have elicited reprisal had they not been under the aegis of role-play.[87]

Like no other culture, Japan maintains a contradictory position to its identity that appears at first glance to be poised in harmonious balance. On one hand, Japan is the most racially pure country on the planet, admitting no foreign citizenship. On the other, Japan has co-opted Western traits and mores with multifaceted subtlety, even such that they have quietly mutated to become "unmistakably" Japanese—manga for example. Japan is also a culture of agonistic identification, as Kawakubo demonstrates in her attempted slipperiness to her inspiration and aesthetic allegiances. Writing about Kazuo Ishiguro's *When We Were Orphans*, Pico Iyer reflects that:

> The very notion of foreignness has changed, you could say, in the global age (this is one if Ishiguro's implicit themes, and one that would no doubt impress itself on a Japanese writer that can't write Japanese). The person who looks and sounds like us may (as in Banks's [a character in the novel] case) be a complete alien; the one who looks quite different from us, and has a funny name to boot, may (as in Ishiguro's case) be so close to us that he sees through all our games. Foreignness has gone underground in our times— become invisible, in a sense—and yet it has never lost its age-old terrors, of being left out or behind.[88]

Or it could be that at the core of Japan is this displacement that it has fought since the second half of the twentieth century so hard to win. It is a displacement that harbors against its failures and which seeks to exist outside of any shadow that history might cast. Hence contemporary Japan is less a series of attributes and qualities, but more the capacity to integrate these qualities into other cultures and back into itself. Japaneseness is not a thing, but a process.

7

INDIAN
INTERDEPENDENCE

If pumping iron and aerobics were the fitness fads of the late twentieth century, yoga belongs to the zeitgeist of the twenty-first. That is, the kinds of yoga practiced in Europe, America, Australia, and other places beyond its ancient place of origin. In the United States in 2016 over 36 million people were reported to practice yoga on a regular basis, which is close to double the figure of twenty million only three years before.[1] And as opposed to the figure of 75 percent aware of the existence of yoga, the number rose to 90 percent. Many availed themselves of yoga not only for flexibility and fitness, but also for its capacity to relieve stress. No doubt where pumping iron was an expression of the late twentieth century corporate will to power, yoga is the relief and retreat from the unavoidable disasters heralded in the new millennium. And like all religions or quasi-religions it propels its own industry, worth over $16 billion in the United States alone.[2] Now a massive portion of the planet has been initiated into Sanskrit with the salutation made with joined hands and bowed head: "Namaste." How a Victorian imperialist of the British Raj would have shaken his head in disbelief.

Yet the yoga that is fashion, social event, health industry, and what fulfills the mandate for a wholesome lifestyle is far different from the yoga as historically practiced, evidence of which dates back 5,000 years. One of the founders of modern yoga, which is practiced and consumed in the West, was Sivananda Saraswati (d. 1963). Saraswati began as a doctor and served in British Malaya in his earlier years before founding the "Divine Life Society" situated on the banks of the Ganges. As James Mallinson and Mark Singleton write in their introduction to their anthology of historic writings on yoga:

> Adaptation and mutation have always been features of yoga's history, as competing and coexisting theories and practices exert their influence on one another, with some practices disappearing while others take on new, sophisticated forms. . . . In the modern period similar processes are at work; however, the sheer range of new ideas and the speed with which they are

transmitted within and between nations and cultures (for example, through travel, print and photography, and more latterly via the Internet) increase exponentially. Modern, global forms of yoga exist in a verity of complex and recursive relationships with "traditional" yoga. Commonly, yoga in its global contexts has been interpreted by analogy with other concepts and practices that are more easily understood within the culture at hand. Thus, for example, over the past century yoga has been conceived variously as psychotherapy, philosophy, hypnotherapy and mesmerism, black magic, chiropractic bodywork, shamanism and sport (among other things). These analogical understandings have had a profoundly transformative effect on the way yoga is interpreted and practiced in the world today.[3]

Although it appears to obey ancient laws, yoga is highly adaptive and malleable. Today, just as it is not unusual to have sushi topped with that most French of sauces, mayonnaise, the yoga in Western gyms and clubs is highly eclectic. It may have music, from ambient sounds to Buddha-Bar mixes to trance music. And chances are that the Indian food that one might have afterward is the kind developed by Indian migrants to Britain.

Visitors to India whose first experience of Indian culture have been with yoga, textiles, and food, are usually shocked by the disparity between their own exotically rarified experience and the grim realities of Indian society. For India is a country of extremes and of vast polarities. This can be attributed to two main factors: the legacy of British colonial rule, and to the ancient caste system.[4] Both remain at the foreground of the debates around Indian identity and reform. The long, dark shadow cast by imperial Britain means that modern India is culturally manifold, while the continuation of enforced poverty through a generic underclass prescribed by religious law is yet another example of the dimension of the faceless poor that have to be factored into the cultural folds of transorientalism. These two factors are the tensile forces within Indian society. While they continue to be a theme for writers, they are generally what the contemporary Indian fashion industry is keen to disavow. Where high fashion is concerned, there is a noticeable absence of the aesthetics of the ruin. It is a contradiction that is despite, or perhaps because of, a country in which the presence of death and decay is so close and so constant. But it is also attributable to other contradictions that have been diagnosed as within the Indian psyche, which is that it is both too inward-looking while also always becoming something other. In this regard, contemporary Indian fashions are a prime example of joining these divergent threads. And it is worth exploring the various, and often unpopular, accounts of India's inner conflict, and the questions regarding its "mimicry," in order to contrast it with the Indian fashion industry that exploded in the 1990s, with its confident reconfigurations of the West and of its own traditions.

A culture of estrangement

These criticisms as to India's problems with cultural inheritance and independence continue to be highly contentious, and well they might. One of the most trenchant and controversial figures to voice them is V.S. Naipaul. In his last novel, *Magic Seeds* (2004), the main protagonist says: "'It's the only thing I have worked at all my life: not being at home anymore, but being at home."[5] In one of his earlier travelogues from 1962, Naipaul speculates: "Perhaps India is only a word, a mystical idea."[6] At this time, India, as Pankaj Mishra writes, was "still in thrall to its ancient, decaying civilization."[7] Curiously enough, the Indian psyche, and the mystification of its past, was a distant cousin of the image of India that Britain had liked best, the India of Kipling and of the maharajas, warming to India's modernization.[8]

When the British Raj disbanded in 1947 it left a country it had divided into 230 districts that had little sense of concrete unity. "India" as something unto itself was doubtful or a dream. The only surety was Britain itself, and what remained of its imperial power, which meant that in rebuilding India, Indians turned to the subjugating master. Mahatma Mohandas Gandhi himself studied law in London, and India's first president Jawaharlal Nehru was educated at Trinity College, Cambridge. While other major leaders were also educated in India, the regularity with which the upper echelons of society are educated abroad—particularly those belonging to the Bania (Vania) or merchant class (to which Gandhi belonged—continues to this day. Most abundantly, the legacy continues with the presence of the English language, of which so many who identify as Indian are such eminent exponents. But English is an inherited and imposed language, as it had been for so many other colonial states, and it is one of the many aspects that consigns the Indian to an odd, or ambivalent, statehood and to mimicking the colonial power.

To this day, India maintains a complex if not troubled relationship with English and "Indian literature." The scare quotes in "Indian literature" point to the vast preponderance of the English language, while also to the position as to whether it is a result of Indian writers choosing to write in English or the imposition of English as the colonial and the international language—with the cause tipping toward the latter no doubt. Given British colonization, writing in English is therefore not simply a matter of expediency, as it is a choice that can never fully wrest from itself what remains of cultural subjugation. Recounting an encounter with a doctoral student of Indian literature at Columbia University, Spivak asked him, "Surely you mean Indian literature written in English?" The student replied that he follows Amit Chaudhuri's proviso that Indian literature only counts as such when written in India, even when written in English. At this Spivak recalls Salman Rushdie's accusation of literature in Indian languages as "parochial."[9]

She counters the argument that the use of English perpetuates the exoticizing of India as much as it deletes the differences in the country itself. The "creolization" of the Indian language artificially in English undoes "the separate yet hierarchically shared histories of North and South Indian literatures."[10] She also warns against the "languages of translation" swallowing up the minor native languages—displacing the original as original into a language to be translated—which leads to the slow eradication of cultural specificity.[11] At the same time Spivak elsewhere acknowledges that: "British colonialism is an enabling violation. Our point has long been that, in the house of language, we must remember the violation as well as the enablement."[12]

The writer that is conspicuously absent in Spivak's capacious writings is V.S. Naipaul, which is partly not so surprising, given the divisive nature of his views as they were aired in his travel writings and essays from the early decades of India's independence in the 1960s and 1970s. Naipaul was struck by the way a wounded colonized country had somehow folded in on itself, to be expressed in what Spivak would later theorize in terms of subalternity. ("Subalternity is where social lines of mobility, being elsewhere, do not permit the formation of a recognizable basis of action.")[13] For Naipaul was acutely sensitive to the crevasse that British colonialism had created between the present and India's vast historical past. It is because of its magnitude and because the Indian people felt discontinuous to it, that it had become a burden, offering laws and ideas that could be read only imperfectly. "Indians are proud of their ancient, surviving civilization. They are, in fact, its victims."[14] The Indian "character" is a list of vague generalities,[15] and Indians were condemned to be copyists of those that had dominated them, thereby becoming an uneven simulacrum, a "hoax."[16] Worse, this was no illusion to most Indians. Reflecting later, Naipaul's view is less condemning but no less forbidding: "So the present suffering linked to past suffering. The heroic past ennobled or gave a different quality to the trials of the present."[17] One has the impression that India's past in all its glory and shapelessness is a touchstone that both adds to, and relieves, the tribulations of the present. It is drawn on as the wellspring of deep traditions, while also being the symbol of the magnitude of loss.

Unlike the white writer who could be poised for the encounter with the exotic, Naipaul (born in Trinidad) was writing from at least a dual perspective that mirrored the duality of India itself. In his early days as a writer he was faced with decisions of language and perspective. For the Indian encounter with itself, Indians writing about India, had either a mixed reception or proved to be dangerously unpopular. ("The Delhi novelist R. Prawer Jhabvala has moved away from the purely Indian themes with which she started; she feels unsupported by the material.")[18] This has changed somewhat, but not fully. In one of the caustic observations that earned him so much opprobrium, Naipaul proclaims that:

Every discipline, skill and proclaimed idea of modern Indian state is a copy of something which is known to exist in its true form somewhere else. The student of cabinet government looks to Westminster as to the answers at the back of the book. The journals of protest look, even for their typography, to the *New Statesman*. So Indians, the holy men included, have continually to look outside India for approval.[19]

This is something that is not unique to India, but is described as endemic to a culture that is always on a cusp, or in a trough. Naipaul describes the national disposition as hinging upon a disturbance of character based on inferiority. "Each Indian, looking into himself and discovering his own inadequacy, attributes inadequacy to every other Indian; and he is usually right. 'Charlatan' is a favorite word of Indian abuse."[20]

In his account from 1977, *India: A Wounded Civilization*, Naipaul tells of a journalist he had met:

Identity was related to a set of beliefs and rituals, a knowledge of the gods, a code, an entire civilization. The loss of the past meant the loss of a civilization, the loss of a fundamental idea of India, and the loss therefore, to a nationalist-minded man, a motive for action. It was part of the feeling of purposeless of which many Indians spoke, part of the longing for the Gandhian days, when the idea of India was real and seemed full of promise, and the "moral issues" clear.[21]

This is echoed more poetically by the narrator of *The Mimic Men*, where he opines that "in a city like ours, fragmented, inorganic, no link between man and the landscape, a society not held together by common interests, there was no true internal source of power, and that no power was real which did not come from the outside."[22] And: "nationalism had become a word. It had no meaning. It held only Asiatic threat and Asiatic hope; to some it was a word of fulfillment and to others a word of revenge. Nationalization became less than a word: it became an emotive sound."[23]

When Naipaul turns to the decorative arts, his judgment is no more temperate. If India displays its gifts of "cultural synthesis," it is also to its detriment.[24] Painting foundered when it was forced to imitate European standards and canon. The imposition of new norms and a condescending audience meant that the painting tradition—the pre-colonial painting for the princely courts—is "broken."[25] This is because "too much has intervened. The Indian past can no longer provide inspiration for the Indian present. In this matter of artistic vision the West is too dominant, and too varied; and India continues imitative and insecure, as a glance at the advertisements and illustrations of any Indian magazine will show."[26]

Naipaul's imprecation that India "has lost the ability to incorporate and adapt,"[27] "and that 'imported skills are rooted in nothing; they are skills separate from principles'[28] has, from a globalized perspective, changed. Yet the unwelcome problems he voices are nonetheless still residual. Indeed the need to bring British imperial atrocities to the fore is something exigent in contemporary India, as with recent books by the politician and diplomat, Shashi Tharoor: *An Era of Darkness: The British Empire in India* (2016), and *Inglorious Empire: What the British Did to India* (2018). Although they are rhetorically framed as such, these compelling works are far from the last word on the matter. Debate is hot as to the best positions from which to write Indian history, since the "Indian point of view" is impossible to essentialize and furthermore a by-product of British rule.[29] (Tharoor was born in England as part of India's high elite—no Indian writer can escape ideological inscription.)

A major voice for the depredations of Indian culture, and the marginalization from within, is Arundhati Roy, who justly received worldwide fame with *The God of Small Things* (1997).[30] This explores what are recurrent themes in Roy's writing, namely social discrimination, class and caste, and people who occupy uncomfortable and unconventional positions within society. The narrative's central figures are two fraternal twins, Rahel and Estha, whose only solace is each other, yet are driven away until an intimate reunion later in life. One of the central characters in Roy's second novel published two decades later, *The Ministry of Utmost Happiness*, is a Hijra, Anjun (formerly Aftab), a transgender of male birth.[31] Although Anjun does not feature fully throughout the novel, s/he, together with the cast of misfits and followers that surround her, are for Roy ciphers for the many placeless beings in India and elsewhere. It is also not insignificant that Anjun sets up her dwelling in a graveyard. Makeshift then permanent, her residence is in turn a symbol of the now multi-generational ghettoed poor, for whom undesignated zones such as the outskirts of airports have now become sites unto themselves, with their own community and their scavenger industry.

Not to be overshadowed, the larger part of Roy's writing has been as an activist and advocate for causes that are compassionately observed in her fiction. These include *The Cost of Living*, on the international reaction to the Indian and Pakistani nuclear tests in 1998,[32] and the more recent account of the lasting national malaise of the caste system, *The Doctor and the Saint*.[33] It examines the debate between Babasaheb Ambedkar and Mahatma Gandhi, who are the "doctor" and the "saint" respectively referred to in the title. For Roy the divergent views of these men are fundamental to the beliefs on caste in India that reign today. She works to peel away the patina of sanctity that covers the real Gandhi, a myth so strong that his name is symbolic of the days of national belief. Yet Gandhi's writings are so voluminous as to be next to impenetrable, and they regularly contain opposing positions depending on the time they were

written. One consistent part of his views was the belief in caste, which he viewed as essential to establishing order in an already populous and diverse state. One observation that Roy does not make is that Gandhi was effectively, consciously or not, returning to Britain's affirmation of caste, which reflected their own entrenched class system.[34] Gandhi's position was firm and influential. Roy suggests that this is one of the reasons—the sanction by the unparalleled and sanctified state-builder—that has allowed the caste system to continue, for the conditions of millions to remain horrific and unimproved, and for the worldwide disinterest in its inhumanity. This is its danger: because it is insidiously inscribed into the sacred dogma and historical pathology of a people it is not subjected to the same critical reproach in the way that "Other contemporary abominations like apartheid, racism, sexism, economic imperialism and religious fundamentalism have been politically and intellectually challenged at international forums."[35] She continues: "To compound the problem, caste, unlike, say apartheid, is not color-coded and therefore not easy to *see*."[36] The class and economic differences are astounding, with 100 of India's richest people owning "assets equivalent to one-fourth of its celebrated GDP."[37]

Ambedkar was a voice against the class of "Untouchables" (*Dalits*) of which he was one. He earned two doctorates, one from Columbia University and the other from the London School of Economics, rose to be India's first law minister, and was a vocal advocate for addressing the rights of those lowest in the caste system. What is conveniently deleted from the history books is that his earlier years working in South Africa had had a profound effect on the young Gandhi, which included a deep-seated antipathy for Black Africans.[38] Gandhi himself was a defender of peace and equality but never were any specific group of people singled out for special attention, nor did he ever speak out against the industrialists or the rich landed class.[39] These were the very groups that defined the lowest caste, for not only did they have to suffer untold humiliations of appearance and meniality, they were deprived of all the entitlements of others: "to land, to wealth, to knowledge, to opportunity."[40] Ambedkar believed in the complete dismantling of caste, which caste defenders saw as a dismantling of the very edifice of India itself. His agitation brought many grim truths to light but if it instrumented any material change it was negligible. Unconsoled, Ambedkar renounced Hinduism, converted to Buddhism, and died in debt.[41] Roy rightly argues for a reclamation of Ambedkar's views and teachings which have been drowned out by the Gandhi cult. Not to turn to him and to ignore the caste system allows the many ills of India to persist. "Until then" Roy concludes, "we will remain what he called the 'sick men' and women of Hindustan, who seem to have no desire to get well."[42]

Unlike Western poverty, in which there is perceived to be some provision of escape, there is no escape from being an "Untouchable." The name says it all, it cannot maneuver anywhere except back to itself. The escape through chance

and happenstance from these circumstances guides the story of the Australian film from 2016, *Lion*.[43] It is a film that captures for contemporary audiences the lives of many who have been taken from their homes forcibly and by chance, and grown up in dramatically foreign environments. It is not a cause for judgment or complaint, but rather to be aware of deracinated identity—a consciousness that is driven to perpetual surmise about the other home, and to endless hypotheses as to what might have been—which is now far less of a remote exception to the global condition.

The film tells of a five-year-old boy, Saroo, who lives with his sister, mother, and older brother, Guddu in Khandwa, India. He and his brother steal coal from trains to exchange for food, which brings them to travel randomly in trains and on foot around the local region. While at a station, Saroo takes a nap during which time Guddu takes a walk. Saroo awakens and, calling for his brother, hastily boards a train believing him to be there. Saroo then embarks on a long journey, tortured by the absence of Guddu, which after some days leads him to Calcutta, far East from his home. Saroo cannot speak Bengali, and is again on the street. After a series of suspicious, odd, and dangerous events Saroo finds himself in an orphanage where he is adopted by an Australian family who take him to Hobart, near the bottom of the farthermost state of Tasmania. A year later the couple adopt another Indian boy, Mantosh, whose reaction to the transition is not as smooth, exhibiting autistic tendencies of fits and self-harm.

The film then jumps to Saroo as a healthy young man of twenty who is in Melbourne to begin a course in hotel management. In the roundtable discussion for the entry students, when he is asked where he was born, he says "Calcutta," whereupon a couple of Indians, or Australians with family in India, begin to make comments. In order to distance himself from them, Saroo replies, "I'm adopted, I'm not really Indian." It is a declaration that becomes the template of what is to follow. At a dinner with the new Indian friends, which also includes his white Australian girlfriend, Saroo chances a *jalebi*—flour soaked in sugar syrup and deep-fried—which has been set aside for dessert. In an earlier scene in the film, he and Guddu had eaten *jalebi* from a street stall. Saroo has his own sensory equivalent to Marcel Proust's madeleine steeped in tea, where he is flooded with longing and memories he cannot piece together. Overcome with feeling he tells his girlfriend who has just stepped into the room that "I'm not from Calcutta. I'm lost." From there on he embarks on an obsessive quest using Google earth and any other tool he can get his hands on to try to find exactly where he was from. Eventually he recognizes the rocky landscape of Ganesh Talai in Khandwa. In a pilgrimage back to his former home, Saroo is reunited with his biological mother and his sister. He learns that Guddu had been killed by a train on the same night as Saroo lost him. In the afterglow of the emotional reunion, Saroo leaves a message for his adoptive family to say that "there are no more dead ends," and assures them that his biological mother "understands that you're my family;

she's happy just knowing that I'm alive. I've found her but that doesn't change who you are. I love you mum. So much. And you dad." The film ends with footage of the actual reunion, and with a message that Saroo had been mispronouncing his name all along, it being Sheru, the diminutive of "sher," the Hindi for "lion." The concluding semantic twist provides the overarching philosophical coda for Saroo/Sheru's transorientalist identity, which as the film tells it is resolved and sure but based on elements drawn from error and chance. Its certainty and reality is the product of distortion and unpredictable events.

Contemporary Indian fashion

Comparatively little has been published on Indian fashion of the last two to three decades, which is surprising given the quantity and depth of the industry, and its economic importance. In 2017 fashion and textiles production equated to 5 percent of its GDP and was one of its largest exports of 13.5 percent of an export total of around 42.2 billion dollars. Estimated to be some 108 billion dollars, the industry is projected to be worth over 223 billion by 2021.[44] The industrial reforms that took place in the 1990s, known as India's economic liberalization, were aimed toward global competitiveness. The socialist policies that had been put in place since independence in 1947 were replaced with policies that stimulated global investment through deregulation, tax reform, and privatization—in short policies precipitate of globalization.[45] Major fashion brands—including Benetton, Zodiac, Zara, Calvin Klein, Tommy Hilfiger, and Diesel—were quick to establish a foothold on the market, while others from Ralph Lauren and Armani to Michael Kors and Zegna have begun to capture the market for the upwardly mobile elite classes. Indian fashion companies have also found a significant stake in the market. The biggest companies are currently Aditya Birla Fashion and Retail with a net worth of two and half billion dollars and an annual revenue of 300 million; the Varhman Group (1.3 billion, revenue 800 million); Arvind (1 billion, revenue 303 million), and Raymond (620 million, revenue 580 million).[46] A large number of high-fashion couture designers have also established themselves; their names include: Anith Arora, Manish Arora (aka Péro), Play Clan, Ritu Kumar, Nida Mahmood, Rahul Mishra, Sabyasachi Mukherjee, and JJ Valaya. But to see them in any sort of isolation is misleading, for all of these designers have had substantial contact with major fashion centers such as Paris and Milan. European houses have actively sought out the parallax perspectives that these designers can potentially bring, such as Paco Rabanne, which enlisted the designer Manish Arora.[47]

Before the 1990s Indian fashion was a mixture of national styles such as the dhoti and the sari, and Western casual vernacular styles. Formal attire was highly worked versions of traditional dress, or Western dress, or a combination of both. For the West, India was a place of production, while Indian dress was a

Figure 36 Designer Manish Malhotra and Rina Dhaka during the Michael Kors store launch on February 26, 2014 in New Delhi, India. Photo by Raajessh Kashyap/Hindustan Times via Getty Images.

niche market that had had its flourishing in the late 1960s, and was associated with light flowing cottons, usually faced with cheap single stitch embroidery. Indian fashion within India drew from the historic tradition of weaving, with an exceptionally plentiful amount of styles—many of whose provenance is untraceable because of the migratory oscillations between the West and China. From 1947 onward, the Indian government made a concerted effort to encourage the production of *khadi*, a fabric made from handspun yarn. In the words of Mikti Khaire, its "use had been exhorted by Mahandas Gandhi as a way of both retaliating against British imported cloth and promoting Indian self-reliance."[48] Support for handicrafts occurred together with that of increased industrialization. As we found in the modernization of Turkish dress, rural areas adapted more slowly to Western styles than in cities, but mainly for men. Until the late 1980s, both urban and rural women tended toward the sari or *salwar-kameez*, a tunic and loose trousers. As Khaire contends, for a married woman to wear Western clothing was deemed unduly progressive and a sign of waywardness.[49] Until the mid–1980s, clothing was made by individual tailors or supplied by retailers but with no organizational reach or franchising. By the 1990s, Indian fashions had undergone a massive transformation into a multi-tiered and confident industry with its own independence. Until very recently Indian styles have had a firm hold, especially for formal celebrations, such as weddings, where to wear Western styles would be seen as a betrayal of Indian identity. In the new millennium,

however, there are growing numbers of women who have not worn the sari, and actively avoid it, with the pejorative *behenji* used for those who insist on wearing traditional kinds of clothing in settings and contexts that are Westernized.[50] Although the sari can be considered cumbersome to those used to simplified Western dress, viewed more broadly however, women's dress seeks to strike a balance between Western influence and more traditional styles.[51]

In a relatively early commentary on the transnational eclecticism of Indian dress, Spivak supplies a biographical note:

> The example is Gayatri Spivak on a winter's day at an opening in New York's New Museum. I was wearing a jacket over a sari, and, to layer myself into warmth I was wearing, under the jacket, a full-sleeved cotton top, rather an unattractive dun colored cheap thing, "made in Bangladesh" for the French Connection. By contrast, the sari I was wearing, also made in Bangladesh, was an exquisite woven cloth produced by the Prabartana Weavers' collective under the co-ordination of Farida Akhter and Farhad Mazhar. Until I saw these weavers at work, I had no idea how the *jamdanis* that I had so admired in my childhood and youth were fabricated. It is complicated teamweaving and simultaneous embroidery at speed, hard to believe if you haven't actually seen it, certainly as delicate and difficult as lacemaking. As a result of the foreign direct investment related to the international garment industry, the long tradition of Bangladeshi handloom is dying. Prabartana not only subsidizes and "develops" the weavers' collective, but it also attempts to undo the epistemic violation suffered by the weavers by recognizing them as artists. This is not merely a reversal, but also a displacement of Ackerman's *Compendium*; there is no allegory-referenced transcoding here. Thus I was standing in the museum wearing the contradiction of transnationalization upon my body, an exhibit, though no one knew it. No persons or groups had moved much to make this possible. There *can* be labor migrancy associated with transnationalization, but in fact it is not necessary—with postfordism and export processing zones. The demographic determining factors for labor migrancy lie elsewhere, and are beyond the scope of these concluding pages.[52]

In many respects, in less than two decades the somewhat *ad hoc* nature of this transnational fusion has found its own discrete, stratified categories. "Visually and conceptually," writes Arti Sandhu, "the co-existence of numerous clothing styles that are also multicultural in their nature remains a key characteristic of Indian fashion."[53] *Desi*, which means "of the nation," when applied to fashion is immediately understood as fusion and juxtaposition. It is also a convenient term to help curb overuse of "tradition," when it is used with tendentious undertones of a more benign and unspoiled past. *Desi*-fashion and *desi*-chic can include a turban with a Nike logo, or variations of the sari, which may be adorned with

Figure 37 Indian Bollywood actors Hema Malini (left) and Deepika Padukone (right) pose for a photograph during a promotional event in Mumbai on late October 16, 2017. Photo STR/AFP/Getty Images.

Chinoiserie-style motifs.[54] India's eclecticism can be found in commissioning Western designers to do Indianized designs, or in the self-Orientalizing that is rife in Bollywood. Another important factor in the rapid evolution of Indian fashion is another change that occurred together with economic reform, namely the roles of women, who have been granted greater mobility and choice. The result has been that the once export-oriented industry is now increasingly directed to toward local consumption, and to nourishing the creation of a design aesthetic that can be set apart from other countries.[55]

It was only in 1985 that designers and related boutiques began to be mentioned in the main women's magazine, *Femina*. Unlike the tailors, who

came from a lower caste-based service, the earliest designers came from wealthier backgrounds and were largely self-funded, employing tailors and weavers to execute their designs. Access to a large pool of cheap labor for garment production was a convenience and a necessity, since the first designers, including Ritu Kumar, Rohit Bal, Abu Jani, and Sandeep Kosla, largely defined themselves as self-taught, as there were at the time no places in India to learn fashion design. The next wave of designers from the end of the 1980s to the 1990s were trained in London, Paris, or New York, with many having undertaken internships in major fashion houses. Again, these designers were from the upper echelons of society and could afford to finance such education and sustain the costs of founding a business. But as Khaire maintains, after 1991 the demographic began to widen through access to the National Institute of Fashion Technology, which had been set up in New Delhi in 1986.[56] From the late 1990s onward, fashion ceased to be a niche industry supported by the elite to one in which designers were receiving support from large corporations. Fashion media grew in response and proportion. Established in Bombay (Mumbai) in 1959, *Femina* was a fortnightly periodical that originally began as dealing with women's issues (careers, relationships) to become a fashion magazine. In the 1990s, the dominance of *Femina* was challenged by a periodical that began in 1992, *Verve*, which modeled itself on *Vogue*. There was also a healthy appetite for magazines from Europe and the United States. Fashion TV, a 24-hour channel devoted entirely to fashion, started in 2001, and by 2005 there were officially seventeen fashion magazines on sale in India followed by *Vogue*, which announced that its Indian edition would launch in September 2007.[57]

In addition to having to overcome the stigma associated with being a "mere" tailor, the earliest designers struggled with the larger public's understanding of independent and varied fashion languages. While simple and cheap Western clothing was worn casually, it was hard to convince consumers of high-end fashion to respond to designs that erred from existing (traditional) styles. Apart from the more traveled and wealthy minority, it was also difficult for designers to demand high prices for clothing for anything other than the ceremonial forms of dress in which the labor and materials were writ large on the garment. This meant that, as Khaire concludes, "early designers in India therefore focused on designing ornate, heavily embellished Indian-style clothing."[58] They produced the kind of clothing with fabrics and embellishments inaccessible to the average lowly tailor. It was a forced compromise that shifted the production of lavish Indian style clothing away from tailors to designers, an echo of the era of Charles Frederick Worth, whose "haute couture" was a dramatic leap beyond the everyday couturier, and where he placed a premium on his hand as an artist and his access to the best fabrics and techniques. Speaking in 2006, Ritu Kumar affirmed the rootedness of the Indian fashion industry in crafts and the Sudra

caste of craftsmen and vowed to be faithful to this.[59] This did not mean that the earliest Indian fashion designers were regressive or reactionary, rather they innovated within accepted styles. For instance, the collaborative team Abu Jani and Sandeep Khosla rejuvenated a traditional form of embroidery, *chikan*, with new designs and stitches.[60] A less salutary effect of the earlier designers needing to succumb to mainstream tastes was to make it difficult for the later generation to be more open and forgiving of Western influence.

Ironically enough, a key agent in the slow loosening of the ties to traditional styles came with the Orientalizing styles of European designers. For her "Indian Saree Show" Zandra Rhodes used the sari as the armature for a series of interventions, including pearls on the hem, and introducing large appliqués to the *pallu* (the end of the sari drape that hangs from the shoulder). She even brought in lines of shortened skirts as "daywear" could be worn together with a bodice made of Lycra.[61] Rhodes' collection was initially met with indignation by the Indian public as a heresy to a garment that stood for their identity—yet another example of colonial presumption. They were also priced well beyond high-quality saris, highlighting the kinds of prices that Western designers were able to command. The effect was that designers such as Galliano, McQueen, and Gaultier all began to look to Indian fashion and embroideries to incorporate into their own work. Their work prompted Indian designers to examine the fidelity and quality of the Indian influences by high-profile designers, concluding that they were still better achieved within India itself. Nonetheless, Indian designers also turned to U.S. and European markets, and, like the burgeoning of Japanese fashion two decades earlier, sought approval in signal events such as Paris Fashion Week.[62] Like the Japanese designers, Indian designers had to approach national identity with considerable delicacy, a combination of admission and elision. For the first show by Sabyasachi Mukherji in New York in 2006, the *Times* thought it relevant to mention that there were no saris.[63]

Yet the articulated absence of the sari did not in any way signify Mukherji's retreat from drawing from the many material and imaged resources of what signifies India. The many gestures of self-Orientalizing and re-Orientalizing ought not to be read as an affirmation of the colonial gaze, rather the opposite, that of mining history and ensuring the maintenance of traditional approaches, and the resuscitation of others, against the merciless onslaught of corporatized globalization. As Sandhu argues: "Much like the way global dress is received and worn in different ways across the globe, the perspective around the inception and reception of re- or self-Orientalizing design methods hinges on collective historic, vernacular (familiar) and ongoing social and cultural contexts within which they are practiced."[64] And Ann Marie Leskovich and Carla Jones, in their important study on Asian chic in Asia, enjoin us to think of self-Orientalizing as self-discovery and interpretation that is reflective so as to disentangle Orientalist stereotypes:

We cannot, however, assume that self-Orientalizing merely replicates or extends Orientalist knowledge/power. Rather, it may be possible for Asians to approach, produce, or use Asian Chic with the intention—and perhaps even the outcome—of countering Orientalist stereotypes. Self-Orientalizing mimicry might, as Homi Bhabha (1984) suggests, open up a critical space that exposes the contingent foundations of Orientalism. This could be an empowering move, an attempt to reclaim the authority to define the meanings associated with a style or aesthetic element.[65]

When the Orient indulges in its own fantasies about itself, the sensitivities also turn on "who is dressing and who is looking."[66]

To approach this in another way, to turn away in the name of ideological skittishness from the many and still proliferating self-Orientalizing, is to deny access to a reservoir of knowledge and a reservoir of potential. To bypass the signs of Indianness and to repackage and relive them is impossible. India is too large, populous, and deep in history and traditions to be able to ignore them. And there are a lot of Indian people looking. Reviving them and reintegrating them is a natural course of action. The now established Indian fashion media are active in fusing Indian and Western in what they choose to represent. This can be in mixing garments of different styles and provenance in a single image, of placing collections of Western designers alongside Indian ones, or having known Western fashion models wear Indian contemporary fashions. This has led to a "global-*desi*" in which the pairings of major recognized Western brands with those from Indian designers are intentional and dramatic: "The pairing of Dolce and Gabanna with Vineet Bahl, Chanel with Tarun Tahlilani, and Sabyasachi Mukherji with Givenchy results in an outcome that is 'fun', 'edgy', 'modern and very, very cool'."[67]

While we are still warmed by the glow of India's globalization, and its assertion through fashion, it is again worth revisiting the many design and economic triumphs in light of the gross inequities in India itself, reiterating some of the observations earlier in the chapter that any discussion of fashion must not occur in a vacuum, but with knowledge of this at least in the wings. Sandhu herself makes the statement that "it is perplexing to note the heightening polarity between India's rich and poor, with widespread consumption and display of fashion products by the elite and middle-classes on one hand and the extreme poverty that exists alongside."[68] Consuming fashion by the monied classes is now an accepted and expected part of life, as a sign of being globally savvy and as sharing in the privileges that their class brings them. On a more positive level, Sandhu suggests that production and consumption brings its benefits, including the elites as "benefactors of liberalization and arbiters of national progress,"[69] although Roy's study of the caste system shows very little will change soon. It is indeed a model of economic disparities that are replicating themselves all around the world.

8
FROM PRIMITIVE TO PROVOCATIVE: FIRST NATIONS IN END TIMES

It has fallen from some people's memories that still in the 1970s, many countries with a colonial past treated the "art" of its indigenous peoples as cultural products, as artifacts. Granted, art is a fairly circumscribed discourse with its roots in European history. Like the ancient Greeks, indigenous cultures did not have a word for art, since what we now classify as such was a component of ritual devotion or social initiation. Indigenous "art" was lumbered with the unwanted problem of either being treated as anthropological data, or being subject to a set of rules and expectations foreign from its meaning and making. Then, in an abrupt turnaround, with the revisionist attitudes that percolated into the last decades of the twentieth century, these artifacts were treated with veneration, bordering on awe. They were the reminders of the culpability and guilt over colonization. Where they had once been scrutinized, analyzed, and placed into taxonomic order, they were the object of a respectful gaze, so respectful that no word or judgment was passed for fear of overstepping one's cultural mark, and of assuming again the role of the presumptuous white man pursuing his colonizing "burden."

Such generalizations are useful, although the details always vary. In the interests of coherence, this discussion will be confined to Australian Aboriginal culture, with the main focus on the visual arts. For, given the political delicacy of the debates over indigenous rights, any analysis can soon spill out. It is also that Indigenous Australians have an unusual, if not unique, claim themselves, with evidence of existence for some 60,000 years. Further, they are far from homogeneous, being as diverse in language and custom upon British settlement in 1788 as Europe itself. And since the 1980s, Aboriginal art has been an object of international fascination. From this time, art was also the singular most significant agent in bringing visibility and traction of Aboriginal peoples to the non-Indigenous population.[1] Now firmly entrenched within national and international art markets, the efficacy of this art for advocacy of rights and identity

is now subject to review. One reason is that where once Indigenous peoples (note the plural) were homogenized like all groups of subaltern status, the sheer growth, depth, and pervasiveness of Aboriginal cultural activities since this time militate against such a view. The effect is to reveal a breadth of experiences, attitudes, and histories that encompass vastly different, and often contradictory, positions.

Not only does the enormous diversity of Indigenous Australian cultures make them a pertinent study for this book, it is also the diversity of the ways in which they have inhabited, appropriated, repositioned the colonial languages—written, verbal, musical, visual—for themselves. Beyond the objects themselves there is the very delicate matter of the Aboriginal self. To begin with, the diversity of Aboriginal peoples was not only of language and custom, it was also in appearance. Not all were "black" in the sense of appearance. The blackness that the settlers reported of the Gadigal people of what is now the Sydney region was not so much their skin, which was comparatively lighter than other groups' from the desert center, it was due to the ash they smeared on their body as protection from the sun (the first settlers arrived in the height of summer).[2] In comparison with other dark-skinned people, Africans and African Americans being the obvious example, the melanin gene for Australian Aboriginals is a recessive. One of the shameful chapters of Australian history was the government policies' attempt to "breed out" the blackness, which could be achieved in only two or three generations. This means that "blackness" for Indigenous Australians is varied according to more than one criterion, and that "blackness" is not limited to appearance—hence the recent coinage of the term "blak" to designate a trait that is expressed through tensile mixture of pride and resentment. Aboriginal identity thereby proves to be a vexingly elusive notion, which makes it so apposite a subject with which to conclude this book. It is a platitude to say that external appearance is a central element of inner identity. But what is it when the conventions governing appearance, held by more than the dominant group, are discordant with inner identity? What is it, for instance, not to know of Aboriginal heritage, only to discover and identify with it later in life? In that case, to what extent can one claim blackness if one had hitherto no experience of it in the material and socio-symbolic sense, that is, as having been treated as "black"? What are the signifiers of identity in such an event? These are very real, and, to wit, insoluble questions from a long-term perspective. For versions of them are pitted daily amongst Indigenous Australians themselves, and one or another is faced with the imprecation of being "not a proper black." This has caused many eminent Aboriginal commentators to turn to the concept of inter-culture, trans-indigeneity—and sundry other cognate neologisms—in order to find a site of identity that is not dogged by an identity politics of insufficiency, which can only be a politics of self-impoverishment.[3] It is yet another manifestation of the transorientalist "third space" or "between zone" in which the genuineness of

belonging is untrammeled by essentialisms such as purity, since "Australia" is from the very first the name of the adulteration and cataclysm of Aboriginal culture, but where there is also the rejuvenated space of renewal and an active future.

Noble savagery, guilt, and globalization

Attempting to assess the status of indigenous art in the last thirty or so decades can never elide the history of its uneven reception by the West since the growth of colonialism and imperialism from the sixteenth century onward. Naval trade and colonial claim occurred together with the birth of modern science and with it the museum. The first museums were collections of "curiosities," or *Winderkammern*.[4] These began as miscellaneous collections of curios consisting of natural and man-made objects, that, when they grew, required ordering, hence the earliest conjunction of curatorial and scientific taxonomy. Objects belonging to "primitive" peoples were part of this mix. It was only in the eighteenth century, with the thought of Herder and Rousseau, that these objects were given a slightly higher value as belonging to a class of people who in some or many ways may be superior to Europeans. The "noble savage" was one class of early modern genre that was unconfined to any land in particular, being another subgenre of Western self-definition. Similar to the roughly contemporaneous conception of the "Madonna-whore" binary, the noble savage-simian was defined by, and situated outside, the realm of the white man. If not treated as subhuman (simian) or as superior humans, both were abstracted out of reach of knowledge or attainability. Hence the famous engraving by William Blake of an Australian Aboriginal family. There is very little to separate them from other indigenous, such as Polynesian, peoples, and apart from a few irregularities such as the child on the mother's back and the weaponry, they resemble Greco-Roman figures only with darker skin.

The noble savage continued to exert a powerful influence over artists, writers, scientists, and philosophers throughout the nineteenth century. Indigenous people, or their interpreted stylization, were regularly inserted into landscapes by Australian colonial artists. The new landforms and foliage were given iconographic security through an idealized pictorial order that paid academic deference to Claude Lorrain, and other progenitors of European Landscape painting such as Salvator Rosa and Nicolas Poussin. In such works, the Aboriginal was placed gingerly leaning on his spear on one side of the foreground, usually contemplating the white men's business of sea-faring or town-building. But the quaint representation of the Aborigines did little to temper the long-held view of the English that they were inferior and objectionable. One of the earliest explorers to touch the shores of Australia, William Dampier, judged the Indigenous people he

encountered to be "the miserablest People in the world."[5] The colonists would not err from this view, ranking them as "scarcely human" and "the most hideous of all living caricatures of humanity."[6] This did not deter artists from images of an Aboriginal arcadia, an unknown place before European contact, which would prove to be popular with naturalists and anthropologists back in Britain.[7] Because these untouched natives were of an inexperienced and non-empirical past, their romanticized repertoire was fairly limited and repetitive, and ultimately expressions of the contradictions within the white man's longing for the Other: the Other was admissible and desirable when inaccessible and a figment of Western desire.

When the already well-established English painter John Glover came to remote Tasmania to retire, he thought he had found an earthly paradise. He arrived in 1831 when whites and blacks were pitted in deadly war. Within a few years the indigenous peoples were all but wiped out, but that did not stop Glover from painting landscapes with Aboriginal ceremonies and activities that showed them to be in a state of ecstatic harmony with nature. In many ways, these efforts to offer an untouched, unharmed representation of Aboriginals were self-serving, and they had the effect of keeping the unwelcome facts from view. Other artists, such as Augustus Earle, made images of the downtrodden Aborigines in towns, inebriated and degraded. But they do not elicit empathy, they only confirm the prejudices of aversion and abjection that Aborigines still, to this day, continue to suffer.

A brief gloss of the history of representation—one that hardly touches on the extent and ugliness of this past—is enough to give some background to the reception of Aboriginal art at the end of the twentieth century until the present. Australian art in the first half of the twentieth century was not so much in thrall with "primitive" art in the way that the European avant-garde was, where it was used as a late-Rousseauean antidote to civilization and as a gateway to spiritual authenticity. One artist, Margaret Preston, used Aboriginal styles and motifs, what might today be called "Aboriginalizing" (in the way that Pre-Raphaelitism was "medievalizing" and, as we saw earlier, how chinoiserie is "chineseifying") in her later works of the 1940s and 1950s. These are quintessential primitivist-modernist works in that they are all surface and style without any interest or understanding of what these styles related, sometimes even submitting the Indigenous look to Christian iconography. Preston was at a certain point later lauded as someone who was a defender of Aboriginal art, a more than disingenuous claim, as she was uninterested in the sacred narratives behind it, let alone the cause of the Aboriginal peoples themselves.[8] With this eccentric exception, apart from working from European stylistic cues, Australian modernist art is notably bereft of primitivist influence. At around the same time that Preston was plundering randomly from Aboriginal art (and originating from areas she had never visited), one Aboriginal artist was active. Albert Namatjira is hailed as one of the pioneers of Aboriginal art, his success at the time a result of having mastered Western representative techniques of landscape painting. (It would

later be uncovered that these were all Aboriginal sacred sites, in keeping with the secret-sacred nature of traditional Aboriginal art.)

Aboriginal art: Origins

Art history tends to like a fixed origin, or the illusion of one to be used as an historical touchstone. The stylistic watershed such as the miraculous and unaccountable invention of Cubism (1907–1914) is one of the modernist myths of vision and capability deemed lost in the chaotic plethora of postmodernism. In the 1970s, art had already branched out into tendencies and practices, many of them of multiple origin and with more than one name (Body Art, Performance Art, Live Art, Happenings, Lettrism, Word Art, Art&Language, Land Art, Process Art, Fluxus), which largely come under the aegis of Conceptualism, art in which the idea has as much or more precedence than its material product. Now seen in retrospect, the birth of Aboriginal Art in 1971 is contemplated with the warm glow of something certain, the beginning of the art of something authentic in a period of artistic indeterminacy and dematerialization. It is also universally considered the point at which Aboriginal visual practices made the turn to enter into the sphere of Western art discourse. There are earlier isolated instances of Indigenous artists encouraged into Western methods—such as in 1946–1947 when the anthropologists Ronald and Catherine Berndt gave the locals in Milingimbi and Yirrkala paper and crayons to illustrate their stories[9]—but the genesis in Papanya was the richest and is referred to the most.

In 1971 Geoffrey Bardon, an art teacher from Sydney, was posted to the remote government settlement in Papanya to the northwest of Alice Springs. Also primly called "missions" to give them an air of purpose and propriety, settlements like Papanya were effectively the equivalent of detention centers for local indigenous people who had been relocated from their ancestral lands and forced to live in semi-captivity. Bardon found over a thousand people living in a state of dejection and unrest. In his words: "I found a community of people in appalling distress, oppressed by a sense of exile from their homelands and committed to remain where they were by direction of the Commonwealth Government. Papanya was filled with twilight people, whether they were black or white, and it was a place of emotional loss and waste, with an air of casual cruelty."[10] The origin story of Aboriginal art is often described with notes of redemption, when its real circumstances were fraught and traumatic. Bardon observed that elders were relating stories to one another, which they recounted while simultaneously drawing patterns in the sand. He provided them with what painting materials were available, and scavenged materials, such as a sawn-up old table, were used to paint on. Their work was also articulated with crayon or pencil on paper. Overall, the imagery depicted their relatedness to the places

from which they had been taken; these are called the "Dreamings" in which the material of nature cannot be extricated from the spiritual within them. Although very little of the earliest works survive except in documentary form, Bardon's insight and initiative led to a movement that has since joined Aboriginal art royalty, including Johnny Warrangkula Tjupurrula, Long Jack Phillipus Tjakamarra, Old Mick Tjakamarra, Johnny Lynch Tjapangati, and Clifford Possum Tjapaltjarri. The paintings that have survived them are now treasured and held in Australia's national and state collections. They are also in eminent corporate collections, many ironically the beneficiaries of the policies that led to the dislocation of these and other peoples in the first place. Indeed just as the Japanese fire-insurance company Yasuda bought one of van Gogh's *Irises* for $39.9 million as a gesture to refute Western suspicions over Japanese corporate stolidness and inhumanity, it is now a common practice for large corporations such as those involved in mining, fracking, and land development, to "sanitize" their activities by investing in Aboriginal art and showing it in their corridors and boardrooms.

Despite Bardon attesting that when the artists felt comfortable and well-treated they were forthcoming about the meanings of what they were painting,[11] there is another layer to Aboriginal art that remains sacred and secret. Strictly speaking, all "traditional" Aboriginal art (in scare quotes as this term has been rewritten several times over the decades) is sacred. There is no separation of activities or genres as there is in Western art. Causing more complications is the matter of the secret, which means that certain meanings are only available to the initiated—it is also possible for an artist to be permitted to use a certain motif without having yet been initiated into its fullest meaning. All of this is anathema to modern Western art, which is accustomed to the separation of church and state, and where it is a given that it is the product of an independent subject. (While attribution to individual works of Aboriginal art is to a single author, traditional Aboriginal artists consider them as belonging to a spiritual and social collective, and it is a regular practice to paint collaboratively.)

Once Aboriginal art had become a cultural quantity on the public market of sales and exhibitions, the tenet of secret-sacred would find itself mired in a number of impasses, beginning with the simple fact of the secularity of the contemporary art market. Many Aboriginal elders were dismayed at the misplacement, popularizing, and ultimately the cheapening of codes and lore that defined the essence of their people for thousands of years. In Christian terms, this amounted to mass desecration. But it was also this awareness by non-Indigenous people that important content is withheld from view that whetted their appetite, and in more than one way. First, it satisfied the primitivist prejudice of something mysterious and proscribed from the white man's eyes—in Orientalist-speak the metonym for this is the harem. And second, when something is not given, it is for that all the more desirable. Third, the visual syntax of the unknown was a hieroglyph to be deciphered at moral cost; such was the will of

the colonialist, not to respect the secrets of the colonized. So for some content to be unknown, and for the non-Indigenous viewer to know this and not to pursue the meaning, was to satisfy the guilt of colonization. Not to overstep the barrier of difference was to show benevolent obedience to revisionist ideology. Finally, the frontier of the unknown and the unknowable proved exceedingly convenient to the Australian and international curatorium, for it meant that there was nothing they needed to find out about. Inaction and a lack of curiosity were rewarded with the belief that you were doing your postcolonial, post-Orientalist duty.

The debates that were waged about the new forms of display within Aboriginal communities themselves were without consensus, revealing the many differences in custom and tradition. Identified early was to resist the restrictive typology enforced by Western "primitivist" anthropology that ritually integrated societies were cyclical, while Western society was progressive. A slow but growing consensus was that for Aboriginal art to be taken seriously as on par with the best non-Indigenous work, it must be open to the same channels of criticism and assessment. This still posed problems for the critics, which included Indigenous ones, uninitiated into the traditions of an artist of a particular country (the name now given the region of a particular group). The big question, the proverbial elephant in the room, was: how does one gauge spirituality? Is one painting more adequately spiritual than another? But the role of critical legitimacy also fed into artistic legitimacy. For the dots that are the most famous feature of Aboriginal art are not germane to all Indigenous peoples. Yet even as early as the 1980s, with the popularization of Aboriginal art, they had begun to be used by artists for whom it was not their indigenous style. Non-Indigenous artists also made forays into dotting, some with the excuse that they had been granted use of the dot by an Aboriginal group. But which group is able to do so? There are also recent cases of young white artists brazenly copying traditional Aboriginal styles, which caused outcry by Indigenous and non-Indigenous alike. Ultimately, the question of appropriating sacred Aboriginal styles and motifs—the question of "who owns a dot?"—boils down to one of disenfranchisement. It is one thing to appropriate Western art, but it is quite another to take indiscriminately from peoples who, at the time of writing this, are still not written into the national constitution.[12]

By virtue of sheer quantity, however, dots are very much the "trans-style" of Aboriginal Australians. Their universality has occurred together with that of the musical instrument, the didgeridoo, the onomatopoeic pidgin, whose real name is the *yidaki*, a sacred instrument of the men indigenous to the northwest cape of Arnhem Land. The dot designs were based on the Papanya "classics" of the Bardon years, but like all overcirculated and hypersimulated imagery, the dot has become unmoored from its origins and assumed its own status as a universal. It is on ties, on tea towels, linen coverlets, T-shirts (most of which are made in China). Dot designs now behave as floating signifiers of Aboriginal presence and identity, with an iconicity rivaling the design of the Aboriginal Flag (the design of

an Aboriginal artist, Harold Thomas). Like all such universals, they slip into becoming solipsistic and static. And like all universals, they are used by people whose cultural positions and identities usually amount to the opposite, namely they are used to give continuity to discontinuity, to give regularity to irregularity, certainty to uncertainty. But in other circles of Aboriginal Australia the dot and the didgeridoo are eschewed, and it is this complex hybridization of identity and identity manufacture that can be the most intriguing and engaging.

Miscegenated cultures

Although the didgeridoo continues to be an item of fascination for Indigenous and non-Indigenous Australians, contemporary popular Indigenous music expresses the plight of its people in forms that blend recent mainstream styles. While many practitioners leaning in preference to country and western and reggae, Indigenous music reveals yet again that the expectations about what such music should be are still those of a largely white outsider's perspective. For while aspects of Aboriginal identity continue to circulate around an instrument like the didgeridoo,[13] the most creative and heartfelt Aboriginal music is a bricolage of elements which are hard to categorize as a whole. As an analogy to much contemporary Aboriginal art, Aboriginal country music reveals how fraught are the notions of what may be deemed correct or authentic. And it is yet more evidence that standards of authenticity belong to the venerable ideology of the Western obsession with primitive man as the bearer of a stable truth.

In her close study of the popular Indigenous music of Central Australia, the Swedish anthropologist, Ase Ottosson, proposes that:

> Every performance is a healthy reminder of the futility in trying to fix categorically what others and selves are and can be. They provide a counter-narrative to a globally widespread preoccupation with defining and purifying national, racial, gendered and other forms of being in ways that delimit, and, at times, violate, people's rights to define their experience and existence in their own terms.[14]

"Mongrel" is used frequently by the musicians themselves for the music they make: a composition of untraceable components and of uneven proportions. It is not a pejorative, as Aboriginal vernacular is much inclined toward giving negatives and expletives positive meanings. Ottosson affirms that "the desert men do not deliver on the privileged and narrow expectations of 'real' and 'authentic' Aboriginal music and people." Rather, there is an "ongoing history of appropriations, adjustments, mutual influences, conflicts and mutual 'othering' among the parties involved." The final point is worth pondering, as what is important is the act of resistance through differentiation, and this is achieved

through exchange of artistic (musical) expression. Thus identity is wrought through conscious enactment through personal choice and communication. For Ottosson these men "are co-implicated and co-productive in their crafting of changing their 'mongrel' selves as men and Aboriginal."[15]

Ottosson reports of repeated cases of reactions of non-Indigenous Australians to such music, which is to be perturbed by how it does not comply with expectations and how it does not follow anything that can gauge its authenticity.[16] Instead, this authenticity lies elsewhere, in the border-zone of the "intercultural."[17] This occurs not only on the level of style and approach but in social interactions. Music becomes a modulator, or a glue, "for connecting and mediating such different ways of being and becoming men and Aboriginal."[18] To the chagrin of the outside observer looking for hints of the afterglow of the noble savage, the musicians of Central Australia actually avoid mixing ancestral content into their music, or making direct references to them.[19] As Ottosson explains, the separation of sacred and secular, of ancestral and non-ancestral, is a given and not the subject of further comment. "If prompted, most of them simply state that 'the Law is too strong, too secret'."[20] "Law" is purposely ambiguous and purposely definite. But that does not mean that the music that they perform is a diversion or straying from traditions. Now that their brand of country music has been played for several generations, it is seen as having its own ancestry, and its own autonomy, with references to white origins long out of the equation.[21] Indeed it is with a miscegenated music that Aboriginal men might share experiences that are global and universal, such as male loneliness, longing for country, falling into crime, or suffering from a broken heart.[22] Like many other Indigenous peoples around the world, including the Native Americans and the Inuits of Greenland and Alaska, it is a separation wherein the ancestral forms remain private and are reserved for their relation and claim to land.[23] The more overarching insight of Ottosson's work is to expose the friction between the hybrid, "mongrel" frameworks alive in Aboriginal cultures as against the still regnant academic impulse to prize out "authentic" and "traditional" features for study over other practices that are integral to the changing and heterogeneous nature of Indigenous groups. "It is through attending to these and other forms of overtly (inter) culturally messy practice that we can begin to account for the multifaceted and place-specific ways in which indigenous people experience, act and identify in their contemporary lives."[24]

Aboriginal art is white, or not black enough

The digression into the contemporary Aboriginal music of Central Australia acts as an alibi and counterpoint to the yet more "messy" philosophical and political

configurations of contemporary Aboriginal art. The artists that are singled out here—Richard Bell, Blak Douglas, Tracey Moffatt, and Christian Thompson—all present provocative alternatives that explode the tenacious beliefs in a homogenized and authentic core to Aboriginal culture and identity. As artists they position themselves against such preconception and stereotype, and they are formidably conscious of the desire of the white public to categorize and quarantine them. Some more activist than others, their work regularly reflects on Aboriginal art not just as a separate entity, but the opposite as a conjunction. Aboriginal art is no longer to be seen as a style per se but a device, a mechanism, and an idea. Facing bigotry and ignorance is inevitable for any Indigenous person, but the art, which may refute and expose injustice, is also a tool for communication. And in its physical presence in the art gallery or elsewhere, it is a continual, persistent assertion of staking a claim to land and of being present. In his comparison of the differences between Aboriginal and European mapping methods, Terry Smith remarks that: "For those artists who live away from their communities, or who are the children of those separated from their families during the assimilationist period of the 1940s and 1950s, actual or *psychic* journeying is a frequent subject."[25] This psychic journey may be to a place that has been effaced and the language lost, but is cherished all the more for that loss. The psychic sojourn to the void is an important movement toward reclamation.

Bell, Douglas, Thompson, and Moffatt are artists who are representative of yet another form of identity agonism. Their own artist personas have been exercises of self-recreation, while an artist such as Tracey Moffatt prefers not to be called an Aboriginal artist, despite some of her most celebrated work being penetrating and moving investigations into some of the many dark and deleted chapters of Aboriginal history after white occupation. (She is far from alone is such reticence, which is chary of the way in which artists of color are "primitivized," and thereby reduced to the tired clichés of "country of origin" and homogeneity.)[26] While all have had their share of international success, however, it is "traditional" Aboriginal art that stays the chief interest of the world art market. The division between modern, contemporary—the corollary in fashion is that between modern and ethnic dress—and traditional has become harder to draw, not that Aboriginal art has become more mainstream and institutionalized. Urban contemporary artists, working within idioms proper to artists around the world, from painting to video and installation, believe the constrictions lie in the assumption that it places an embargo on their own claim to spiritual content, while "traditional" artists defend their art to be as contemporary and evolving as any other.

What is certain is that the Aboriginal artists working in the international styles of contemporary art—and this holds for almost all indigenous art that employs similar methods—occupies a transorientalist "third" or middle space. In the 1980s, when urban contemporary Aboriginal artists began to be identified as

such, the common ethos was that of an anomie to the visual languages they were using, as they were not of their choosing. (The paradigm in literature is Irish writers writing in English.) However this has changed for many artists who simply see the numerous styles and conventions of contemporary art as a global lingua franca—much as Indian literature embraces English. To advance this notion, one need only look at Blak Douglas, the trade sobriquet for Adam Hill. Born of a dark-skinned Aboriginal father and a white mother of Irish extraction, "Blak Douglas" signals this duality in a synthesis in which this duality is maintained. In name, it enunciates Spivak's "double bind" but displaces the need for a solution, the solution lies in the symbiosis not the sublation.

In 2003 Richard Bell won the Telstra National Aboriginal and Torres Straight Islander Award, considered the most prestigious of its kind, with the painting, *Scientia E Metaphysica (Bell's Theorem)*. It is an iridescent irregular patchwork grid dominating a black ground on the left and a white ground to the right, with the words in various fonts, "Aboriginal Art is a White Thing." Overlaying the primary surface is a large red triangle and snaking dribbles of white and black paint. (By this time the references to Pollock had become fairly established, as it drew a parallel between the desert artists who painted on the horizontal with Pollock's drip technique.) These words would soon become a mantra for Aboriginal artists. The use (imposition) of Western techniques, media, and ideas had long been politely questioned, but Bell's work, and others related to it, had a catalytic effect. For one, they placed the ethics of making, exhibiting, and selling Aboriginal art at the epicenter of contemporary Aboriginal culture, exposing the many acts of bad faith by white people. This included the well-known exploitation of Aboriginal artists with limited English, reluctance to enter cities, and no knowledge of the art market. By the new millennium, Aboriginal art had reached the establishment, and it was a convenient means of assuaging the conscience, a mechanism of cleansing the past, in which Aboriginal art performed an erasure, literally a protective aesthetic screen over the traumatic core.

A year before, in 2002, Bell wrote his polemic "Bell's Theorem," with the ironic reference to the original Bell's theorem propounded by the Irish physicist John Stewart Bell (questioning the consistency of predictions in quantum mechanics), whose alternative title, in a convenient twist for the artist, is "Bell's Inequality." Richard Bell immoderately argued that the spiritualism in Aboriginal art—which is after all an impassable frontier for the uninitiated—is a form of aesthetic quarantine that is in the guise of respect. Bell demands that Aboriginal art "be seen for what it is—as among the world's best examples of Abstract Expressionism. Ditch the pretense of spirituality that consigns the art to ethnography and its attendant 'glass ceiling.' Ditch the cultural cringe and insert the art at the level of the best in Western art."[27] In the introduction, Bell announces that "There is no Aboriginal art industry. There is, however, an industry that caters for Aboriginal art." These words have a ringing sound. Aboriginal art is, by implication, both packaged and

consumed by forces that are, in truth, hostile or indifferent to Aboriginality as such. Bell counters that Aboriginal art be placed on a par with one of the heroic narratives of twentieth-century modernism, only to suggest that Indigenous Australians had it in the bag thousands of years before Clement Greenberg's climactic and heroic vision was ever conceived. There are of course more than a handful of problems with this assertion: that it dehistoricizes an historical moment; that it plays loose with spiritual content that many Aboriginal artists hold dear; that it defies cultural specificity—yet these same problems are precisely those that are perpetrated against Aboriginal art. Bell has just turned them on their head. To go back to the art of the white men and say that it has been done better is to perpetrate the same solecisms disregarding context and intention that have ensured that Aboriginal art remains to a large extent insulated from criticism (especially when "traditional") and ensured its status as floating aesthetic signifiers.

Rousing as it is, Bell's exhortation that Indigenous artists divest themselves of spiritualism is anathema to other Aboriginal artists who have a sincere and deep bodily connection to people, land, and lore. It does however help to locate another blind spot in how Aboriginal art is consumed as a commodity and an intelligible object. The spiritualism debate with Aboriginal art, or indeed with any culture whose religious beliefs do not conform to the Judeo-Christian model, is subject to adulation or vilification. The spiritualism in Aboriginal art is a convenient no-go zone that insulates Aboriginal artists from commentary, and non-Aboriginal voices from commenting about it. The greatest beneficiaries, however, of this semantic limbo are artists who manipulate the muteness of the spirituality card and the curators who have no stake in formulating any other message than the semblance of "balanced representation." Nor can the spiritual dimension that ties people, language, and land together, of the majority of genuine (which include ostensible non-"traditional") Aboriginal art be ignored or transvaluated. Broadly speaking, Aboriginal art, and especially the "traditional" kind, inhabits two realms: that of pure earth and pure spirituality; prethought matter and omniscience. One is particular, the other is universal; both are unknowable and inarticulable. Non-Aboriginal art exists between these two poles, aspiring to both. And yet it is the non-Aboriginal settings of art as we know it—the art market and the loaded ideology of the museum—that foisted these expectations on Aboriginal art in the first place. Since non-Indigenous people "made" Aboriginal art in the sense of enframing it and controlling the way it is distributed and seen, it is preposterous to then expect this art to be more forthcoming about its content. To ask why Aboriginal art is more insulated from criticism than non-Aboriginal art avoids the deeper truth that the non-Aboriginal "system" has made it this way. Airy realms of the inarticulable accommodate a convenient platform for non-Aboriginal art to shape its own fantasies of identity and awareness.[28] It is also fair to assert that this is a global problem that spreads to all art identified as

First Nations and belonging to a religious ritual system unlike that of the mainstream models.

The quandaries, for both Indigenous and non-Indigenous people alike, of the legitimacies inherent in Indigenous art will remain persistent so long as the subaltern of the "aboriginal" (in the sense of the first person) is maintained, either through neglect or fetishization. But such politics will not allow other perceptions and procedures to circulate. As Ian McLean observes of Bell's provocation, it "seems more postmodern irony than serious critique, not because it may not be true but because the postmodern condition is as ubiquitous in remote Aboriginal communities as it is elsewhere."[29] By this McLean means the ways that artists exchange motifs, borrow (and steal, following the meaning in the euphemism "appropriation") from one another, and therefore engage in intertextual experiments. It is also the way that artists play with appearances with strategies reflecting a non-linear perspective of history.

Occupying multiple spaces

Such ranging across different continuities of time that McLean compares to standards of postmodernism is not a science fiction conceit but is highly credible when considering the much-omitted historical fact of the vast diversity of Aboriginal peoples at the time of colonization. Unlike the residual myths of the noble savage lording over a pristinely contained culture, Aboriginal cultures both past and present have actively sought out exchanges with other groups that help enrich their own. With the introduction (imposition) of other cultures, occupying multiple cultural spaces is the norm for almost all Aboriginal peoples, and for many a cause of pride. The "trans" space not only straddles the white–black nexus or divide, it is global: prominent artists such as Vernon Ah-Kee and Jason Wing identify with both Indigenous and Asian ancestry, Korean and Chinese respectively.

For such artists, including Blak Douglas, mentioned earlier, their work regularly turns to the space of the multiple—it is not the language of the exile or the displaced, but one of ardent dissent predicated by their assertion of a form of belonging not readily given them. For Blak Douglas confronts these issues directly, with exhibition titles such as *NotaProppaBlak*, signifying the gatekeeping that occurs among Indigenous communities themselves based on the precepts of authenticity used as hierarchical standards. In other works Blak Douglas has made doctored flags with text, which are displayed as floor mats, as commentaries on the barriers and rites of passage between, and within, different racial identities. Moreover, an important arm of Blak Douglas' practice is collaborative (including with the present author). Since he is seen as an Aboriginal artist (despite the cognate that his assumed name denotes), he sees his collaborations with non-Indigenous artists as more

than a complement of minds, but also a political act of common activity, but more than that, as a creative performance that defies categorizing. To what extent can a collaboration between white and black be called "Aboriginal art"? Where is "Aboriginality" situated? What is appropriate to Aboriginal art and what is not? These are questions that need to be asked regularly and will always be met with different answers. Douglas' work, as in the cultural portmanteau of his name, is a deliberate ideological adulteration that is a fillip to the glib curatorial taxonomies rife in contemporary art.

Similarly, the work of the photographer and filmmaker Tracey Moffatt traverses multiple domains, including a longstanding collaboration with the non-Indigenous filmmaker Gary Hillberg. One of Moffatt's most celebrated earlier works is the photographic series, *Up in the Sky* (1997), which reads as film stills taken from a larger narrative about events involving the stolen generation, where children were forcibly removed from their parents and "civilized" by Christian missionaries and white parents. In their visual poetry and their haunting empathy, these works had a lasting presence in Australian contemporary art, and have moreover acted as a resonant conscience for the injustices on Aboriginal people. In contrast, her work with Hillberg is predominately of film montages or mash-ups, the best known of which is *Love*. Consisting of excerpts from the golden age of Hollywood cinema, the work is in two parts, first of violent acts (shouting, slapping) of men to women, then of women to men (shooting). More recent series, such as her contribution to the Sydney pavilion of the 57th Venice Biennale (2017) saw a return to earlier themes. However the suite *My Horizon* carefully resisted being locked or reduced to Indigenous themes as such. While proclaiming "Indigenous rights," her installation also proclaimed "refugee rights." The works spoke to the very present problem of refugeeism and that indigenous rights continue to be

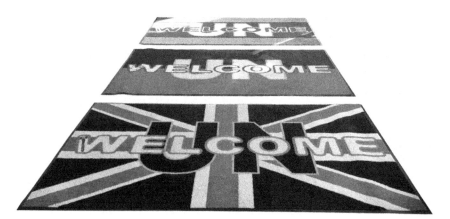

Figure 38 Blak Douglas, *(Un)Welcome Mats*, 2010, industrial floor mats, 90 × 180 cm. Courtesy the artist.

Figure 39 Tracey Moffatt, *Up in The Sky #9*, 1997. Off-set print, 61 × 76 cm. (71 × 102 cm. paper size). Courtesy the artist and Roslyn Oxley9 Sydney.

bypassed. Searching and contemplative, the photographs and videos revolved around themes of yearning for place and home, all the more powerful for being free of sentimentality.

Also photographic, the work of Christian Thompson engages with the decentered self both as an Indigenous artist of mixed heritage and as a gay male. The armature of his work is almost exclusively his own body, which he drags or dehumanizes. In some works he is a strange and sinister carnivalesque character, in others he is all but effaced by elaborate improvised masks made by leaves or flowers, in some sequences natives. One much-reproduced work is exclusively in the colors of the Aboriginal flag—red, yellow, and black—where the artist is against a red ground, his body painted yellow staring forebodingly at the viewer with blackened eyes, his head covered in feathers, two shooting out on either side. In keeping with what in Western parlance we would call the Dionysian ritual, pleasure and danger come together: this figure is both "primitive" totem and demonic clown. Queering occurs in Thompson's work in the more subtle sense of drag as an enactment into a transitional state in which the biological self is all but obliterated for the sake of becoming an impossible ideal, an ideal whose traits are often so extreme as to become grotesque.

Figure 40 Tracey Moffatt, *Tug*, 2017 from the series *Passage*. Digital C-print on gloss paper, 102 × 153 cm. Courtesy the artist and Roslyn Oxley9 Sydney.

These artists are potent examples of cultural practices—not only in the visual arts but in theater, film, literature, and music—of First Nations peoples in the era of globalization. There is still the need to reclaim place and nation and to safeguard community, language, and lore, but a salient trait is the lack of essentialism in the best of these artists. Many, such as those discussed briefly above, do not see themselves as occupying margins, although they do deal energetically with marginalization, which is not necessarily confined to their own immediate people or group. "Miscegenation" is an unfortunate term for the negative connotation of the prefix, "mis," which implies an incompleteness or an error. Better to use the term "cognation" to define a state of multiple belonging, and plural commensurability. We all share the same sky, and it can be read in more than one way, and, comfortably, in several ways by the one person.

9
CONCLUSION: FLOATING SIGNIFIERS

And as memory, when duly impregnated with ascertained facts is
sometimes surprisingly fertile, Mr. Snell gradually recovered a vivid
impression of the effect produced on him by the peddler's countenance
and conversation. He had a "look with his eye" which fell unpleasantly
on Mr. Snell's sensitive organism. To be sure, he didn't say anything
particular—no, except that about the tinder-box—but it isn't what a
man says, it's the way he says it. Moreover, he had a swarthy
foreignness of complexion which boded little honesty.[1]

GEORGE ELIOT, *SILAS MARNER*

Of the many speculations over the stolen gold of the humble village weaver, Silas Marner, one turns to a nameless peddler whose wares include earrings. When asked if he also wears them, Mr. Snell replies, "Well, he'd got ear-rings in his box to sett, so it's nat'ral to suppose he might wear 'em." The earrings become the topic of village-wide speculation, and "the parson had wanted to know whether the peddler wore ear-rings in his ears, and an impression was created that a great deal depended on the eliciting of this fact."[2] Given the overall uncertainty, the power of mass speculation led to the "image of him *with* ear-rings, as the case may be; and the image was presently taken for vivid recollection," coalescing into a number of earnest testimonials of conviction, each one feeding on the one before it.[3] When the matter is later brought before the local magistrate, "an inquiry was set on foot concerning a peddler, name unknown, with curly black hair and a foreign complexion, carrying a box of cutlery and jewelry, and wearing large rings in his ears."[4] The anonymous culprit of the theft of Marner's much toiled-for small fortune is a foreigner and therefore suspicious. The conviction of his guilt mounts in proportion to the circulation of rumor, insinuation, and suggestion. So does his description, with a "foreign" (meaning swarthy) complexion and large earrings. He is the ultimate floating signifier. The vagaries

of Orientalism are conveniently deployed to a scapegoat who neither exists nor is actually to blame. But the idea of the quasi-oriental peddler-cum-thief has become thoroughly ingrained, the truth firmly harnessed to the exotic qualities in his creation. While baseless to the problem at hand, he has qualities that fit criteria that have once been grounded in facts. The facts have subsequently gone astray to be governed by the inventions of the will.

It is also the intangibility of the idea, plucked from nowhere, then becoming a persuasive and genuine alibi, that makes this scene an apt way of conceiving transorientalism. It is a transferable agent that is transacted across ideas, bodies, materials, and places. It is a credible fantasy. Like myth, it holds together the mobility of values according to an ostensibly stable order. As entrenched within the intricate and contested notion of Orientalism, transorientalism is a tarrying with otherness, and deeply imbibed with the frisson of exoticism. It can be nostalgic, and as it is tied to a nameless past, it is unencumbered by verification. Yet to call it fantasy is not to imply that it follows no rules. Fantasies tend to follow fixed, often clichéd, structures, as psychoanalysis has shown us.

The arguments and examples of transorientalism proposed in this book speak to this mobility, but with constant cause to note that the recognition of the processes of fluidity, variability, and imagination are not themselves sole justifications for complete freedom of appropriation. Chinoiserie is a special case, as it is something that was created in an historical osmotic collaboration between East and West. For Japan, it is hard to extricate what is "genuinely" itself, what is given priority as Japanese, and what is forcibly molded or invented to be Japanese as such. Meanwhile Islamic contemporary art continues to flourish in the urban centers condemned by fundamentalism. While rooted in respective histories of multiple oscillations of cultural exchange and appropriation, especially in the eras of art, film, and fashion, "Asia" the "East" and the "Orient" are manifestly floating signifiers. What is "repressed" is in fact empty, but the language of repression, of withholding, of a secret, keeps the fascination alive. Transorientalism is the recognition of the fluidity of culture yet simultaneously that a sense of circumscription, autonomy, and coherence needs to be believed in order for "Orientalism" to be inscribed within art and culture. This is in no way to say that transorientalism is an admission of some counterfeit status, rather it is more a cultural version of the death of God: one needs the death of God to realize the extent to which He persists. Transorientalism is a powerful device of self-registration. It also brings to the fore the persistence of the imaginative effort in the many acts of identifying as man or woman, as belonging or as other.

If we look back to the many melancholy statements made by Edward Said about exile, in a contemporary light we can look on it from two angles. The first is from the perspective of the displaced and alienated voiceless millions due to war, disease, environmental disaster, and victims to political whim. This is forced

exile shorn of the romantic exile's bittersweet regret. Refugeeism is a neologism for a worldwide malaise that is to remain for a long while yet.

The other is that the feeling of exile and belonging has shifted dramatically: it is now common for people to identify in different ways according to the spaces—physical, virtual—they might occupy. The hyphenated and "trans" identity less seen as a subsidiary of the unitary (white, Anglo) identity, but something unto itself with numerous members and a long history. Members of minority groups such as those identifying as indigenous, may enunciate and interpolate themselves as indigenous in one forum, and not in another. Thus the visual, aesthetic registers to assert such experiences, as well as the ownership, authenticity, and legitimacy of signs of identity, have become subject to scrutiny and to renewal. A keynote to all of this is belonging. The choices of the belonging can be inherited, consensual, but more importantly, shaped and asserted by the creative performances of the cultural self.

NOTES

Introduction

1 Hermann Hesse, *Aus Indien*, Frankfurt am Main: Suhrkamp, 1980, 81.

2 Hesse, *Aus Indien*, 80.

3 Ibid., 85.

4 Edward Said, *Orientalism: Western Conceptions of the Orient* (1978). Harmondsworth: Penguin, 1991.

5 Ibid., 290.

6 Said: "unlike normal ('our') societies, Islam and Middle Eastern societies are usually 'political', an adjective meant as a reproach to Islam for not being able to separate (as 'we' do) politics from culture. The result is an invidiously ideological portrait of 'us' and 'them'." Ibid., 299.

7 Said, *Culture and Imperialism* (1993). London: Vintage, 1994, xxiii.

8 Ibid.

9 Ibid., xxx.

10 Said, *Reflections on Exile and Other Essays*, Cambridge MA: Harvard University Press, 2000, 87.

11 A forceful recent revision of Said's thesis can be found in *The Birth of Orientalism* by Urs App. As opposed to Said's predominately nineteenth-century emphasis, App turns to the eighteenth. He also looks more broadly at the way that Asian documents were studied, translated, and interpreted, and their profound influence in the burst of knowledge creation in this period. Urs App, *The Birth of Orientalism*, Pennsylvania: University of Pennsylvania Press, 2015. I am grateful to Rey Chow for bringing this book to my attention.

12 Teju Cole, *Known and Strange Things*, New York: Random House, 2016, 11.

13 Ibid., 10.

14 Ibid., 104.

15 Chinua Achebe, "The African Writer and the English Language," in Patrick Williams and Laura Chrisman, *Colonial Discourse and Post-Colonial Theory*, New York: Columbia University Press, 1994, 434.

16 Geczy, *Fashion and Orientalism: Dress, Textiles and Culture from the 17th to the 21st Century*, London and New York: Bloomsbury, 2013.

17 Said, *Culture and Imperialism*, xxviii.

18 Cit. Tony Judt, "Edward Said: The Rootless Cosmopolitan," in *Reappraisals: Reflections on the Forgotten Twentieth Century*, New York: Penguin Press, 2008, 166.

19 Ibid., 164.

20 Ibid., 165.

21 Derived personal interaction with the late Ihab Hassan.

22 Homi Bhabha, *The Location of Culture*, London and New York: Routledge, 1994, 51.

23 It would be distracting at this point, and would involve an abrupt change of tone, to go into detail as to the philosophical dimensions of this dynamic which now has a considerable history in the wake of Marx and Freud. The notion that antagonism lies at the heart of identity, that the wholeness of identity is not so much defined by what it is not, but more subtly that the wholeness is itself an incompleteness whose very ontic truth is that of perturbation itself. As Slavoj Zizek puts it: "Let's take the most traditional case imaginable: class struggle. There is no 'neutral impartial' approach to it, no metalanguage, every apprehension of class struggle is already 'distorted' by the subject's engagement in it, and this distortion, far from preventing our direct approach to the actuality of class struggle — it is in this very failure to subtract its own partial perspective and reach the object that the Real inscribes itself, that the subject touches the Real. So it is not just that the subject always fails, etc.: *it is through this failure that the subject reaches the Real*" (*Disparities*, London and New York: Bloomsbury, 2016, 103). These observations can easily be translated to the thesis of this book in terms of the tensile relationship between self and cultural other.

24 Norman Davies, *Vanished Kingdoms: The Rise and Fall of States and Nations*, London: Viking, 2011, 2.

25 Peter Sloterdijk, *Im Weltinnenraum des Kapitals*, Frankfurt am Main: Suhrkamp, 2006, 53.

26 Ibid., 49.

27 Ibid., 19ff. See also Slavoj Zizek: "What Sloterdijk correctly points out is that capitalist globalization stands not only for openness and conquest, but also for the idea of a self-enclosed globe separating its privileged Inside from its Outside. These two aspects of globalization are inseparable: Capitalism's global reach is grounded in the way it introduces a radical class division across the entire globe, separating those protected by the sphere from those left vulnerable outside it." *Against the Double Blackmail: Refugees, Terror and Other Troubles With Neighbours*, London: Penguin/ Allen Lane, 2016, 5–6.

28 Cole, *Known and Strange Things*, 345. Cole also writes: "I write all this from multiple positions. I write as an African, a black man living in America. I am every day subject to the many microaggressions of American racism. I also write this as an American, enjoying the many privileges that the American passport affords and the residence in this country makes possible. I involve myself in this critique of privilege: my own privileges of class, gender, and sexuality are insufficiently examined. My cellphone was most likely manufactured by poorly treated workers in a Chinese factory. The coltan in the phone can probably be traced to the conflict riven Congo. I don't fool myself that I am not implicated in these transnational networks of oppressive practices." Ibid., 344.

29 Orhan Pamuk, "André Gide," *Other Colours: Writings on Life, Art, Books and Cities*, trans. Maureen Freely, London: Faber and Faber, 2007, 210, emphasis added.

30 Bhabha, *The Location of Culture*, 37. Writing on the identity of Turkish women living in Germany, Katherine Pratt Ewing states that: "Cultural production in this domain has increasingly elaborated a fluid space of integration that is moving away from the dichotomies of earlier films into what Bhabha has called the 'third space of enunciation' (Bhabha 1994a: 37). As film-makers of Turkish background establish themselves in German cinema, cinematic depictions of youth of Turkish background are showing new flexibility, but they continue to be shaped by these founding dichotomies. Bhabha's (1994b) concept of mimicry is apt for characterizing the discursive space of this cultural production: almost German, but with a difference." "Between Cinema and Social Work: Diasporic Turkish Women and the (Dis)Pleasures of Hybridity," *Cultural Anthropology*, 21.2, May 2006, 275.

31 Trinh Minh-Ha, *Elsewhere, Within Here: Immigration, Refugeeism and the Boundary Event*, London and New York: Routledge, 2011.

32 Slavoj Zizek, *The Ticklish Subject: The Absent Centre of Political Ontology*, London and New York: 1999, 264–265.

33 Gayatri Chakravorty Spivak, *An Aesthetic Education in the Era of Globalization*, Cambridge MA: Harvard University Press, 2012, 30.

34 G. W. F. Hegel, *Lectures on the History of Philosophy*, trans. E.S. Haldane and Frances E. Simson, Lincoln: University of Nebraska Press, 1995, 1: 150.

35 Zizek, *Disparities*, 152.

36 Paul Bowman, in Paul Bowman ed., *The Rey Chow Reader*, New York: Columbia University Press, 2010, xii–xiii.

37 Rey Chow, *Sentimental Fabulations, Contemporary Chinese Films*, New York: Columbia University Press, 2007, 11.

38 Ibid., 12.

Chapter 1

1 Friedrich Nietzsche, "On Truth and Lying in the Extra-Moral Sense," in *Werke*, Munich: Verlag Das Bergland-Buch, 1985, 4: 546.

2 Ibid.

3 Slavoj Zizek, *Less Than Nothing: Hegel and the Shadow of Dialectical Materialism*, London and New York: Verso, 2012, 313–314.

4 Gary Saul Morson, "Will We Ever Pin Down Pushkin?," *New York Review of Books*, March 23, 2017, 43.

5 Zizek, *The Ticklish Subject: The Absent Centre of Political Ontology*, London and New York: Verso, 1999, 453.

6 Davies, *Vanished Kingdoms*, 4.

7 Zizek, *Less Than Nothing*, 914.

8 Ibid., 733.

9 Ibid., 738.

10 Ibid.

11 Benedict Anderson, *Imagined Communities: Reflections on the Origin and Spread of Nationalism*, London and New York: Verso, 1986, revised 2006, 6.

12 Ibid., 209–210.

13 Partha Chatterjee, *Nation and Its Fragments: Colonial and Postcolonial Histories*, Princeton: Princeton University Press, 1994.

14 Zeynep Kezer, *Building Modern Turkey*, Pittsburgh: University of Pittsburgh Press, 2015, 197.

15 Anderson explains that preoccupation of his book "was both visibly sympathetic to many forms of nationalism and yet deliberately interested less in the particular nationalist mythologies dear to nationalists' hearts, than in the general morphology of nationalist consciousness." Ibid., 227.

16 Gyan Prakash, "Writing Post-Orientalist Histories of the Third World: Perspectives from Indian Historiography," in Vinayak Chaturvedi ed., *Mapping Subaltern Studies and the Postcolonial*, London and New York, 2000, 163.

17 Trinh Minh-ha, "Outside In Inside Out," a paper delivered at the Conference, "Third Cinema and Practices," Edinburgh International Film Festival, August 1986, reprinted in *When the Moon Waxes Red: Representation, Gender and Cultural Politics*, London and New York: Routledge, 1991.

18 Ibid., 65.

19 Ibid., 70.

20 Ibid., 70–71.

21 Ibid., 72.

22 Ibid.

23 "A Minute Too Long" (1988) in ibid., 107–108; emphasis in the original.

24 Ibid., 76.

25 Ibid., 76.

26 Ibid., 112; emphasis in the original. The passage from which this statement comes is worth quoting more thoroughly: "The notion of the film image as a precise observation of our daily environment and activities, takes us straight back in the case of Tarkovsky, who like Sergei Eisenstein in part likened his filmmaking to the poetic principle of the haiku. 'What attracts me to Haiku', wrote Tarkovsky, 'is its observation of life—pure, subtle, one with its subject . . . And although I am very chary of making comparisons with other art forms, this particular example from poetry seems to me close to the truth of cinema.' To me, the inspiring works of art are those that cut across the boundaries of specific art form and specific cultures, *even in their most specific aspects*. ('Whenever culture is limited,' says filmmaker Sarah Maldoror, 'it stagnates.') Some well-known examples in the arts and the humanities of the West include Brecht's powerful work influenced by Chinese and Japanese theaters; Eisenstein's filmic portraits and methods of montage inspired by Sharaku's drawings and paintings; John Cage's silences and music inspirited by Zen Buddhism; Roland Barthes' *écriture* informed by the principles of Asian art, which he describes as 'always seeking to paint the void' or better, as grasping the 'representable object in that rare moment when the plenitude of its identity falls abruptly into a new space, that of the *Interstice*.'"

27 Ibid., 152.

28 Spivak, *An Aesthetic Education*, 120. Another version of this reads: "Culture is a package of largely unacknowledged assumptions, loosely held by a loosely outlined group of people, mapping negotiations between the sacred and profane, and the relationship between the sexes." Ibid., 465.

29 Ibid., 471.

30 Ibid.

31 Ibid.

32 Stuart Hall, "Cultural Identity and Diaspora," in Williams and Chrisman eds., *Colonial Discourse and Post-Colonial Theory*, 393.

33 Ibid., 394.

34 Ibid., 402.

35 Trinh, *Lovecidal*, 2.

36 Giorgio Agamben, *Homo Sacer: Sovereign Power and Bare Life*, trans. Daniel Heller-Roazen, Stanford: Stanford University Press, 1998.

Chapter 2

1 Pamuk, "André Gide," *Other Colors:* 207.

2 Ibid., 211.

3 Ibid.

4 Ibid., 211–212.

5 Ibid., 212.

6 Ibid., 213.

7 Maximillian Novak, "Crime and Punishment in Defoe's 'Roxana'," *The Journal of English and Germanic Philology*, 65.3, July 1966, 459.

8 Isabel Breskin, "'On the Periphery of Greater World': John Singleton Copley's 'Turquerie' Portraits," *Winterthur Portfolio*, 36. 2/3, Summer–Autumn 2001, 123.

9 Onur İnal, "Women's Fashions in Transition: Ottoman Borderlands and the Anglo-Ottoman Exchange of Costumes," *Journal of World History*, 22.2, June 2011, 250–251.

10 Ibid., 252.

11 Ibid.

12 These included, as İnal enumerates, "Sophia Lane Poole (1804–1891), (Miss) Julia Pardoe (1806–1862), Isabel Burton (1831–1896), Isabella (Lucy) Bird (1831—1914), and Lady Anne (Isabella) Blunt (1837–1917)." Ibid., 254.

13 Ibid., 270.

14 In the words of Gábor Ágoston: "Hungarian political thinking and historiography in the late 19th Century were also influenced by the growing fear of the political aspirations of Hungary's stronger neighbour, Czarist Russia, in the Balkans, as well as by fears of Pan-Slavism and the nationalist-separatist movements of the Slavic people within the borders of the Austro Hungarian Monarchy. In the early 1870s, during Gyula Andrâssy's ministry of foreign affairs, anti-Slav friendship with Istanbul and

the defense of the Ottoman Empire's integrity (in Order to counter-balance Russian influence in the Balkan Peninsula and to maintain the status quo there) became an official policy of Austria-Hungary. All these circumstances produced a strong pro-Turkish political climate, which was reinforced by the belief, at least in certain intellectual circles, of the Hungarians' Turkic origin, a hot topic of scholarly debates and the popular press of the late 19th Century, when the country and its historians were preparing for the millennium celebrations of Hungary's foundation. The so-called 'Ugor-Turkish war' (i.e., the Ugor-contra Turkish debate) about the Finno-Ugric or Turkic origins of the Magyars or Hungarians, which reached far beyond the scholarly Community, raised the interest of the public in studies related to the Turks and their history." "The Image of the Ottomans in Hungarian Historiography," *Acta Orientalia Academiae Scientiarum Hungaricae*, 61.1/2, March, 2008, 16.

15 Kezer, *Building Modern Turkey*, 5–6.

16 Lenore Martin, *Great Decisions*, Foreign Policy Association, 2014, 30.

17 Ussama Makdisi, "Ottoman Orientalism," *The American Historical Review*, 107.3, 2005, 2.

18 Ibid., 18.

19 Ibid.

20 Hale Yilmaz, *Becoming Turkish: Nationalist Reforms and Cultural Negotiations in Early Republican Turkey (1923–1945)*, Syracuse: Syracuse University Press, 2013, 23.

21 Camilla Nereid, "Kemalism on the Catwalk: The Turkish Hat Law of 1925," *Journal of Social History*, 44.3, Spring, 2011, 709–710.

22 Moreover, his revolutionary ideas had selectively drawn from principles of Jacobinism, and it was from the French word for "secular," *laïque*, that the words *laisizm* and *laiklik* were coined—there being until then no equivalent word in Turkish. Cengiz Çandar, "Atatürk's Ambibuous Legacy," *The Wilson Quarterly (1976–)*, 24.2, Autumn, 2000, 95.

23 Nereid, "Kemalism on the Catwalk," 710.

24 Yilmaz, *Becoming Turkish*, 27.

25 Ibid.

26 Cit. Nereid, "Kemalism on the Catwalk," 707.

27 Cit. Çandar, "Atatürk's Ambibuous Legacy," 90.

28 Yasemin Gencer, "Pushing Out Islam: Cartoons of the Reform Period in Turkey (1923–1928), in Christiane Gruber and Sune Haugbolle eds., *Visual Culture in the Modern Middle East*, Indiana: Indiana University Press, 2013, 194–195.

29 Ibid., 207.

30 Nereid, "Kemalism on the Catwalk," 709.

31 Ibid.

32 See Nereid, "Kemalism on the Catwalk," 716.

33 Ibid., 723.

34 Ibid., 724.

35 Yilmaz, *Becoming Turkish*, 34.

36 As Sahar Amer opens her book: "Islam did not invent veiling, not is veiling a practice specific to Muslims. Rather, veiling is a tradition that has existed for thousands of

years, both in and far beyond the Middle East, and well before Islam came into being in the early seventh century. Throughout history and around the world, veiling has been a custom associated with 'women, men, and sacred places, and objects'." *What is Veiling?*, Chapel Hill: University of North Carolina Press, 2014, 1.

37 Ibid., 6.

38 Ibid., 3.

39 Cit. Elizabeth Fernea and Robert Fernea, "Symbolizing Roles: Behind the Veil," in Mary Ellen Roach-Higgins et al. eds., *Dress and Identity*, New York: Fairchild, 1995, 287.

40 Ibid.

41 Ibid., 291.

42 Amer, *What is Veiling?*, 5.

43 See also Étienne Balibar, *Saeculum: Culture, religion, idéologie*, Paris: Galilée, 2012, 25.

44 For a more detailed commentary see my *Fashion and Orientalism*, 67–72.

45 Matthew Beeber, "Fashionable Misconceptions: The Creation of the East in Virginia Woolf's *Orlando*," in Pamela Caughie and Diana Swanson eds., *Virginia Woolf: Writing the World*, Liverpool: Liverpool University Press, 2015, 104.

46 Ibid., 106.

47 Ibid.

48 Ibid.

49 Yilmaz, *Becoming Turkish*, 82.

50 O. Inal, "Women's Fashions in Transition," 270.

51 Yilmaz, *Becoming Turkish*, 81.

52 Ibid., 87.

53 Ibid., 94–97.

54 Ibid., 99.

55 Celia Marshik, *At the Mercy of their Clothes*, New York: Columbia University Press, 2017, 103.

56 Ibid., 110.

57 Emelie Olson, "Muslim Identity and Secularism in Contemporary Turkey: 'The Headscarf Dispute'," *Anthropological Quarterly*, 58.4, October 1985, 161.

58 Ibid.

59 Ibid., 163.

60 H. Bhabha, *The Location of Culture*, 89, emphasis in the original. He also writes: "In the ambivalent world of the 'not quite/not white,' on the margins of metropolitan desire, the *founding objects* of the Western world become the erratic, eccentric, accidental *objets trouvés* of the colonial discourse—the part-objects of presence." Ibid., 92, emphasis in the original.

61 Valorie Vojdik, *Masculinities and the Law*, New York: New York University Press, 2012, 272.

62 Ibid., 275.

63 Ibid., 287.

64 Amer, *What is Veiling?*, 197.



Chapter 3

1 Curated by Nick Waterlow.

2 Curated by Nick Waterlow.

3 Curated by René Bloch.

4 Curated by Tony Bond.

5 K. Pratt Ewing, "Between Cinema and Social Work," 266.

6 Ibid., 285.

7 Zdenka Badovinac, "Future from the Balkans," *October* 159, Winter 2017, 106.

8 Cit. ibid. The full quotation reads: "a state without nation, a state which would no longer be founded on an ethnic community and its territory, towards a purely artificial structure of principles and authority which will have severed the umbilical cords of ethnic origin, indigenousness and rootedness."

9 For the so-called pie chart of global culture and the contrivances of representation in contemporary art see my introduction and chapter one in Geczy and Jacqueline Millner, *Fashionable Art*, London and New York: Bloomsbury, 2015.

10 Noëll Carroll, "Art and Globalization: Then and Now," *The Journal of Aesthetics and Art Criticism*, 63.1, Winter 2007, 136.

11 Geczy and Millner, *Fashionable Art*, 44.

12 Maymanah Farhat, "Imagining the Arab World: The Fashioning of the 'War on Terror' through Art," *Callaloo*, 32.4, Winter 2009, 1223.

13 Ibid.

14 http://www.ahmetogut.com/ahmetwebexploded.html, accessed May 18, 2017.

15 Ibid.

16 https://www.haticeguleryuz.com/strange-intimacies-video/, accessed May 22, 2017.

17 Ibid.

18 Zizek, *Less Than Nothing*, 846.

19 https://www.haticeguleryuz.com/strange-intimacies/

20 Avishai Margalit, "Miral: *Miral-Miriam*," *October* 136, Spring 2011, 201. Writing in this case about the Israeli–Palestinian conflict, the remainder of this passage reads: "A person with such a need makes an effort *not* to understand, because understanding the humanity of the other is too disturbing, since the group you identify with might be morally on the wrong side. Such people cannot afford empathy for the other aide, let alone to extend sympathy."

21 http://servetkocyigit.net/portfolio/shpilman-international-prize-for-excellence/, accessed May 14, 2017.

22 Claire Bishop, "Delegated Performance: Outsourcing Authenticity," *October* 140, Spring 2012, 51–79.

23 http://servetkocyigit.net/portfolio/my-heart-is-not-made-from-stone/, accessed May 27, 2017.

24 Ibid.

25 Ibid.

26 http://servetkocyigit.net/portfolio/maps/, accessed May 24, 2017.

27 Ibid.

28 Arthur Rimbaud, letter to Georges Izambard, May 13, 1871. "*Il s'agit d'arriver à l'inconnu par le dérèglement de tous les sens.*" http://www.mag4.net/Rimbaud/Documents1.html, accessed May 11, 2017.

29 T. Cole, *Known and Strange Things*, 66.

30 As the artist states: "One year I was in Paris then was invited to Nantes. I could not produce anything there. This order, this sterile life, the clean streets, the controlled subculture—even graffiti artists do their work with the permission of the state. I had to go back to Istanbul, where my art can be nourished. I am not the kind of person that only looks after his own happiness. I am concerned for Istanbul, for this country. I am interested in its development. I know that I can't make great waves with my art, but I want to do my share." Halil Altindere im Gespräch mit Çetin Güzelhan, "Für Istanbul, für dieses Land trage ich Sorge," trans. Çetin Güzelhan in Johannes Odenthal and Claudia Hahn-Raabe eds., *Zeitgenossische Kunst aus der Turkei*, Göttingen: Steidl Verlag, 2009, 168.

31 http://www.pilotgaleri.com/en/artists/detail/30, accessed May 21, 2017.

32 http://momaps1.org/exhibitions/view/383, accessed May 2, 2017.

33 http://www.dw.com/en/report-merkel-and-rutte-made-concrete-promises-with-turkey-over-refugee-quota/a–37913580, accessed May 14, 2017.

34 http://www.al-monitor.com/pulse/originals/2017/03/turkey-germany-merkel-rally-ban-appeasement.html, accessed May 14, 2017.

35 Zizek, *Against the Double Blackmail*, 54.

36 See also http://bb9.berlinbiennale.de/participants/altindere/, accessed May 17, 2017.

37 "Both Guiseppe Rotunno and Marcello Gatti—cinematographers who had been imprisoned for anti-Fascist activities and returned to work in Rome during this period—recounted on separate occasions how professionals in the industry were aware of the camp on the studio grounds, but could not face the '*poveri disgraziati*,' the miserable wretches who now populated to capacity what had been a state-of-the-art movie studio." Noa Steimatsky, "The Cinecittà Refugee Camp," *October* 128, Spring 2009, 30.

Chapter 4

1 Virginia Woolf, "A Room of One's Own," 1928, http://gutenberg.net.au/ebooks02/0200791h.html, accessed May 27, 2017.

2 Edward Said, *Reflections on Exile and Other Essays*, Cambridge MA: Harvard University Press, 2000, 186. As Amei Wallach adds, "immigrant artists turn what Said called a 'contrapuntal' awareness of now and then, here and there, on their heritage, their present, and, increasingly, on a problematic future, the viewer becomes a spectator at a tennis match. Keep your eye on the ball and you are presented with an unparalleled opportunity to focus on each side, glimpsed in context of the changing background of the entire field." "Missed Signals Nuance and the Reading of Immigrant Art," *American Art*, 20.2, Summer 2006, 127–128.

3 As Amy Malek explains: "Despite this growth and unlike other more established diaspora communities, such as the Irish, South-Asian, or African diasporas, the Iranian diaspora has only recently developed Persian and/or Iranian Studies departments, created scholarships for Iranian diaspora students, and encouraged members of its community to engage in political and civic responsibility in the diaspora. While many studies of the Iranian diaspora have been conducted, sociological and anthropological scholarship have failed to produce quality quantitative information, particularly in the last five years." "Memoir as Iranian Exile Cultural Production: A Case Study or Marjane Satrapi's 'Persepolis' Series," *Iranian Studies*, 39.3, September 2006, 353.

4 Spivak, *An Aesthetic Education*, 108.

5 Ibid., 109.

6 Valentine Moghadam, "Islamic Feminism and its Discontents: Toward a Resolution of the Debate," *Signs*, 27.4, Summer, 2002, 1142.

7 Ibid., 1165.

8 Lynne Hume, *The Religious Life of Dress: Global Fashion and Faith*, London and New York: Bloomsbury, 2013, 71.

9 Ibid., 70.

10 To quote Nasr of her own situation: "I've been frequently asked why I make this art and the answer is because I am in Australia, and this is something I can't do inside my own country. Now I've got all my freedom . . . but there is displacement between my past and present. It naturally comes to my mind always to think about what I was experiencing, my past . . . the difficulties women are experiencing . . . I'm really not free from these things, they are always with me, like a shadow." Cit. Anne Marsh, "Nasim Nasr: The Language of the Veil," *Contemporary Visual Art + Culture Broadsheet*, 44.1, 2015, 40–42.

11 Bowman ed., *The Rey Chow Reader*, 52.

12 Ibid., 53.

13 Somayeh Noori Shirazi, "Mundana Moghaddam: 'Chelgis II' and the Iranian Woman," *Women's Art Journal*, 33.1, Spring/Summer 2012, 13.

14 Bhabha, *The Location of Culture*, 149.

15 Malek, "Memoir as Iranian Exile Cultural Production," 359.

16 As Amy Motlagh asks: "Are artists like [Sara] Dolatabadi, Neshat, and [Marjane] Satrapi, who center Iran in the work they produce and show abroad, best understood as Iranian or diasporic ones? We must ask at what point an artist ceases to be most appropriately associated with the nation of her/his birth, and belong instead to the nation to which s/he has immigrated. And perhaps more importantly still, we must ask what influence and relationship Iranian artists living abroad have on those living at home." But there is never a discernible point, even if only one, and the association will vary according to the work, personal disposition, and outside perception that is itself colored by contemporary events. "Introduction" to Amy Motlagh and Sara Dolatabadi, "Child of the Revolution: Sara Dolatabadi and the Esthetics of memory (An Interview)", *Alif: Journal of Comparative Poetics*, 30, 2010, 245.

17 Aphrodite Navab, "Unsaying Life Stories: The Self-Representational Art of Shirin Neshat and Ghazel," *The Journal of Aesthetic* Education, 41.2, Summer 2007, 40.

The beginning of the next paragraph is also worth quoting: "Culturally hybrid persons are often caught in the crossfire of prejudices. For hybrid Iranians, these prejudices are exacerbated by political tensions that fall along three dimensions of limited and include *historical prejudice*, where each nation dominates the telling of history; *cultural prejudice*, stemming from mutual suspicion and ignorance; and *political prejudice*, as a result of inflexibility, or an unwillingness to envision the other's view." Emphasis in the original.

18 See Melissa Chiu and Melissa Ho eds., *Shirin Neshat: Facing History*, exh. Cat, Washington: Smithsonian Books, 2015, 13.

19 Shirin Neshat, "زنانِ خدا (ویّهّ محرَم) (Women of Allah: Secret Identities)," *Grand Street*, 62, Fall 1997, 145.

20 No one's thinking about the flowers
 No one's thinking about the fish
 No one wants to believe the garden's dying
 That its heart has grown swollen under the sun
 That its mind is being drained of green memories
 That its senses lie huddled and rotting in a corner.

Trans. Jasmin Darznik in Jasmin Darznik, "Forough Goes West: The Legacy of Forough Farrokhzad in Iranian Diasporic Art," *Journal of Middle Eastern Women's Studies*, 6.1, Winter 2010, 109. See also Jasmin Darznik, "Forugh Farrokhzad: Her Poetry, Life, and Legacy," *The Women's Review of Books*, 23.6, November–December 2006, 21–23.

21 Ibid., 111.

22 Ibid., 115.

23 As Çagla Hadimioglu continues: "The chador is thus conceptualized as a mobile home that facilitates a woman's movement around the city and her dealings with men. It essentially describes an extended boundary that assures that she always occupies a private space." "Black Tents," *Thresholds*, 22, 2001, 19.

24 Ibid.

25 Ibid.

26 Siamak Movahedi and Gohar Homayounpour, "Fort!/Da! Through the Chador: The Paradox of the Woman's Invisibility and Visibility," in Wolfgang Müller-Funk, Ingrid Scholz-Strasser, and Herman Westerink eds., *Psychoanalysis, Monotheism and Morality*, Leuven: Leuven University Press, 2013, 129.

27 L. Moore, "Frayed Connections, Fraught Projections: The Troubling Work of Shirin Neshat," *Women: A Cultural Review* 13.1, 2002, 1–18; Wendy Meryem Shaw, "Ambiguity and Audience in the Films of Shirin Neshat," *Third Text*, 15.57, 2001, 43–52.

28 Movahedi and Homayounpour, "Fort!/Da!," 132.

29 Iftikhar Dadi, "Shirin Neshat's Photographs as Postcolonial Allegories," *Signs*, 34.1, Autumn 2008, 128.

30 Ibid., 135–136.

31 Ibid., 136.

32 In the words of Trinh: "If the act of unveiling has a liberating potential, so does the act of veiling. It all depends on the context in which such an act is carried out,

or more precisely, on how and where women see dominance. Difference should neither be defined by the dominant sex nor by the dominant culture. So that when women decide to lift the veil, one can say that they do so in defiance of their men's oppressive right to their bodies; but when they decide to put back on the veil they once took off, they may do so to reappropriate their space or to claim anew difference, in defiance of genderless hegemonic standardization." *When the Moon Waxes Red*, 151.

33 Shirin Neshat, "Art in Exile" (lecture, TEDWomen 2010, December 2010), http://www.ted.com/talks/shirin_neshat_art_in_exile?language=en

34 Chiu and Ho, *Shirin Neshat*, 18.

35 For a more detailed description of these works see ibid. 18–19.

36 Arthur Danto and Shirin Neshat, "Shirin Neshat," *BOMB*, 73, Fall 2000, 66.

37 Ibid.

38 Jessica Winegar writes: "At times, Neshat herself traffics in orientalism, for example when she tells the audience in the audio tour that Muslim women are 'the sexiest women on the planet' because their veils are seductive and mysterious. This kind of framing of art and Islam involves a critique of Muslim gender relations (e.g. the perceived heightened sexuality of Muslim women) is particularly effective if one judges from Neshat's massive art sales and the ubiquity of this framing in many arts events around the country [the US]." "The Humanity Game: Art, Islam, and the War on Terror," *Anthropological Quarterly*, 81.3. Summer 2008, 670.

39 Hamid Naficy, "Making Films with an Accent: Iranian Éigré Cinema," *The Journal of Cinema and* Media, 43.2, Fall 2002, 28.

40 Manya Saadi-Nejd, "Mythological Themes in Iranian Culture and Art: Traditional and Contemporary Perspectives," *Iranian Studies*, 42.2, April 2009, 243.

41 See also Terry Smith, who writes of this work: "Anachrinism *is* relevant, but it is questioned. The very idea that one kind of culture, the modernizing ones, gets to decide that another is questioned (not least in Neshat's activation of the aesthetics of Iranian film)." "Contemporary Art and Contemporaneity," *Critical* Inquiry, 32.4, Summer 2006, 689.

42 See also John Di Stefano: "For film and videomakers—such as Trinh T. Minh-ha, Elia Suleiman, Richard Fung, or Shirin Neshat—the logic of difference reveals the artificiality of any and all closure. Eventual closures must be considered as impermanent and necessarily provisional, temporary, and partial, and this is reflected in the vocabulary employed in their works and the diversity of their practices." "Moving Images of Home," *Art Journal*, 61.4, Winter, 2002, 45.

43 Neshat in Chu and Ho eds., *Shirin Neshat*, 163.

44 Ibid.

45 Shirin Neshat and Babak Ebrahimian, "Passage to Iran," *PAJ: A Journal of Performance Art*, 24.3, September 2002, 53.

46 Hamid Dabashi, "It Was in China, Late One Moonless Night," *Social Research*, 70.3, Fall 2003, 936.

47 Ghada Amer, interview with Estelle Taraud, tr. Estelle Taraud, *Studies in 20th Century Literature*, 26.2, Winter 2002, 237–238.

48 Author's interview with the artist, April 26, 2017.

49 See for instance Francesco Pellizzi, "Mésaventures de l'art: Premières impressions des Magiciens de la Terre," *RES: Anthropology and Aesthetics*, 17/18, Spring–Autumn, 1989, 198–207.

50 See Hou Hanru, "In Defense of Difference: Notes on Magiciens de la Terre, Twenty-five Years later," *Yishu: Journal of Contemporary Chinese Art*, 13.3, 2014, 7–18.

51 Amer and Taraud, interview, 241.

52 Ghada Amer, interview with Maura Reilly, *Ghada Amer: Colour Misbehaviour*, New York: Cheim & Reid, 2010, n.p.

53 Ghada Amer, interviewed by Marina Kotzamani, *PAJ: A Journal of Performance Art*, 28.2, May 2006, 19.

54 Amer and Taraud, interview, 248.

55 David Frankel, "Ghada Amer: Deitsch Projects," *Artforum,* February 2002, 130.

56 Candice Breitz, "Ghada Amer: The Modelling of Desire," *Nka: Journal of Contemporary African Art*, 5, Fall 1996, 16.

57 See also Mary Trent : "To me, Amer's art seems less about posing a radical challenge to masculine language than about exploring how women incorporate that language into their own psyches and lived experience." Book Review of *Ghada Amer* by Maura Reilly, *Women's Art Journal*, 33.2, Fall/Winter 2012, 47.

58 Chika Okeke-Agulu, "Politics by Other Means: Two Egyptian Artsits, Gazbia Sirry and Ghada Amer," *Nka: Journal of Contemporary African Art*, 25, Winter 2009, 25.

59 Maura Reilly, *Writing the Body: The Art of Ghada Amer*, New York: Gregory Miller, 2010, 200.

60 Ibid., 212–214.

61 Reilly, *Writing the Body*, 42.

62 Fereshteh Daftari, "Beyond Islamic Roots: Beyond Modernism," *RES: Anthropology and Aesthetics*, 43, Spring 2003, 179.

63 Laura Auricchio, "Works in Translation: Ghada Amer's Hybrid Pleasures," *Art Journal*, 60.4, Winter 2001, 36.

64 Marie-Christine Eyene, "Ghada Amer, du porno populalaire à l'érotologie arabe," *Africultures*, 63, 2002, 96.

65 Robert Pincus-Witten, "Ghada Amer," *Artforum*, Summer 2014, 365.

66 Auricchio, "Works in Translation," 32.

67 Emma Tarlo, *Visibly Muslim*, Oxford and New York: Berg, 2010.

68 Discussion with the artist, July 15, 2017.

69 Marsh, "Nasim Nasr," 43.

70 John Neylon, "Nasim Nasr: The Home, The Habit," *Art Collector*, 81, July–September, 2017, 216.

71 Ila Sheren, *Portable Borders: Performance Art and Politics on the US Frontera since 1984*, Austin: University of Texas Press, 2015, 120.

72 Ibid., Chapter 4, "Post-Border?," 120–134.

73 Mona Hatoum, *Measures of Distance*, https://www.youtube.com/watch?v=WXMFZIkKPzw

74 Ella Shohat, "The Cinema of Displacement: Gender, Nation, and Diaspora," *On the Arab-Jew, Palestinian, and Other Displacements*, London: Pluto Press, 2017, 275.

75 Siona Wilson, "Abstract Transmissions: Other Trajectories for Feminist Video," in Gabrielle Jennings ed., *Abstract Video*, Los Angeles: University of California Press, 2015, 62.

76 See also Griselda Pollock, "moments and Temporalities of the Avant-Garde 'in, of, and from the feminine'," *New Literary History*, 41.4, Autumn 2010, 795–820.

77 Najat Rahman, *In the Wake of the Poetic: Palestinian Artists After Darwish*, Syracuse: Syracuse University Press, 2015, 98–99.

78 As Tamar Tembeck confirms: "Hatoum's 1994 *Corps étranger* is not, at first glance, directly tied to themes of diaspora and exile or east/west relations. However, a brief analysis . . . will hopefully draw parallels between the operation of *Sorps étranger* and its manifestation of a certain 'diasporic consicousness'" "Mona Hatoum's Corporeal Xenology," Thresholds, 29, Winter 2005, 58.

79 Stephen Monteiro, *Cinema Culture and the Art of Warhol, Rauschenberg, Hatoum and Gordon*, Edinburgh: Edinburgh University Press, 2016, 107–108.

80 Marisa Yu, "Politics of the Light Object: Transformative Architectural Installations," *Journal of Architectural Education (1984–)*, 63.1, October 2009, 108.

81 Ursula Panhas-Bühler, "Being Involved," *Mona Hatoum*, exh cat., Ostfindern-Ruit: Hatje Cantz Verlag, 2004, 32.

82 In the words of Helen Thein: "Anhand von Arbeiten der Videokünstlerin Mona Hatoum sprach Sabine Flach über die 'mediale Selbstentfremdung'. Projizierte Bilder aus dem Inneren köerpers verweisen den Betrachter auf die fremden Welten unter der eigenen Haut und führen ihm gleichzeitig das voyeuristische Begehren vor, um das fremde Innere einzudringen." "Fremdes Begehren: Repräsentationsformen transkultureller Beziehungen," *Zeitschrift für* Germanistik, 12.3, 2002, 643.

83 Jaleh Mansoor adds: "Mona Hatoum . . . frames the way in which thinking the specific body—inscribed by gender, class, race, history—so central to feminism necessitates the very forms of abstraction-as-modernist universalism that had disavowed it in the early twentieth century. Her work occupies those universals in order to dismantle them. For Hatoum the body is only ever abstracted through the biopolitical forms of disciplinary order set in place by modernity." Hal Foster et al., "Questionnaire on 'The Contemporary'," October 130, Fall 2009, 106.

84 Ibid., 108.

85 Randall Halle, *The Europeanization of Cinema*, Bloomington: University of Illinois Press, 2014, 162.

86 Deborah Cherry, "Troubling Presence: Body, Sound and Space in Installation Art of the mid-1990s," *RACAR: revue d'art canadienne/Canadian Art* Review, 25.1/2, 1998, 26.

87 Mignon Nixon, "After Images," October, 83, Winter 1998, 123.

88 Julia Kristeva, *Powers of Horror: An Essay on Abjection*, Trans. Leon Roudiez, New York: Columbia University Press, 1982.

89 Christine Ross, "Redefinitions of Abjection in Contemporary Performances of the Female Body," *RES: Anthropology and* Aesthetics, 31, Spring 1997, 152.

90 Mona Hatoum cit. Jaleh Mansoor, "A Spectral Universality: Mona Hatoum's Biopolitics of Abstraction," *October*, 133, Summer 2010, 50.

91 Ibid., 52.

92 Ibid.

93 Ibid., 58.

94 Ibid., 62. Later Mansoor adds "refugee" to the list of monikers: "Like the 'woman' and the 'Palestinian', the 'refugee' stands simultaneously and indeterminately outside and inside the auto-generated system of meaning set by power, guaranteeing it." Ibid., 69.

95 Ibid., 74.

96 Edward Said, "The Art of Displacement: Mona Hatoum's Logic of Irreconcilables," *Mona Hatoum: The Entire World as a Foreign Land*, exh. cat., London: Tate Gallery, 2000, 14.

Chapter 5

1 Robin Ghivan, "The Fantasy of China: Why the New Met Exhibition is a Big, Beautiful Lie," *Washington Post*, May 2, 2015, https://www.washingtonpost.com/news/arts-and-entertainment/wp/2015/05/05/the-fantasy-of-china-why-the-new-met-exhibition-is-a-big-beautiful-lie/?utm_term=.14307480f916, accessed July 2, 2017.

2 Holland Cotter, "In 'China: Through the Looking Glass', Eastern Culture Meets Western Fashion," *The New York Times*, May 7, 2015, https://www.nytimes.com/2015/05/08/arts/design/review-in-china-through-the-looking-glass-eastern-culture-meets-western-fashion.html, accessed July 2, 2017.

3 Ibid.

4 Ibid.

5 Andrew Bolton, "Toward an Aesthetic of Surfaces," in Andrew Bolton ed., *China: Through the Looking Glass*, exh. cat., New York and New Haven and London: the Metropolitan Museum of Art and Yale University Press, 2015, 20.

6 Allison McNearney, "'China: Through the Looking Glass' is the Met's Most Popular Fashion Show Ever," *The Daily Beast*, 9 June, 2015, http://www.thedailybeast.com/china-through-the-looking-glass-is-the-mets-most-popular-fashion-show-ever, accessed July 2, 2017.

7 *The First Monday in May* (Andrew Rossi, dir.), Madman Entertainment, 2016.

8 Ibid.

9 Adam Geczy, "A Chamber of Whispers," in Bolton ed., *China: Through the Looking Glass*, 27.

10 "To address the multiple meanderings of Orientalist influence, where there is more than one thread and the threads are seldom straight, I have coined the term 'transorientalism'. It is a more serviceable term that, while admitting of the ethical aspects of cultural appropriation, also supports the undeniable circumstances of exchange, retranslation, and re-envisioning embedded in the Orientalist idea, and a dynamic that today that shows no sign of abating." Ibid., 24.

11 Rachel Silberstein, "Andrew Bolton, *China: Through the Looking Glass*," CAA Reviews, November 2, 2016, http://www.caareviews.org/reviews/2755#.WVsqMxOGPOQ; accessed July 5, 2017.

12 Ibid.

13 "For with chinoiserie, as the Metropolitan's exhibition amply demonstrates, ideology was left at the door; there was no truth to form, only the space for experimentation and visual conceit. And as numerous textiles and artifacts show us, the Chinese for their part were happy to take up where their Western counterparts left off, visibly flattered and enthused by the level of interest." Geczy in Bolton ed., *China: Through the Looking Glass*, 28.

14 Homay King, "Lost in Translation," *Film Quarterly*, 59.1, Fall 2005, 46.

15 Ibid.

16 As King writes elsewhere, "'Chinatown' thus becomes a metaphor for something traumatic and sexual from a distant, perhaps repressed prior era—something that cannot be processed or consciously comprehended and that threatens to resurface in the present." Homay King, *Lost in Translation: Orientalism, Cinema, and the Enigmatic Signifier*, Durham: Duke University Press, 2010, 76.

17 King, "Lost in Translation," 48.

18 King, *Lost in Translation*.

19 Ibid., 20.

20 Homay King, "Cinema's Virtual Chinas," in Bolton ed., *China: Through the Looking Glass*, 57.

21 Ibid., 58.

22 Ibid., 59.

23 Ibid., 61, my emphasis.

24 *Westworld*, created by Jonathan Nolan and Lisa Joy, HBO, 2016; *Westworld*, Michael Crichton dir., Metro-Goldwyn Mayer, 1973.

25 Chow in Bowman ed., *The Rey Chow Reader*, 104.

26 Ibid., 105.

27 Ibid., 113.

28 Ibid., 115

29 Ibid., 122

30 Chow, *Sentimental Fabulations*, 43.

31 King in Bolton ed., *China: Through the Looking Glass*, 71.

32 "Zhang's work challenges us with the following questions: how might one approach *any* representation of the non-West as such without immediately resorting to the (by now) familiar and secure means of attacking orientalism, by nailing down a certain culprit, in the form of 'What is to be done now?' Is it all possible to conceive of a noniconophobic way of handling social and visual relations?" Chow, *Sentimental Fabulations*, 148, emphasis in original.

33 Ibid., 165.

34 Chow, "China as Documentary: Some Basic Questions (inspired by Michelangelo Antonioni and Jia Zhangke)," *Journal of European Studies*, 17.1, 2014, 17.

35 Ibid., 27.

36 Paul Bowman, *Beyond Bruce Lee: Chasing the Dragon through Film, Philosophy, and Popular Culture*, New York: Columbia University Press, 2013, 3.

37 Ibid.

38 Ibid., 6.

39 Ibid., 8ff.

40 Ibid., 168.

41 Bowman also calls attention to the way that the Ip Man films, together with the Bruce Lee legacy, have caused an overheated and perhaps unjust veneration for Wing Chun: "Many Hong Kong and Chinese martial arts traditionalists do not even regard wing chun as a 'proper' martial art at all—because, for one thing, it is not old enough, and for another, again, its popularity derives from the Bruce Lee movies." Ibid.

42 Grady Hendrix, "A Brief History of the Ip Man Movie Craze," *Film Comment*, 49.5, September/October 2013, 57.

43 Ibid.

44 Ibid., 172.

45 Ibid.

46 Chow, *Sentimental Fabulations*, 17.

47 Ibid., 18.

48 Ibid., 19.

49 Ibid., 22, emphasis in the original.

50 Lenika Cruz, "*Marco Polo*: Netflix's Critical Flop that Dared to Be Diverse," *The Atlantic*, December 20, 2014, https://www.theatlantic.com/entertainment/archive/2014/12/in-defense-of-marco-polo/383905/, accessed July 31, 2017. All but one of the principal recurring cast were not Chinese. Benedict Wong, who played Kublai Khan, was born in Manchester, England; Prince Jingim was born in Australia and educated in Sydney; Tom Wu who plays the blind martial arts master, "Hundred Eyes," identifies as Canadian British. Only Joan Chen, who plays Empress Chabi, was born in Shanghai and, after playing parts in several Chinese films, emigrated to the United States, starring in *The Last Emperor*, and after that *Twin Peaks*, as well as continuing to star in Chinese films.

51 https://www.rottentomatoes.com/tv/marco_polo/s01/reviews/, accessed July 30, 2017.

52 T. Minh-ha, *Lovercidal: Walking with the Disappeared*, New York: Fordham University Press, 2016, 229.

53 Ian Johnson, "Novels From China's Moral Abyss," *New York Review*, June 22, 2017, 55.

Chapter 6

1 Oe Kenzaburo, *Okinawa Notes*, Tokyo: Iwanami Shoten, 1970, 16.

2 Roland Barthes, *Empire of Signs* (1970), trans. Richard Howard, New York: Noonday, 1982, 4. At the end of the book Barthes writes: "One might say that an age-old technique permits the landscape or the spectacle to produce itself, to occur in pure significance, abrupt, empty, like a fracture. Empire of Signs? Yes, if it is understood that these signs are empty and that the ritual is without a god," 108.

3 Dorinne Kondo, *About Face: Performing Race in Fashion and Theater*, New York and London: Routledge, 1997, 57.

4 Ihab Hassan, *Between the Eagle and the Sun: Traces of Japan*, Tuscaloosa and London: University of Alabama Press, 1996, 71.

5 The concluding sentence reads: "Or, to paraphrase the great architect Arata Isozaki, 'I work in mental equidistance from Kyoto's Katsura Detached Palace and the Greek Pantheon.'" Ibid., 71–72.

6 Ibid., 183.

7 Keiichiro Nakagawa and Henry Rosovsky, "The Case of the Dying Kimono: The Influence of Changing Fashions on the Development of the Japanese Wool Industry," in Mary Ellen Roach-Higgins et al. eds., *Dress and Identity*, New York: Fairchild, 1995, 467.

8 As Liza Dalby elaborates: "Just as for everyone else, geisha dress was first classified by status. Formal party kimono (*zashiki-gi*) were appropriate for banquet attendance, as opposed to off-duty, everyday clothes (*findangi*). Party kimono were further divided into formal (*de*) and regular (*futu*) categories. Regular party kimono were specialized for either daytime or party wear. In addition, these three basic types of a geisha's working wardrobe—*de*, regular daytime, and evening wear—each has seasonal variants, not to mention patterns appropriate to different ages, regional preferences, and passing fads." "Geisha and Kimono" in Higgins et al. eds., *Dress and Identity*, 151.

9 Ibid., 153.

10 Ofra Goldstein-Gidoni, "Kimono and the Construction of Gendered and Cultural Identities," *Ethnology*, 38.4, Autumn 1999, 353.

11 Ibid., 355.

12 Masami Suga, "Exotic West to Exotic Japan: Revival of Japanese Tradition in Modern Japan," in Joanne Eicher ed., *Dress and Ethnicity*, Oxford and New York: Berg, 1995, 97.

13 Ibid.

14 Goldstein-Gidoni, "Kimono," 358.

15 Suga, "Exotic West to Exotic Japan," 101–114.

16 Ibid., 365.

17 As Dalby explains, irrespective of whether a Japanese "has ever met a geisha or used her specialized service (and most have not), a feeling remains that Japan would be losing something unique and precious by allowing geisha to disappear. Kimono has a similar hold on the Japanese imagination. Although most people seldom wear it, they take ineffable pride in the appearance and form or traditional wafuku." In Roach-Higgins et al. eds., *Dress and Identity*, 154.

18 Goldstein-Gidoni, "Kimono," 365.

19 Hassan, *Between the Eagle and the Sun*, 160.

20 Yuniya Kawamura, *The Japanese Revolution in Paris Fashion*, Oxford and New York: Berg, 2004. See also Geczy, *Fashion and Orientalism*.

21 Kawamura, *The Japanese Revolution in Paris Fashion*, 113.

22 Ibid., 115.

23 Kondo, *About Face*, 60–61.

24 Ibid., 61. See also Kondo, "The Aesthetics and Politics of Japanese Identity in the Fashion Industry," in Higgins et al. eds., *Dress and Identity*, 475–479.

25 Cit. in Andrew Bolton ed., *Rei Kawakubo/Comme des Garçons: Art of the In-Between*, exh. cat., New York and New Haven and London: The Metropolitan Museum of Art and Yale University Press, 2017, 84.

26 See Geczy and Vicki Karaminas, "Rei Kawakubo's Deconstructivist Silhouette" in *Critical Fashion Practice: From Westwood to Van Beirendonck*, London and New York: Bloomsbury, 2017, 29–43.

27 Theodor W. Adorno, "Cultural Criticism and Society," in *Prisms*, trans. Sam and Shierry Weber, Cambridge MA: MIT Press (1981) 1990, 34.

28 Gayatri Chakravorty Spivak, *A Critique of Postcolonial Reason: Toward a History of the Vanishing Present*, Cambridge MA: Harvard University Press, 1999, 339.

29 Ibid.

30 Ibid., 340.

31 Ibid., 346–347.

32 Ibid., 344.

33 Ibid., 352.

34 Ibid., 353.

35 Cit. in Bolton ed., *Rei Kawakubo*, 220.

36 Ibid.

37 Cit. in Bolton ed., *Rei Kawakubo*, 98.

38 "Rei Kawakubo/Comme des Garçons: Art of the In-Between," https://www.youtube.com/watch?v=4ghlzREu1fE.

39 David Salle, "Clothes That Don't Need You," *The New York Review of Books*, September 28, 2017, 14.

40 Ibid., 12.

41 Ibid.

42 See Goldstein-Gidoni, "Kimono," 361.

43 Daisuke Okabe, *Fandom Unbound: Otaku Culture in a Connected* World, New Haven and London: Yale University Press, 2012, 229.

44 Therèsa Winge, "Costuming the Imagination: Origins of Anime and Cosplay," *Mechademia* 1, 2006, 66. See also M. Bruno, "Cosplay: The Illegitimate Child of S F Masquerades." *Glitz and Glitter Newsletter*, Millennium Costume Guild. October, 2002; http://millenniumcg.tripod.com/glitzglitter/1002articles.html, accessed September 2015.

45 Winge, ibid., 66–67.

46 Susan Napier, *From Impressionism to Anime*, New York: Palgrave Macmillan, 2007, 172–173.

47 Diana Crane, *Global Culture: Media, Arts, Policy, and Golbalization*, London and New York: Routledge, 2002, 268.

48 Douglas McGray, "Japan's Gross National Cool," *Foreign Policy*, June/July, 2002, http://foreignpolicy.com/2009/11/11/japans-gross-national-cool/, accessed August 24, 2017.

49 Spivak, *A Critique of Postcolonial Reason*, 340.

50 Cit. Crane, *Global Culture: Media*, 256, 258.

51 Ibid., 268.

52 Jacqueline Berndt, in Monica Chiu ed., *Drawing New Color Lines: Transnational Asian American Graphic Narratives*, Hong Kong: Hong Kong, 2015, 257.

53 Berndt, in Chiu ed., *Drawing New Color Lines*, 269.

54 Ibid., 270.

55 Ibid.

56 A parallel can also be drawn from the manga and cosplay inspired performances of Mariko Mori. As Allison Holland writes, "Mori's avatars responded to the conclusions of Toshiya Ueno's notion of 'techno-orientalism'. This twofold concept considers both (1) the relationship between humanity and technology, and (2) the cultural positioning of Japan in terms of the West in a kind of sub-imperialism. In other words, it is expressive of Japan's advances in the human-technology interfaces, both actual and virtual, that inform the trading of the national identity and culture by the West. On a second level, whereas Japanese culture had previously been dominated by 'Americanization', in the 1980s and 1990s Japan exerted both cultural and economic hegemony through a subcultural, consumer-based phenomenon." "From Gothic Lolita to Radiant Shaman: The Development of Mariko Mori's Ethereal personae," *US-Japan Women's Journal*, 40, 2011, 12–13.

57 Nissim Kadosh Otmazgin, *Regionalizing Culture: The Political Economy of Japanese Popular Culture in Asia*, Honolulu: The University of Hawaii Press, 2014, 52.

58 Ibid.

59 Anthony Pym, *Method in Translation Theory*, Manchester: St Jerome Publishing, 1998, 177–192.

60 Cathy Sell, "Manga Translation and Interculture," *Mechademia*, 6, 2011, 95.

61 Ibid., 106.

62 See also Patrick Galbraith and Thomas Lamarre, "Otakuology: A Dialogue," *Mechademia*, 5, 2010, 360–374.

63 Otmazgin, *Regionalizing Culture*, 60–61.

64 Ibid., 61.

65 Galbraith and Lamarre, "Otakuology," 365.

66 Winge, "Costuming the Imagination," 68.

67 See also Koen Leurs, "Selfies and the Hypertextual Selves on Social Networking Sites," in *Digital Passages*, Amsterdam: Amsterdam University Press, 2015.

68 See also Jin-Show Chen, "A Study of Fan Culture: Adolescent Experiences with Animé/manga Dooujinshi and Cosplay in Taiwan," *Visual Arts Research*, 33.1, 2007, 14–24; Anne Peirson-Smith, "Fashioning the Fantastical Self: An Examination of the Cosplay Dress-Up Phenomenon in Southeast Asia," *Fashion Theory*, 17.1, 2013, 77–112.

69 Otmazgin, *Regionalizing Culture*, 84.

70 Okabe, *Fandom Unbound*, 228.

71 Napier, *From Impressionism to Anime*, 56.

72 Geczy, *The Artificial Body in Fashion and Art: Marionettes, Models and Mannequins*, London and New York: Bloomsbury, 2017, 133–137.

73 *The Doll*, dir. Susannah O'Brien, Sahara Productions, 2016.

74 Daisuke Okabe, "Cosplay, Learning, and Cultural Practice," in Mizuko Ito, Daisuke Okabe and Izumi Tsuji eds., *Fandom Unbound*, New Haven and London: Yale University Press, 2012, 238.

75 Ibid.

76 Ibid., 239.

77 Mari Kotani, for instance, warns against the association, arguing that being/playing Lolita is a mechanism of self-affirmation, not sexual solicitation. "Doll Beauties and Cosplay," *Mechandemia*, 3, 2008, 49–63.

78 See Therèsa Winge, "Undressing and Dressing Loli: A Search for the Identity of the Japanese Lolita," *Mechandemia*, 3, 2008, 48.

79 See for example Morton Cohen, *Lewis Carroll: A Biography*, New York: Vintage, 1995, 228.

80 Therèsa Winge, "Undressing and Dressing Loli," 60.

81 In the words of Lisa Blauersouth, a self-confessed Lolita: "The idea that people 'dress up as' a Lolita is a little offensive to those who *are* Lolita. There is some merit to this—especially since folks who see Lolita as a costume are far less likely to pay attention to the basic, underlying ideals behind the subculture. For most of the Lolitas, there is a huge difference between 'costume' and 'fashion', but not for me: that is because I define *all* fashion as costume. Dressed up in Lolita, I get more polite, I'm better at small talk, and I allow myself to squee about adorable shoes. With Lolita, the sheer *otherness* is part of it, its positives and negatives and shallowness; I get to explore parts of me that normally don't get much airtime." "Wherein the Author Documents Her Experience as a Porcelain Doll," *Mechademia* 6, 2011, 316.

82 Winge, "Undressing and Dressing Loli," 51.

83 Dragging can be a festive, even necessary form of engaging in otherness in order to resituate the self into a site of belonging. It is also dragging insofar as the term can be used in a universal sense of dressing up and masking, not limited to drag kings and queens. What also the person who dresses up as a type and the drag king/queen have in common is that they are attempting to bring something imaginary and non-existent into existence, to bring something different and "unnatural" into being. But the principal difference is that whereas the drag king/queen assumes a new identity in the manner of a rebirth—in which s/he assumes a new face and new name—the masquerader/cosplayer inhabits an imaginary type that has already been, using the associated narrative in order to mobilize character traits, and, indeed to mobilize the self. This is no longer a vicarious relationship but rather a way in which the player/cosplayer can actively participate in forms and ways of being that are inextricable from an aesthetic and narrative structure.

84 Winge, "Undressing and Dressing Loli," 48.

85 Ibid., 61.

86 Frenchy Lunning, "Under the Ruffles: Sojo and the Morphology of Power," *Mechademia*, 6, 2011, 18.

87 Isaac Gagné, "Urban Princesses: Performance and 'Women's Language' in Japan's Gothic/Lolita Subculture," *Journal of Linguistic Anthropology*, 18.1, June 2006, 130–150.

88 Pico Iyer, "A Foreigner at Home," *Sun After Dark: Flights From the Foreign*, New York: Vintage, 2004, 196.

Chapter 7

1 Alice Walton, "How Yoga is Spreading in the U.S.," *Forbes* March 15, 2016, https://www.forbes.com/sites/alicegwalton/2016/03/15/how-yoga-is-spreading-in-the-u-s/#704ca61d449f, accessed August 4, 2017.

2 Ibid.

3 James Mallinson and Mark Singleton trans. and ed., "Introduction," *Roots of Yoga*, London: Penguin Random House, 2017, xxi–xxii.

4 At the top are Brahmins (priests and spiritual men), followed by Kshatriyas (rulers and warriors), then Vaisayas (merchants and farmers) and Sudras (craftsmen and workers). Below this are the Dalits or "untouchables."

5 V. S. Naipaul, *Magic Seeds*, New York and Toronto: Knopf, 2004, 74.

6 Naipaul, *The Writer and His World: Essays*, London: Picador, 2002, 7.

7 Pankaj Mishra, "Introduction" in ibid., xi.

8 David Cannadine, *Ornamentalism: How the British Saw Their Empire*, Oxford: Oxford University Press, 2001, 56.

9 Spivak, *An Aesthetic Education*, 286.

10 Ibid., 287.

11 "When the powerful languages are taken as the language of translation and people read only in those powerful language translations, the fact of being translated disappears. This is not a helpful thing." Ibid., 297.

12 Ibid., 315.

13 Spivak, *An Aesthetic Education*, 431.

14 Naipaul, *The Writer and His World*, 30.

15 Ibid., 27.

16 Ibid., 16.

17 Naipaul, *India: A Million Mutinies Now*, New York: Viking, 1990, 430.

18 Naipaul, *The Writer and His World*, 27.

19 Ibid., 31.

20 Ibid.

21 Naipaul, *India: A Wounded Civilization*, London: André Deutsch, 1977, 71.

22 Naipaul, *The Mimic Men*, London: André Deutsch, 1967, 246.

23 Ibid., 262.

24 Naipaul, *India: A Wounded Civilization*, 125.

25 Ibid.

26 Ibid., 126.

27 Ibid.

28 Ibid., 127.

29 A good reference for these debates is Chaturvedi ed., *Mapping Subultaren Studies*.

30 Arundhati Roy, *The God of Small Things*, London: Random House, 1997.

31 Roy, *The Ministry of Utmost Happiness*, London: Random House, 2017.

32 Roy, *The Cost of Living*, London: Harper Collins, 1999.

33 Roy, *The Doctor and the Saint: Caste, Race, and Annihilation of Caste*, Chicago: Haymarket Books, 2017.

34 As Cannadine writes: "Beginning with 'their own forms of knowledge and thinking', they came to look upon caste as the 'essential feature of the social system', as the analogue to their own carefully ranked domestic status hierarchy, which seemed to make India familiar." *Ornamentalism*, 42.

35 Ibid., 6.

36 Ibid. Emphasis in the original.

37 Ibid., 11.

38 See also ibid., 101.

39 Ibid., 74.

40 Ibid., 82.

41 Ibid., 123.

42 Ibid., 124.

43 *Lion*, dir. Garth Davis, Weinstein, 2016.

44 https://fashionunited.in/fashion-industry-statistics-india, accessed October 7, 2017.

45 Arti Sandhu, *Indian Fashion: Tradition, Innovation, Style*, London and New York: Bloomsbury, 2015, 3.

46 https://fashionunited.in/fashion-industry-statistics-india, accessed October 7, 2017.

47 See also Simona Segre Reinach, "Ethnicity," in Alexandra Palmer ed., *A Cultural History of Dress and Fashion in the Modern Age*, London and New York: Bloomsbury, 2017, 151–170.

48 Mikti Khaire, "The Indian Fashion Industry and Traditional Indian Crafts," *The Business History* Review, 85.2, 2011, 348.

49 Ibid., 349.

50 Sandhu, *Indian Fashion*, 64.

51 Ibid.

52 Spivak, *A Critique of Postcolonial Reason*, 414.

53 Sandhu, *Indian Fashion*, 17.

54 Sandhu, *Indian Fashion*, Plate 13.

55 Ibid., 3.

56 Khaire, "The Indian Fashion Industry," 353.

57 Ibid., 354.

58 Ibid., 358.

59 Ibid., 359.

60 Ibid., 362.

61 Sandhu, *Indian Fashion*, 163.

62 Khaire, "The Indian Fashion Industry," 364.

63 Ibid., 365.

64 Sandhu, *Indian Fashion*, 21,

65 Ann Marie Leskovich and Carla Jones, "What Happens When Asian Chic Becomes Chic in Asia?" *Fashion Theory*, 7.3/4, 2003, 285.

66 Ibid., 295.

67 Ibid., 114.

68 Ibid., 71.

69 Ibid.

Chapter 8

1 A note here on the alternating use of "Aboriginal" and "Indigenous" and why the latter is capitalized: "Aboriginal," meaning "primary" or "originary," is inscribed in its meaning and application with the stigmas applied by colonists. It is also a term not confined to the first Australians, and used for many other indigenous populations. Amongst many indigenous groups in Canada, it is a highly emotive and much-debated word. However, it is still used widely in Australia, and to some extent in its historical use has become something of a more substantive epithet. In the last two decades or so, "Indigenous," which is ideologically and historically more neutral, has gained increasing use, but is capitalized to distinguish it from its neutrality. In the same evolution, the plural, "peoples" is now used more commonly as it acknowledges the lack of homogeneity, and the extraordinary diversity of cultures, many of which have no longer survived.

As to the efficacy and role of Aboriginal art, Judith Ryan, writing in 1991, affirms: "Instead of being ignored, the downtrodden and dispossessed first Australians are at last being listened to in their own eloquent language. The acrylic paintings, more potent than any politicized slogans, have enabled Aboriginal people to assert their fundamental right—their right to land." Preface in Geoffrey Bardon, *Papanya Tula: Art of the Western Desert*, Ringwood: Penguin Australia, 1991, xi.

2 I am grateful to Jakelin Troy for this observation.

3 See Barry Judd, Adam Geczy, and Jakelin Troy (with contributions by Mick Adams and Len Collard), "Letter from the Editors," *ab-Original: Journal of Indigenous Studies and First Peoples' and First Nations' Cultures*, 1.1, 2017, v–xiv.

4 See Geczy, "Curating Curiosity: Imperialism, Materialism, Humanism and the *Wunderkammer*," in Brad Buckley and John Conomos eds., *Companion to Curation*, London: Wiley Blackwell, 2018.

5 Cit. Tim Bonyhady, *Images in Opposition: Australian Landscape Painting 1801–1890*, Oxford and Melbourne: Oxford University Press, (1985) 1991, 23.

6 Cit. ibid., 25.

7 Ibid., 25–26.

8 See also Alexa Moses, "Shadow Cast over a Painter's Legacy," *Sydney Morning Herald*, July 25, 2005, http://www.smh.com.au/news/arts/shadow-cast-over-a-painters-legacy/2005/07/24/1122143723289.html, accessed September 12, 2017.

9 See Wally Caruana, "The Past 100 Years: A Brief History of the Artists and their Art," in Caruana and Nigel Lendon eds., *Painters of the Wagilag Sisters Story 1937–1997*, exh. cat., Canberra: National Gallery of Australia, 1997, 12.

10 Bardon, *Papanya Tula*, 10.

11 Ibid., 25.

12 See Geczy, "Who Owns Dots? Or, Spirituality for the Highest Bidder, or, Can You Buy Aura?" *Contemporary Art + Culture Broadsheet*, 42.3, 2013, 16–19.

13 In the words of Ase Ottoson: "The didjeridu was never a traditional instrument in Central Australia but nevertheless reappears in the hands of Aboriginal people in tourist and media representations of the desert region, and in soundtracks to video clips, television images and films picturing Central Australia. It is a generic and popular piece of merchandise in Alice Springs tourist shops, too." *Making Aboriginal Men and Music in Central Australia*, London and New York: Bloomsbury, 2016, 31.

14 Ibid., xi.

15 Ibid., xiii.

16 Ibid., 4.

17 Ibid., 5.

18 Ibid., 18.

19 Ibid., 31.

20 Ibid., 51.

21 Ibid., 39.

22 Ibid., 45.

23 Ibid., 52.

24 Ibid., 178.

25 Terry Smith, "Visual Regimes of Colonization: Aboriginal Seeing and European Vision in Australia," in Nicholas Mirzoeff ed., *The Visual Culture Reader*, London and New York, 1998, 487, emphasis added.

26 In his study of Afro-American contemporary art, Darby English writes: "It is an unfortunate fact that in this country, black artists' work seldom serves as the basis of rigorous, object-based debate. Instead, it is almost uniformly generalized, endlessly summoned to prove its representativeness (or defend its lack of same) and contracted to show-and-tell on behalf of an abstract and unchanging 'culture of origin'. For all this, the art gains little purchase on the larger social, cultural, historical, and aesthetic formations to which it nevertheless directs itself with increasing urgency." *How to See a Work of Art in Total Darkness*, Cambridge MA: MIT Press, 2007, 7.

27 Richard Bell, "Bell's Theorem," http://www.kooriweb.org/foley/great/art/bell.html, accessed January 9, 2017.

28 See also Geczy, "The Air-Conditioned Desert: Curating Aboriginal Art," *Art Monthly Australia*, 250, 2012, 44–46.

29 Ian McLean, "Aboriginal Art and the Artworld," in McLean ed., *How Aborigines Invented the Idea of Contemporary Art*, Brisbane and Sydney: IMA and Power Publications, 2011, 55.

Conclusion

1 George Eliot, *Silas Marner* (1861), London: Macmillan, 1984, 54.

2 Ibid., 55.

3 Ibid.

4 Ibid., 66.

BIBLIOGRAPHY

Adorno, Theodor W. *Prisms*, trans. Sam and Shierry Weber, Cambridge MA: MIT Press (1981) 1990.

Agamben, Giorgio. *Homo Sacer: Sovereign Power and Bare Life*, trans. Daniel Heller-Roazen, Stanford: Stanford University Press, 1998.

Ágoston, Gábor. "The Image of the Ottomans in Hungarian Historiography", *Acta Orientalia Academiae Scientiarum Hungaricae*, 61.1/2, March, 2008, 15–26.

Amer, Ghada. interview with Estelle Taraud, tr. Estelle Taraud, *Studies in 20th Century Literature*, 26.2, Winter 2002, 237–248.

Amer, Ghada interviewed by Marina Kotzamani. *PAJ: A Journal of Performance* Art, 28.2, May 2006, 18–26.

Amer, Ghada and Maura Reilly. *Ghada Amer: Colour Misbehaviour*, New York: Cheim & Reid, 2010,

Amer, Sahar. *What is Veiling?*, Chapel Hill: University of North Carolina Press, 2014.

Anderson, Benedict. *Imagined Communities: Reflections on the Origin and Spread of Nationalism*, London and New York: Verso, 1986, revised 2006.

Apel, Dora. *War Culture and the Contest of Images*, New Brunswick: Rutgers University Press, 2012.

App, Urs. *The Birth of Orientalism*, Pennsylvania: University of Pennsylvania Press, 2015.

Auricchio, Laura. "Works in Translation: Ghada Amer's Hybrid Pleasures", *Art* Journal, 60.4, Winter 2001, 26–37.

Badovinac, Zdenka. "Future from the Balkans", *October* 159, Winter 2017, 103–118.

Balibar, Étienne. *Saeculum: Culture, religion, idéologie*, Paris: Galilée, 2012.

Barthes, Roland. *Empire of Signs* (1970), trans. Richard Howard, New York: Noonday, 1982.

Bardon, Geoffrey. *Papanya Tula: Art of the Western Desert*, Ringwood: Penguin Australia, 1991.

Bell, Richard. "Bell's Theorem", http://www.kooriweb.org/foley/great/art/bell.html, accessed January 9, 2017.

Bhabha, Homi. *The Location of Culture*, London and New York: Routledge, 1994.

Bishop, Claire. "Delegated Performance: Outsourcing Authenticity", *October*, Vol. 140, Spring 2012, 51–79.

Blauersouth, Lisa, 'Wherein the Author Documents Her Experience as a Porcelain Doll', *Mechademia*, 6, 2011, 312–316.

Bolton, Andrew. ed., *China: Through the Looking Glass*, exh. cat., New York and New Haven and London: the Metropolitan Museum of Art and Yale University Press, 2015.

Bolton, Andrew. ed., *Rei Kawakubo/Comme des Garçons: Art of the in-Between*, exh. cat., New York, New Haven and London: The Metropolitan Museum of Art and Yale University Press, 2017.

Bonyhady, Tim. *Images in Opposition: Australian Landscape Painting 1801–1890*, Oxford and Melbourne: Oxford University Press, 1985, 1991

Bowman, Paul, ed. *The Rey Chow Reader*, New York: Columbia University Press, 2010.

Bowman, Paul. *Beyond Bruce Lee: Chasing the Dragon Through Film, Philosophy, and Popular Culture*, New York: Columbia University Press, 2013.

Breitz, Candice. "Ghada Amer: The Modeling of Desire", *Nka: Journal of Contemporary African Art*, 5, Fall 1996, 14–16.

Breskin, Isabel. "'On the Periphery of Greater World': John Singleton Copley's 'Turquerie' Portraits", *Winterthur Portfolio*, 36.2/3, Summer-Autumn 2001, 97–123.

Bruno, M., 'Cosplay: The Illegitimate Child of S F Masquerades'. *Glitz and Glitter Newsletter*, Millennium Costume Guild. October, 2002; http://millenniumcg.tripod.com/ glitzglitter/1002articles.html.

Buckley, Brad and John Conomos eds. *Companion to Curation*, London: Wiley Blackwell, 2019.

Çandar, Cengiz. "Atatürk's Ambiguous Legacy", *The Wilson Quarterly (1976-)*, 24.2, Autumn, 2000, 88–96.

Cannadine, David. *Ornamentalism: How the British Saw Their Empire*, Oxford: Oxford University Press, 2001.

Carroll, Noëll. "Art and Globalization: Then and Now", *The Journal of Aesthetics and Art Criticism*, 63.1, Winter 2007, 131–143.

Caruana, Wally and Nigel Lendon eds., *Painters of the Wagilag Sisters Story 1937–1997*, exh. cat., Canberra: national Gallery of Australia, 1997.

Caughie, Pamela and Diana Swanson eds. *Virginia Woolf: Writing the World*, Liverpool: Liverpool University Press, 2015.

Chatterjee, Partha. *Nation and Its Fragments: Colonial and Postcolonial Histories*, Princeton: Princeton University Press, 1994.

Chen, Jin-Shiow, 'A Study of Fan Culture: Adolescent Experiences with Animé/manga Doujinshi and Cosplay in Taiwan', *Visual Arts Research*, 33.1, 2007, 14–24.

Chaturvedi Vinayak ed. *Mapping Subultaren Studies and the Postcolonial*, London and New York, 2000.

Cherry, Deborah. "Troubling Presence: Body, Sound and Space in Installation Art of the mid–1990s", *RACAR: revue d'art canadienne/Canadian Art* Review, 25.1/2, 1998, 12–30.

Chow, Rey. *Sentimental Fabulations, Contemporary Chinese Films*, New York: Columbia University Press, 2007.

Chow, Rei. "China as Documentary: Some Basic Questions (inspired by Michelangelo Antonioni and Jia Zhangke)", *Journal of European Studies*, 17.1, 2014, 16–30.

Chiu, Melissa. *Breakout: Chinese Art Outside China*, Milan: Edizioni Charta, 2006.

Chiu, Monica ed. *Drawing New Color Lines: Transnational Asian American Graphic Narratives*, Hong Kong: Hong Kong, 2015.

Cohen, Morton. *Lewis Carroll: A Biography*, New York: Vintage, 1995.

Cole, Teju. *Known and Strange Things*, New York: Random House, 2016.

Cotter, Holland. "In 'China: Through the Looking Glass', Eastern Culture Meets Western Fashion", *The New York Times*, May 7, 2015, https://www.nytimes.com/2015/05/08/arts/design/review-in-china-through-the-looking-glass-eastern-culture-meets-western-fashion.html, accessed July 2, 2017.

Crane, Diana. *Global Culture: Media, Arts, Policy, and Golbalization*, London and New York: Routledge, 2002.

Cruz, Lenika. "*Marco Polo*: Netflix's Critical Flop that Dared to Be Diverse", *The Atlantic*, 20 December, 2014, https://www.theatlantic.com/entertainment/archive/2014/12/in-defense-of-marco-polo/383905/, accessed July 31, 2017.

Dabashi, Hamid. "It Was in China, Late One Moonless Night", *Social* Research, 70.3, Fall 2003, 935–980.

Dadi, Iftikhar. "Shirin Neshat's Photographs as Postcolonial Allegories", *Signs*, 34.1, Autumn 2008, 125–150.

Daftari, Fereshteh. "Beyond Islamic Roots: Beyond Modernism", *RES: Anthropology and Aesthetics*, 43, Spring 2003, 175–186.

Danto, Arthur and Shirin Neshat. "Shirin Neshat", BOMB, 73, Fall 2000, 60–67.

Darznik, Jasmin. "Forugh Farrokhzad: Her Poetry, Life, and Legacy", *The Women's Review of Books*, 23.6, November–December 2006, 21–23.

Darznik, Jasmin. "Forough Goes West: The Legacy of Forough Farrokhzad in Iranian Diasporic Art", *Journal of Middle Eastern Women's Studies*, 6.1, Winter 2010, 103–116.

Davies, Norman. *Vanished Kingdoms: The Rise and Fall of States and Nations*, London: Viking, 2011.

Di Stefano, John. "Moving Images of Home", *Art* Journal, 61.4, Winter, 2002, 38–51.

Downey, Anthony. "Children of the Revolution: Contemporary Iranian Photography", *Aperture*, 197, Winter 2009, 38–45.

Eicher, Joanne ed. *Dress and Ethnicity*, Oxford and New York: Berg, 1995.

Eliot, George. *Silas Marner* (1861), London: Macmillan, 1984.

Elwes, Catherine. *Installation and the Moving Image*, New York: Columbia University Press, 2015.

English, Darby. *How to See a Work of Art in Total Darkness*, Cambridge MA: MIT Press, 2007.

Eyene, Marie-Christine. "Ghada Amer, du porno populaire à l'érotologie arabe", *Africultures*, 63, 2002, 89–96.

Farhat, Maymanah. "Imagining the Arab World: The Fashioning of the 'War on Terror' through Art", *Callaloo*, 32.4, Winter 2009, 1223–1231.

Fokdis, Marina. "Hijacking Cultural Policies: Art as a Healthy Virus within Social Strategies of Resistance", *The International Journal of Social and Cultural Practice*, 51.1, Spring 2007, 58–67.

Foster, Hal et. al. "Questionnaire on 'The Contemporary'", October 130, Fall 2009, 3–124.

Frank, Peter. "Mona Hatoum: Hair There and Every Where", *Art on Paper*, 8.5, May/June 2004, 40–42.

Frankel, David. "Ghada Amer: Deitsch Projects", *Artforum*, February 2002, 130–131.

Gagné, Isaac. "Urban Princesses: Performance and 'Women's Language' in Japan's Gothic/Lolita Subculture", *Journal of Linguistic Anthropology*, 18.1, June 2006, 130–150.

Galbraith, Patrick and Thomas Lamarre. "Otakuology: A Dialogue", *Mechademia*, 5, 2010, 360–374.

Geczy, Adam. "The Air-Conditioned Desert: Curating Aboriginal Art", *Art Monthly Australia*, 250, 2012, 44–46.

Geczy, Adam. *Fashion and Orientalism: Dress, Textiles and Culture from the 17th to the 21st Century*, London and New York: Bloomsbury, 2013.

Geczy, Adam. "Who owns dots? Or, spirituality for the highest bidder, or, can you buy aura?", *Contemporary Art + Culture Broadsheet*, 42.3, 2013, 16–19.

Geczy, Adam. *The Artificial Body in Fashion and Art: Marionettes, Models and Mannequins*, London and New York: Bloomsbury, 2017.

Geczy, Adam and Jacqueline Millner. *Fashionable Art*, London and New York: Bloomsbury, 2015.

Geczy, Adam and Vicki Karaminas. "Rei Kawakubo's Deconstructivist Silhouette" in *Critical Fashion Practice: From Westwood to Van Beirendonck*, London and New York: Bloomsbury, 2017.

Ghivan, Robin. "The Fantasy of China: Why the new Met exhibition is a big, beautiful lie", *Washington Past*, May 2, 2015, https://www.washingtonpost.com/news/arts-and-entertainment/wp/2015/05/05/the-fantasy-of-china-why-the-new-met-exhibition-is-a-big-beautiful-lie/?utm_term=.14307480f916, accessed July 2, 2017.

Goldstein-Gidoni, Ofra. "Kimono and the Construction of Gendered and Cultural Identities", *Ethnology*, 38.4, Autumn 1999, 351–370.

Gruber, Christiane and Sune Haugbolle eds. *Visual Culture in the Modern Middle East*, Indiana: Indiana University Press, 2013.

Hadimioglu, Çagla. "Black Tents", *Tresholds*, 22, 2001, 18–25.

Halle, Randall. *The Europeanization of Cinema*, Bloomington: University of Illinois Press, 2014.

Hanru, Hou. "In Defense of Difference: Notes on Magiciens de la Terre, Twenty-five Years later", *Yishu: Journal of Contemporary Chinese Art*, 13.3, 2014, 7–18.

Hao, Sophia Yadong. "Memory is Not Transparent", *Art Journal*, 70.3, Fall 2011, 46–70.

Hassan, Ihab. *Between the Eagle and the Sun: Traces of Japan*, Tuscaloosa and London: University of Alabama Press, 1996.

Hatoum, Mona. *Measures of Distance*, https://www.youtube.com/watch?v=WXMFZlkKPzw

Hegel, G. W. F. *Lectures on the History of Philosophy*, trans. E.S. Haldane and Frances E. Simson, Lincoln: University of Nebraska Press, 1995, vol 1.

Hendrix, Grady. "A Brief History of the Ip Man Movie Craze", *Film Comment*, 49.5, September–October 2013, 57.

Hesse, Hermann. *Aus Indien*, Frankfurt am Main: Suhrkamp, 1980.

Holland, Allison. "From Gothic Lolita to Radiant Shaman: The Development of Mariko Mori's Ethereal personae", *US-Japan Women's Journal*, 40, 2011, 3–28.

Hume, Lynne. *The Religious Life of Dress: Global Fashion and Faith*, London and New York: Bloomsbury, 2013.

Inal, Onur. "Women's Fashions in Transition: Ottoman Borderlands and the Alnglo-Ottoman Exchange of Costumes", *Journal of World History*, 22.2, June 2011, 243–272.

Ito, Mizuko, Daisuke Okabe and Izumi Tsuji eds., *Fandom Unbound*, New Haven and London: Yale University Press, 2012.

Iyer, Pico. *Sun After Dark: Flights From the Foreign*, New York: Vintage, 2004.

Jennings, Gabrielle ed., *Abstract Video*, Los Angeles: University of California Press, 2015.

Johnson, Ian. "Novels From China's Moral Abyss", *New York Review*, June 22, 2017, 53–55.

Judd, Barry Adam Geczy and Jakelin Troy (with contributions by Mick Adams and Len Collard). "Letter from the Editors", *ab-Original: Journal of Indigenous Studies and First Peoples' and First Nations' Cultures*, 1.1, 2017, v–xiv.

Judt, Tony. *Reappraisals: Reflections on the Forgotten Twentieth Century*, New York: Penguin Press, 2008.

Kadosh Otmazgin, Nissim. *Regionalizing Culture: The Political Economy of Japanese Popular Culture in Asia*, Honolulu: The University of Hawaii Press, 2014.

Kawamura, Yuniya. *The Japanese Revolution in Paris Fashion*, Oxford and New York: Berg, 2004.

Kenzaburo, Oe. *Okinawa Notes*, Tokyo: Iwanami Shoten, 1970.

Kezer, Zeynep. *Building Modern Turkey*, Pittsburgh: University of Pittsburgh Press, 2015.

Khaire, Mikti. "The Indian Fashion Industry and Traditional Indian Crafts", *The Business History* Review, 85.2, 2011, 345–366.

Kiliç, Zeynep and Jennifer Petzen. "The Culture of Multiculturalism and Racialized Art", *German Politics & Society*, 31.2, Summer 2013, 49–65.

King, Homay. "Lost in Translation", *Film Quarterly*, 59.1, Fall 2005, 45–48.

King, Homay. *Lost in Translation: Orientalism, Cinema, and the Enigmatic Signifier*, Durham: Duke University Press, 2010.

Kondo, Dorinne. *About Face: Performing Race in fashion and Theater*, New York and London: Routledge, 1997.

Kotani, Mari. "Doll Beauties and Cosplay", *Mechandemia*, 3, 2008, 49–63.

Kristeva, Julia. *Powers of Horror: An Essay on Abjection*, Trans. Leon Roudiez, New York: Columbia University Press, 1982.

Leskovich, Anne Marie and Carla Jones, "What Happens When Asian Chic Becomes Chic in Asia?", *Fashion Theory*, 7.3/4, 2003, 281–299.

Leurs, Koen. *Digital Passages*, Amsterdam: Amsterdam University Press, 2015.

Lunning, Frenchy. "Under the Ruffles: Sojo and the Morphology of Power", *Mechademia*, 6, 2011, 3–19.

Makdisi, Ussama. "Ottoman Orientalism", *The American Historical Review*, 107.3, 2005, 1–27.

Malek, Amy. "Memoir as Iranian Exile Cultural Production: A Case Study or Marjane Satrapi's 'Persepolis' Series", *Iranian Studies*, 39.3, September 2006, 353–380.

Mallinson, James and Mark Singleton trans. and ed. "Introduction", *Roots of Yoga*, London: Penguin Random House, 2017.

Mansoor, Jaleh. Mansoor, "A Spectral Universality: Mona Hatoum's Biopolitics of Abstraction", *October*, 133, Summer 2010, 49–74.

Margalit, Avishai. "Miral: *Miral-Miriam*", *October*, No. 136, Spring 2011, 197–201.

Marsh, Anne. "Nasim Nasr: The Language of the Veil", *Contemporary Visual Art + Culture Broadsheet*, 44.1, 2015, 40–43.

Marshik, Celia. *At the Mercy of their Clothes*, New York: Columbia University Press, 2017.

Martin, Lenore. *Great Decisions*, Foreign Policy Association, 2014.

McGray, Douglas. "Japan's Gross National Cool", *Foreign Policy*, June/July, 2002, http://foreignpolicy.com/2009/11/11/japans-gross-national-cool/.

McLean, Ian ed. *How Aborigines Invented the Idea of Contemporary Art*, Brisbane and Sydney: IMA and Power Publications, 20

McNearney, Allison. "'China: Through the Looking Glass' is the Met's Most Popular Fashion Show Ever", *The Daily Beast*, 9 June, 2015, http://www.thedailybeast.com/china-through-the-looking-glass-is-the-mets-most-popular-fashion-show-ever, accessed 2 July, 2017.

Meryem Shaw, Wendy. "Ambiguity and Audience in the Films of Shirin Neshat", *Third Text*, 15.57, 2001, 43–52.

Minh-ha, Trinh. *When the Moon Waxes Red: Representation, Gender and Cultural Politics*, London and New York: Routledge, 1991.

Minh-ha, Trinh. *Elsewhere, Within Here: Immigration, Refugeeism and the Boundary Event*, London and New York: Routledge, 2011.

Minh-ha, Trinh. *Lovercidal: Walking with the Disappeared*, New York: Fordham University Press, 2016.

Mirzoeff, Nicholas ed. *The Visual Culture Reader*, London and New York, 1998.

Moghadam, Valentine. "Islamic Feminism and its Discontents: Toward a Resolution of the Debate", *Signs*, 27.4, Summer, 2002, 1135–1171.

Mona Hatoum: The Entire World as a Foreign Land, exh. cat., London: Tate Gallery, 2000.

Mona Hatoum, exh cat., Ostfindern-Ruit: Hatje Cantz Verlag, 2004.

Monteiro, Stephen. *Cinema Culture and the Art of Warhol, Rauschenberg, Hatoum and Gordon*, Edinburgh: Edinburgh University Press, 2016.

Moore, L. "Frayed Connections, Fraught Projections: The Troubling Work of Shirin Neshat", *Women: A Cultural Review*, 13.1, 2002, 1–18.

Morson, Gary Saul. "Will We Ever Pin Down Pushkin?", *New York Review of Books*, March 23, 2017, 43–45.

Moses, Alexa. "Shadow cast over a painter's legacy", *Sydney Morning Herald*, July 25, 2005, http://www.smh.com.au/news/arts/shadow-cast-over-a-painters-legacy/2005/07/24/1122143723289.html.

Motlagh, Amy and Sara Dolatabadi. "Child of the Revolution: Sara Dolatabadi and the Esthetics of memory (An Interview), *Alif: Journal of Comparative Poetics*, 30, 2010, 240–260.

Movahedi, Siamak and Gohar Homayounpour, "Fort!/Da! Through the Chador: The Paradox of the Woman's Invisibility and Visibility", in Wolfgang Müller-Funk, Ingrid Scholz-Strasser and Herman Westerink eds., *Psychoanalysis, Monotheism and Morality*, Leuven: Leuven University Press, 2013, 113–132.

Naaman, Dorit. "Middle Eastern Media Arts: An Introduction", *Framework: The Journal of Cinema and Media*, 43.2, Fall 2002, 5–13.

Naficy, Hamid. "Veiled Voice and Vision in Iranian Cinema: The Evolution of Rakhshan Benietemad's Films", *Social Research*, 67.2, Summer 2000, 559–576.

Naficy, Hamid. "Making Films with an Accent: Iranian Émigré Cinema", *The Journal of Cinema and* Media, 43.2, Fall 2002, 15–41.

Naipaul, V. S. *The Mimic Men*, London: André Deutsch, 1967.

Naipaul, V. S. *India: A Wounded Civilization*, London: André Deutsch, 1977.

Naipaul, V. S. *Finding the Centre: Two Narratives*, London: André Deutsch, 1984.

Naipaul, V. S. *The Enigma of Arrival*, New York: Viking, 1987.

Naipaul, V. S. *India: A Million Mutinies Now*, New York: Viking, 1990.

Naipaul, V. S. *The Writer and His World: Essays*, London: Picador, 2002.

Naipaul, V. S. *Magic Seeds*, New York and Toronto: Knopf, 2004.

Namjoo, Mohsen, Shirin Neshat and Siavash Karimzadegan, "Mohsen Namjoo", *BOMB*, 119, Spring 2012, 82–87.

Napier, Susan. *From Impressionism to Anime*, New Tork: Palgrave Macmillan, 2007.

Navab, Aphrodite. "Unsaying Life Stories: The Self-Representational Art of Shirin Neshat and Ghazel", *The Journal of Aesthetic* Education, 41.2, Summer 2007, 39–66.

Nereid, Camilla. "Kemalism on the Catwalk: The Turkish Hat Law of 1925", *Journal of Social History*, 44.3, Spring, 2011, 707–728.

Neshat, Shirin. "زَنان†خدا†ُهُویَت†مَخمى (Women of Allah: Secret Identities)", *Grand Street*, 62, Fall 1997, 140–145.

Neshat, Shirin. "Art in Exile" (lecture, TEDWomen 2010, December 2010), http://www.ted.com/talks/shirin_neshat_art_in_exile?language=en

Neshat, Shirin and Babak Ebrahimian. "Passage to Iran", *PAJ: A Journal of Performance Art*, 24.3, September 2002, 44–55.

Neylon, John. "Nasim Nasr: The Home, The Habit", *Art Collector*, 81, July–September, 2017, 216.

Nietzsche, Friedrich. in *Werke*, Munich: Verlag Das Bergland-Buch, 1985, v. 4.

Nixon, Mignon. "After Images", October, 83, Winter 1998, 114–130.

Noori Shirazi, Somayeh. "Mundana Moghaddam: 'Chelgis II' and the Iranian Woman", *Women's Art Journal*, 33.1, Spring/Summer 2012, 10–16.

Novak, Maximillian. "Crime and Punishment in Defoe's 'Roxana'", *The Journal of English and Germanic Philology*, 65.3, July 1966, 445–465.

Odenthal, Johannes and Claudia Hahn-Raabe eds. *Zeitgenossische Kunst aus der Turkei*, Göttingen: Steidl Verlag, 2009.

Okabe, Daisuke. *Fandom Unbound: Otaku Culture in a Connected* World, New Haven and London: Yale University Press, 2012.

Okeke-Agulu, Chika. "Politics by Other means: Two Egyptian Artsits, Gazbia Sirry and Ghada Amer", *Nka: Journal of Contemporary African Art*, 25, Winter 2009, 8–29.

Olson, Emelie. "Muslin Identity and Secularism in Contemporary Turkey: 'The Headscarf Dispute'", *Anthropological Quarterly*, 58.4, October 1985, 161–171.

Ottoson, Ase. *Making Aboriginal Men and Music in Central Australia*, London and New York: Bloomsbury, 2016.

Palmer, Alexandra ed. *A Cultural History of Dress and Fashion in the Modern Age*, London and New York: Bloomsbury, 2017.

Pamuk, Orhan. *Other Colours: Writings on Life, Art, Books and Cities*, trans. Maureen Freely, London: Faber and Faber, 2007.

Peirson-Smith, Anne. "Fashioning the Fantastical Self: An Examination of the Cosplay Dress-Up Phenomenon in Southeast Asia", *Fashion Theory*, 17.1, 2013, 77–112.

Pellizzi, Francesco. "Mésaventures de l'art: Premières impressions des Magiciens de la Terre", *RES: Anthropology and Aesthetics*, 17/18, Spring–Autumn, 1989, 198–207.

Pincus-Witten, Robert. "Ghada Amer", *Artforum*, Summer 2014, 364–365.

Pollock, Griselda. "moments and Temporalities of the Avant-Garde 'in, of, and from the feminine'", *New Literary History*, 41.4, Autumn 2010, 795–820.

Pratt Ewing, Katherine. "Between Cinema and Social Work: Diasporic Turkish Women and the (Dis)Pleasures of Hybridity", *Cultural Anthropology*, 21.2, May 2006, 265–294.

Pym, Anthony. *Method in Translation Theory*, Manchester: St Jerome Publishing, 1998.

Rahman, Najat. *In the Wake of the Poetic: Palestinian Artists After Darwish*, Syracuse: Syracuse University Press, 2015.

Reilly, Maura. *Writing the Body: The Art of Ghada Amer*, New York: Gregory Miller, 2010.

Rimbaud, Arthur. letter to Georges Izambard, May 13, 1871. http://www.mag4.net/Rimbaud/Documents1.html, accessed May 25, 2017.

Roach-Higgins, Mary Ellen, Joanne Eicher, and Kim Johnson eds., *Dress and Identity*, New York: Fairchild, 1995.

Ross, Christine. "Redefinitions of Abjection in Contemporary Performances of the Female Body", *RES: Anthropology and* Aesthetics, 31, Spring 1997, 149–156.

Roy, Arundhati. *The God of Small Things*, London: Random House, 1997.

Roy, Arundhati. *The Cost of Living*, London: Harper Collins, 1999.

Roy, Arundhati. *The Ministry of Utmost Happiness*, London: Random House, 2017.

Roy, Arundhati. *The Doctor and the Saint: Caste, Race, and Annihilation of Caste*, Chicago: Haymarket Books, 2017.

Saadi-Nejd, Manya. "Mythological Themes in Iranian Culture and Art: Traditional and Contemporary Perspectives", *Iranian Studies*, 42.2, April 2009, 231–246.

Said, Edward. *Orientalism: Western Conceptions of the Orient*, (1978) Harmondsworth: Penguin, 1991.

Said, Edward. *Culture and Imperialism*, (1993) London: Vintage, 1994.

Said, Edward. *Reflections on Exile and Other Essays*, Cambridge MA: Harvard University Press, 2000.

Salle, David. "Clothes That Don't Need You", *The New York Review of Books*, Septermber 28, 2017, 10–14.

Sandhu, Arti. *Indian Fashion: Tradition, Innovation, Style*, London and New York: Bloomsbury, 2015.

Sell, Cathy. "Manga Translation and Interculture", *Mechademia*, 6, 2011, 93–108.

Sheren, Ila. *Portable Borders: Performance Art and Politics on the US Frontera since 1984*, Austin: University of Texas Press, 2015.

Shohat, Ella. *On the Arab-Jew, Palestinian, and Other Displacements*, London: Pluto Press, 2017.

Shohat, Ella and Evelyn Alsultany. *Between the Middle East and the Americas: The Cultural Politics of Diaspora*, Michigan: University of Michigan Press, 2013.

Silberstein, Rachel. "Andrew Bolton, *China: Through the Looking Glass*", CAA Reviews, November 2, 2016, http://www.caareviews.org/reviews/2755#.WVsqMxOGPOQ, accessed July 5, 2017.

Sloterdijk, Peter. *Im Weltinnenraum des Kapitals*, Frankfurt am Main: Suhrkamp, 2006.

Smith, Terry. "Contemporary Art and Contemporaneity", *Critical* Inquiry, 32.4, Summer 2006, 681–707.

Spears, Dorothy. "Evidence of a Life Lived", *Art on Paper*, 10.3, January/February 2006, 64–66.

Spivak, Gayatri Chakravorty. *A Critique of Postcolonial Reason: Toward a History of the Vanishing Present*, Cambridge MA: Harvard University Press, 1999.

Spivak, Gayatri Chakravorty. *An Aesthetic Education in the Era of Globalization*, Cambridge MA: Harvard University Press, 2012.

Steimatsky, Noa. "The Cinecittà Refugee Camp", *October* Vol. 128, Spring 2009, 23–50.

Tarlo, Emma. *Visibly Muslim*, Oxford and New York: Berg, 2010.

Tembeck, Tamar. "Mona Hatoum's Corporeal Xenology", Thresholds, 29, Winter 2005, 57–60.

Tharoor, Shashi. *An Era of Darkness: The British Empire in India*, London: Aleph, 2016.

Tharoor, Shashi. *Inglorious Empire: What the British Did to India*, London: Allen Lane, 2018.

Thein, Helen. "Fremdes Begehren: Repräsentationsformen transkultureller Beziehungen", *Zeitschrift für* Germanistik, 12.3, 2002, 642–643.

Trent, Mary. Book Review of *Ghada Amer* by Maura Reilly, *Women's Art Journal*, 33.2, Fall/Winter 2012, 46–47.

Vojdik, Valorie. *Masculinities and the Law*, New York: New York University Press, 2012.

Wahl, Chris. *Preserving and Exhibiting Media Art: Challenges and Perspectives*, Amsterdam: Amsterdam University Press, 2013.

Wallach, Amei. "Missed Signals Nuance and the Reading of Immigrant Art", *American Art*, 20.2, Summer 2006, 126–133.

Walton, Alice. "How Yoga is Spreading in the U.S.", *Forbes* March 15, 2016, https://www.forbes.com/sites/alicegwalton/2016/03/15/how-yoga-is-spreading-in-the-us/#704ca61d449f

Williams, Patrick and Laura Chrisman. *Colonial Discourse and Post-Colonial Theory*, New York: Columbia University Press, 1994.

Winegar, Jessica. "In Many World: A Discussion with Egyptian Artist Sabah Naeem", *Meridians*, 2.2, 2002, 146–162.

Winegar, Jessica. "The Humanity Game: Art, Islam, and the War on Terror", *Anthropological* Quarterly, 81.3. Summer 2008, 651–681.

Winge, Therèsa, 'Costuming the Imagination: Origins of Anime and Cosplay', *Mechademia*, 1, 2006, 65–76.

Winge, Therèsa. "Undressing and Dressing Loli: A Search for the Identity of the Japanese Lolita", *Mechandemia*, 3, 2008, 47–63.

Woolf, Virginia. "A Room of One's Own", 1928, http://gutenberg.net.au/ebooks02/0200791h.html

Yilmaz, Hale. *Becoming Turkish: Nationalist Reforms and Cultural Negotiations in Early Republican Turkey (1923–1945)*, Syracuse: Syracuse University Press, 2013.

Yu, Marisa. "Politics of the Light Object: Transformative Architectural Installations", *Journal of Architectural Education (1984–)*, 63.1, October 2009, 107–119.

Zizek, Slavoj. *The Ticklish Subject: The Absent Centre of Political* Ontology, London and New York: 1999.

Zizek, Slavoj. *Less Than Nothing: Hegel and the Shadow of Dialectical Materialism*, London and New York: Verso, 2012.

Zizek, Slavoj. *Against the Double Blackmail: Refugees, Terror and Other Troubles With Neighbours*, London: Penguin/Allen Lane, 2016.

Zizek, Slavoj. *Disparities*, London and New York: Bloomsbury, 2016.

Filmography

Chinatown, dir. Roman Polanski, Paramount, 1974.

The Doll, dir. Susannah O'Brien, Sahara Productions, 2016.

The First Monday in May, dir. Andrew Rossi, Madman Entertainment, 2016.

Game of Death (incomplete; dir. Bruce Lee, Golden Harvest, 1972.

In the Mood for Love, dir. Wong Kar-wai, Universal Pictures, 2000.

Ip Man, dir. Wilson Yip, Mandarin Films, 2008.

Ip Man 2, dir. Wilson Yip, Mandarin Films, 2010.

Ip Man 3, dir. Wilson Yip, Pegasus Motion Pictures, 2015.

Ip Man: The Final Fight, dir. Herman Yau, Emperor Motion Pictures, 2013

Kill Bill, dir. Quentin Tarantino, Miramax, part 1, 2003; part 2004.

The Legend is Born: Ip Man, dir. Herman Yau, Mei Ah Entertainment, 2010.

Lion, dir. Garth Davis, Weinstein, 2016.

Lost in Translation, dir. Sofia Coppola, Focus Features/Universal, 2003.

Marco Polo, created by John Fusco, Weinstein/Netflix, 2014–2016.

Rocky III, dir. Sylvester Stallone, MGM/UA Entertainment, 1982.

Rocky IV, dir. Sylvester Stallone, MGM/UA Entertainment, 1985.

Star Wars: Rogue One, dir. George Lucas, Lucasfilm, 2016.

Temptress Moon, dir. Chen Kaige, Tomson and Miramax, 1996.

Westworld, dir. Michael Crichton, Metro-Goldwyn Mayer, 1973.
Westworld, created by Jonathan Nolan and Lisa Joy, HBO, 2016.

Websites and links not cited above
http://www.ahmetogut.com
http://www.al-monitor.com/pulse/originals/2017/03/turkey-germany-merkel-rally-ban-
 appeasement.html
http://bb9.berlinbiennale.de/participants/altindere/
http://www.dw.com/en/report-merkel-and-rutte-made-concrete-promises-with-turkey-
 over-refugee-quota/a-37913580.
https://fashionunited.in/fashion-industry-statistics-india
https://www.haticeguleryuz.com
https://www.mca.com.au/collection/work/2015.1/
http://momaps1.org/exhibitions/view/383
http://www.pilotgaleri.com/en/artists/detail/30
"Rei Kawakubo/Comme des Garçons: Art of the In-Between", https://www.youtube.
 com/watch?v=4ghlzREu1fE.
https://www.rottentomatoes.com/tv/marco_polo/s01/reviews/
http://servetkocyigit.net

INDEX

9 781350 175334